THE POLITICS OF URBAN BEAUTY

THE POLITICS
OF URBAN BEAUTY

NEW YORK & ITS ART COMMISSION

MICHELE H. BOGART

THE UNIVERSITY OF CHICAGO PRESS
Chicago & London

MICHELE H. BOGART
is professor of art history at the State University of New York at Stony Brook.
She was vice president of the Art Commission of the City of New York
from 1999 to 2003 and is a member of the Conservation Advisory group
to the commission. She also is the author of *Public Sculpture and the Civic
Ideal in New York City, 1890–1930* and *Artists, Advertising, and the Borders
of Art,* both published by the University of Chicago Press.

The University of Chicago Press, Chicago 60637
The University of Chicago Press, Ltd., London
© 2006 by The University of Chicago
All rights reserved. Published 2006
Printed in the United States of America
15 14 13 12 11 10 09 08 07 06 1 2 3 4 5

ISBN-13: 978-0-226-06305-8 (cloth)
ISBN-10: 0-226-06305-4 (cloth)

Library of Congress Cataloging-in-Publication Data

Bogart, Michele Helene, 1952–
 The politics of urban beauty : New York and its Art Commission /
Michele H. Bogart.
 p. cm.
 Includes bibliographical references and index.
 ISBN 0-226-06305-4 (cloth : alk. paper)
 1. Art Commission of the City of New York—History. 2. Public art—
New York (State)—New York. 3. Urban beautification—New York
(State)—New York. 4. Art, American—New York (State)—New
York—20th century. I. Title.

N8845 .N7B64 2006
706'.07471—dc22

 2006005611

In memory of my father,

L E O B O G A R T

(September 23, 1921–October 15, 2005)
For me, the greatest New Yorker

CONTENTS

ILLUSTRATIONS

ACKNOWLEDGMENTS

Although I had studied the Art Commission of the City of New York while working on other projects, it would not have occurred to me to write this book had I not myself joined the commission and engaged in the politics of public beauty. Hence I owe much to my friend Deborah Gardner of Hunter College, who first recommended me for the lay member's slot. I am grateful as well to Jennifer J. Raab, president of Hunter College and former chairwoman of the Landmarks Preservation Commission, for mentoring me through the lengthy appointments process. That process initiated an extraordinary intellectual journey that has culminated in this publication.

Many people and institutions helped to make this book possible. A John Simon Guggenheim Memorial Fellowship in 2001–2 provided me with financial support and that great gift of time, which enabled me to draft my manuscript. I am indebted as well to my home institution, the State University of New York at Stony Brook, and to its president, Shirley Strum Kenney, Provost Robert McGrath, Dean James Staros, and former Art Department Chair James Rubin for a sabbatical leave that enabled me to finish. The ever helpful staff of the Stony Brook and New York University libraries, the Archives of American Art (especially Joy Wiener and Justin Brancato), the New York Public Library, the Brooklyn Public Library, and Municipal Reference Library all helped to make research a productive and pleasurable experience.

I could never have completed the project without the support and assistance of the staff of the Art Commission of the City of New York. I thank Art Commission Executive Director Jackie Snyder and especially her predecessor, Deborah Bershad, for facilitating my research. I appreciate the help provided by former Art Commission Deputy Directors Lynn Bodnar, Katherine Romero, Victoria Jennings, and Molly Gaynor, and by Capital Projects Coordinator Meredith Topper. Chief of staff to the deputy mayor for administration, Nanette Smith, and her assistant, Degan Mercado; the Art Com-

mission's project manager, Sara Lev; and Art Commission interns Widad Echaly, Laura Notaro, and Jenina McCormack deserve special thanks for all that they did to supply me with images. The staff's hard work and commitment have been key to the success of the Art Commission. I want to acknowledge here my deep appreciation for all that they do.

The members of the Art Commission who sat alongside me—Estrellita Bograd Brodsky, Barbara Fleischman, Bud Konheim, Abby Milstein, Otis Pratt Pearsall, Jean Rather, Nancy Rosen, Robert Rubin, Ted Shen, and Don Walsh—were inspiring, dedicated, and wonderfully good-humored colleagues. I will never forget the mundane experiences—or the memorable ones: standing in Union Square, attempting to scrutinize site plans and blueprints during a monster thunderstorm; riding to a site visit in an un-air-conditioned police bus in 102 degree temperatures; scrutinizing the old City Island Bridge in bone-chilling damp and fog; and cowering under the boardroom table in the aftermath of the horrible murder of City Councilman James Davis. I applaud Art Commission President Joyce Frank Menschel and former president Jean Parker Phifer for all that they have contributed. Jean also was a great listener who made really helpful comments when I was thrashing out my ideas. I thank her for all the encouragement.

Many individuals involved with New York City's public cultural and political spheres helped me better to understand the challenges of designing the municipal built environment, past and present. I am grateful to the Art Commission liaisons and former liaisons who helped to position projects in context and perspective: Frederic Bell, American Institute of Architects; Michele Cohen, Board of Education; Susan Chin, Department of Cultural Affairs; Cathie Behrend and Charlotte Cohen, Percent for Art; Michael Cetera, Department of Design and Construction; John Leonforte, Department of Environmental Protection; Bonnie Koeppel, John Krawchuk, Jonathan Kuhn, Amie Uhrynowski, and George Vellonakis, Department of Parks and Recreation; Mike Friedlander, Department of Sanitation; Nancy Wright, Department of Transportation; Terri Elizabeth Bahr and Sandra Tomás, Economic Development Corporation; Greg Mink, Health and Hospitals Corporation; and Sandra Bloodworth and Hollie Wells, Metropolitan Transit Authority. I would also like to express appreciation to: Commissioner Adrian Benepe and Deputy Commissioner Amy Freitag of the Department of Parks and Recreation; Eve Michel, vice president, Economic Development Corporation; Judith Bernard, Department of City Planning; Councilwoman Eva Moskowitz; former councilman, Ken Fisher; Conservation Advisory Group members Joseph Bresnan, Lisa Bruno, Phyllis Cohen, Stephen Gottlieb, and Shelley Sass; Art Commission Associates and Friends Kent Barwick, Constance Christensen, Emily Folpe, Richard Haas, Ellen LeCompte,

Nicholas Quennell, Frank Sanchis III, Murial Silberstein-Storfer, Whitney North Seymour, Jr., Don Weston, and John Willenbecher; art commissioners Alice Aycock, Signe Nielsen, and LeAnn Shelton. I learned much from the earnest activism of Kate Wood and Arlene Simon of Landmarks West! and John Reddick, Cityscape Institute.

Thanks are due to the special scholars who have patiently listened to me rant and provided constant encouragement: Josh Brown, Erika Doss, Vivien Green Fryd, Diana Linden, Peggy Olin, Mary Panzer, Jan Seidler Ramirez, Harriet Senie, Ellen Wiley Todd, and Sally Webster. Casey Blake, Derrick Cartwright, Wanda Corn, John Davis, Barbara Frank, Krin Gabbard, Ann Gibson, Michael Leja, Gail Levin, Margaretta Lovell, Karal Ann Marling, Joan Marter, Katharine Martinez, Angela Miller, Nick Mirzoeff, Anita Moskowitz, Maren Stange, Alan Trachtenberg, Alan Wallach, Barbara Weinberg, and Gwendolyn Wright have offered much-appreciated friendship and professional support. Sarah Burns lives in Indiana but must surely consider herself to be an honorary Friend of the Art Commission. My friends Kathy Capsouto, Barbara and Joe Ciccone, Sandra Kaplan, Lisa Karlin and Jim Kunin, Greg Nolan, Miriam Mandelbaum, and friends and faculty from the Third Street Music School Settlement have kept me on track by reminding me that there is life beyond work.

I also want to express my gratitude to my editor Susan Bielstein, whose encouragement and constructive suggestions helped to make my journey into print an extremely smooth and pleasant one. Thanks as well to Anthony Burton for his help and expertise during the publication process and to Senior Manuscript Editor Yvonne Zipter for her incisiveness and good humor. The two anonymous readers for the Press offered insightful comments and extremely helpful recommendations, for which I am very grateful.

My family, as always, has been outstanding. Although he probably doesn't realize it, my son Nick Pauly has encouraged me a great deal by showing occasional pride in my Art Commission activities. By virtue of being both a teenager and a really good kid, he has generously provided me with lots of stress-free time in which to do my work. I hope that some day he'll read this book. My husband Philip Pauly commented on an early draft of the manuscript and offered his usual expert judgment, thus enabling me really to get going. Gardener, carpenter, electrician, plumber, geek, and intellect extraordinaire, he continues to be the ideal spouse, and unquestionably one of the kindest. My brother Greg Bogart listened patiently from afar. My parents Agnes and Leo Bogart both read through the entire manuscript and made extensive comments. They have been my greatest supporters, always encouraging me to do my best but not to get hysterical about it. In my eyes, they are the greatest New Yorkers of them all.

ABBREVIATIONS

ACNY	Art Commission of the City of New York
BID	Business Improvement District
BOA	New York City Board of Education
DCA	New York City Department of Consumer Affairs
DDC	New York City Department of Design and Construction
DEC	New York City Department of Environmental Conservation
DOITT	Department of Information Technology and Telecommunications
DOT	New York City Department of Transportation
DPR	New York City Department of Parks and Recreation
EDC	New York City Economic Development Corporation
FAF	Fine Arts Federation
FAP	Federal Art Project
LMDC	Lower Manhattan Development Corporation
LPC	New York City Landmarks Preservation Commission
MAS	Municipal Art Society
MTA	Metropolitan Transit Authority
NSS	National Sculpture Society
USPOD	U.S. Post Office Department
WPA	Works Progress Administration

INTRODUCTION

The Art Commission of the City of New York, custodian of the city's aesthetic realm, is a governmental oddity with a long, colorful history. Although ostensibly independent, it is part of the municipal administration. The commission was mandated by the City Charter in 1898 when Greater New York City itself was created, and given authority over the city's built environment. The commission has engaged major political figures as well as those in the arts and in community affairs.

From 1998 until mid-2003, as a member of this commission, I traveled two or three times a month to City Hall, a Federal-era building as fine as a jewel box. I mounted a sweeping double staircase to the second floor, passing the elegant Governor's Room, the city council chambers, and the minority leader's office (fig. I.1). Westward across the stairway is the security barrier leading to the mayor's offices. Gazing skyward, I would admire the exquisite light-filled dome, emblem of the city's grandeur. At the base of the dome a small clerestory hints of a third floor. Ascending a narrow, winding back staircase (no choice here—there is no elevator), I would arrive at the Art Commission's third-floor attic offices, which are ringed with dusty boxes and tall files.

There, on the second Monday and third Wednesday of the month, an assemblage of New Yorkers jams the cramped quarters, pacing the floor, talking animatedly, in groups and on cell phones, propping up large boards and models. For over a century, groups like this have collectively shaped the cityscape—artists, architects, and landscape architects, both the world-famous and the third-rate; engineers; conservators; representatives of community boards; neighborhood civic groups and residents; lawyers; immigrant newsstand operators; corporate businessmen; war veterans; representatives of the Department of Transportation; college interns; Business Improvement District officials; museum directors; dog owners; and an occasional city councilman or agency commissioner.

I

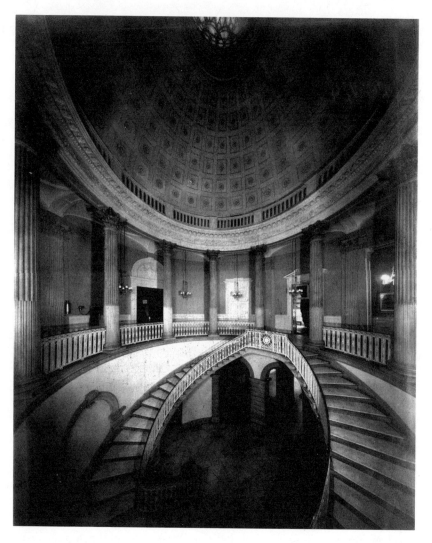

I.1 Interior stair and dome, City Hall, New York, 1939. (Collection of the Art Commission of the
City of New York; photo by Irving Underhill.)

These individuals make the trek upstairs to present projects or testify to
the Art Commission (ACNY), seeking design approval for work on city
property. In the overheated third-floor boardroom (see fig. 4.1), all these
groups must curry favor, so they start out smiling and enthusiastically de-
scribing their projects. Many emerge looking considerably less cheerful as the
result of the give and take. The den of confined space outside the boardroom
also highlights the tensions surrounding the process in which all are engaged:
negotiating the forms and meanings of the public spaces of New York City.

Cities have used a variety of strategies and degrees of regulation to control the appearance of individual aspects of the built environment. For example, authorities in Paris and Washington, D.C., set height limitations. In Jerusalem, the law requires a specific kind of stone that has been used historically for centuries. In the United States, most cities have grown anarchically and present a disorganized appearance. To impose municipal standards of taste or aesthetics is difficult or impossible in private construction, but possible when building on public land.[1]

How should excellence be defined for urban structures erected on municipal property? What kinds of meanings should be conveyed? Should the principles or expectations be any different if those structures are built by individuals whose decisions are guided by perceptions of community will or market demand? Who establishes the standards and enforces them? Both in setting criteria and in implementing their specific applications, the values and short-term perspectives of local residents, pressure groups, and politicians often clash with those of civic elites and of professionals in urbanism, architecture, and the plastic arts. What place should aesthetics have in shaping the municipal landscape, which is determined by many warring practical concerns?

This book is a case history that illuminates these issues as they arise in one of the world's largest cities. It examines an agency that has tried to cope with the perennial problem of maintaining civic order and visual appeal amid the chaos of an urban landscape, a farrago of individual impulses, interests, and tastes. The ACNY's activities reveal the challenges of resolving conflicts between informed and popular tastes in a democratic society.[2]

The ACNY is a singular and somewhat hybrid form of authority, reviewing all works of art designated for city property. It does not function as designer or patron but as evaluator of public art, architecture, and landscape plans. Over the past century, its purview has broadened to include virtually all aspects of the municipal built environment, from parks, playgrounds, courthouses, and prisons to trash receptacles, sidewalks, and access ramps for the disabled.

The ACNY's powers do not extend to structures on private property; it has rarely influenced the design of commercial buildings. At the same time, it represents an unusual and at times uneasy mesh of public and private interests. It is a division of the mayor's office, and a majority of its members are his appointees, yet they serve without pay and in theory at least are not beholden to anyone. It is composed of professionals—two artists, an architect, a landscape architect, and an occasional professor—as well as trustees of three major New York cultural institutions who can serve as long as they choose, plus three mayorally appointed lay members with set terms. Art commissioners are archetypes of expertise, wealth, cultivation, and status. The ACNY is

endowed with a great deal of power. It is symbolic that the commission's work takes place both at the heart of city government and also above it all.

For all its authority as a part of municipal government, the Art Commission has occasionally seemed marginal to it. Its status has not always been apparent or acknowledged. Considering the popular fascination with the so-called New York experience, with skyscrapers, landmarks, and their development, it is noteworthy that few people are aware of an institution that theoretically can determine the appearance of much of what we know as "New York." Even city leaders themselves are not especially familiar with the ACNY's mandate; some who are familiar with it have willfully ignored it. The ACNY's third-floor offices may be viewed metaphorically in relation to another, more troubled aspect of its operations and reputation: the garret-like spaces are tucked away where no one notices.

After climbing three flights of stairs to get there, many visitors find the ACNY literally painful to deal with. This book describes some of the interactions of commissioners and those who seek their approval and argues that the discomfort of reaching this destination is ultimately of public benefit. Urban beauty is a political matter, but I shall demonstrate that New York's public realm does not exclusively reflect the interests of any singularly powerful individual or group, in part because of the ACNY. The commission represents an obstacle without which the only constriction on constructing whatever one chooses would be ownership, will, and circumstance. New York City would look quite different had the ACNY not existed, and, as I will contend, it would be a less appealing place.

In *The Politics of Urban Beauty,* I probe the history of the ACNY's presence and significance in generating the civic images of modern New York City. Many superb analyses of New York City and its architecture already exist, along with case studies of major individual creators and design projects. Other scholars have examined the politics of using public space in New York and other cities. This study examines the historical relationships between New York politics and public design, through a focused examination of how one institution has operated.

Why the Art Commission? One could fruitfully study the Department of Parks and Recreation, the Department of Design and Construction, or other important New York City agencies that are more intimately engaged, as patrons, sponsors, or developers, with the realities of public design. But the work of the ACNY is crucial to understanding the full picture of how municipal art and architecture are generated and city government actually operates.

A study of the ACNY is desirable precisely because it is not like other city agencies, like the Departments of Transportation or Sanitation. It does not initiate, design, or construct public art or architectural projects. Rather, it

evaluates the designs proposed or sponsored by all the other elements of municipal government. The ACNY is an oversight agency, engaged with all the others and with the public. Its members operate on a different level. Members of the ACNY receive very little information about a project's history and context before they review it. Consequently, the reviews are intentionally very superficial. On the positive side, ACNY members theoretically bring no preconceptions or vested interests to the table. They arrive without prejudices and try to judge a design strictly on its aesthetic merits. Working without pay, art commissioners have nothing to lose by disagreeing with their colleagues or with the applicant. Hence the nature and stakes of the discourse are different than within other agencies or in circumstances where practitioners are employees.

Like agencies' design teams or their consultants, ACNY members attend to details—choice of color, quality of materials, horticultural conditions, physical context, and neighboring structures: Is the paint powder-coated? Could granite be substituted for the cast stone? Can women walk on that pavement in high heels? Will the advertising wrapper on that telephone kiosk withstand key scratches and graffiti? Do the neighbors have to look at it? Can more year-round greenery be provided? Who will maintain the plants? How high will the tree grow?

But the ACNY also comes into the discussion with an eye to the impact of these other elements on the urban scene as a whole. It is not that the agencies are not preoccupied with similar discussions or concerns—they are—but that the ACNY, mandated to deal with aesthetics, is technically in the position of pushing matters further. As the court of last resort on the appearance of individual structures, it is the nexus for public discussion about design activity and the cityscape and for negotiating the creation of urban identity.

Given the relatively unauthoritarian stance of New York City government, its generally noninterventionist approach in dealing with public places (compared to Paris, for example, where local and national government maintain strict control), it is rather remarkable that New York City instituted and has maintained a body to regulate the external design of public structures and monuments. The ACNY emerged as a product of the Progressive-era reforms of the turn of the twentieth century and as an organizational outgrowth of the newly consolidated five boroughs of Greater New York. The city charter that articulated the powers of the new municipality provided for a commission that from the outset limited authority, setting up government in opposition to itself in the aesthetic arena.

This book will explain how these developments came to pass, the challenges that ensued, and how they worked to change the face of the city. It explores the histories, institutional structures, work cultures, procedures,

dialogues, and products of the design review process, as they developed over time within the ACNY. Chapter 1 examines conflicts of taste and power in late nineteenth-century New York City, clashes that became particularly intense as the result of efforts to place monuments on municipal property and that resulted in establishing, through the new city charter, the Art Commission of the City of New York. Chapters 2 and 3 spotlight the first three decades of the new century and the new metropolis. Chapter 2 probes how the new commission negotiated the boundaries of its authority over streets, sidewalks, bridges, and other public spaces and struggled to enrich the built environment as a form of what I call "visual culture." Chapter 3 analyzes the ACNY's role in shaping the material culture of New York memory and identity and its members' skirmishes with politicians and ethnic factions over design and placement of memorials and other commemorative forms.

Examining the period from the 1920s into the 1970s, Chapter 4 surveys the ACNY's actions through changing circumstances. The Depression, for example, with its New Deal public art projects, produced new challenges, as the ACNY struggled with shifting artistic styles and political ideologies, class and racial politics, and mayoral hostilities. The chapter highlights the vacillating alliance between the ACNY and the Department of Parks (especially during the long tenure of Commissioner Robert Moses), over design and control of parks and monuments.

Chapter 5 focuses on public aesthetics at the turn of the twenty-first century: the eras of mayors Rudolph W. Giuliani and Michael R. Bloomberg. The city's public landscapes, continuing to be shaped by commercial interests, experienced a revitalization, especially in Manhattan and portions of Brooklyn, but were also shattered by the unthinkable atrocities of September 11, 2001, an event that destroyed a substantial area of downtown Manhattan and reverberated throughout the five boroughs. In this chapter, picture captions amplify stories of certain notable projects from the ACNY's centennial years.

The story of the ACNY is one in which educated professional and economic elites with rarified conceptions of design came to function as part of municipal bureaucracy and influenced the development of New York's municipal (in contrast to commercial) built environment. Its members were able to operate as they did because of the ACNY's peculiar structure and make-up. Throughout the twentieth century, the ACNY remained a bastion of elite-establishment aesthetic ideals; its standards were those established by the alliances of groups of cultivated practitioners, collectors, and institutional leaders, embodied in the persons of the commissioners themselves.

Although the ACNY's taste preferences differed from individual to individual, case to case, and epoch to epoch, they had certain constant features.

The outlook has been governed by principles of nuance, moderation, and restraint. As chapters 2–4 will demonstrate, the simplicity, clarity, and logic deemed "classical" were the marks of quality and authenticity for ACNY members in the early twentieth century. Similar tastes for formal harmony guided ACNY members at the turn of the twenty-first century, but their preferences shifted definitively from a classical idiom to those associated with "high modernism": the complex vision of simplicity epitomized in architecture, for example, by the work of James Stuart Polshek, Richard Meier, and especially Rafael Viñoly and Santiago Calatrava. These aesthetic and intellectual predilections, bred of social class, education, and to some extent (before the 1950s), ethnicity, consistently affected the commission's deliberations.

The commissioners' partialities were not necessarily in line with the tastes and design solutions of the sponsors and designers whose work the ACNY has reviewed. Occasionally conflict was generated through the intersection of the elite-establishment professional and institutional New York art world, represented by ACNY members individually, with another—the municipal bureaucratic public art worlds—with which the ACNY collectively had been formed to engage. The commission, which would reinforce elite influence in the municipal cultural sphere, had emerged, after all, at a turn-of-the-twentieth-century moment when Democratic politicians, responsive to the needs and desires of ethnic and immigrant groups, were challenging the authority of Anglo-American Brahmins in the political sphere. The resulting tensions that inevitably emerged between the cultural leaders and the local organizational/ethnic interests were battled out in the aesthetic arena.

The ascendance and interactions of these opposing forces, affiliations, and aesthetic preferences produced numerous clashes throughout the twentieth century, and the conflict between politics and taste is a crucial theme of this book. While the penetration of elites into municipal bureaucracy was certainly consistent with the dominant cultural tendencies at the start of the twentieth century, it is noteworthy, given the city's democratic and multicultural orientation in the recent present, that such a structure remains in place in the twenty-first.

The ACNY has often prevailed but certainly not always. Just as the book highlights the ongoing elite influence on the public face of the city and the conflicts between taste and power, so too it reveals the limits of elite authority, especially outside of Manhattan. That authority was often challenged by the mayor of New York City. The mayor's shifting stance vis-à-vis the ACNY and the centrality of his role in determining the parameters and the course of urban design cannot be overemphasized.

There are many dimensions to this complex story that I do not consider. Dealing as it does with the "real world" of New York art and politics, this

book is empirical rather than theoretical in emphasis. Specific events serve as points of departure for exploring larger issues: the operations and institutional structures of city government, the intricacies of public urban design, the role of elites in the public sector, and continuities and transformations in notions of sophisticated taste. This analysis does not offer detailed histories of specific commissions. Rather, it examines one segment of the process—the point of contact, among applicants, designers, and city agencies, with the members of the ACNY.

Nor does the book attempt to map out every type of project with which the ACNY engaged; there are simply too many. I have omitted the ACNY's numerous discussions of school-window and play-equipment colors, subway elevator shafts, restroom signage, pump stations, sanitation garages, and day-care facilities, trash receptacles, parking lots, dog runs, park plantings, and salt sheds, among other mundane but extremely important projects. One crucial additional factor that readers must consider is the fact that in the case of architecture, the ACNY's review powers have always only extended to a public building's external face. Spatial layout and programmatic features may be taken into account, but the ACNY cannot approve or disapprove any aspect of them. Such stipulations set limits on what the commission can do.

This book is also not an "anniversary Festschrift." While I think that the ACNY's work has done much to improve the New York built environment, my purpose is not to celebrate the ACNY or the many successful public designs it has helped to encourage. For that, I urge readers to visit the ACNY's official Web site.[3] Instead, I call attention to cases representative of the internal and public challenges with which the ACNY (and its critics) have grappled over time. The goal is in part to illuminate the operations of a segment of municipal government that negotiates public aesthetics and the image of the city. While I believe in the centrality of individual actors, my analysis pays most attention to leadership figures, such as the Art Commission president and the commissioners of agencies like the Department of Parks. I present the ACNY as a collective, acknowledging even as I do so that this is, largely, a misrepresentation. In my own observation, each commission member has played a crucial role. As with any group endeavor, individual commissioners have often disagreed, cajoled, compromised, and changed opinion before a consensus was reached. Some of those debates took place publicly, some in private, but when it came time to render a decision, individual members usually would not stand on principle unless a quorum had been attained. Since the quorum (six) represented the majority necessary to pass a vote, decisions became expressions of the entire group. I thus refer to ACNY decisions as "communal" for simplicity's sake, even if a decision was embraced enthusiastically by only one person. I have devoted little space to

the contributions of individual commission members and the staff, not to mention the designers themselves, to avoid overwhelming the reader with detail. Readers will nonetheless glean a sense of the intricacy of architectural and landscape practice, and of public art and sculptural commemoration, within the framework of a single municipality.

New York City is just one locale. Although its art commission has served as a model for other American cities, the organization and responsibilities of commissions in other places have been different.[4] One cannot assume that conditions and consequences have been the same elsewhere. Comparative scholarly studies of urban aesthetic patronage and regulation are much needed but are beyond the scope of this project.

Within this book there are differences in tone between the first four chapters and the last one. While my analyses in chapters 1–4 derive from archival research, much of my data for the final chapter stem from personal experience. I came to this inquiry as a historian of the public art process who serendipitously became a participant in that process, as a mayorally appointed lay member of the Art Commission (1998).[5] Subsequently elected ACNY vice president (1999), I served until the Bloomberg administration, seeking to put its own stamp on the ACNY, appointed new commissioners in September 2003.

On first joining the ACNY as a scholar and public university professor, I felt acutely conscious of being an outsider. I had never before engaged in public service or experienced the frisson of having power and status. I was acquainted with the ACNY's executive director (Deborah Bershad) from my research in the archive some years earlier, but apart from a one-time meeting with the president, Reba White Williams, I was unacquainted with my fellow commissioners. A business executive with an art history Ph.D., Williams was the wife of Alliance Capital's CEO and a major print collector. One of my fellow lay members was the president of a successful New York fashion house. A number of others had similar wealth and social standing. The gatherings of this group were certainly unlike my previous experiences of academic grant panels and faculty meetings. It soon became apparent, however, that there was little reason for me to feel self-conscious. Almost everyone treated me quite collegially. It did not take long to become a part of the process.

Within a year, when I decided to write this book, I became a participant-observer as well as an art commissioner. There has been much debate in recent years about the role of the participant-observer and about the appropriate "voice" to use in ethnographic narratives. Several approaches have prevailed. Traditional "realist tales" of the field (to use a term coined by ethnographer John Van Maanen) purported to be neutral, matter-of-fact accounts of exotic peoples by a "disembodied" onlooker. Concealing the

presence of the participant-observer, realist tales disavowed his or her impact on the culture studied and presented. A contemporary generation of "post-modern" scholars challenged this perspective, contending that the ethnographer's "reality" was neither disinterested nor objective but, rather, filtered through individual subjectivity and influenced by biography, worldview, and events. These scholars insisted that narratives be more honest and "transparent," that the ethnographer be forthright and acknowledge authorial presence and agency. Hence some ethnographies read like autobiography or fiction rather than academic social science.[6]

Although I have sought to avoid inserting myself into the text, it has been impossible to examine recent developments with the same dispassion with which I approached the past. I was, after all, an agent of change in the very culture that I was studying. Portions of my account are thus written in the first person singular or plural, and some of my assertions are decidedly one-sided. As this book will show, the process of determining aesthetic merit is highly political. Expertise often triumphed in the ACNY process, but compromise and concession just as often ruled the day; I will argue in chapter 5 that this sometimes had negative consequences. My goal, however, is not to provide a kiss-and-tell memoir. My perspective is that of a historian, and my methodological aim is to make my final chapter as consistent in tone and outlook as possible with the earlier ones. I have tried to provide a balanced account, to offer a focused historical analysis of one major city's process of shaping and enhancing the municipal civic realm by policing public design.

On joining the ACNY, I found myself in the odd position of fighting on behalf of standards of quality that I was more accustomed to critiquing. As an art historian, I have never denied the possibility of aesthetic standards but have objected to the idea of using aesthetic hierarchies as grounds for evading the histories of certain forms of artistic production (such as twentieth-century academic monuments or commercial art). As a commission member, I invariably drew on my personal aesthetic preferences—honed through youthful study of drawing and painting at the Museum of Modern Art, the Art Students League, and Smith College—when evaluating projects. In undertaking this study, my own positions became a part of the story. The conflict (which has parallels to some of the tensions between elite and popular tastes to be discussed in this book) drove home the imperative of distinguishing the process, or the stakes involved in the battles to define "art," from the meanings that emerged from lost aesthetic confrontations. While facing particular issues on the ACNY, I made choices and argued for them. Once I left these battles behind, I sought to step back and chronicle the events in a way that acknowledged their complexity.

Thus, at a deeper level, this project builds quite consistently on my previous work. For over twenty years my research has focused on worlds of art that many art historians have overlooked because they involved works that did not measure up to the standards of aesthetic quality usually deemed necessary to qualify as art. The urban arts and artifacts mentioned in this book, as well as the issues surrounding their development, are therefore very different from what the museum and the academy typically explore. *The Politics of Urban Beauty* casts light on the very different and important world of municipal cultural activity. It seeks to show how "art" is not only a function of aesthetic experience but also the outcome of a dynamic social process, epitomized in the public realm by the activities of the Art Commission of the City of New York.

CHAPTER ONE

FROM CHAOS TO STRUCTURE IN NEW YORK'S PUBLIC AESTHETIC REALM

The charter of Greater New York that took effect on January 1, 1898, provided for an art commission, charged with approving all works of art acquired for city property. Its emergence as the Art Commission of the City of New York (ACNY) has been told as a story of simple origins, based on a 1910 account by architect John Carrère. But, as with many origin myths, the truths are more complicated. The formation of the art commission had an immediate impetus but also stemmed from broader local, and even national, impulses.

This chapter will map out that "prehistory" to shed light on the shaping of the landscape in late nineteenth-century, precharter New York City, particularly on the fractious political machinations of both public and private sectors when dealing with the placement of monuments on municipal property. The story reveals the intricate and changing sociopolitical configurations of art worlds during this period, as well as the pliancy of such categories as "public" and "expertise." [1] It also reveals the shifting contours of elite and popular tastes and their relationship to the development and implementation of a form of a kind of "aesthetic police power." [2]

As we shall see, the ACNY was born out of a perceived need not only to order the city's public spaces but also to give some consistency to a chaotic decision-making process with many civic, political, and aesthetic dimensions. Each point of discussion threatened to fracture whatever fragile civic unity and stability existed in that instance. Irreconcilable opinions about expertise, quality, affiliation, nationalism, and artistic authority in conflicts over public art and urban representations more generally, convinced artists and civic activists that there was a need to put into place a consistent legal mechanism for the city to control the design of its built environment and public spaces. The Greater New York charter commission, through providing for an art commission, legalized a claim that the city should be empowered to override the efforts not only of individual citizens and groups but also

of the city's own departments to relay their own values in urban public places. Such prohibitions were deemed necessary to represent municipal identity on behalf of all citizens.

Under what circumstances would a city government legislate, in effect, against its own interests, as defined by the particular powers-that-be of the moment? The specific cases that became the impetus for establishing the commission illuminate the pertinence of this question and encompass other peculiar tensions created within urban cultural history. The rights of neighborhoods and interest groups have been pitted against those of the public or the municipal government. So have the articulations of ethnic affiliation, cultural distinctiveness, and citizenship and the relative powers of professionals, connoisseurs, and amateurs on questions of aesthetics. The debates over urban public monuments that inspired the ACNY's formation revealed crucial differences between proponents of what constituted elite versus popular aesthetics and their relationship to stylistic modes and hierarchies: simple as opposed to complex, clean rather than cluttered, nuanced as opposed to simplistic. Negotiations over the relationship between such distinctions and the civic interest would continue long after the ACNY was established.

A Progressive belief in the power of municipal government to control its own affairs did not jibe with the conviction that government oversight of itself was needed in matters of taste. The formation of an art commission also acknowledged that urban aesthetic matters were, in the end, public political matters, too murky and contentious for private citizens to negotiate effectively. The story to be told here is about how the new New York City acquired a framework for rendering aesthetic judgments by the public, for the public, and in the public eye. The events leading up to the ACNY's creation were driven by monuments. However, this discussion is not principally about sculptors or artworks but about who would control the disposition of monuments, the structure of urban spaces, and the appearance and identity of the city. Some of these circumstances and the organizational structure of the patronage process are discussed elsewhere at greater length, but a brief overview of relevant issues will help to clarify subsequent developments.

MONUMENT MANIA

One of the major concerns from the post–Civil War period on into the 1890s was how to order and manage large cities and protect their citizens. These preoccupations encompassed public health, sanitation, and safety, areas with an undeniable bearing on the quality of life for city dwellers and visitors. Municipal departments were reorganized, officials passed new legislation, and citizens formed civic groups to implement reforms and improvements.

Matters of health, hygiene, and policing all involved values and judgments but were widely believed to be grounded in objective knowledge about the world and its workings. Whether the same general principles should apply to the realm of public beauty, encompassing memorials and municipal buildings, for example, was a question that remained uncertain.

Among the late nineteenth-century advocates of urban reform and regulation were some who believed that public aesthetics were just as bound up with the public welfare as sanitation and health and, thus, deserved management. As early as the immediate postwar period, aesthetic judgment emerged as an organized public issue, not just a matter of private experience and taste. Beginning in the 1870s (especially around the time of the Centennial), many groups sought to leave their mark on cities by sponsoring monuments to political, ethnic, labor, and cultural heroes. Each project had its own distinct subject and site, and each entailed its own peculiar avenues of influence in order to be implemented. In New York City, for example, these monuments included a Seventh Regiment memorial (John Quincy Adams Ward, 1869) and bronzes of Daniel Webster (Thomas Ball, 1876), Fitz-Greene Halleck (James Wilson Alexander McDonald, 1876), Giuseppe Mazzini (Giovanni Turini, 1876), and Simon Bolívar (Rafael de la Cova, 1884) in Central Park and a portrait of Benjamin Franklin on Park Row (Ernst Plassmann, ca. 1872). The wave of new monuments continued on. United States letter carriers erected a statue of a former Ohio congressman Samuel Sullivan Cox (fig. 1.1) at Lafayette Street and Fourth Avenue in appreciation for Cox's successful efforts to get them a pay raise.[3] In 1892 the state legislature, following a well-trodden path, authorized creation of a soldiers' and sailors' monument to commemorate the Civil War and the preservation of the union. The urge to commemorate acquired additional force as a result of the successful World's Columbian Exposition, an astounding temporary spectacle showcasing public monuments and murals as proof of the nation's new global eminence.[4]

By the mid 1890s the commemorative enterprise had become a veritable industry.[5] In 1895, for example, the *New York Times* reported happily that, in addition to the proposed soldiers' and sailors' memorial, plans were in the works for no fewer than sixteen other monuments for New York City alone. Some commemorated long-dead patriots; others were inspired by a recent death. Subjects included Simon Bolívar, William the Silent (or William of Orange, Dutch statesman), Louis Kossuth, Aloys Senefelder (inventor of lithography), Irish poet and nationalist Robert Emmet, Thomas Jefferson, Gouverneur Morris (representative of Pennsylvania at the Convention in Philadelphia in 1787), the Marquis de Lafayette, banker and philanthropist Jesse Seligman, architect Richard Morris Hunt, Judge Charles P. Daly, Congressman James G. Blaine, Chester A. Arthur, Peter Cooper, a late Brooklyn Commissioner of

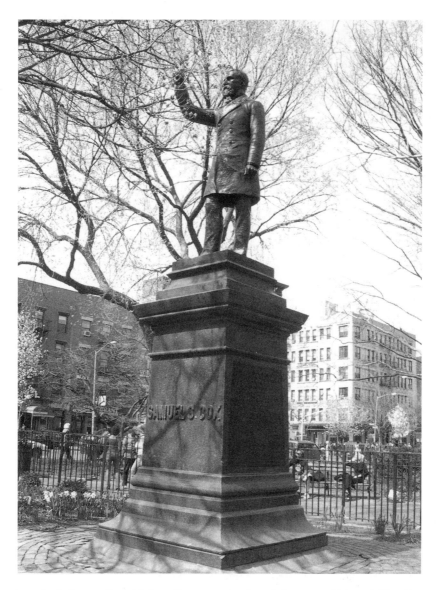

1.1 Louise Lawson, Samuel Sullivan Cox statue, 1891, Seventh Street east of Avenue A, Tompkins Square Park. (Photo by author.). This statue originally stood at Lafayette Street and Fourth Avenue.

Public Works, General Henry Warner Slocum, and Henry C. Work, composer of "Marching through Georgia" the rousing Civil War anthem.[6]

During the early 1890s, artists and the arts establishment sought to participate in the monument-building process and began staking claims on public space. They formed professional organizations with national memberships and civic groups with a more local emphasis in order to assert their centrality. In 1893 a group of prominent sculptors, joined by *New York Times* art and literary critic Charles de Kay, formed the Sculpture Society (renamed National Sculpture Society [NSS] in 1896), an organization dedicated to advancing the medium in the United States through exhibitions, interorganizational alliances, and other forms of public education and outreach. The NSS hit the ground running, actively lobbying the press and other arts groups and government officials to sponsor more public monuments, to set their aesthetic sights high, and to heed the society's advice on matters aesthetic. The Municipal Art Society (MAS), established the same year by artists William Vanderbilt Allen, Evangeline and Edwin Blashfield, Richard Watson Gilder, and Richard Morris Hunt (among others) to advance urban beautification, saw its mission initially as being sponsors of public art and design for donation to the city. To that end, the MAS raised money to commission fine works of art, and an electrolier (a large street lamp), from members of the NSS or other professional societies (like the National Society of Mural Painters). That particular aspect of the MAS enterprise quickly foundered, but the MAS remained a vocal spokesman on matters of preservation and urban aesthetics. Together with the NSS, the MAS insisted on being actively involved in decisions about which monuments belonged in municipal public spaces. The NSS in turn took an active interest in securing some of the proposed projects for its own members.[7]

The NSS and the MAS, representatives of professionals and civic elites, aspired initially to be a positive influence on the design of New York's changing public spaces. They contended that expertise, whether gleaned through the experience of superior practitioners or that of cultivated and learned connoisseurs, should determine the delegation of authority for decisions affecting the aesthetics of the public realm. It would be misguided to develop the city on the basis of political exigencies as a response to popular enthusiasms. Paralleling the concerns of other civic groups agitating for reform, the NSS and MAS, along with groups like the Architectural League (formed in 1881 to advance the artistic development of architects), argued that government needed oversight from the private sector; its involvement was needed to put a check on laissez-faire monument policy and thereby reduce the potential for urban chaos.[8]

The NSS and MAS would seek to broker the delegation of major public commissions as well. Thus in 1894, along with the Architectural League, they formed a "triple alliance" to try to develop a "number of good designs" for the state-legislated Soldiers and Sailors' Memorial Monument.[9] In spite of their efforts, the organizations encountered difficulty convincing others to accept their recommendations. Too many other interest groups were sponsoring too many other monument projects for a limited number of choice municipal sites. The professional groups feared that those who raised the money first would win the race. Competition developed into conflict. By the late 1890s, the NSS and MAS changed emphasis, from participation to policing: from placing good works on city property to preventing the installation of bad ones.

Desires for aesthetic administration had already been communicated. The 1893 World's Columbian Exposition in Chicago may have exemplified the promise of civic monuments, but New York City's humiliating 1890 loss of that event to the "Second City" had spurred demands for greater control over public aesthetics. Despairing spokesmen for the real estate industry blamed New York's defeat on the corruption and tawdriness of its civic, political, and artistic cultures. Linking the unfortunate aesthetic condition of the city's built environment with a breakdown of sanitation, health, transportation, and overall civic engagement, the *Real Estate Record and Guide* sent a wake-up call: the public, through its government, had to take charge of the city.[10]

Some art practitioners suggested what such aesthetic policing practices might entail. For example, in an 1895 lecture "How to Make New York a Beautiful City," designer Candace Wheeler envisioned for New York a board of municipal art, with sweeping powers, related to other realms of government dedicated to employing the police power to protect public health and welfare.[11] Wheeler's board would encompass private as well as public structures; it would deal with "the tenement house question," "cooperate with the Board of Health and Department of Buildings," and "bring expert knowledge to bear on public safety as well as artistic knowledge to bear on improvements of public property." It would offer the "power to accomplish," to help change "squalor into dignity, ugliness into attractiveness, and eliminat[e] dirt and disorder." The board would be composed of men "educated in all means of art—architects and painters and landscape gardeners, who should agree on schemes of improvement and be able to carry them out." Wheeler contrasted her vision of the ideal board member with a less desirable group of New Yorkers "whose early and respectable occupation was that of a hod-carrier, or whose later business is the sustainment of the grog-shops." Her

comparisons were not arbitrary; they were a direct put-down of men like George Ehret, a brewer who was a key benefactor of the memorial to Heinrich Heine (see below).[12]

For Wheeler, municipal aesthetics, sanitation, and public health were integrally connected, but in the real world of New York City artistic affairs, her proposals were taken, for a time at least, as a mere woman's fancy. In fact, however, the issue of regulation had already arisen within the isolated, idiosyncratic context of public parks. Since 1873, a three-man art Committee of Experts, in effect the city's first art commission, had advised the Board of Parks Commissioners on the aesthetic merits of the numerous monuments and structures being proposed for the municipal parks. The committee consisted of the presidents of the National Academy of Design, American Institute of Architects, and the Metropolitan Museum of Art but did not include a sculptor, even though it dealt primarily with monuments.[13]

The scope of regulatory action broadened in 1890 in Boston. There, during the late 1880s, Brahmin leaders had agitated against the persistent "foisting" of Cogswell (temperance) fountains and clunky "mortuary monuments," on the Public Garden. (The rectilinear and stone temperance fountains, built by dentist Henry D. Cogswell to discourage consumption of alcohol, typically consisted of a four columned square water source supporting a hipped roof with a statue on top.) These actions were spearheaded, the New York press implied, by the Irish. In an act of "self protection," a group of Bostonians successfully petitioned the Massachusetts legislature to pass an 1890 bill authorizing a municipal art commission. Comprising five members, selected by the mayor, the Boston commission was empowered to "accept or reject" public monuments (only) and in some cases to select the sculptor and site.[14] New Yorkers had better take comparable action, the *New York Times* warned, or the parks would be flooded with tawdry monuments. Such calls were ultimately heeded in the metropolis, but the process took longer and was far more complicated.

These earliest attempts to control monuments and public spaces were crucial. They were nonetheless limited in scope, since they pertained mostly to parks, regulated districts where aesthetics had long been acknowledged to be legitimate concerns. In New York City, the transition went from positive to negative, from guiding to policing aesthetics within a more general municipal setting. This can be tracked concretely in the saga of the Heine Memorial, also known as the Lorelei Fountain (fig. 1.2). The NSS and MAS initially became involved not because they objected to the design but also because they had competing ideas for the site. Those differences developed into an extended debate. Questions were raised about the relationship of subject matter to site, style and quality of execution and expression, social networks

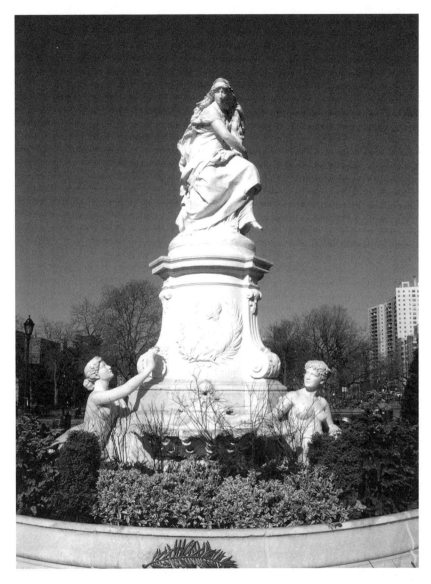

1.2 Ernst Herter, Heinrich Heine Memorial (Lorelei Fountain), 1899, Grand Concourse, Bronx, 1899. (Photo by author.)

and pressure politics, and the relative authority of expertise and Anglo-American nationality versus popularity regarding decisions on public aesthetics. These controversies were consequential not only in their own right but also as backdrops for the activities that resulted in the creation of an art commission, a formalized mechanism for policing urban beauty.

THE HEINE MEMORIAL

In the early 1890s, a group of Heine admirers had attempted to erect a memorial, first in his birthplace of Düsseldorf, then in Mainz. Urban authorities rebuffed these efforts. They regarded the deceased lyric poet as a libertine and a subversive—that he was a Jew made matters only worse. A New York–based choral group, the Arion (one of the numerous *Vereine* [societies] that had reinforced ethnic solidarity among German Americans since the mid-nineteenth century) stepped in. In January 1893, Arion members resolved to erect the Heine Memorial in a prominent place in their city. They established a memorial committee, enlisted such illustrious German New Yorkers as Ostwald Ottendorfer, Joseph Pulitzer, and William Steinway, contracted the highly respected German sculptor Ernst Herter to create designs for a monument in Tyrolean marble, and reached out to fellow German Americans to help pay for it. The project was delayed for some two years because of the downturn in the economy but revived in 1895, when the memorial committee approached the New York City Board of Park Commissioners proposing to place the memorial in the plaza at Fifty-ninth Street and Fifth Avenue, at the southeastern entrance to Central Park (see fig. 1.3).[15] The selection of this site, at the heart of an upscale and expanding east-side district on the edge of the park, seemed, in the eyes of the Memorial Committee, perfectly appropriate, given the international reputation of the great poet and the causes of liberty that he had championed. It also happened to be two blocks away from the Arion's clubhouse at the southeast corner of Park Avenue at Fifty-ninth Street.[16]

The Heine enterprise was thus typical of monument campaigns in late nineteenth-century New York and elsewhere. A private organization (a German American choral society) sought to celebrate an individual and cause that they regarded as having broader national and humanistic importance. Because the subject was conceived to have wider significance, the initiating group offered the work to the city. Through the fundraising process, the initially small group acquired a wider constituency. The Arion reached out successfully to a broadly constituted nondenominational public of German Americans; members used that support to bolster their claims that the Parks Board, representing the city, should accept this gift on behalf of the citizenry.

The announcement that a Heine memorial was planned for the plaza did not sit well with the NSS or MAS. The societies were vexed on a number of counts, not the least of which was that the Heine project threatened to upset their plans for a soldiers' and sailors' memorial in the same locale.[17] The Fine Arts Federation (FAF), consisting of the city's principal professional arts

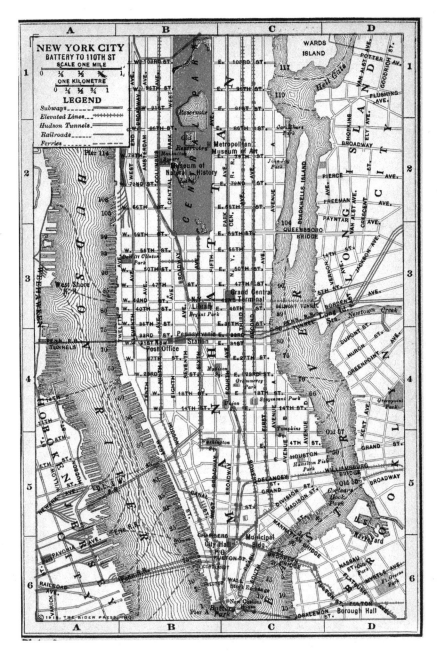

1.3 "New York City: Battery to 110th Street," from *Rider's New York City* (New York: Henry Holt & Co., 1916). Perry-Castañeda Library Map Collection, http://www.lib.utexas.edu/maps/historical/manhattan_1916.jpg (accessed 9 February 2004). Courtesy of the General Libraries, University of Texas at Austin.

1.4 Columbus Monument, 1892. (Library of Congress Prints and Photographs Division digital ID# ppmsca 05881.)

groups, had been formed in 1895 to lend additional influence on matters of advocacy and policy involving the visual arts. As FAF comembers, the NSS and MAS sought to shore up their authority by joining forces with the consortium in fighting the Heine Memorial group's efforts to usurp their plaza site. They were determined to explain to city officials and the public why the Heine Memorial should be abandoned and their project implemented in that locale. This approach, although negative and critical in tone, focused on achieving their own artistic participation and positive results.

The three organizations launched a first assault, challenging the competence of the Arion Society and its choice of monument subject for that particular site. From the NSS, MAS, and FAF perspective, the Heine Memorial project had been initiated merely by aesthetic amateurs, a small local ethnic group. The Arion Society proposed to commemorate a foreigner with no observable ties to that locale, in one of the most conspicuous potential monument sites in the city, and furthermore, had selected another foreigner, not an American, to create the design. A commanding monument to Christopher Columbus by Roman sculptor Gaetano Russo, sponsored by publisher Carlo Barsotti and his newspaper *Il Progresso Italo-Americano,* had recently been erected at Fifty-ninth Street at the intersections of Broadway and Eighth Avenue (fig. 1.4). Thus the vicinity was already well-represented by nonnative artists. The Columbus project had been initiated before the formation of the NSS, MAS, and FAF, however, and had the enthusiastic support of an official Committee of One Hundred, established to plan festivities

surrounding the four-hundredth anniversary of Columbus's arrival; it included some of New York City's most respected artists and architects.[18] Columbus, moreover, was central to the mythology of discovery and manifest destiny articulated within the visual arts since the mid-nineteenth century. Therefore no one thought the subject posed a problem, and there were no major objections to Russo's column.

The NSS, MAS, and FAF believed that the sponsors and choice of subject in this new instance were an inappropriate combination for another of the city's key plazas. A subject of broad national significance ought to be there.[19]

These initial assertions were inauspicious. The arts groups' challenge was a real, if misguided, expression of resistance, on the part of dominant Anglo-American cultural elites, to a changing articulation of national identity, grounded in ethnic and religious assimilation. That transformation, however, was already well underway. In fact, the NSS membership itself was representative of such shifts, insofar as its members included Germans and Austrian (i.e., Catholic) émigrés. As we shall see, Heine Memorial supporters realized that the arts societies had taken a political misstep by casting their objections so baldly in terms of a battle, staged on municipal terrain, between Anglo-American national traditions and German, ethnic, local interests. The NSS, MAS, and FAF themselves appear to have realized their error. They began to take a different, more subtle tack, redirecting the discussion toward the matter of artistic quality. Although no less inflected by ideologies of class and nationalism, public aesthetic judgment was one arena in which the art societies believed they should and could prevail.

By November 1895 the NSS had seen photographs of Ernst Herter's sketches for the proposed Heine Memorial, titled the Lorelei Fountain. From the NSS perspective, the design had notable problems that made it unacceptable not only for that site but for public space in general. The nudity of the female figures (conceivably acceptable in a European context) was inappropriate for display in such a central locality in the United States. The treatment of the details and surfaces was overly "rococo" and fussy, and the overall iconography, with its feminized allegorical personifications, lavish flora-and-fauna details, and smallish relief head of the hero in question, was old-fashioned and hackneyed. On the surface, the work looked good, at least to some sympathetic viewers. Yet the NSS believed that although Herter's Lorelei Fountain had the trappings of authentic high art, in fact it betrayed a very limited and bourgeois aesthetic and cultural vision. The design and technique, though good enough by some people's standards, did not meet the exacting requirements of the Sculpture Society, American sculptors who aimed to see implemented public art characterized by a more rigorous, simple, stolid "classical" realism and restraint.[20] The design had already been rejected elsewhere, ostensibly for political reasons. But the sculptors and their advocates expressed suspicion; perhaps the work had in fact been rejected on aesthetic, not political, grounds.[21]

The NSS and FAF knew that it would be a challenge to get the city to listen to their aesthetic objections. They represented, after all, but one more small group of citizens, organized around artistic-professional interests rather than ethnic or political ones. Herter, moreover, had an eminent reputation abroad, notably among Germans; he came to the job with strong artistic credentials. Nonetheless the NSS, MAS, and FAF officials were adamant that Herter's work was aesthetically inadequate and inappropriate for one of New York's major public places. They proceeded to link nationalism and aesthetic expertise to claim a privileged authority over uses of public space. Thus ensued a debate in which one influential art world—that constituted by New York City's self-designated professional artists and their advocates—insisted on claiming priority over another—that occupied by German academic artists, theorists, and critics and by intellectual leaders and their German American metropolitan followers.

To communicate their concerns, the NSS and FAF appealed to the Board of Parks Commissioners of the city of New York and the already-mentioned three-member advisory Committee of Experts. Powerful and controversial, the four-member appointed Parks Board (in the Strong administration, David H. King, George D. Haven, James A. Roosevelt, and Augustus D. Juilliard) had control over all of the built environment in parkland and its immediate environs. The plaza was not technically part of Central Park, but

was close enough to give the Parks Board jurisdiction. In 1895 the "experts" committee members consisted of National Academy of Design president Thomas Waterson Wood, American Institute of Architects president Richard Upjohn, and Henry Marquand, president of the Metropolitan Museum of Art.[22] The NSS, MAS, and FAF thus presumably hoped that a body combining a Republican-dominated Parks Board and a subcommittee of museum and arts-professional elites would look on their arguments sympathetically, whatever the political pressures at hand.

Officials from NSS and FAF maintained that not all subjects or modes of aesthetic execution were equal. In the absence of a knowledgeable public body of experts with official decision-making power, the true experts should have that power. No matter that the Lorelei Fountain had popular support or prompted the enthusiasm of German art critics. Expertise had to take priority over popularity, and in the event of two claims to expertise, national expertise—their expertise—had to take priority over that of aliens. As the *New York Times* put it in an unattributed article (probably written by its art critic, NSS lay member, and Berlin correspondent Charles de Kay), New York had "suffered in the past from the mistaken leniency" of individuals or groups "who, incompetent to judge, or lacking the moral courage to be true to their convictions, have failed in their duty to the best interests of their fellow-citizens, and, have allowed wretched, abortive, inartistic failures in stone or bronze to desecrate the city, standing as awful monuments either to unpardonable stupidity or miserable taste." Those accountable for erecting such work in unavoidable public places, in which "daily observation . . . offends the judicious," were irresponsible citizens, corrupting "the ideas of the masses."[23]

It appeared that the arts establishment groups would have the upper hand. The NSS, which included nonprofessional members with some very good social and political connections, convinced the Parks Board without much difficulty that, as the professional organization of experienced monument experts, the NSS should weigh in on the merits of the Heine Memorial. To no one's surprise, a November 1895 report by the NSS urged the city to reject the Heine Memorial for the plaza at Fifty-ninth Street.[24]

Heine Memorial supporters rallied to protest. The sculptor of this memorial was not some little-known hack, contended the Heine Memorial Committee. Herter was a distinguished artist, with numerous important commissions in Germany and Austria.[25] To shore up its claims, the committee reminded opponents that the designs had won an enthusiastic endorsement from none other than Ludwig Pietsch, one of the foremost art critics in Germany, who had attested that the Lorelei Fountain, "through its abundance of intellectual ideas, its thoughtful poetic invention, its conscientious

and masterly execution, is an extraordinary work of art."[26] Would the Board of Parks Commissioners accept the word of a cultivated intellect or that of a group of jealous and biased competing practitioners?

The New Yorker Staats-Zeitung—whose publisher Ostwald Ottendorfer was a Heine Memorial sponsor as well as an important force in New York City politics—put matters more bluntly. Bringing the NSS stance on the choice of Heine as subject back to haunt the society, the paper accused the NSS of nativism. This was understandable, inasmuch as the NSS vice president, Russell Sturgis, had reportedly stated that statues to German poets belonged in *Kleindeutschland,* "where their sauerkraut eating countrymen lived," and nativism was ascendant in the wake of the 1893 Depression. Others imputed anti-Semitism.[27] Hoards of German Americans responded by turning out for a Heine Memorial Fair at the Lenox Lyceum, organized by German American women, which raised $12,000 toward the $35,000 monument. Former statesman Carl Schurz (then the editorial writer for *Harper's Weekly*) went before the Parks Board to plead the case for the memorial.[28] What had been the pet project of one *Verein* became a broader cause, affirming solidarity among German Americans, who could now claim to be a viable national public to whom the Heine Memorial would be dedicated. From the perspective of the Heine Memorial supporters, there was no reason why the civic aspirations and aesthetic tastes of one large public should be thwarted by another, smaller one.

The problem in late 1895, then, for both sides, was that on the face of it, there was nothing wrong with the work. For the Germans, the Lorelei Fountain exemplified good art, in the academic, classical tradition that was typically taught in that nation at the time. Sculptors from the NSS, too, were academically trained, but in a different manner, more severe and restrained, and (for pragmatic, climactic reasons) more oriented toward bronze or limestone than marble.[29] Hence the NSS, FAF, and Parks Board believed that there were no grounds for the charges of nativism and anti-Semitism. Indeed, Sturgis's biases aside, most NSS and FAF members had nothing against Heinrich Heine or Germans.[30] Ethnicity, they contended, was not the issue. The subject was controversial, but the more notable concern was the formal and iconographic treatment of that subject for the proposed locale. The three societies remained intransigent despite the attacks, for in their view, much was at stake. Although writing in another context, planner Charles Mulford Robinson would express the attitudes succinctly: "All is not art which adopts art's form."[31]

The Heine Memorial Committee made additional attempts to negotiate, first with the NSS, then with the FAF. As far as FAF/NSS members were concerned, however, it was irrelevant who had first raised money and developed a design; the priority had to be the aesthetic quality of the work, not good

organization or timing. The NSS/FAF advisory "tribunal" had the final say, and the discussions seemed to be of no avail. Disgusted, the memorial committee withdrew their offer to donate the monument, but the matter was by no means resolved.[32] The idea that one private group's gift to the city could simply be blocked by another made the approval process seem arbitrary and capricious. That perception was shared by others, including those who believed that the city had to be more discriminating. As we shall see, these debates would prompt artists to press for more formalized mechanisms to control the built environment.

The irresolution with the Heine Memorial continued, with party politics conjoining ethnic politics. Politicians, not previously involved, joined the debates. Following the advice of the NSS deputized committee, the Board of Parks Commissioners, appointees of Mayor William Strong (1894–97), a reform Republican, had for all intents and purposes rejected the memorial in December 1895. In January 1896, the Board of Aldermen, dominated by Tammany Democrats and speaking for its local constituents, stepped into the fray. The aldermen appointed a committee to hold public hearings on whether the Heine Memorial should be erected elsewhere, "under the auspices of some other department that is not so particular about the quality of its statuary." The *New York Times,* not surprisingly, given De Kay's involvement with the NSS, argued that the move was "not the act of public-spirited persons or good citizens."[33] The aldermen were not fazed. They took advantage of the lack of any broader public aesthetic authority to locate another acceptable municipal site.

One alderman proposed a resolution empowering Commissioner of Street Improvements Louis F. Haffen of the Twenty-third and Twenty-fourth Wards of the annexed district of the north side (soon to be the borough of the Bronx) to accept the memorial for placement at the intersection of the new Grand Concourse and 167 Street (see fig. 1.5)—on land that would be under a different departmental jurisdiction than parks. After some political jostling, it appeared likely that the proposal would go through—thereby undercutting the expert advice of the NSS/FAF "tribunal." With no "official," impartial, or independent method in place for determining the acceptability and location of monuments, the process of negotiation had begun to break down. Resolution would hinge on power politics.[34]

Reform-minded Republicans in the state legislature, mindful of this reality, got into the picture. Swept into power in 1893 and 1894 in a wave of Progressive backlash against the corruption of urban Democrats, the Republicans were not about to allow their opponents to undermine the work of Mayor Strong's appointees. Reform Republican Assemblyman Samuel G. French decided that it was now time to impose some order and consistency

1.5 "New York City: Bronx and Northern Manhattan Section" from *Rider's New York City* (New York: Henry Holt & Co., 1916). Perry-Castañeda Library Map Collection, http://www.lib .utexas.edu/maps/historical/manhattan_bronx_1916.jpg (accessed 9 February 2004). Courtesy of the General Libraries, University of Texas at Austin.

on the municipal monument process. In March 1896 he introduced a bill that established an official body—consisting of the mayor and the presidents of the Board of Aldermen, the NSS, and the MAS—to approve or disapprove any monument or memorial intended for city property. It also stated that the power of other city departments having jurisdiction in a given case—such as the Board of Parks Commissioners—could not be curtailed, thus in effect retaining their power to rule on works within their jurisdiction. Approvals required a unanimous vote.[35]

The French bill was intended to establish procedures that would encourage judicious negotiation and compromise. In requiring approval by the mayor and the president of the Board of Aldermen as well as by the representatives of the artists and civic beautification activists, the goal was to create some consistency and a balance of power between the "representatives of the people" and experts.[36] However, given the timing, and the speed with which the bill was pushed through, it was clear to advocates of the Heine Memorial that, altruistic intentions aside, partisan motives drove this bill. Hence for Heine Memorial supporters, the French bill was a bald effort to foil the Board of Aldermen.[37]

The state legislature passed the bill on March 4, 1896, but still had to receive the mayor's approval. On March 10, while the mayor held hearings on the French bill, the Board of Aldermen voted twenty-five to five to accept the Lorelei Fountain. An additional series of political machinations ensued, the upshot of which was that the status of the Heine Memorial remained in limbo. The newly established Municipal Art Commission, had not approved it, and it was unclear whether it would be grandfathered in because the Board of Aldermen had taken action before the state bill's passage. At this juncture, the press coverage ceased.[38]

The Lorelei Fountain debate had consequences, prompting New York City's professional artists' organizations and civic cultural activists to press for a more formalized governmental mechanism for controlling—impartially, but in accord with their artistic standards of taste—the aesthetics of the public built environment.

In hindsight, from the point of view of the NSS, MAS, and FAF, the political maneuvers and aesthetic disagreements provided ample rationale for having a municipal art commission, an independent body. In 1896, with the final outcome yet undetermined, it still appeared that the NSS and MAS, through their inclusion in the French bill's new Municipal Art Commission, were succeeding in calling the shots. At that time, with the seemingly imminent defeat of the Heine Memorial and its banishment from the plaza, the NSS, MAS, and FAF appeared to have scored a victory. Expertise ruled over popularity. The organizational victory in this instance proved,

moreover, that national expertise would be associated with the expertise of the municipality and would take precedence over the expertise of the "alien," of Germans like Herter and Pietsch. The art societies had won a partial victory, but their reputations had been assailed. Although their values would be harnessed and codified as part of municipal government, those standards nonetheless did not ultimately prevail in the case of the Heine Memorial.

The Soldiers' and Sailors' Memorial Monument was another test case that indicated that the organizational structure of the French bill's Municipal Art Commission, from the artists' and their advocates standpoint, was less than ideal. The arguments over the Soldiers' and Sailors' Memorial Monument highlighted all the more the complex and contingent nature of the issues surrounding the placement of public art.

SOLDIERS' AND SAILORS' MEMORIAL MONUMENT

The Heine memorial—in-the-plaza idea seemed to have been put to rest, but the soldiers' and sailors' memorial idea was still brewing in 1896 and generating a concern less about keeping a monument out of a given location (the plaza) than about making sure that the place itself was worthy of the monument. The president of the Board of Parks Commissioners (Col. S. V. R. Cruger) wanted to see the memorial placed in the plaza, as did the president of the Department of Public Works (General Charles H. T. Collis), who now formed part of the Soldiers' and Sailors' Memorial Monument Commission that had been convened to determine the site.[39] The FAF, which now joined with the NSS to advise the Parks Board and municipal agencies as to the location of statues, sought to make itself—as the representative of all the major New York arts groups—the authoritative spokesman. Having seen the plans for the proposed soldiers' and sailors' monument in the plaza, the FAF council now opposed that locale, arguing that the $250,000 monument would be dwarfed by the surrounding "tall buildings" around the plaza (mentioned were the Metropolitan Club, Park and Tilford's, the Savoy, Plaza Hotel, and the Vanderbilt Mansion) and would be more suitable for West Seventy-second Street at Riverside Drive. This pronouncement set off a dispute with the Upper East Side Association, representing property owners on Fifth, Madison, Park, and Lexington avenues and the side streets, who wanted the monument as a landmark and as an anchor for east-side development.[40] An aesthetic debate that evolved into a controversy over representation, ethnicity, and cultural authority had now devolved into a dispute cast in

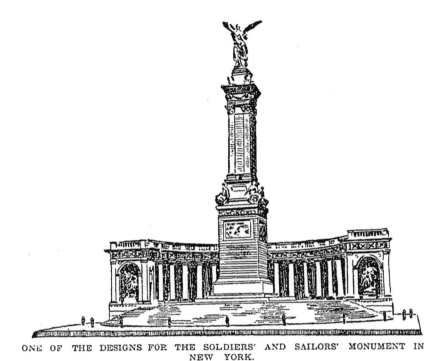

ONE OF THE DESIGNS FOR THE SOLDIERS' AND SAILORS' MONUMENT IN
NEW YORK.

1.6 "One of the Designs for the Soldiers and Sailors Monument in New York," *Brooklyn Daily Eagle,*
17 October 1897, 21. (Courtesy of Brooklyn Public Library—Brooklyn Collection.) Some of the
architects assumed that the memorial would be built at the southern edge of Central Park, and
others designed for the plaza farther south at Fifty-ninth Street.

terms of geography and real estate: the "prominent men" of the east side (as
the *New York Times* described them) pitted against those characterized as
"the west side people."[41]

Notwithstanding the debates between east and west side people, the Sol-
diers' and Sailors' Memorial Monument Commission held a limited com-
petition for designs for the plaza area, eight of which were displayed at the
Central Park Arsenal in October 1897 (fig. 1.6).[42] In December, however,
when the 1896-legislated Municipal Art Commission voted on the winning
design, a schism between commission members—Mayor Strong and the
Board of Aldermen president John Jerolomon, on the one side, and the NSS
president John Quincy Adams Ward and MAS president, banker Charles T.
Barney, on the other—prevented the design from being accepted. The
makeup and approval procedures of the French bill's Municipal Art Com-
mission stymied the process.[43] (The process would continue, however, and
will be discussed in chap. 3.)

CHARTERING AN ART COMMISSION

The art societies and Fine Arts Federation believed that a solution was needed that did not require unanimity or deals with politicians fearful of alienating veterans and other constituents. A municipal art commission was still necessary but had to be reorganized in such a way that its members could act impartially, independently, and authoritatively. The timing of these circumstances coincided with an imminent opportunity: the city's consolidation was underway just at that point (fall 1896), and the Committee on Draft of the Greater New York Commission, charged with developing a charter, was meeting to structure the new municipal government. The art organizations thus again sprang into action. In September 1896, architect John Carrère proposed that the FAF take advantage of the moment. No doubt after many conversations with his colleagues, he recommended to the membership of the Society of Beaux-Arts Architects (the organization for which he served as representative in the FAF) that the FAF put forth a plan for a reworked official Municipal Art Commission. Carrère suggested an emendation of the charter's draft chapter on parks that would establish an art commission and also change its configuration. He proposed that it include the mayor; the presidents of the Metropolitan Museum, Brooklyn Institute of Arts and Sciences, and the newly formed New York Public Library; a painter; a sculptor; an architect; and "three citizens not having any professional connection with art." This department would, as the *New York Times* put it, "have control of all works of art in the parks, avenues, and streets of the city." No monument, painting, or other artwork would be accepted without the commission's approval.[44]

The Society of Beaux-Arts Architects enthusiastically endorsed Carrère's idea and made the recommendation to the FAF. The FAF, in turn, endorsed the plan and formed a committee of its council members (Sturgis, Walter Cook, Henry Rutgers Marshall, and Frederick Crowninshield) to try to take up the matter with the Committee on Draft, chaired by Seth Low.[45] That committee was at work in December 1896, developing the charter and integrating it into a unified whole.[46]

Although the FAF committee at first had to struggle to gain Low's attention, its lobbying ultimately paid off. This was hardly surprising, given his political, cultural, and social connections and affinities to at least some of the men involved—Elihu Root, in particular. Low, former mayor of Brooklyn, was a reformer who would soon be put forward as Fusion Party candidate for mayor of Greater New York by the newly formed Citizens Union (an organization seeking separation of municipal elections from national and state races), of which Root was a cofounder. Carrère, who claimed authorship of the initial commission conception, had been Root's architect, designing the

latter's home with his partner Thomas Hastings, an old and very close Root family friend.[47] Thus when Root, who had previously argued strenuously in favor of the French bill, now appeared before Low and the charter commission to argue that the current Municipal Art Commission should be modified, it was obvious that Low would give the idea serious attention. The interests of the FAF were sufficiently allied with those of powerful Republicans and reform Democrats to succeed in determining which artistic configurations would best serve the public interest.

Carrère and Root had big plans in mind for the scope of their proposed new art commission but decided that, given the vicissitudes of its 1896 predecessor, it would be prudent initially to tread a conservative path and follow Boston: limiting the reconfigured commission's purview to monuments and works of art rather than to the broader built environment.[48] Like Root, Low and Citizens Union members more generally were wary of the negative potential of municipal unification, fearing that Tammany Hall would consolidate its power and extend its web of corruption. Thus they were determined to craft a charter that would advance the ideal of a nonpartisan metropolitan government and extend the power of the municipality to oversee certain aspects of private activity in the public sector, like the construction of private structures on public land and public franchises. At the same time, they advocated placing limits and checks on municipal power. The thirty-seventh chapter in the Greater New York Charter, which established an art commission, would be an expression of their fundamental optimism on the one hand and their caution on the other regarding the potential and beneficence of municipal government. The structure of the commission, as we shall see, articulated the rights of the municipality to regulate private enterprise in the interests of the public welfare, and the concomitant need for private citizens to join forces to combat abuse of public power.[49]

Appearing in January 1897 on behalf of the Fine Arts Federation before Low's charter drafting committee, Root argued that the commission structure created by the French bill ten months earlier, although basically a good idea, was ultimately inadequate and too risky. The federation certainly did "not want another incident like the attempted foisting on the city of the Heine monument." An official regulatory body was very much needed, as the *New York Sun* put it more than forthrightly, to impose "a limitation, on the part of the community, of the right of the individual to do what he likes with his own, if he likes to present freaks and eyesores to the contemplation of his fellow-citizens. Such a restriction on individual liberty would be opposed in practice; but it is absolutely necessary to the production of a handsome and attractive city, such as we all hope that we, or our successors, will see New York."[50]

Experience had shown, Root continued, that individual prejudices and "caprice" could all too easily impede the completion of good work (as with the Soldiers' and Sailors' Memorial Monument).[51] "The absolute veto power" of members of the then-current (French-bill) commission encouraged political deal making, especially by the "officials elected by the people" for whom the desires of their constituents might take a higher priority than exercise of independent judgment about aesthetic suitability. The possibilities of being swayed by prejudices extended to the presidents of the NSS and MAS as well as the mayor and the president of the Board of Aldermen. "The men who are likely to make good Presidents of art societies might not necessarily make the best servants of the people in this particular respect." Furthermore, there was also the risk that as a member of the commission, the NSS president might at some point be "compelled to join issue with the President of one of the societies of which the federation itself is composed," an eventuality that would not be in the interest of the FAF or its members.[52] Such conflicts of interest were unlikely to advance the progress of municipal art.

Thus, Root contended, a change in the nature of membership and modus operandi was necessary. The "whole matter" would be better off "in the hands of trained and skilled artists," but artists acting independently, not necessarily as the representatives of their professional groups. Root also claimed that the scope of the current commission's purview—the approval of works of art—was insufficient: a new commission should be empowered to review the design of such structures as major buildings and bridges, should the mayor request it. The charter commission needed to consider the city's future needs.[53]

The Greater New York Commission essentially followed the FAF's recommendations and provided for a new art commission in the Greater New York Charter. In the end, the Board of Aldermen was no longer represented. The mayor, as the representative of all New Yorkers, retained sweeping powers. Not only was he an ex officio commission member (with the hope that he would not be swayed by petty political interests), but he also was empowered to appoint all but three of its ten members. (The charter also stipulated that when a project came under the jurisdiction of a particular city department, its head would become an art commission member ex officio during the approval process.) Built into the process, however, were provisions that endowed the private Fine Arts Federation with extraordinary power in the public sector; the charter specifically put the FAF in charge of nominating three candidates for each position appointed by the mayor. Its lists, each with three names, had to include architects, sculptors, and painters; the mayor would choose one of each. The federation also provided the mayor with two lists of three names each for the two lay members. These individuals would

be businessmen, lawyers, and other municipal leaders who, the FAF averred, would secure the public's confidence and represent its interests, yet who, unlike the mayor, could assuredly remain above the fray. In developing an art commission, then, the FAF had successfully laid claim to the privilege of representing public aesthetic expertise and succeeded in further reinforcing that association by linking its own aesthetics to the good of the city.

The city's preeminent cultural institutions also won a victory. The charter required that the members of the art commission include the presidents of the Brooklyn Institute of Arts and Sciences, the Metropolitan Museum of Art, and the newly established New York Public Library, all of which were housed in publicly funded structures on municipal property. The rationale was that these individuals "would be certain to be in sympathy with the highest art interests," as the Fine Arts Federation put it. They represented the values and experience of art connoisseurs and would bring to their review of municipal projects a depth of knowledge, incisiveness, and independence comparable to that brought to the review of potential accessions for their own institutions. As the "best men," they would be "free from prejudice, impracticableness, and captious obstinacy." Significantly, in contrast to the professional and lay members, who would be appointed for terms of three years, the institutional members did not have specific term limits. In positions of leadership, they would command the trust of the people.[54]

The art commission, then, an official body representing the public's engagement with the appearance of New York City, consisted of individual artists/citizens whose tastes would be synonymous with good taste and, thereby, identified closely with the welfare of the municipality. Unlike the Parks Board's committee of art experts and the precharter Municipal Art Commission, the Art Commission of the City of New York was not advisory. Although it was reactive rather than proactive, it was given real authority. Like the municipal departments of health and sanitation and the federal Interstate Commerce Commission, the art commission was in a position to exercise the police power to control urban space and the environment to protect the public good.[55] Whether the commission could implement successfully this aesthetic regulatory power, akin to the models of sanitation, health, and public safety, would, however, be uncertain. The departmental mechanisms of sanitation, health, and police allowed control from within municipal government. The aesthetics of the built environment proved to be more of a problem. Art, as legislated through the Greater New York Charter, required other, special arrangements.

In the cases of health, sanitation, and policing, municipal government offered specific rules and lessons by which citizens were expected to abide, and it employed the police power on behalf of the common good. Within these

departments, employees worked under a single, strong-willed, and relatively independent leader and were paid to implement his goals.

Public aesthetics were deemed more nebulous. Aesthetics were not an outgrowth of habits, behaviors, or biological phenomena; they were not straightforward in their effects, consequences, or constitution. It was harder to prove results. Hence the exercise of aesthetic judgment allowed for democratic access. Each citizen had the right to have an opinion. Nevertheless, advocates of civic reform determined that in the public realm, at least, aesthetic anarchism was unacceptable. Aesthetic interests had to prevail on behalf of the public interest; discrimination was needed. Just as museums showcased the best art, as judged by experts and connoisseurs, so too, the city needed an impartial, incorruptible board to vet submissions that ultimately affected and represented the public understanding and knowledge of art and life and that affected the quality of life. Representing reformers' fears of municipal government and their sense of its possibilities, the art commission was judged the optimum instrument by which the city could exert control over the aesthetics of public spaces.

Forged by Republicans and independents, chapter 37 of the charter reflected the Republican and Citizens Union's concern for a private watchdog over municipal operations, configuring the commission as a semipublic body. Its members were not employees but were to act in concert as private citizens on behalf of the city. Through their actions they would offer standards. At the same time, in contrast to the health and sanitation departments, the board would not be governed from the top down by a paid executive. Decisions would be made through negotiation by men accustomed to doing so, behaving like gentlemen. Approvals would not require unanimity but, rather, a quorum.

All the members except the mayor, as unelected appointees, were ostensibly not subject to local political pressures. Their mission was to insure that the public culture of urban aesthetics remained disinterested, and that negotiation over the aesthetic health of the city would not succumb to localized, parochial concerns.

THE NEW INSTITUTION

Established in 1898, the Art Commission of the City of New York was the product of a successful movement to implement legislatively and politically the idea that public aesthetics, like sanitation, health, and the public welfare more generally, were a matter of definition and action deserving of municipal vigilance and control. Concerns about public cleanliness and order, rampant commercialism, and individualism would, as we shall see, find a parallel in

commissioners' aesthetic proclivities for "classical" restraint and simplicity within the academic artistic vocabulary. The ACNY was an affirmation of the ability of municipal government to control its own affairs, a conviction that government protection was needed because matters of taste concerning the public realm were clearly too variable for private parties to negotiate. It was an expression of the belief in an enlightened municipality taking responsibility for its property and image, a conviction that was hard to square with a fully democratic receptivity toward all modes of artistic expression.

A precedent for this existed in Europe. In Paris, jurisdiction over placement of public monuments within the city was divided between the municipality and the state. The Municipal Council (Conseil municipal) approved requests for monuments for city property (such as the Hôtel de Ville or the Jardins de Luxembourg) from citizens groups; sometimes the council also sponsored monuments. The Préfet de la Seine handled public works in general, and the director of fine arts of the Ministry of Public Instruction (Ministère de l' instruction publique), within the Préfet de la Seine, had jurisdiction over works on state property (such as the Panthéon). Sometimes the jurisdictions could overlap, as when the Societé des gens des lettres sought to persuade both the Conseil municipal and the Ministère de l' instruction publique to prevent the placement of Rodin's *Balzac* in a public space in Paris.[56]

New York City's art commission represented a triumph of the Fine Art Federation's values—in alignment with those of powerful politicians. Its formation was an outgrowth of a broad and chaotic power struggle in which no one party's victory was assured. Thus strains and uncertainties continued. The challenge for the ACNY would become how to balance the desire for democratic access, popular public desires, interests, and aesthetic preferences with a demand for artistic quality. Sometimes it would maintain that balance more effectively than others.

At certain points the ACNY was strong, reinforcing elite domination of the cultural sphere. At the same time, the configuration of the ACNY reflected other tensions arising at that moment. The distrust of power exercised by Democratic Party government in New York resulted in provisions intended to protect urban citizens and communities from unscrupulous individual politicians purporting to represent the public interest. The ACNY's structure thus represented an effort to incorporate a system of checks and balances. As configured, it had weakness built in, since it represented a government body that worked as a potential adversary to municipal government as well as to individuals. Consequently, the enterprise was always very fragile. As a result, in general, the art commission process would involve a great deal of negotiation and the participation of diverse individuals and groups. The goal was aesthetic resolution, not power. Nonetheless, it would quickly become

evident that power was a necessary evil to realize effectively the commission's ultimate mission.

This reality became clear in the final phase of the efforts to install the Lorelei Fountain.[57] The Heine Memorial ultimately found a place on municipal property during the new administration of Tammany Democrat Robert Van Wyck, the first mayor of Greater New York. As historian Thomas Reimer has shown, Van Wyck was indebted to German Americans and especially the *Staats-Zeitung*—infuriated with Seth Low's endorsement of the blue laws outlawing sale of alcohol on Sundays—for voting him into office.[58] At some point between November 1898 and June 1899, the newly appointed—and, significantly, German-Jewish—president of the Board of Aldermen Randolph Guggenheimer, a member of the Arion, brokered a compromise, grandfathering in the board's earlier resolution to allow the Bronx street improvements commissioner (now borough president) Haffen to accept the work and convincing opponents to look the other way to avoid further damaging political fallout.[59] (The action represented a victory for the newly appointed Haffen, who would soon seek to assemble his own fiefdom, which would position him to lock horns with the art commission on future occasions.) The Heine Memorial was erected at the entrance to the Grand Concourse, on a "conspicuous knoll that rises above East One Hundred and Sixty First Street and Mott Avenue." On 8 July 1899, Guggenheimer accepted the memorial on behalf of the city at an elaborate dedication ceremony. The participants celebrated, with great satisfaction and no little irony, the quest for freedom from oppression that Heine's life and work represented and the virtues of German Americans' adopted home, New York City, which could accommodate all races, creeds, and, implicitly, aesthetic preferences.[60] No sooner had the art commission been created than its authority was circumvented, along with that of the artistic and civic leaders its members represented. Such mixed successes were the reality of doing business in the realm of public aesthetics in Greater New York—in 1898 and a century later.

IN SEARCH OF

VISUAL CULTURE

January 1, 1898, inaugurated a new era, during which the five boroughs were consolidated into Greater New York. The city's population grew from 1,441,216 in 1890 (a figure that did not yet include Brooklyn) to 3,437,202 in 1900 and to 4,766,883 in 1910. By 1900 New York was also the "preeminent port of entry for European immigrants to the New World."[1] Metropolitan growth ushered in crucial changes in the city's appearance, most conspicuously, the ascendance of the commercial skyline. Urban expansion also extended to the public realm, with the restructuring of municipal institutions, authorities, and alliances; redistributions of power; and construction of new civic buildings, parks, and streetscapes. The Art Commission of the City of New York (ACNY) would become a notable participant in the drama of urban transformation.

The new ACNY's activities illuminate one aspect of complex arbitrations that shaped the city's public image. This chapter examines the organization and development of this new municipal department. (In its early years the ACNY was known nominally as a "department" of city government). It explores how the parameters of the ACNY's powers were negotiated during its first two decades and its impact on specific projects and on the civic image of early twentieth-century New York City. Spotlighting the ACNY will illuminate the public culture of municipal urban design.[2] The identity of the city was also bound up with memory, but this chapter focuses on the conceptualization of the city of the present.[3]

The 1898 charter of Greater New York mapped out the ACNY's basic structure and membership but did not delineate the scope and confines of its power. The ACNY quickly sought to expand its authority to advance urban "visual culture"—an honorable, rational, inspiring, and communal-minded civil society, manifested by compelling civic structures. Tensions ensued over the ACNY's authority to initiate, revise, and regulate municipal design. Support from elected officials, especially the mayor, would be crucial

in determining the ACNY's successes and failures in these circumstances. Activists in the city's powerful professional art societies and civic arts associations (especially the Municipal Art Society [MAS]) also played an important role.

Personal and political interactions among ACNY presidents, staff, municipal officials, politicians, artists, architects, and civic activists determined the effectiveness of the ACNY's powers and agenda between 1898 and 1920. These enterprises would also be influenced by related but subsequently tangential conditions, like the efforts to control the development of New York and the metropolitan region. The ACNY's early administrators—its second president, John De Witt Warner, and assistant secretary, Milo Maltbie—regarded the department's mission as being crucial to the project of urban beautification and civic reform as well as planning. Under the twenty-five-year leadership of the ACNY's third president, lawyer Robert De Forest, the commission ceased to operate deliberately with initiation or the big picture in mind. It instead functioned as counsel, setting its sights on incrementally enhancing the public landscape. Individuals made a difference.

SETTING BOUNDARIES

The Greater New York Charter took effect on January 1, 1898, and along with it, the provisions for a new municipal art commission. The new mayor, former judge and Tammany organization man Robert Van Wyck, made the first appointments. He selected Daniel Chester French as the ACNY's first sculptor member, John La Farge as painter, and Charles F. McKim as architect member. Financier Charles T. Barney, former judge Henry E. Howland, and collector/art dealer Samuel P. Avery received appointments as lay members. The Metropolitan Museum of Art's president Henry Marquand, New York Public Library president John Bigelow, and A. Augustus Healy of the Brooklyn Institute of Arts and Sciences were the other charter members.

Van Wyck's appointments must have seemed auspicious for activists in the MAS and the FAF who had engaged in civic art battles for the previous eight years. The new ACNY initially operated rather informally, rather like a small club. All its members were active MAS members and, thus, could be expected to look favorably on MAS projects. Barney, subsequently elected ACNY president, was also MAS president.[4] In addition, he had been FAF representative on the now-defunct 1896 (French bill) Municipal Art Commission. His appointment represented an extension of that membership and relationship; Barney brought credibility and experience in mediating between civic groups and state and local politicians on controversial aesthetic matters. Daniel Chester French himself was an NSS representative on the FAF and had served

on advisory committees on placing statues in the New York City parks. Like French, McKim and La Farge had national reputations and high standing among professionals. Since the charter mandated that the FAF (made up of the professional societies) develop the list of names from which the mayor made his selections, none of these Van Wyck selections seemed especially surprising. Nonetheless, for the arts groups the choices were heartening. Reveling in their now-official influence on cultural organizational structures and on policies in the public sector, the arts organizations were poised to advance their vision for the city's civic arts and public improvements.

While the first ACNY included some of the nation's most illustrious artists and wealthy and powerful men, their dominion turned out to be quite limited. It soon became clear how much control remained in the hands of the mayor. His selections underscored the pragmatic aspects of cultural politics in the city. He paid lip service to the culture groups by appointing prominent cultural advocates, but in practice, he gave the ACNY nothing to do.

Van Wyck was, to say the least, unsympathetic to the aims of the ACNY. He had no intention of enabling the group to encroach on local political fiefdoms or to meddle with the operations of his favorite municipal architectural firm, Horgan and Slattery.[5] The charter stipulated that the ACNY had authority to approve or disapprove municipal art and to function as curator of the city's art collections but could only review public buildings and other structures (like bridges) if the mayor or Board of Aldermen requested it.[6] Neither Van Wyck nor the Board of Aldermen recommended ACNY review of any building or large public structure during Van Wyck's entire time in office.[7] The group was thus left with little purpose other than to evaluate a few submissions for portraits for City Hall and public monuments (the latter of which will be discussed in chap. 3). And although the charter delegated the ACNY specifically to assess the merits of art for municipal property, we have seen (in chap. 1) that Van Wyck had already bypassed the ACNY on the Heine Memorial (fig. 1.2) which by statutory mandate should have fallen within the ACNY's jurisdiction.

Van Wyck understood how to get his way. He pressured the new commissioners to accept the Heine Memorial, but there is no evidence that they explicitly agreed. It appears that Van Wyck enabled Board of Aldermen president Randolph Guggenheimer effectively to circumvent the commission in brokering the compromise that led to the realization of the project.[8]

The administration's lack of support was underscored in other ways. The ACNY had a miniscule budget and no real office or staff.[9] Given the circumstances, it is unclear that the commissioners themselves took the enterprise very seriously. The group met late in the day in friends' and officers' homes and in exclusive social clubs. Little transpired at the ACNY's early

meetings. Their conferences were sporadic and, sometimes, even failed to occur for lack of a quorum or items for the agenda.[10] Nor could the commission be assured of support from the press, who dubbed it "the Beauty Commission." The early ACNY was a conflicted entity because, from the perspective of the Tammany administration and its loyal party operatives, the commission had been jammed down their throats by the "Goo-Goos" (a term of derision referring to idealist supporters of political reform).[11] The ACNY had status in some circles, but as an arm of municipal government, between 1898 and 1902 it was more a symbol than an instrument.

THE LOW ADMINISTRATION

Friends in High Places

A change in administration could make a significant difference. When Fusion mayor Seth Low (1850–1916) came into office in 1902, he invigorated ACNY aims and influence. A former two-term mayor of the city of Brooklyn (1882–86), Low engaged with issues of home rule and educational and civil service reform. As president of Columbia University (1890–1901), he forged new institutional ties, built up the professional schools, and oversaw the college's move to from midtown to Morningside Heights. An advocate of expertise, Low fully supported the notion of utilizing an art commission for aesthetic oversight of public works. He had served on the 1898 Charter Revision Commission and had helped to draft the original legislation establishing an art commission. Low had close ties to George L. Rives, chairman of the 1900–1901 Charter Revision Commission and, without question, supported its recommendations. (Rives became corporation counsel in the Low administration.)

The 1901 charter that the New York State legislature ultimately passed extended ACNY powers to include review of municipal structures costing more than $1 million. Although the $1 million ceiling limited the scope of the ACNY's authority, the 1901 charter gave the ACNY veto power over New York City's largest and most significant public building projects. The revisions established a system of checks and balances within the municipal construction process. This mechanism was intended to rein in the architectural ambitions of local officials—like the borough presidents to whom the new charter had endowed authority over municipal building projects in individual boroughs (thus replacing the now-defunct citywide Board of Public Improvements).[12] The ACNY posed no threat to the influence and purview of these local politicians, but it was an annoyance. Politicians now had to deal with the ACNY if they wanted to see big projects realized.

By contrast, newly formed art commissions in Boston, Baltimore (1895), Chicago (1899), and Denver (1904) had far more limited powers. They reviewed only works of art, unless the mayor made a specific request for them to evaluate a public building.[13]

The ACNY's powers were expanded all the more because Low authorized it to vet smaller projects as well as large ones. The new ACNY president, John De Witt Warner, kept the mayor (as ex officio member of the commission) informed about upcoming public works projects costing less than the $1 million ceiling, above which art commission review was required. Low, in turn, routinely used his discretionary powers to refer such projects back for ACNY review; these included courthouses in the Bronx and Brooklyn, Richmond Borough Hall, the Blackwell's Island Bridge, street-sign boxes for the five boroughs, and public baths and comfort stations being constructed throughout the city.[14] Low also symbolically advanced the ACNY's newfound powers. He put an end to the commission's itinerant meetings by requesting that the Manhattan borough president find the ACNY a suitable space on the north side of the second floor of City Hall, thus situating the department squarely in the heart of municipal government.[15] Such arrangements also enabled Low to attend ACNY meetings when he chose.

Low's administration, inaugurating a fifteen-year succession of New York City mayors who aspired to achieve reforms and resist pressure from Tammany Hall, marked a new turn for the ACNY. In contrast to circumstances under Van Wyck, the involvement on the commission of prominent, ostensibly nonpartisan independent Republicans and Democrats now enabled the ACNY to have influence. Low's support was crucial for putting the ACNY on more secure professional footing, with ambitions that meshed with city beautification movements galvanizing Washington, D.C., Hartford, Conn., Chicago, and other cities and with other progressive era enterprises dedicated to ordering and improving municipal government and public infrastructure, health, and welfare.[16] By 1904 the ACNY would become, procedurally, ideologically, and functionally, a model of progressive municipal bureaucracy.

Low's commitment would also encourage the ACNY to seek a role beyond that of jurist, to test the boundaries of municipal aesthetics over which it had power. The mayor's appointment in 1902 of John De Witt Warner as an ACNY lay member was crucial to this enterprise.[17] Warner (1851–1925), a Cornell graduate who had taught Latin, German, and elocution before entering law school, migrated from upstate to New York City after entering the bar. An avid spokesman for free trade, he was elected on the Democratic ticket to Congress, where from 1891 to 1895 he fought for the interests of New York merchants who opposed high protectionist tariffs advocated by Republicans. After leaving Congress, Warner turned citizen-activist, writing

pamphlets on subjects ranging from free trade to Shakespeare and serving as president of the Reform Club and as founding editor of its journal *Municipal Affairs*, an extraordinary but short-lived journal devoted to a wide variety of urban issues. As architectural historian Gregory Gilmartin has observed, Warner's work in Congress, especially on behalf of free trade, gave him strong support among New York merchants, enabling him subsequently to bring about change without having to seek elective office. Warner also moved to the vanguard of arts professionalization and advocacy, becoming an active member of the National Sculpture Society and MAS before being appointed to the ACNY.[18]

Warner was a central figure in the creation of a powerful, activist ACNY. He had major ties to improvement and civic art causes. Like Charles T. Barney before him, Warner served simultaneously as MAS and ACNY president. Thus he symbolized the meshing of private oversight and initiative with public authority that was at the heart of the reform agenda and would characterize the ACNY's peculiar status. Like Low, Warner envisioned the ACNY's work as a core aspect of municipal reform. The department would be the counterpart to other agencies of good government. Warner's savvy and experience gave him credibility that enabled him to maneuver and forge alliances among Democrats and Republicans, artists, lawyers, politicians, and businessmen. His clout put the new ACNY on much firmer political ground.

Warner envisioned the ACNY as a good government enterprise. Nevertheless, he did not hesitate to maneuver when expedient. Warner manipulated the system in order to structure the ACNY in a manner that would suit his interests yet that could still be claimed to advance the broader reform movement, one of whose priorities was the primacy of expertise over political fealty in municipal employment. When it came to hiring staff, "reform" was a secondary concern.

The ACNY had to be a model of municipal efficiency. The Board of Estimate (consisting of the mayor, the comptroller, the presidents of the five boroughs, and the president of the Board of Aldermen) had appropriated only a very small budget, possible because the ten-member art commission worked unpaid for terms of three years. The Board of Estimate agreed to provide $6,000 for staff and office space; $900 per year of that sum was earmarked to hire a "typist-stenographer," and "$3,000 for an "Assistant Secretary" (so named because the charter already called for an unpaid "Secretary" to be elected from within the commission's ranks).

Warner quickly learned that the title and salary of this staff person did not mesh with the duties he proposed, nor did municipal hiring procedures insure the likelihood of hiring a suitable candidate. Thanks to reformers, appointments to the ACNY, like other city departments, were expected to go

through the municipal Civil Service Commission. New York City and Brooklyn had been the first cities to establish civil service reforms (1883) to eliminate party-based patronage and corrupt appointments. (According to reformers, party loyalists were hired in effect to do nothing.) The state constitution of 1894 mandated that state and local officials could be appointed and promoted only if judged suitable in "merit and fitness," a determination made through competitive examination. Consolidation of the five boroughs produced struggles between reformers and party leaders to control municipal hires. Political scientist Gerald Benjamin has noted that although the parties lost control, they welcomed the civil service notion of "merit and fitness," but then manipulated the terms in ways that circumvented and undermined the very civil service reforms and procedures that they ostensibly embraced.[19] Reformers could just as readily manipulate the system.

Warner already had a suitable candidate in mind. He fully intended to hire Milo Roy Maltbie (1871–1962), a Ph.D. in political science from Columbia University, specializing in municipal government and public law, a fellow Reform Club member, and (along with Warner) coeditor of *Municipal Affairs*.[20] In order to hire Maltbie, Warner insisted on circumventing civil service. The circumstances reveal the ways in which the effectiveness of the ACNY and the reform enterprise did not rest solely on achieving honesty in government but, rather, winning battles to put the appropriately connected men in office.

Warner's efforts to hire Maltbie represented just such a case. In early 1902 the Civil Service Commission sent Warner a list of three "eligibles" for the assistant secretary position. Maltbie was not on the list, and Warner immediately set about to bypass the civil service process. He argued to the Civil Service Commission that the eligibles list provided to him was for a different job in the Department of Parks, a different agency; that the list that had been compiled for the position was in fact three years old; that none of the men on the list were qualified for a job with the specific and exacting responsibilities that this one demanded; and further, that the position title itself was a misnomer because the job (as conceived by Warner) called for someone with a far greater level of intellect, competence, and ambassadorial skills than the term "assistant secretary" seemed to imply. Following in the fine tradition of the many who sought to dodge civil service procedures, Warner requested permission to hire the assistant secretary as a "temporary" appointment and then to interview Maltbie as part of a "noncompetitive" examination.[21] (The job title would prove in fact to be a misnomer. The assistant secretary would consistently belong to the same core of civic cultural activists from which the commissioners themselves were drawn and was their social and educational peer.) The president of the Civil Service Commission granted Warner's request, and Maltbie was hired.[22] Thus in pursuing excellence, even the

champions of reform were not above skirting the rules, if it meant loosening Tammany Hall's stranglehold on political patronage and bestowing it on the "best men"—civic elites.

Low's support enabled Warner and Maltbie to take an activist approach to the ACNY's affairs. Operating on the principle that the ACNY was an arm of progressive municipal government, the two established routines and standards that would legitimate the ACNY as a rationalized, bureaucratic department; these included the development of consistent submission and review rules and application forms and mechanisms for insuring systematic recordkeeping.[23] To handle submissions, the president was to delegate each project to subcommittees of three, generally presided over by a professional member, such as an artist or architect. The committees would meet late in the day during the week before the regular monthly meeting and, subsequently, offer to the full commission its recommendation, sometimes accompanied by a report.[24]

Warner deemed recordkeeping especially crucial. He insisted on maintaining duplicate forms and at least one set of complete drawings for all submissions as well as a proper archival system that required "that there shall be always kept on record at the office of the commission, properly filed and indexed, all papers on which the commission shall have acted."[25] Since years could sometimes go by between the first preliminary submission and a final approval, Warner's emphasis on accurate recordkeeping helped to insure that the commission would always be able to account for its previous actions, particularly if its decisions were challenged or ignored or when individual or institutional memories failed.[26] (At the same time, however, since much of the real dialogue about submissions took place in committees, and committee discussions were not put on the record—unlike meetings of the full commission, which voted on committee decisions—vital aspects of the department's process remained off-limits.[27] Though the ACNY was a municipal department acting on public space matters, its deliberations were not considered to be essential to the public record.)

Maltbie initiated another form of recordkeeping: he compiled a catalog of artworks in the city's collection, as a means of enabling the art commission to ascertain what statues, monuments, or artistic structures already stood in the vicinity of proposed new projects they would be evaluating. Such information would help the commission determine the "suitability" of locating particular new projects on specific sites and anticipated the ACNY'S future role as curators of the municipal art collections.[28]

The ACNY had additional procedures. Before coming to the ACNY, an applicant (if not itself a city department) obtained approval from the appropriate city department, then submitted the project drawings, plans, and

forms to the assistant secretary for the ACNY's evaluation.[29] The head of the department in whose jurisdiction a given project was located served as an ex officio commissioner—and hence could vote—during the review. Such a stipulation secured the cooperation of the department heads, who were encouraged to experience deliberations and assess for themselves the reasonableness of the commission's methods and actions. The ACNY would vote to approve or disapprove the project; a disapproved project could be modified and resubmitted, unless, in the case of an artwork, the disapproval stemmed from the choice of site; in this case, if a new site could not be found, the project could not go forward.[30] Sometimes the venture would not progress because the budget proved to be prohibitive, but this factor did not always result from an ACNY action.

Maltbie and Warner believed that appropriate management would enable the ACNY to participate in an important new phase and conception of urban development that Low's Fusion administration was initiating as an integral part of progressive municipal government. The codification of ACNY procedures and regularization of its affairs would not only advance a vision of an ordered municipality but also demonstrate that ACNY operations were clear, fair, and accountable. Such actions would shield the ACNY from detractors who contended that its decisions were either too arbitrary or insufficiently attentive to contingency. Under Warner and his successor, Robert De Forest, the ACNY sought to operate authoritatively; it was imperative that its decisions not be perceived as capricious or conditional.

"Visual" Culture, Ensemble Planning, and Limits of Power

Warner and Maltbie promoted the importance of consistency because they kept the bigger picture in mind. As activists in the municipal reform movement, they envisioned ACNY work as contributing to broad structural change. Their actions were driven by the conviction that the ACNY would serve as an agent of reform through the visible, by a belief in the ameliorative social powers of visual culture—"popular culture" (as City Beautiful theorist and planner Charles Mulford Robinson coined it) articulated and advanced by "City Embellishment," the "Arts of Sight."[31]

Such conceptions were indeed in line with the ideals of the nascent City Beautiful movement. Originating during the years from 1897 to 1902, the City Beautiful was a widespread popular effort to enhance the appearance of towns and cities nationwide through civic art, parks and parkways, and clean, well-manicured streetscapes. Inspired by major European centers like Paris, Rome, and Vienna, as well as by the successes of the 1893 World's Columbian Exposition in Chicago and the 1902 McMillan Plan for Washington, D.C.,

City Beautiful advocates espoused an ideal of urban planning as design, an integration of architecture, landscape and streetscape design, street fixtures, and public art into one harmonious whole. City Beautiful sympathizers contended that individual structures were but one element within a total composition. A design might be suitable in isolation, but the object's aesthetic impact could not be gauged without assessing its impact on the surrounding locale, and vice versa.

The City Beautiful would have necklaces of parks, civic centers with grand classical-style public buildings arranged in unified ensembles, and processional boulevards with sweeping vistas ending in breathtaking monuments. Major arteries would connect districts by cutting diagonally through the street grids, as in Paris; some would encircle the city, as in Vienna, enhancing circulation. Collaborations among artists, architects, landscape architects, urban activists, civic organizations, and local government resulted in a series of grand plans for cities like Harrisburg, Philadelphia, Saint Louis, Kansas City, MO, San Francisco, and New York. Few were fully realized, but some were partially implemented.[32]

This impulse, embraced by Warner, Maltbie, and other members of the ACNY, was grounded on the assumption that municipal beauty, articulated through such principles as clear sightlines, classical form, and axial and symmetrical arrangement of buildings and streets, would enhance the quality of urban life and contribute to the cultivation and pleasure of the citizens.[33] "The happier people of the rising City Beautiful will grow in love for it, in pride for it," wrote Robinson. "They will be better citizens, because better instructed, more artistic, and filled with civic pride."[34] For Maltbie, Warner, and their fellow commission members, as for civic art enthusiasts more generally, the task of regulating urban beauty was integrally linked to the enterprises of social and political improvement.

The Warner ACNY conception of visual culture, then, was driven by ambitions not only to regulate but also to initiate, enhance, and plan. The charter was unclear about the ACNY's limits in fulfilling these agendas, stating what it could do but not what it could not do. Warner and Maltbie set out to test the possibilities. They would work toward advancing a City Beautiful ideal by seeking to insure that municipal art, architecture, and other structures would be both worthy designs in their own right and vehicles of urban enhancement and cultural uplift.

The ACNY also saw its role as one of undertaking aesthetic regulation. The experience of art experts in New York City had convinced them that aesthetic deficiencies were often symptomatic of other, larger, malfeasances, such as assigning big contracts to architectural hacks with good connections. As we shall see, ACNY members bristled at the results when ornament

seemed to be applied indiscriminately, decoration was overdone, or a structure appeared to be an awkward accretion of parts. Gussied-up designs were too often an expression of extraneous and corrupt interests governing public design. If the ACNY could not control the delegation of municipal architectural contracts, it would seek to use the veto power to undermine the cronyism that they believed permeated the system of architectural patronage and construction utilized by the Tammany Democrats who were politically dominant in local wards.

Municipal embellishment hinged on individual projects; but ACNY ideals for public improvement extended beyond regulating specific projects to include consideration of the broader urban context. Warner and Maltbie believed that the ACNY should have input on aesthetic planning.

In Europe, planning was overseen by the state, under the auspices of centralized national government agencies (like Paris's Préfet de la Seine within the Ministère de l'Intérieur).[35] New coordinated streetscape and public works projects were transforming capital cities like Paris, London, Rome, and Vienna. Likewise, the development of the MacMillan Plan hinged on Washington, D.C.'s special status as a national capital, for which Congress and the Department of the Treasury controlled much of the planning.

Planning power in the new New York City was neither so centralized nor so organized, in good part because New York—although the nation's metropolis—was not the national capital. No municipal planning body existed during the Low administration, though the MAS and other civic groups lobbied, unsuccessfully, for one. The charter did not delegate to the ACNY the power to determine the location and grouping of public buildings; nor did it specify that the ACNY had authority to decide on the aesthetics of a building in conjunction with its surroundings. Such matters were troublesome. Were the ACNY to have the power of initiation it would effectively be approving a project in which it had a vested interest. Hence few of the city's civic arts activists felt that a single group of unpaid citizens should be in a position to amass such potential power.[36] Even many art commissioners themselves would come to concur; if the ACNY had too much initiating power, it risked becoming an instrument of municipal government, a creature of the state, rather than an odd-duck organization whose members could stop the worst excrescences without having to work or answer to anybody to do so.

Nonetheless, in the early years, in the absence of any official planning body, Warner and even Low himself apparently saw no problem in engaging the ACNY to advise on planning issues on a limited basis. In one instance, for example, the mayor charged a commission committee to suggest approaches to the new Williamsburg and Blackwell's Island bridges. In another, the committee advised Low on planning in Brooklyn.[37] Periodically using the

ACNY as advisers enabled Low to skirt more sweeping and costly official initiatives, like developing an official planning commission—an ideal toward which he was lukewarm. Administration officials resisted delegating power officially to any body that might diminish the autonomy of local officials to plan within their own fiefdoms.[38]

Such engagements emboldened the Warner ACNY to make decisions with planning implications. In 1902, for example, the ACNY vetoed plans to extend the New York County Courthouse into City Hall Park, because it would encroach on a major historic public space.[39] Warner and Maltbie insisted, moreover, that ACNY review of structures not be limited to buildings themselves, but also take into account the suitability of the proposed location. Hence the early ventures to delegate to the ACNY official authority to control municipal public aesthetics, interpreted in its broadest sense, often pitted the cosmopolitan values of wealthy Anglo-Protestant, unpaid commission members from Manhattan against the more localized and diverse interests of Irish and Italian Catholic politicians, contractors, and architects, working in the other four boroughs. The case of the Bronx County Courthouse highlighted such circumstances.

BRONX COUNTY COURTHOUSE

The Bronx County Courthouse (figs. 2.1, 2.2) debate exemplified the limits of ACNY power with respect to the question of initiation versus regulation that the commission was seeking to manage. It served as a case in which the fluid boundaries of the ACNY's official terrain in the aesthetic sphere were negotiated and solidified. It was also an instance in which the ACNY sought to weigh in on design very broadly conceived to include location, hence attempting to define its aesthetic purview as encompassing planning as well as aesthetic policing of discrete structures. As in opposing the extension of the New York County Courthouse, ACNY efforts to control Bronx courthouse planning would have ramifications that both took appearances into account and went beyond them. It involved fighting corruption and asserting the authority of both Manhattanites over citizens of the outer boroughs and of municipal power over the local. The ACNY sought to avert what its members contended was the inappropriate placement and design of the building: design decisions that they believed to be made for any reason other than "appropriately aesthetic" reasons. The ACNY spoke out on the building's formal arrangement, citing a need for greater simplicity and unity, a more seamless integration or organic treatment of parts in relation to the whole. Such notions were linked to very definite style preferences and representations, but they also had an unspoken political dimension. For the art authorities, the

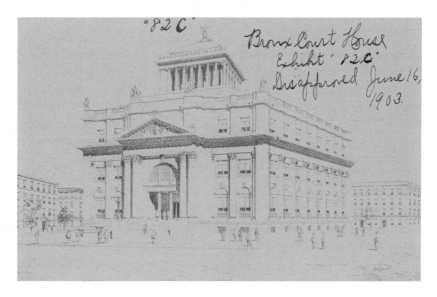

2.1 Bronx County Courthouse, elevation drawing, disapproved 16 June 1903. (Collection of the Art Commission of the City of New York, Exhibition file 82-C.)

courthouse exemplified urban vulgarity and insularity in opposition to decency and breadth of vision. In spite of their ambitions, the ACNY had limited success in controlling the aesthetic aspects of the project in its broadest conception.

With the Bronx County Courthouse, the commission entered the fray of "outer borough" politics, shouldering the role of naysayer that the NSS and FAF had assumed earlier with the Heine Memorial. In the aftermath of consolidation and the 1901 charter, empowering borough presidents to authorize new local construction, each of the boroughs initiated plans for new courthouses to house the expanding municipal system of justice (and to mete out jobs.) On June 1, 1903, Bronx borough president, Louis F. Haffen, submitted to the art commission preliminary plans and drawings for a new courthouse at the intersection of 161st Street and Third and Brook Avenues (see fig. 1.5).[40] The structure was rendered in a "Greco-Roman" style with rusticated blocks. The lower two-storied section had large, arched, and heavily linteled first-floor windows and smaller rectangular second-story windows, with colossal Corinthian piers separating each bay, and quoined piers at each end (fig. 2.1). An ornate portal with pediment flanked by double columns surrounded a monumental arched entrance. A large entablature divided these two lower stories from a more "refinedly" rusticated upper section whose squat piers visually extended those of the lower section. The rectangular block was capped by

a balustrade with allegorical sculpture and a hipped roof. Above that, the architects added a mansarded peripteral temple tower, which looked much like a widow's walk. To use today's parlance, the design was exceptionally "busy."

As mentioned in chapter 1, Haffen, as commissioner of the Board of Public Improvements for the North Side, had been a key supporter of the Heine Memorial project. A Tammany man and Bronx borough president since 1898, Haffen was engaged in Bronx empire building: dispensing patronage, amassing power, and developing what turned out to be a corrupt fiefdom. Haffen selected as courthouse architect Michael J. Garvin, a former tenement house builder and former head of the Building Department. By virtue of being, in the words of a *New York Times* reporter, "Louis F. Haffen's most trusted lieutenant in Bronx politics," a secretary of Haffen's "political club" there, Garvin had suddenly assumed the mantle of public architect.[41] As the circumstances surrounding the Bronx courthouse will suggest, the *New York Times* probably had additional reasons for remarking on these distinctions.

The art commission committee assigned to this project (Henry Rutgers Marshall, author Loyall Farragut, and merchant William J. Coombs) deemed Garvin's courthouse design totally unsuitable and described its concerns in an unusually detailed report that the full ACNY accepted. Extending its reach to include considerations of planning, the committee observed that the problem, first and foremost, was location. The proposal to place this courthouse next to the elevated railroad station made no sense, aesthetically or pragmatically. On a purely practical level, they noted, the noise from the El trains would disrupt the court proceedings and create an intolerable condition for those inside. (The proposed courthouse contained a jail within it.) The plan to site the courthouse in, effectively, a low-lying area, a depression, "so that the building, which would face the south, could not be seen from any great distance," would obviously detract from its aesthetic success. The only decent view of the building would be from the El itself. A site "in close proximity" to the elevated railroad was "an unworthy location for a building which is supposed to be monumental in character," and to cost "at least $800,000."

Location, the report continued, was not the only problem. The designs for the exterior were "common-place and inferior" in proportion, with the "central oblong tower" being "especially objectionable." The committee also commented that designs for interior decorations lacked proper study and proportion and the interior plans themselves were illogical. Such observations on interiors were without question beyond the ACNY's proper purview, which extended only to mural paintings for the inner walls of municipal structures, not to interior plan.[42] The assessments were consistent with the ACNY's preference for classical simplicity and restraint versus what members regarded as baroque excess. However, the ACNY's aesthetic pronouncements had a

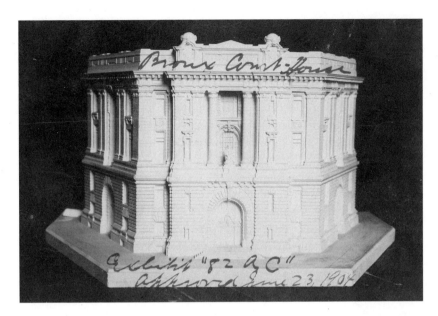

2.2 Bronx County Courthouse, approved 23 June 1904. (Collection of the Art Commission of the City of New York, Exhibition file 82-AD.) In the revised design, the architect limited rustication to the lower stories and reduced significantly the amount of decoration, now used only to accent the harmony of the whole. The temple entrance, balustrade, upper-story sculpture, and "widows walk" were eliminated in favor of a projecting baroque-manner entrance pavilion with colossal piers and columns flanking centralized windows that carried the line of the arched entrance doors up through the upper stories.

decidedly class and ethnic resonance that did not endear it to the architect or borough politicians. Not surprisingly, the ACNY disapproved the plans in June 1903 and then again in December (the latter, for an incomplete submission).[43]

In the case of the Bronx County Courthouse, however, Low was forced to acknowledge the limits of his and the ACNY's powers to affect contracts and intervene with planning decisions. On June 25, 1903, Low's corporation counsel, George L. Rives, issued a finding that the art commission did not have power to review the aesthetic merits of a building's location, and thus the commission had to review the exterior designs without respect to site. Aesthetics could not take priority over municipal real estate development.[44] The confines of the ACNY's proprietorship over the aesthetic had been set.

The commission objected strenuously to this finding; but forced to relinquish its engagement with locale and urbanism, it pressed on with its review of the building in isolation. Haffen submitted a revised and greatly simplified design for the courthouse in June 1904 (fig. 2.2). The compositional weight was devoted to the upper stories, and the proportions of the building

as a whole were more attenuated, centralized, and unified. This time, unable to consider location as part and parcel of their aesthetic assessment of the building's effect, the commission approved the modified designs.[45] The revised structure was more consistent with the City Beautiful vision of coherent municipal image and identity.

However, Garvin's revisions and clarifications proved to be merely superficial. Diverging from ACNY aspirations for the "Arts of Sight," the new plans failed to signify good, honest government. After approving the courthouse plans, the ACNY soon learned that although Garvin had submitted them under his name, another architect, Oscar Bluemner (who would subsequently win renown as a modernist painter), had in fact conceived the courthouse building accepted by the ACNY.[46] Bluemner, who claimed to have designed the structure with the understanding that he was to receive half of the commission, was incensed at the falsification and Garvin's efforts to cheat him. He filed suit in New York State Supreme Court, arguing he was due $20,000 according to the agreement forged with Garvin. Garvin had done Bluemner "a number of kindnesses" while head of the building department. In return, Bluemner had agreed to let Garvin submit the designs under his name, with the understanding that Garvin would share the credit were they to be accepted. Instead, Garvin gave Bluemner the "cold shoulder," and, since Bluemner had signed no contract, his only recourse was to file suit. Garvin, sniffed Bluemner, "couldn't draw the plans for a big thing like the new Court House to save his life." Garvin denied the charges, insisting that he had hired Bluemner only as a draughtsman at a fixed salary.[47] Even decent design could breed fraudulence.

The ACNY was powerless to respond to the Garvin-Haffen deceptions. Its only option was to disapprove subsequent submissions for the architectural sculptural details. Although the city launched an investigation of Haffen's involvement and corrupt dealings in this and other instances, (including consideration of why the 161st Street site was so dear to his heart and why granite contracts were awarded to a firm controlled by a Bronx alderman), and although New York's governor Charles Evans Hughes ultimately ousted Haffen from office in 1909, the Bronx County Courthouse was built according to the ACNY-approved plans.[48]

Even Low was forced to acknowledge that he could not delegate to self-appointed Manhattan cultural influentials the political authority over local elected officials to situate projects where they so chose in their own boroughs. The case established the limits of the aesthetic terrain over which the ACNY could claim powers of oversight: the ACNY could not rule on the location of buildings. Indeed, officials were undoubtedly swayed by their recognition that metropolitan interventions in local projects had the potential to churn up

political resistance. Neither Low nor his successor George B. McClellan, Jr., moved forward very boldly with any official planning ventures. As far as the ACNY was concerned, the Bronx courthouse was a turning point. The case tested the scope of the ACNY's powers, and Rives's decision set the limits. In later projects, the boundaries of the ACNY's aesthetic activities were more clearly delineated.

TRANSITIONS AND CONTINUITIES

For several years after Warner's departure as ACNY president, the ACNY continued to render decisions that linked aesthetic and political reform and highlighted tensions between aesthetics and politics of ethnicity and class. With the 1906 submissions for the Queens County Courthouse, for example (fig. 2.3), the ACNY would attend to the reform aspects of aesthetic regulation by objecting to visual excesses of a design whose architect, Pietro M. Coco (dubbed "rococo coco" by the *New York Press*), was subsequently indicted for grand larceny. But with the ACNY presidency of Robert De Forest, which spanned the administrations of three democratic administrations, ACNY ambitions were cut back; the Warner-era ACNY's initial claims to broad interpretations of the aesthetic became more constricted.

When De Forest came on board as president in 1905, Milo Maltbie was still on staff. Maltbie continued to push for a broad agenda that could potentially offer a national standard. He convinced De Forest that the ACNY should press for a charter revision that would enable it to consider aesthetics in conjunction with locale in its review of architecture, just as it was empowered to do with works of art.[49] He also persuaded De Forest to seek a significant reduction in the budget ceiling—from $1 million to $100,000—for structures that would require ACNY review.[50] "The location of public structures is such an important matter that sites ought not to be selected by the City without the approval of the Art Commission," Maltbie wrote De Forest. The problem was that, presently, location questions came to the ACNY too late for it to provide meaningful input—action that was no doubt deliberate. Maltbie knew that the borough presidents, department heads, and architects and contractors would resist such a move toward design micromanagement. For aesthetic review, after all, affected not only the look of the city but also what kinds of deals were struck, contracts written, and monies exchanged. Maltbie acknowledged that the ACNY was "not well organized to take up the large questions of city planning" but saw no reason why it should not be empowered "to make such suggestions as it might seem to it advisable. It could then develop this line of activity as action required or as it was considered advisable."[51]

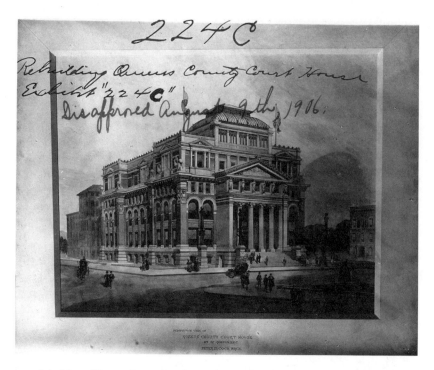

2.3 Rebuilding of Queens County Courthouse, elevation drawing, disapproved 9 August 1906. (Collection of the Art Commission of the City of New York, Exhibition file 224-C.) The courthouse, in Long Island City, was being reconstructed after fire had gutted all but the exterior walls of an 1876 Second Empire–style court building. Pietro M. Coco's plans utilized the older walls but extended the height. In the words of architectural historian Christopher Gray, Coco added a "Parisian looking dome and a temple front, both clashing with the salvaged façade of the older style without subtlety or finesse" ("Beneath the Grime, Corruption," *New York Times,* 15 December 1991, Real Estate, 5). Two pillars with lamps flanked a Greek-style pediment. "The top of the edifice is a kind of pergola," wrote the *New York Times,* "but almost wholly of glass, which, it was pointed out, was not in keeping with the Greek façade" ("The Art Commission Halts Many Contracts," *New York Times,* 21 August 1906, 7). The building was colored brown, white, red, and green. The ACNY considered the whole thing garish and vulgar and rejected the design. Queens borough president, Joseph Bermel (also subsequently indicted on corruption charges), who mistakenly thought he had struck a deal with Mayor McClellan for the project to bypass the ACNY, was livid. The courthouse was "actually too handsome. . . . too beautiful" for the ACNY to appreciate it, he said. The ACNY ultimately approved a scheme that was "still rather jumbled but at least toned down and more English in feeling" (Gray, "Beneath the Grime, Corruption," 5).

Maltbie's efforts, combined with his ongoing ties to civic reform activists, especially Warner (who now chaired the MAS Charter Revision Committee), led to one key success: a decrease of the minimum expense from $1 million to $250,000 necessary for ACNY review of architectural structures.[52] But Maltbie's attempts at a more radical change, to enable the ACNY to include site as part of its aesthetic deliberations on nonart structures, was

unsuccessful. The New York City charter revisions, which went into effect in 1907, reinforced the limits set by the 1903 Rives ruling, thus constraining as well as extending the ACNY's potential actively to advance visual culture in the municipal public realm.

The years 1905–7 were transitional, with the ACNY still testing some of the boundaries of its authority over initiation, planning, and regulation. After Maltbie left in 1907, the ACNY's activism diminished. This may be attributed in part to shifting mayoral administrations and agendas and in part to the personality, career, and commitments of Robert Weeks De Forest. De Forest (1848–1931; fig. 2.4), identified as a descendant of early Huguenot settlers, was son of attorney Henry G. De Forest and Julia Weeks De Forest, whose father, Robert D. Weeks, was the former president of the New York Stock Exchange. De Forest grew up in Greenwich Village, received his B.A. from Yale (1870), and a law degree from Columbia (1872). After graduating he joined the family law firm of De Forest and Weeks and embarked on a successful and highly lucrative law and business career, during which he amassed multiple positions of power and leadership in the railroad, insurance, banking, and real estate industries.

These ventures enabled De Forest to engage, through public service, with a host of civic, charitable, and philanthropic enterprises, dedicated to alleviating maladies of immigration and urbanization (made worse, some might argue, by some of the same institutional forces that had enabled De Forest himself to prosper)—especially in the arenas of social welfare and housing reform. He was a founder of the Charity Organization Society (1882, which coordinated the work of New York's relief agencies) and of the New York School of Social Work (1898). He served on numerous boards, was president of the New York Welfare Society and the National Conference on Charities and Corrections, was chairman of the State Housing Commission (1900), and was appointed by Mayor Low to be commissioner of the city's first Tenement Housing Department. As family lawyer to the Russell Sage family, he became the trusted adviser to Sage's widow, Olivia Sage, who designated him president of the Russell Sage Foundation (1907). In that capacity he became one of the principal developers of Forest Hills Gardens in Queens.[53]

De Forest's involvement with the arts of early America long matched his engagement with housing reform and charity work. His marriage in 1872 to Emily Johnston, daughter of Metropolitan Museum cofounder John Taylor Johnston, cemented his ties to the new institution. He became a trustee in 1889, vice president in 1909, and the museum's fifth president in 1913. The De Forests amassed a major collection of American decorative arts, which they donated to the Metropolitan Museum of Art in 1922 to establish the

2.4 John C. Johansen, *Robert De Forest*. (Collection of the Art Commission of the City of New York.)

American Wing. It was in his capacity as a trustee, then president of the museum that De Forest came to the ACNY.[54]

De Forest was a pragmatist, not a wheeler-dealer or an activist. He had a distaste for controversy and criticism and tended to take whatever measures were necessary to uphold the ACNY's mission and its respectability. For De Forest this meant accepting a narrower conception of the ACNY authority, one that excluded considering locations for buildings or nonart structures.

Under De Forest the ACNY would play a far more active role in spheres of retrospection than in planning and development (as we shall see in chap. 3), serving as urban curators rather than as a bold instrument of municipal government.

De Forest would serve as the ACNY's president for twenty-five years. The longevity of his tenure, combined with his justified repute as a well-entrenched member of the moneyed elite, would work to the ACNY's advantage but also against it. De Forest's leadership and influence extended the commission's alliances and authority. His presence enabled the group effectively to negotiate with the city's cultural Brahmins but earn the mistrust of municipal officials and other elected representatives of the citizenry. De Forest offered the board the benefits of hindsight and experience, which put the ACNY on firmer footing. Within a body that by its very nature was subject to constant changes in membership, De Forest represented not just commitment but also continuity and expertise.

Given his experiences, De Forest was extremely attuned to criticism that he felt might weaken the ACNY's reputation and power. He was not a micromanager but clearly believed that progress hinged on a willingness to sacrifice pure ideals, to negotiate and compromise. Thus he would prod the ACNY to move forward when it seemed in danger of being branded as, in his words, "fussy." "Fussy," or nitpicky, overly concerned with detail and "municipal housekeeping," was a term with distinctly gendered and, here, negative connotations. At the turn of the century, it was women's civic groups who were associated with such specifics. Hence when De Forest perceived that the reputation of the (then) all-male ACNY was being undermined by being associated with women's concerns, he urged action to countermand negativity and any doubts about its masculine image.[55]

The ACNY's shifting ambitions during the early years of the De Forest presidency derived in part from an altered relationship with city hall. The sympathies between the mayor and ACNY president, a hallmark of the Low administration, were no longer present. The situation did not revert to that of the Van Wyck mayoralty, but Mayor McClellan's relationship with the ACNY varied from supportive to lukewarm or uncooperative. De Forest might do good, but in McClellan's opinion, he did not do well. The mayor regarded De Forest as a hypocrite and a disengaged figurehead, a "very poor" ACNY president. "I always found De Forest unreliable," McClellan gossiped in his autobiography. "He became a sort of first citizen, accepting any appointment he was offered on any committee or board and never pretending to do any work or even attend meetings."[56] This statement may be somewhat exaggerated, but McClellan's perception that De Forest was spread thin was very real, as was his irritation with the relative autonomy and influence of a quixotic

group of unpaid "first citizens." The ACNY served the municipality, but its members were also in the peculiar position of being able, on some level, to do as they liked. Others had similar concerns, and the tensions between dependency and autonomy would continue to affect the commission's deliberations. Indeed, De Forest's relationship with mayors William J. Gaynor, John Purroy Mitchel, and John F. Hylan would fluctuate. Gaynor (an independent Democrat) and Mitchel (Fusion) were cordial; Hylan, (a Tammany party loyalist) was outright disdainful. By Hylan's time (1918–25), De Forest had overextended his tenure. Illness, age, and perhaps tedium would lead De Forest to become more detached from the public aesthetics process in the post–World War I period, leaving the ACNY without strong leadership.

The ACNY under Robert De Forest represented a continuation of John De Witt Warner's earlier commitment to use the veto power in service of an aesthetic and cultural vision that remained notably consistent over twenty-five years, despite changes in membership and staff. Although the New York City charter mandated the art commission as being as much a legitimate part of government as any other department, its authority and impact were not foreordained. For some, it represented government's trampling on its own right to free expression. Thus deliberations demanded effective, productive negotiation within various sectors, including those of the municipality, public utilities, the federal government, and private businesses, groups, and individuals. The clash between members' grand visions and New York City realities thus constituted a crucial aspect of the review process. A look at selected projects will illustrate how the ACNY, for all the status, wealth, and influence of individual members, had limited means to shape the visual culture of the municipal public sphere to suit their broader sensibilities, even while bringing about discrete and consequential alterations to the New York built environment.

THE URBAN ARTS OF SIGHT

Streets and Circulation

The ACNY would be marginal to any larger planning enterprise, but its members recognized early on that they could influence individual details and, by demanding modifications, make cumulative improvements to the civic landscape. This section examines ACNY work in two crucial areas of turn-of-the-century development: streets and structures. The ACNY reviewed designs for individual streetscape features that would have a large-scale impact on the urban experience. Commissioners scrutinized not just the designs but also the aesthetic effect of the accumulation of a wide array

of fixtures—lighting, signage, letter boxes, fire hydrants, fire call boxes, water fountains, and other receptacles—products of the city's expanding geography, communications, utilities, and other infrastructure. The ACNY believed that its members should monitor the street with an eye to maintaining clear sightlines, quality of materials and execution, durability of decoration, and free-flowing pedestrian circulation. Mayor Low agreed. Although the designs themselves cost less than the $1 million ceiling and thus fell outside the charter-mandated monetary base for mandatory ACNY review, Low referred most street fixture designs to the ACNY. Street lamps (figs. 2.5, 2.6) were among the first items the ACNY considered. Neither the fixture designs nor the quality of fabrication posed many problems in the ACNY's early years.[57]

Street signage was a different matter. Here, as with lighting, the ACNY's engagement indicated its desire to modernize the streets by promoting simplicity and functionality. Beauty and clarity of form would signal the triumph of social order over the disruptions and visual obfuscations that were themselves expressions of urban modernity's ill effects. Signage discussions were among the ACNY's earliest encounters with multiple organizations and interests, at a point when the potential degree of the department's involvement was still negotiable. The problems with signage highlighted, as well, both the ACNY's expanding scope of influence and boundaries of its authority to initiate.

At the turn of the century, almost everyone agreed that street signs were needed to help people navigate the urban landscape. Signs had hung from gas lamps in earlier days, but when the lamps were removed the signs were not replaced. In Greater New York City, many politicians and cultural activists disagreed about what future signs should look like and where they should be situated. Municipal officials debated whether such features were a city obligation or whether building owners should be required to display numbers and street signs on their buildings, ultimately determining that the city could not infringe on private property rights in such fashion. In 1899 the commissioner of Public Buildings, Lighting, and Supplies, Henry S. Kearney, put into place a novel system whereby "the name of any given street shall be at right angles to the street, instead of read along the street as heretofore."[58] On arriving at the street corner, pedestrians would be able to read head-on the sign for the street on which they were walking. The new policy, implemented with no prior announcement, produced total confusion. Kearney argued that his system made the signs easier to read, but not surprisingly, many begged to differ, and the street-signage venture made little headway.

John De Witt Warner had been engaged with the street-sign issue even before he was appointed as ACNY president. In 1901, while MAS president, he

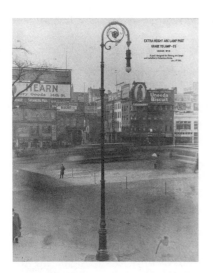

2.5 Bishop's crook light fixture. (Collection of the Art Commission of the City of New York.) City streets had been lit by gas lamps since the 1830s. Electric lighting was introduced in 1880 and, following improvements in its illuminating power, rapidly supplanted gas lighting. By 1902, when the art commission became involved in reviewing light poles and luminaires, several of the major and most enduring street-lighting designs had already been in place for a decade and included this distinctive structure known as the "bishop's crook," with its curvilinear filigreed tendril counterbalancing an elegantly and dramatically arched pole.

2.6 Arc lamppost, twin lamp fixture, 1911. (Collection of the Art Commission of the City of New York.) The twin lamp design, along with other prestanding designs like the straight-armed and filigreed *M* poles and *G* poles, were approved by the ACNY in a 1911 courtesy review. The ACNY studied lighting designs with an eye to the relationships among luminaire, arm, and pole, the height and bulk of the base, the relationship of decoration to the unity of the whole, and overall proportion, mass, and scale.

had offered to help the Board of Aldermen find a better solution by having the MAS sponsor a competition for more suitable signage. The structures would combine an array of functions (lampposts, letter boxes, fire alarms, and even fire hydrants) and, thereby, reduce obstructions of space and sight-lines. Warner proposed that the designs should be considered works of art, so that they could hopefully be reviewed by the ACNY without first having to convince Mayor Van Wyck to request an evaluation (which, given past experiences, he was unlikely to do).[59] Ultimately the MAS found it unfeasible to combine all the different functions on one pole; the designs they helped develop, by MAS activist and architect and designer Charles Rollinson Lamb, were for two sign boxes meant to be fit onto existing poles. The project did not move forward.

Signage efforts resumed in 1902 as one of the new Fusion administration's development initiatives, promoted by the new Manhattan borough president Joseph A. Cantor, an MAS member. In February 1902, Cantor submitted to the ACNY an MAS-supported design for a street-sign box that could be attached to a light fixture or separate post; this received ACNY approval.[60]

Given the Low administration's support for the ACNY, it is not surprising that Cantor's plans involved the commission. But the ACNY's role was still unfixed, and Low and Cantor interpreted the ACNY's duties as including design initiation. In March 1902, in a move spearheaded by Cantor, the Board of Estimate asked Mayor Low to request that the ACNY "suggest appropriate forms of street signs to be used in different Boroughs and different parts of Boroughs."[61]

The ACNY certainly wanted to have a say in the design of signage, but Warner, Maltbie, and ACNY members recognized—given the constrictions of time, budget, and staff—that the commission had to set limits on what it could do—quite apart from the potential conflict of interest issues mentioned earlier and their potential political fallout. So, while the Warner-led ACNY unquestionably regarded its main task as discouraging overdesign, it refused to take on the task itself. Citing the charter—incorporated to articulate and limit the municipal government's power—the ACNY, through spokesman Maltbie, stipulated that the art commission was not "invested with any authority by law" to initiate designs.[62]

The move clearly irritated municipal officials because crucial questions of procedure and design remained unclear. Confusion ensued when Warner received specifications for bidders for street-sign boxes in patterns that the ACNY had never seen, and one other for a design that resembled one approved earlier (in February 1902) but that had significant revision and, thus, looked nothing like the original. When Warner turned to the mayor (as an ex officio commission member) for clarification, Low, presumably annoyed

2.7 Street sign, approved 13 May 1902. (Collection of the Art Commission of the City of New York, Exhibition file 23-B.) This triangular cast iron sign-box frame, painted dark brown, with projecting cornice and base and flattened corners with relief fasces, bore street numbers and avenues in white lettering on a dark blue background. The second, rectangular frame, also painted dark brown, with white lettering against dark blue glass, had narrower panels.

with the ACNY's failure to cooperate, now took him to task for reviewing the design without a formal mayoral request. Thanks to the recordkeeping system he had recently implemented, Warner offered proof that Low's office had in fact made such a request.[63]

Having determined that it had to stick to aesthetic evaluation, the ACNY collaborated with Cantor to reach a mutually satisfactory goal. A subcommittee (Painter Frederick Dielman, sculptor Daniel Chester French, and merchant magnate William J. Coombs) deliberated and ultimately agreed on the revised designs, color, and lettering. By 1903, two kinds of "self-illuminating (by reflection)" signs, simplified versions of Charles Lamb's designs, began to appear midpoint on the shaft of the city's electric light poles and atop many of the remaining gas lampposts (fig. 2.7).[64] The ACNY approved these designs because they exhibited a certain compositional seamlessness, a unified formal structure that evoked stability. Both designs won praise from arts groups.[65] Thus in the end, Cantor got his lights. The ACNY in turn made strides toward its goal of advancing urban visual beauty, while also encouraging urban legibility: comprehensible design, clear lines of sight, an unambiguous awareness of place and locale, and a sense of order.[66]

The degree to which the ACNY was involved in the urban aesthetic process was a matter of negotiation in 1902, contingent to some extent on how much work members were willing to undertake without pay. The situation

was fluid, and the ACNY might have acquired more power than it ultimately did. In most instances, political forces pushed it back. In the case of signage, the ACNY clarified its own definition of the limits. The ACNY would soon revisit the question of its purview, however, when it faced a new challenge involving government chain of command over the aesthetics of New York City streets.

Letter Boxes

Controlling the visual culture of the street involved dealing with utility companies, manufacturers, neighborhood and borough politicians, and matters of citizen safety and place orientation. Efforts to manage sidewalks as spaces of circulation and sites of cultural uplift also meant negotiating with the federal government and with the relative priorities of aesthetics, utility, convenience, and cost. The protracted case of letter boxes was a situation in which the ACNY's preferences and agendas—at the outset probably unwittingly—were connected to reform: deliberations over artful mailboxes were bound up with matters involving corruption, tensions over home rule, and mail service. These circumstances ultimately worked against the City Beautiful ideal. Neither rain nor sleet nor snow nor an art commission would make mail collection any easier.

Street signage was an internal affair, testing the ACNY's powers as a peculiar body whose interests were suspended between the public and the private. With mailboxes, the ACNY, claiming to represent the municipality, took on the federal government, which had always operated on the assumption that its interests superseded those of local government. New Yorkers were suspicious of centralized authority, and although municipal-federal relations were generally cordial and mutually accommodating, longstanding tensions existed. These resurfaced to some extent as explosive growth and immigration put new demands on the municipality, just as the U.S. government was stepping up its presence, constructing a major new customs house in lower Manhattan, for example.

The U.S. Post Office Department (USPOD) was one federal agency that depended on the cooperation of the city. New York City was a major center of mail distribution and a gateway for international mail. The USPOD struggled perennially with the huge volume of correspondence that passed through the city. Communications networks were becoming more complex in the new age of the mass print media at the turn of the century. During the presidential administration of Theodore Roosevelt, a new postmaster general, William R. Willcox, sought reorganizations and reforms, decentralizing the system by instituting branch stations and substations in drugstores. Within

the confines of the city, collection of mail from home boxes became less feasible, and the USPOD determined to supply Greater New York (and other cities) with letter boxes on the street.[67] The sidewalks were New York City property, however, and during the Low administration, the municipality insisted that mailbox designs be submitted for ACNY review. The USPOD complied, partly as a courtesy, partly to keep a low profile and avoid any conflict with the city.

Quite apart from wanting the USPOD to abide by the municipal charter mandate, the city of New York had reasons to insist on an aesthetic review. The mailboxes the USPOD used at the time were notoriously cheap and ugly. The various box styles it had previously adopted were mostly inexpensively produced and developed by Midwestern ironworks companies. Especially favored were a low-cost, sheet-metal type—basically a rectangular box with a rounded hood—and a more elaborate, iron, rounded-top box with a pull-down opening. The USPOD used both boxes widely nationwide; and, much to the consternation of those who cared about the streetscape, they submitted the iron box for use in New York City. The ACNY disapproved the box with its bulky pedestal in April 1903 (fig. 2.8), presumably dismissing it as an unenlightened design with an overabundance of compositionally fragmented parts.

There was more to the matter, however. Corruption cases periodically wracked the USPOD, and the ACNY had good reason to be wary in 1903. In fact the USPOD's adoption of the other, sheet metal, or Scheble, mailbox proved to have been the result of illegal deals.[68] Whether ACNY members knew that something was afoot is uncertain, but when the news broke in September 1903 the ACNY could certainly feel vindicated. New York City would not suffer the consequences of postal fraud, which had resulted in "excessive quantities of [Scheble] boxes" being stashed away in USPOD warehouses.[69] The case was clearly one in which problems on the surface were symptomatic of deeper structural deficiencies; excess parts and shoddy design were blatant expressions of political corruption. Whatever mode of acquisition had led to the interest in the iron, pull-down-top mailbox, the ACNY would refuse to allow it or other possible substandard inventory to be unloaded on New York City.

Meanwhile, however, New Yorkers still needed mailboxes. Borough president Cantor, as an MAS member, was one of those dismayed by the sheet metal mailbox. He sought to provide an alternative, submitting to the art commission a sturdier iron box with a flap top and convenient drop-bottom, which had been adopted by the postmaster of Milwaukee, Wisconsin. In April 1903 Cantor proposed placing the boxes on pedestals in six Manhattan locations. The ACNY thus had to assess, first, whether the proposed letter

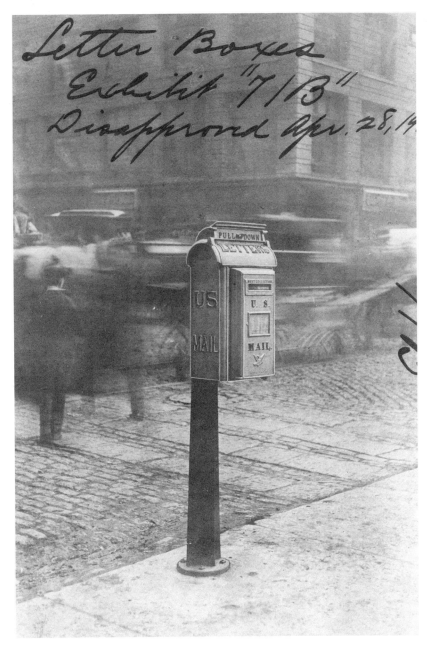

2.8 Mailbox and pedestal, disapproved 28 April 1903. (Collection of the Art Commission of the City
of New York, Exhibition file 71-B.)

boxes were sufficiently attractive and well made and, second, whether the mailboxes should best stand on their own or be affixed to a light pole. An attempt to answer this mundane question meant resolving the question of how much clutter on the city sidewalks was too much, and for whom. The ACNY disapproved both the box and the proposed locations.[70] Not only was the design "objectionable in itself," having many disparate parts and harsh edges, but the plan to mount it on "independent posts," commissioners contended, would further obstruct the streets.[71]

With no resolution of the problem, the project, as would often happen, went into limbo in the hands of the client. For the next seven years, the USPOD channeled its efforts into other enterprises, like constructing a new central post office building at Eighth Avenue and Thirty-third Street. For mail collection, as a stopgap, they simply placed out on the streets a few of the letter boxes they had available.

In 1911 the U.S. Post Office Department renewed its efforts to find a letter box design that would placate the ACNY and the McClellan and Gaynor administrations (which supported the ACNY's position). Collaborating with the Edison Electric Company, the city's major electric utility, and the MAS's Street Fixture Committee, Postmaster General E. M. Morgan developed a new "Renaissance"-style letter box that would be attached to electric light posts in Manhattan to create a stately and unified appearance. The ACNY approved the design on 14 November 1911, but the USPOD then decided that it would be too expensive and did not adopt it.[72] Two and a half years later, in May 1914, the USPOD returned to the ACNY with another design for a letter box on independent, fluted column-style posts. Citing the same concern about obstructing the street as in 1903, the ACNY, even though composed of a wholly different group of people, again disapproved the design.[73]

The ACNY's membership changed frequently (with individuals usually rotating off after three to six years), but in general its members approached projects like this one with consistent attitudes about what was "good" design. The continuity in aesthetic preferences was hardly surprising. The FAF, after all, selected the three names from which the mayor chose one for each category of appointment; the FAF was made up of the establishment professional arts societies, whose members had moderate to conservative tastes grounded in the academic tradition. As the case of the Heine Memorial demonstrated, there were multiple academic traditions. Thus the FAF sought to insure that its lists included people whose aesthetic vision was consistent with that of its members. As seen with signage and with the Bronx County Courthouse, they displayed a clear preference for refined decoration combined with formal simplicity and designated as a key priority spareness and integration of parts. There was a practical as well as an aesthetic aspect to this. Seamless formal

integration helped to reduce long-term costs by reducing the need for maintenance and the likelihood of injury from seams or other parts. Although deliberations of the commission's meetings were rarely incorporated into the record, such rationales unquestionably informed their exchanges and decisions. They undoubtedly informed the ACNY's decision of May 1914.

By 1914, intergovernmental tensions were clearly rising.[74] In an attempt to break the standoff, the USPOD (represented by its purchasing agent, J. A. Edgerton) and ACNY (represented by a subcommittee) began further protracted negotiations. Members of ACNY were unswerving in their insistence that the mailbox be a work of art, not a utilitarian enterprise. They reaffirmed this commitment by endorsing the USPOD's employment of professional sculptor Charles Keck to create a new design.[75]

Keck's strong artistic credentials were what made him an acceptable choice. He also had ties with the USPOD, having undertaking decorative work for postal facilities. Keck's classical-style mailbox (fig. 2.9), with low-relief eagles design integrated into the sides, satisfied the ACNY subcommittee's "art" criteria.[76] The post office's Edgerton felt that the classical Keck design was "too elaborate."[77] In February 1916 he submitted a pared-down revision of the Keck design that replaced the eagles with a shield. The ACNY regarded the alternative Keck design as "distinctly inferior" but, under USPOD pressure, said it would be willing to approve this "comparatively inartistic" design along with the other one. Nonetheless, haggling continued about issues of cost and whether the details could be properly executed in steel. The USPOD solicited bids on the boxes and balked on learning what they would cost.[78]

The USPOD now began to voice open frustration with the seemingly futile efforts to "please the taste of New York," but in fact the delays were not entirely the ACNY's doing. The difficulties were exacerbated by a larger internal USPOD problem that the differences with the ACNY merely helped to deflect. The USPOD had been dragging its feet about installing numerous street letter boxes in New York City because more mailboxes would mean "more work for letter carriers." Mail pickup would become more cumbersome and costly, and the boxes themselves risked being robbed. The USPOD would have preferred to limit the numbers of boxes or, at the least, put more of them inside office-building lobbies. By 1916, however, the situation had become untenable. Building owners were tired of having people walking in from the street to mail letters. New Yorkers more generally were weary of traipsing for blocks to drop off mail.[79] The clamor for more mailboxes grew louder. The Broadway Business Men's Association and several newspapers—notably the *World* and *Evening Telegram*—mounted a campaign, excoriating the ACNY, Mayor Mitchel, and the USPOD for their inaction.[80]

2.9 U.S. Post Office letter box, Charles Keck design (from *Annual Report of the Art Commission of the City of New York for the Year 1916* [New York: ACNY, 1917], n.p.).

In contrast to Warner's confidence and proactive approach, ACNY president De Forest maneuvered through the negative reaction. Fearing that the ACNY would lose respect and influence by being deemed fussy (with its connotations of being nitpicky, procrastinating, and, by inference, feminine), he appealed to Mayor Mitchel. The USPOD cast the commission as being obstructionist and overly attentive to detail, but from the ACNY's standpoint, that detail was crucial. "Designs for comparatively small objects which are repeatedly reproduced in the City" might seem "comparatively insignificant," argued De Forest, but cumulatively, these elements made a crucial difference in the urban experience—more so, he contended, than even for individual monuments.[81] De Forest sought to impress on the mayor that the ACNY had consistently been cooperative and urged Mitchel to try to pull his weight to convince the post office to use the Keck design.[82]

Meanwhile, the post office's counsel began exploring whether the USPOD could pull rank by proclaiming the streets of New York to be federal post roads.[83] Although USPOD was not enthusiastic about the idea of more boxes, pressure from the public forced its hand and ultimately tipped the balance of power in the public's favor. By 1917 the USPOD and the ACNY appeared to have come to an unspoken resolution, using a strategy that the *World* and the *Telegram* had advocated for months. The tactic hinged on the New York City charter, which stipulated that if the ACNY did not act on a submission within sixty days, the project could go forward without its approval.

The ACNY took no action on the revised Keck designs, or on any other design, thus empowering the USPOD legally to put boxes onto the streets, theoretically without undercutting local authority, as the post-road idea would have done. Declaring even the revised Keck design too expensive, the USPOD installed a stopgap substitute: a group of "standard" and decidedly inartistic Bucyrus, Ohio–type mailboxes that the USPOD had stashed away in warehouses.[84] "Better an ugly box than no box," rejoiced the Boston-based *Evening Transcript*'s Franklin Clarkin. "New York has decided for convenience first."[85] The ACNY, on the losing end, remained silent, enabling it at least to save face.

With letter boxes, the ACNY review process became a forum for considering the relative importance of an attractive city, as decreed by experts whose refined standards were hardly universal, versus an aesthetics of exigency, giving priority to amenities judged to be needed more immediately for "quality of life." The ACNY contended that aesthetic quality of life superseded expediency or convenience, but such a stance (agreeable, perhaps, for those who did not have to post their own letters) was unsustainable in a modernizing New York City on the brink of world war. Hence in the discussions over

mailboxes, an exercise in taste, power, and judgment bound up with the re-
lations between the federal and the local, the federal ultimately won.

Fountains

Beginning under Warner, the ACNY also found that an aesthetics of exi-
gency and utility extended to street fixtures meant to serve animals as well as
people. Private groups also competed for space to erect fountains "for man
and beast" on New York City's streets and sidewalks.[86] Because of the size,
number, and various purposes of these fountains, the ACNY's attempts to
control them proved to be politically controversial.

Fountains were part of the activist agenda of the New York branch of the
American Society for the Prevention of Cruelty to Animals (ASPCA) and its
women's auxiliaries and also of the New York Humane Society. Highly or-
ganized animal advocacy groups, their New York City activities included
establishing clinics and shelters for stray animals and developing educational
efforts to combat cruelty, especially toward the workhorses that remained the
core of the city's transportation networks through the first decade of the
twentieth century.[87] Since the 1880s, ASPCA members in particular had un-
derwritten the cost of fountains for horses and stray cats and dogs. By the
turn of the century, for the ASPCA and other humanitarian organizations,
success hinged on appeals that linked animal welfare to human concerns and
benefits.[88]

In the wake of the metropolitan expansion that followed consolidation of
the five boroughs, the New York ASPCA and Humane Society renewed their
efforts, begun in the 1880s, to install more animal water fountains around the
city. In late summer 1902 they approached Cantor, the Manhattan borough
president, who was agreeable to the idea but informed them that art com-
mission approval would be necessary. The ASPCA, one of many private or-
ganizations that had previously had the freedom to do what it wanted, now
encountered an obstacle in the form of a new bureaucracy. On submitting
designs for cast-iron fountains to the ACNY, they received a rude awaken-
ing. The commission not only rejected the design but also admonished the
ASPCA for having already erected one at the intersection of Liberty Street
and Maiden Lane without ACNY approval.[89] (It is unclear whether the
ACNY told the ASPCA to remove this fountain; with its two-person staff,
the ACNY would not likely have had the means to enforce such a demand.
Lack of enforcement power was an ongoing problem and a sign of the
ACNY's ultimate weakness within the municipal bureaucratic hierarchy.)

Asked to prepare more "artistic" designs, ASPCA president John P. Haines
shot back that this particular fountain type had been in use by the society for

some fifteen years. The ACNY was insisting on changing the rules of the game.[90] The irritated Haines asked the ACNY to come up with a better design. Warner refused, stating, as he had on the street-sign matter, that the ACNY was not permitted to design projects, only to review them. Warner noted pseudo-diplomatically that he was sure that, given the ASPCA's "public spirit," they surely would not do anything that would not "embellish" the "public streets."[91] Haines did not respond for some time, perhaps trying to raise money to develop what the ACNY might consider to be more suitable designs. Two years later he wrote indignantly that the society had been powerless to erect additional fountains. Animal lovers had begun writing letters to the press, complaining about the lack of proper facilities for horses suffering in the torrid summer heat. Haines blamed the commission for the problem, telling its members that no new and more artistic design could be had for the $105 per fountain that the society was in a position to spend.[92]

Exasperated, the ASPCA ultimately decided that the best way to move forward was to convince the ACNY to come on board, to collaborate to obtain a design the ACNY could not refuse. A change in the presidencies of both the ASPCA and the ACNY (from Warner to the more moderate De Forest) may have prompted the two groups to take a more conciliatory stance. In 1906, the ASPCA sponsored a competition for a fountain that could be erected for $250.[93] The jury included the presidents of the ASPCA, the MAS, and the ACNY. They selected, and the ACNY subsequently approved, designs by architects H. Van Buren Magonigle and John S. Humphreys, with William Sanger receiving honorable mention. The ASPCA's Board of Managers established a fund to produce and maintain the new fountains, and the Board of Aldermen (which dealt with land use on city streets) approved a range of sites.[94]

The competition demonstrated that the borders of the ACNY's powers over the aesthetic still remained somewhat fluid in the early De Forest years. The ACNY might be unwilling to design and unable to plan, but its members were able to select, under certain limited circumstances, ostensibly without compromising their impartiality. Indeed, De Forest informed the ASPCA that although the designs in themselves might be satisfactory, the ACNY would have to examine each individually to assess its impact and suitability for specific locations.[95] The ACNY had authority over the choice of place because fountains fell within the definition of a "work of art," according to the New York City charter.

It might be questioned whether the ACNY would truly be in a position to turn down a design coselected by its president. The ACNY subcommittee structure did in fact enable the board to recommend disapproval of particular locales proposed for those works, although such an action would certainly

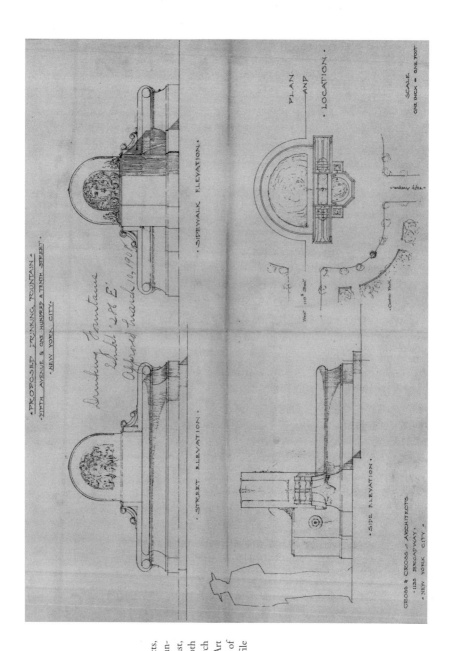

2.10 Cross and Cross, architects, proposed drinking fountain for man and beast, Fifth Avenue and 110th Street, approved 10 March 1908. (Collection of the Art Commission of the City of New York, Exhibition file 286-E.)

be more difficult. The subcommittee also took account of questions of maintenance. Just as in 2001 the ACNY would challenge telecommunications corporation Verizon on its upkeep of telephone enclosures already in place on the streets and question newsstand operators about the condition of newsstands old and new, so, too, an earlier ACNY commanded the ASPCA to repair decrepit fountains put in place some fifteen years earlier.[96] The ACNY noted that the choice of concrete for many of the fountains could be an issue as well, not only because it was cheaper looking than granite but also because it required greater maintenance. Commission members insisted that quality should take higher priority than cost, even if it meant installing fewer fountains.

The possibility of having fewer fountains must have appealed to the ACNY subcommittee delegated to assess them. The 1906 approval of the ASPCA designs had opened the floodgates; hundreds of proposals for animal drinking fountains poured into the ACNY office over the next two years. The matter, De Forest wrote in his 1907 annual report to Mayor McClellan, was "one of the most perplexing . . . with which the Commission has had to deal."[97] The fountains subcommittee scrutinized closely each submission, making site visits to assess the merits of the specific design in the specific location. Overwhelmed by the number of submissions, the subcommittee now felt compelled to pose a negative question: "Is a fountain needed in that place?"[98]

Some projects succeeded, such as a marble fountain for 110th Street and Fifth Avenue, designed by architects Cross and Cross (fig. 2.10): a horizontal semicircular bowl extending out from a thick, vertical, rounded panel, adorned with a sculpted relief face-spout and visually and physically tied to the bowl with scrolled brackets.[99] Others, like the proposed "combination seat, horse trough, and dog fountain in connection with central shaft and electric light" (fig. 2.11), designed to replace a ventilating shaft in a triangle at Longacre Square (Forty-seventh Street between Seventh and Broadway), did not initially pass muster. A disapproved preliminary plan consisted of a Doric column and globe luminaire that rested atop a base; the latter had a seat on the one side and, on the other, a low dog bowl at ground level, with a larger basin with faucets above (enabling buckets to be filled instead of having horses drink directly from the trough).[100] The committee probably rejected the scheme for having too many disparate, unintegrated parts. Concerns in various cases ranged from shoddy materials to unsuitable locations—some in midstreet, some too close to traffic, some too close to other fountains, others blocking sightlines down the street.[101] The subcommittee felt that some fountains were simply ugly (fig. 2.12). In general, they preferred elegance and simplicity. When confronted with designs involving combinations of different

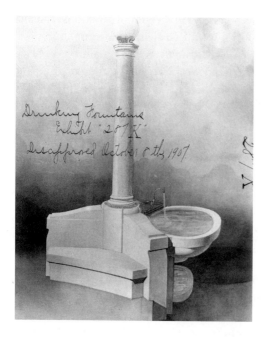

2.11 Charles Lamb, column fountain, Longacre Square, disapproved 8 October 1907. (Collection of the Art Commission of the City of New York, Exhibition file 287-K.)

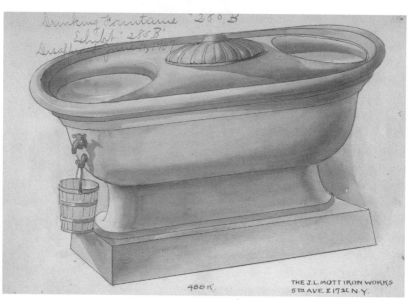

2.12 J. L. Mott Iron Works, drinking fountain, disapproved 11 June 1907. (Collection of the Art Commission of the City of New York, Exhibition file 285-B.)

size oval basins, light fixtures, benches, and vents, they sometimes openly expressed exasperation. Shunning odd "mixes and matches" (fig. 2.11), the ACNY followed their typical preferences and approved compositions whose parts seemed related deliberately and seamlessly to each other. At the same time, simplicity without a sense of substantiality did not go over well, as with some of the cast-iron basins that the ACNY deemed overly lightweight and undistinguished in appearance.

Many fountain proposals were quite elaborate because they served commemorative as well as utilitarian purposes. A fountain was cheaper, less controversial, and easier to get approved than a statue. Fountains, like monuments, were also a good vehicle for what in today's parlance would be "donor recognition."[102] Hence many horse troughs became memorials by incorporating inscriptions (fig. 2.13). The ACNY was amenable to some of these, but hardly all of them.[103] Hence the board remained under pressure when it came to animal drinking fountains. Numerous ACNY-approved fountains were installed, but animal welfare advocates nonetheless regarded the ACNY itself as insufficiently accommodating, and many citizens agreed with them.[104] The committee's members might regard themselves as protectors of the street, but fountains were perceived to fulfill an important need.

In addition to the political dimension there were pragmatic considerations with which to contend. The animal drinking fountains generated disputes between tradition and modernity in New York City's streets: what amenities and how many should the Greater New York City's streets and sidewalk actually accommodate? The concerns of the ACNY were exacerbated by the fact that automobiles and engine-powered trucks were beginning to supplant horses and horse cars for transportation purposes, increasingly so by the second decade of the twentieth century. These new vehicles constantly bashed into the troughs and fountains, many of which subsequently had to be removed later as traffic obstructions.[105]

With fountains, the ACNY found itself moving into complicated territory. The ACNY remained wary because its members evaluated the troughs and fountains with an eye to the long term and worried about the cumulative impact of numerous street fixtures. They also demanded a huge amount of work, necessitating review case by case. Moreover, fountains involved interaction with strongly committed sponsors, for whom the stakes were often far more personal than with letter boxes or signs. Problems were thus more likely to arise, albeit fewer than with sculptural memorials. With fountains the ACNY moved beyond street fixtures into the realm of urban structures, which also included the bridges, piers, and buildings that would constitute the more commanding images and places of New York City.

Drinking Fountain
Exhibit "328 B"
Approved April 14, 1908

IN MEMORY OF · GEORGE DIXON · ERECTED BY THE EXEC

PLAN

SECTION

· ELEVATION ·

SKETCH OF PROPOSED HORSE TROUGH
AT THE INTERSECTION OF EIGHTH AVENUE AND HORATIO ST · FOR THE
· A · S · P · C · A ·

Infrastructure

As representations of the modern corporate city, bridges, ferry terminals, and piers facilitated circulation and movement of goods and people. The 1901 amendments to the New York City charter placed these big-budget structures within the ACNY's sphere of review.[106]

The ACNY's actions with regard to the built environment indicated the extent of its authority under a supportive mayor—the remarkable degree to which it was able to prioritize art over engineering and to beget a time-consuming, expensive revision process instead of immediate implementation. The ACNY's work with bridges and buildings also demonstrated the extent to which—at least for a time—the "disinterested" interests of unpaid citizens with time to spare were privileged over those of paid officials, who were operating within a two-year electoral cycle and under pressure to reign in budgets and show visible results.

BRIDGES

Under Low and Warner, as we have seen, the ACNY had been able to take an activist approach. In November 1902, Low gave the commission unprecedented and not fully legal authority to suggest approaches for the Williamsburg and Manhattan bridges.[107] This was an example of how thin the line was sometimes between revision and initiation. The ACNY's assertive tactics extended to its evaluations of bridge plans. Arts professionals had spurned the functionalist scheme of the Williamsburg Bridge (begun

2.13 Dixon Memorial Fountain, approved 14 April 1908. (Collection of the Art Commission of the City of New York, Exhibition file 328-B.) The fountain dedicated to the memory of African American champion featherweight boxer George Dixon was a notable example of a memorial fountain. Dixon (1870–1908), known as "Little Chocolate," was the first to win paperweight, bantamweight, and featherweight championships. Although boxing was illegal during a key portion of Dixon's career (legalized in New York City in 1896), it had many enthusiasts and backers among Tammany influentials (like Lower East Side boss Tim Sullivan and Police Chief Bill Devery). This enabled it to continue while police looked the other way. By the turn of the century, the sport, with its associations with brawny virility, competitive striving, and exhilarating aliveness, enjoyed increasing legitimacy among urbanites fearing the debilitating and "feminizing" effects of white-collar work and "over-civilization." Dixon lost his title to "Terrible Terry" McGovern in 1900 and never bounced back. He died in penury in the alcoholic ward at Bellevue Hospital in January 1908, and hundreds came to mourn him. McGovern and other admirers raised funds to bury Dixon in his hometown of Boston, but after their proposal to erect a memorial over his grave was turned down, the group proposed a memorial fountain for New York City. The ACNY approved the design, a peculiar rounded basin with an ornate spiked light pole sticking out of it, in March 1908. The fountain was installed at the intersection of Eighth and Horatio streets. Set within an ethnically and racially diverse West Village neighborhood, dominated by the Irish, the memorial basin celebrated Dixon's achievements and an ideal of class and interethnic solidarity grounded on mutual admiration for heroism in sport. (The fountain was removed at a later date, presumably during a reconstruction of the triangle, but there is no record of when exactly this happened.)

1896), approved before the ACNY was formed and from its members' point of view, an aesthetic debacle. The results prompted Warner, A. Augustus Healy, and Henry Rutgers Marshall (among others who served on commission bridge subcommittees) to take a firm stand on bridge submissions. Designs believed to be deficient would be disapproved outright. The ACNY would not be troubled by the possible repercussions if this action resulted in significant delays in the project's completion.

These events did occur with small bridges, both public and private. Some were erected several stories above the public streets, connecting two private buildings. City officials had to approve these when they extended over city property. The Board of Estimate and Apportionment provided permits for them, enabling building occupants to avoid waiting for elevators, climbing stairs, or crossing busy thoroughfares. The ACNY disliked such bridges on principle, contending that they disfigured the streets and blocked vistas. Elevated railroad bridges or viaducts whose ends rested on municipal land also came under ACNY purview. Those deemed "overloaded with filigree," "meaningless and ugly"—such as those for Eighty-sixth Street and Columbus Avenue and 105th Street and Second Avenue on the Interborough Rapid Transit (IRT) line—were disapproved.[108]

The ACNY also delayed major projects, the Blackwell's Island (Queensboro) and Hell Gate bridges, and others, just as they had with mailboxes. Bridge subcommittee members Healy, Marshall, and Rhinelander disliked the ornamental treatment of the Blackwell's Island Bridge and turned down that portion.[109] Five years later, ACNY disapproval of details on the towers of the Connecting Railroad Bridge (Hell Gate) contributed to a three-year delay (fig. 2.14). In this instance, committee members felt that the tower ornamentation was out of character with the otherwise "strictly utilitarian" treatment.[110] A similar clash provoked the ACNY to pass a negative judgment on the Hudson Memorial Bridge (which extended Riverside Drive over the Spuytn Duyvil Creek). Such objections struck critics like Montgomery Schuyler as imperious and misguided.[111] In the view of commission members, however, this bridge was more than just an overpass—it was an attraction being erected "at a very prominent and beautiful place" and a major landmark. As an enduring monument, it needed to be suitably monumental and compelling. From commissioners' perspective, the stark design did not fulfill such requirements, and they disapproved it on 19 July 1907. The board approved a revised plan on December 10 of that year, but this proved to be too late to enable politicians to unveil the structure for the 1909 Hudson-Fulton celebration, which, of course, infuriated them. Although the plans were in fact approved, a taxpayer suit held up the project, which was not actually completed until 1939, under Parks Commissioner Robert Moses.[112]

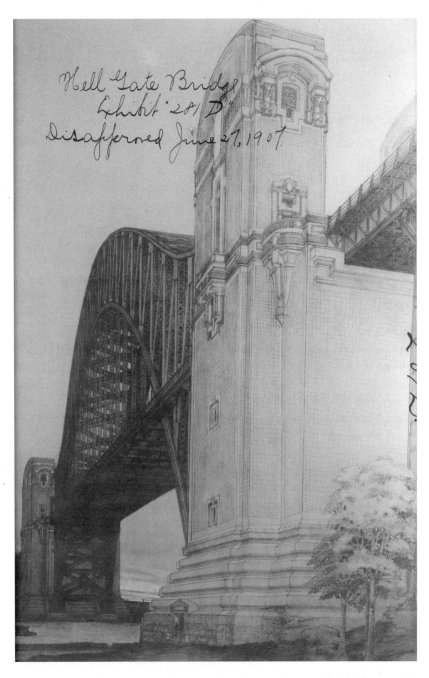

2.14 Gustave Lindenthal, architect, Hell Gate Bridge, disapproved 27 June 1907. (Collection of the Art Commission of the City of New York, Exhibition file 281-D.)

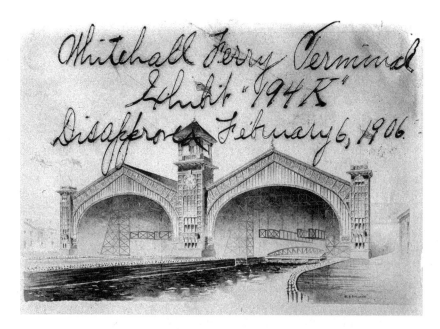

2.15 James J. Gavigan, architect, Whitehall Ferry Terminal, waterfront elevation, disapproved 6 February 1906. (Collection of the Art Commission of the City of New York Exhibition file 194-K.)

The ACNY sought to make "timeless decisions." From its members' point of view, it was unfortunate if projects had to be deferred, but time and budgetary matters had to be set aside to achieve superior results: the city could just wait.

FERRY TERMINALS

Such attitudes applied not only to Greater New York's points of crossing but also to its gateways. The waterways between Staten Island and Manhattan saw new development, as ferry terminals and piers became key elements of a broader urban picture. The municipality took over operations of the Staten Island Ferry in 1905 and brought into the ACNY plans for a new Whitehall Terminal (fig. 2.15). Commission members disapproved it. The committee reported that the drawings on the initial submission merely resembled "a construction of iron sheds, with the arrangements usual for ferry houses, in general appearance not dissimilar to other buildings on our waterfront, better than some and not so good as the best." [113]

The border between critique and design initiation again became indistinct when the disapproval resulted in the original architect's being replaced by another, the firm of Walker and Morris. This firm willingly followed the ACNY's suggestions for a more monumental treatment, thereby rendering

the project approvable. Walker and Morris lowered the terminal's waterfront entrance and removed three large gables surmounting the three entrance portals. In the view of the ACNY's generally affluent members, New York City should spare no expense to perfect the details, no matter the urgency of the project. The changes resulted not only in a revised design but also in a notable expansion of the project's scope (five slips instead of the original three), with a concomitant rise in cost. The city's comptroller, when questioned about the city's considerable budgetary woes, cited the art commission's actions on the Staten Island ferry terminals as one reason for the skyrocketing cost of public improvements.[114]

Cases like the Whitehall Ferry terminal and the bridges were controversial. Democratic officials did not appreciate having a group of nonpartisan aesthetes undercut their patronage in the name of beautification and attacked the ACNY in the press for jacking up project costs. Such incidents nonetheless provided cover for independent mayors like Low, McClellan, Gaynor, and Mitchel, who sought to leave a legacy in the form of ambitious architectural projects.[115] The ACNY could take the heat for delays and expense, insofar as the mayor authorized commissioners to uphold their standards on behalf of the city's built environment.

PIER SHEDS

Gateways entailed not only problems of expense and deferral but also clashes over expertise, professional turf, and power. Such conflicts, often inflected by class and ethnicity, were expressed in debates surrounding the public aesthetics of classical restraint and simplicity versus eclecticism and baroque excess. The ACNY's deliberations over piers highlighted these differences. Piers and pier shed construction by the city's Department of Docks increased significantly during the last two decades of the nineteenth century and on into the twentieth. With ever more shipping along the Erie Canal, the Hudson River (known as the North River) in particular became a major channel. Piers and pier sheds lined the Hudson and other city river walls, manifesting the city's preeminence as a manufacturing center and port and the centrality of commercial shipping, not just to Greater New York but also to the national and global economy.[116]

The ACNY reviewed the new pier sheds. Some of the large ones for major transatlantic steamship lines, like Chelsea Piers (Warren and Wetmore, 1910), offered a positive model. Constructed in steel and brick, these French Beaux-Arts-style structures was conceived on a monumental scale deemed consistent with the splendor of the civic waterfront.[117] The ACNY examined other plans that its members considered much less satisfying, that simply augmented the unsightly waterfront clutter and congestion caused by the

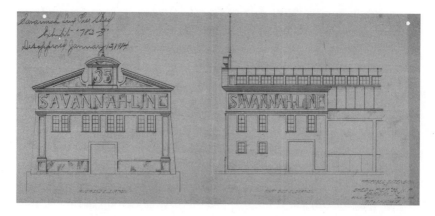

2.16 Savannah Line pier shed, disapproved 12 January 1914. (Collection of the Art Commission of the City of New York, Exhibition file 782-B.) Designed by architects R. P. and J. H. Staats, this pier shed was to stand at the foot of Spring Street at the North River.

carts, crates, animals, and dockworkers. "Shipping itself is not ugly," wrote Robert De Forest, but "it seems to be taken for granted that commerce and ugliness go hand in hand." [118]

The majority of pier sheds presented a twofold problem. Some, especially those designated for cargo, were underdesigned, constructed on the cheap. The undesign aesthetic looked "flimsy," according to De Forest, with facade details made of less inexpensive sheet metal and with little thought given "beyond making a convenient corrugated iron covering for the pier." [119]

Other pier sheds, attributed to structure-conscious engineers (as opposed to architects), were overdesigned, with little concern for a unified or civic architectural treatment. Engineers attempted to inject a greater ornateness, with little conception of how to do so. Such overornateness betrayed a vulgar, low-class sensibility that the ACNY would continually seek to transcend. Thus, complained De Forest, "where ornament has been attempted, in most cases it has only increased the ugliness." [120] De Forest undoubtedly had in mind the pier shed for the Savannah Line (fig. 2.16), whose initial facade included a broken pediment with a segmented arched bay with the pier number in its center, large letter signage extending from edge to edge, and an asymmetrical window arrangement that was jammed right beneath the signage, all creating a strong and jarring tension between the vertical and horizontal. [121] De Forest's pronouncements were symptomatic of an emergent divide between engineering and architectural considerations, as they pertained to municipal design and construction, that would persist on into the twenty-first century.

The ACNY sought to transform the waterfront, so that—as De Forest put it—"what may be called the *frame* of New York" will be rendered "more

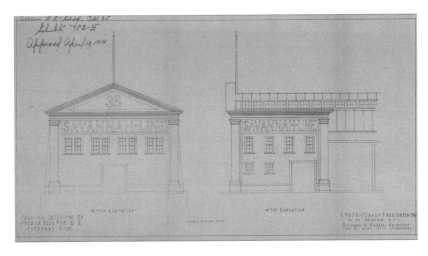

2.17 Savannah Line pier shed, approved 13 April 1914. (Collection of the Art Commission of the City of New York, Exhibition file 782-H.) The approved version tightened the composition by substituting a triangular pediment, more even window treatment, and smaller signs that deferred to the corner piers instead of capping them like an entablature.

appropriate to its dignity and importance."[122] With its authority to veto individual exteriors, the commission used its power to encourage simpler, "well-proportioned," and more visually cohesive pier designs that would relate to other structures and express their utilitarian aspects while simultaneously evoking the magnificence of the waterfront (fig. 2.17).

Municipal Identity

The ACNY's work was not just about the mere appearance of public structures but also about the nature of municipal identity. Having no real authority to control structural issues like planning and development, the ACNY under De Forest was attentive to individual statements and their broader cumulative impact. Such effects could be managed, for example, by keeping an eye on the building designs for specific municipal departments. Mindful of how municipal operations ought best to be represented, De Forest attempted to raise these issues to the public and the mayor. For the mayor, after all, the aesthetics of municipal department identity could have very consequential political implications.

De Forest recommended that distinct municipal identities and activities be articulated architecturally on the exterior of important civic buildings. He wished to follow the classical tradition but to shape it by the logic of modern commercial culture, expressed through advertising and the iconography

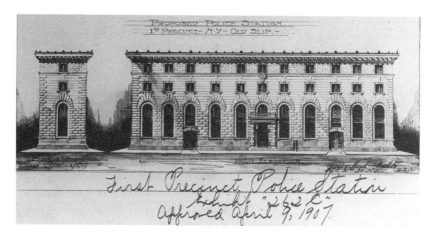

2.18 Hunt and Hunt, architects, First Precinct police station, Manhattan, 1911, Old Slip between Front and South streets, Manhattan. (Collection of the Art Commission of the City of New York, Exhibition file 262-C.)

of branded product. The building's function needed to convey the unique identity of its occupants, and the city needed to impose greater architectural supervision and coordination. That coordination would best be undertaken with the art commission in an advisory role, especially to insure aesthetic continuity when department heads changed.

With the consolidation of the five boroughs, the roles of major departments engaged in municipal operations and security—like the police and fire departments—were vastly augmented. In 1887, for example, the New York City (Manhattan) Fire Department employed 750 men. The Greater New York Fire Department (FDNY) workforce rose to about 4,000 in 1910.[123] Seventy-five hundred officers patrolled Greater New York in 1900; by 1913, 10,847.[124] The growing numbers of men, horses, and equipment necessitated more and larger buildings, and a succession of reform mayoral administrations from Low through Gaynor supported such initiatives. Thus proposals to the ACNY for police precincts and firehouses multiplied during the commission's first ten years of existence.

The post-1900 submissions for the police and fire departments represented two very different approaches, reflecting long-time differences in structures and cultures. Submissions for the police stations were more uniform and, from De Forest's point of view, more satisfactory. The police station architects had adopted a policy of maintaining a general stylistic consistency, designing police precinct stations as variations on the Florentine and Roman Renaissance palazzo (fig. 2.18).[125] From the ACNY standpoint, these neo-Renaissance forms offered an appropriate measure of classical simplicity

and restraint and, thus, served as suitable symbols of centralized order, state power, and civilized society. The relative uniformity in turn reflected the new metropolitanism, regimentation, and cohesion imposed on the department after Police Commissioner Theodore Roosevelt's crackdown and reforms.[126] Police precinct designs proclaimed the commonality of mission that united the department, in service across the five boroughs of Greater New York. In short, the visual language and signification of these structures were in keeping with reformist ideals.

The Fire Department had taken a different tack. New firehouses were far more stylistically diverse than police precinct houses. In 1906–7, for example, the ACNY approved ten new fire department headquarters. Some of these originated from in-house architects. Others were designed by outside firms. The station for Hook and Ladder Company Number 17 on East 143rd Street in the Bronx was designed in a staid, if ornate, manner described as "classical French" and resembled a Parisian *hôtel*.[127] Walter E. Parfitt designed a Venetian palazzo for Engine Company 69 on Union Street in Park Slope, Brooklyn (fig. 2.19) but rendered the Hook and Ladder Number 20 station on Ralph Avenue in Brooklyn with a curved gable and brickwork in the Flemish manner (fig. 2.20).

The problem, from the ACNY's perspective, was that although individual designs might have merit, the total effects were confusing in their variety. Diversity was less a problem than the lack of discipline it implied. The stylistic hodgepodge of the firehouses did in fact articulate the culture of the FDNY, whose predominantly Irish engine and ladder companies had long operated as independent, local, neighborhood-oriented, and competitive clans. The exuberant Renaissance, Baroque, and rococo decorative vocabularies evoked not only public, civic values but also the private realm of the domestic. Such associations were perfectly in keeping with the role of the firehouse as a firefighters' "second home." So, too, was the FDNY's reputation for lack of discipline, an aspect of government that municipal reformers had long found troubling.[128] It is perhaps in part for this reason that the ACNY delegated President De Forest to comment on the matter of incoherence.

Individual architectural statements were not inherently bad, but their variety struck ACNY members as too "dissimilar and incongruous." "There should be," De Forest wrote Mayor McClellan, "a harmony and unity of design for all city buildings erected for similar uses and purposes—a design thoroughly adapted to and expressive of the use of the structure. It does not follow, of course, that all fire stations should be absolutely alike . . . but that certain fundamental rules should be adopted which will produce harmony and symmetry between all buildings used for fire stations and establish a style or type that will indicate a fire station whenever seen."[129] The FDNY

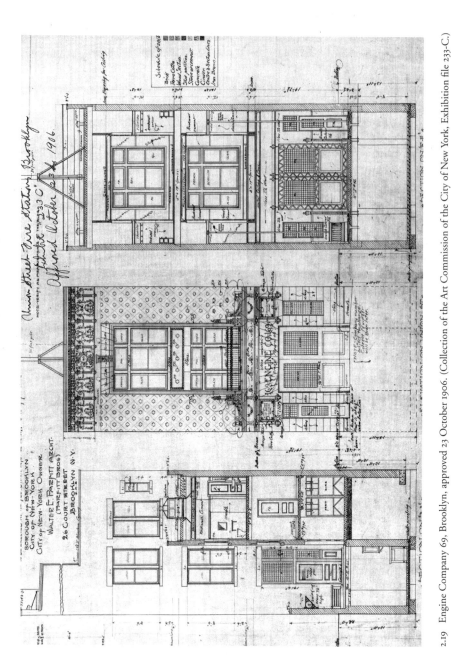

2.19 Engine Company 69, Brooklyn, approved 23 October 1906. (Collection of the Art Commission of the City of New York, Exhibition file 233-C.)

2.20 Hook and Ladder No. 20, Brooklyn, approved 18 September 1906. (Collection of the Art Commission of the City of New York, Exhibition file 232-C.)

building plans offered no overarching conception of what kind of departmental identity was being conveyed. In an urban commercial culture in which growing numbers of products, structures, and experiences were being patented, branded, categorized, and marked by trademarks or signage, the municipality had to communicate in a comparable manner.

De Forest and the ACNY urged municipal departments to develop a more monumental and uniform civic face, one that would command respect and be readily identifiable. Such visibility served a dual purpose. Consistency of style would be functional; buildings would serve as identifiable markers, letting the public know exactly where to find crucial municipal services. Clarity of presence would also have a symbolic function, contributing to an image of New York City as unified, well-coordinated, and efficient.

De Forest's and other commissioners' concern for cohesion and urban legibility and the display of an appropriately civic face was surely a response to the distractions and disorder of the modern commercial city. At the same time, De Forest's emphasis on facade as sign and identification reflected an innate desire for the municipality's civic realm to achieve successes comparable to its business sector, which had forged an image of the city centered around the coalescence of architecture, signage, consumer brands, and commerce.

The ACNY sought to configure Greater New York in a different fashion: to create images of the city as an exciting but orderly, civic-minded, and public-spirited place. The ACNY's exhibit for the Saint Louis Louisiana Purchase

Exposition of 1904, organized by Assistant Secretary Maltbie, sought to pros-
elytize for this ideal, displaying successful New York City projects that in many
cases the ACNY had helped to improve. The show represented a city that cared
for the design of its bridges, public baths, police precincts, arts, and other ser-
vices, linking New York's arts of sight to international developments (like the
magnificent new public buildings of Paris, Rome, London, and Vienna) but
simultaneously highlighting its uniqueness.[130] Maltbie, like most exhibitors,
envisioned the Louisiana Purchase Exposition display quite forthrightly as
a civic art public relations campaign. Police stations, firehouses, bridges,
schools, and other urban structures, if designed in accord with ACNY direc-
tives, would tangibly implement civic ideals and prove the merits of aesthetic
management in the municipal public realm. With help from the ACNY, New
York City's built environment might literally not just become a model of good
government but also embody the good city. A controlled public aesthetic
would produce a New York City far superior to one left merely to follow the
dictates of the marketplace or of Tammany Hall.

De Forest and fellow commissioners did not oppose the modern city.
De Forest's work, after all, in all of its various configurations, was part and
parcel of modernization. His outlook and activities nevertheless revealed a
decided ambivalence toward some of its manifestations. He was hardly an
escapist by any stretch of the imagination, but a number of his professional
projects had a decidedly retrospective turn, as we shall see in the following
chapter.

THE POWERS THAT BE

By the 1920s, the ACNY's membership and organizational structures were
firmly established, with the limits of its supervisory scope also clarified. The
ACNY would operate on a microcosmic rather than a macroscopic basis; it
would not engage in project initiation or city planning but focus, instead, on
individual cases, mundane matters, and details. These responsibilities, nar-
rowly defined on the surface, endowed the ACNY, in theory at least, with
considerable and broad-ranging powers. However, several factors mitigated
that authority. Charged with assessing a multitude of projects, the ACNY
was thrust into a process of negotiating with the numerous local, national,
public, and private groups and individuals involved in public operations and
public life and in shaping the public experience of the city. Faced with many
pressures from many applicants, ACNY members were hard-pressed to up-
hold their high-minded aesthetic principles in all instances. At the very least,
the realities of New York politics demanded negotiation, which ultimately
affected the course of the projects and the ACNY's reputation.

Indeed, although the ACNY was part of "government," its status as such continued to vacillate, positioning it outside of conventional municipal networks. This was in part a result of the privileged socioeconomic standing of its membership and in part because the ACNY was only as strong as its individual president—and his relationship with the mayor. Indeed, one of the ACNY's most peculiar aspects, as a government agency, was that the tenure of the president—if he was one of the cultural institution presidents—could be virtually indefinite, as long as commission members reelected him each year as the charter mandated. De Forest, representing the Metropolitan Museum of Art and not a mayoral appointee, held the ACNY presidency for over two decades. This longevity became stultifying, especially at the point when De Forest appeared to become disengaged from the ACNY's affairs. But for the most part De Forest's reign proved beneficial, providing continuity, insight, and stability that enabled successive groups of ACNY newcomers to negotiate the process more effectively.

In 1910, as in the present day, artists and architects, government officials, and other sponsors and citizens wanted to make their marks, in bold strokes, on the cityscape. For "municipal embellishment" constituents seeking immediate solutions or to maintain the bottom line, the ACNY's presence was an irritation. The group's peculiar status allowed it to distance itself from such mundane concerns as contracts and deadlines. From the commissioners' perspective, the structures they approved were part of the permanent fabric of the city, there for the ages. The details mattered. The messy exchanges that resulted from this clash of priorities and interests were one of the many contingencies that affected the look of twentieth-century New York City.

In spite of the ACNY's aspirations for the City Beautiful, New York's built environment would never be so consistent or monumental as to link its image with that of Washington, D.C., or major European cities like Paris, London, or Berlin. Both the review process and the cityscape were by comparison, too decentralized, and the commercial ethos and image remained predominant. The results were mixed and varied. Nevertheless, had the ACNY not existed, had the city's public realm been subject merely to the marketplace, as in the commercial sector, New York City would have been a very different place, with a far less coherent and enduring municipal identity than otherwise would have been the case.

The art commission envisioned its activities as transcending the present to shape the New York City of the future. But the urban identities negotiated through its process were not limited to urban novelties or to creative construction. From the outset, the ACNY was also preoccupied with shaping images of the city as bound up with its past.

CHAPTER THREE

MONUMENTS, PLACE,

AND MUNICIPAL IDENTITY

The ACNY wielded its veto power with its eye trained on the present when dealing with bridges, letter boxes, street signs, and animal drinking fountains. It aimed to enhance New York City's future built environment, conceived in the broadest sense. The commission had been formed, however, specifically around the issue of memorials. This chapter focuses on the ACNY's role in determining the ways that the city's appearance and identity would be bound up with the past—with how history and memory would be expressed and, hence, how the city's character would be represented for posterity. The debates were exemplars of the struggles over space, place, and taste that were outgrowths of ethnic, class, and cultural differences in the metropolis. My discussion in this chapter will concentrate on monuments and memorials prior to the Depression—cases that are representative in terms of patronage and process as well as genre and style—and will consider two other endeavors, the Governor's Room in City Hall and the New York City flag.[1] I will highlight further how the ACNY itself attempted to shape the civic image of Greater New York. A view of these activities offers additional texture to the broader story—the relationship between civic commemoration and the development of modern New York City.

The city's rapid expansion went hand in hand with a yearning to celebrate and commemorate aspects of the past identified with contemporary citizens' aspirations and contributions. Development also spurred efforts to create a civic memory, what historian Randall Mason has called "collective memories of the past that would be inscribed into and evoked by the public built environment."[2] Mason, Max Page, and others have explored the centrality of civic memory, preservation, and urban development, taking particular note of the activities of men like Robert Weeks De Forest, I. N. Phelps Stokes, and several other important ACNY staff and members.[3]

Though this chapter touches on these matters, it does not deal with the commemorative process per se. Rather, it addresses the politics of memory

and the expression of the city's image as they intersected over issues of aesthetics within the ACNY's review process. During the ACNY's first three decades, these debates revolved around three key concerns—the "purely" formal aesthetic, the historical and associational, and the political. These frequently intersected. From the ACNY's standpoint, a community's mere desire for a memorial was insufficient rationale for allowing it to be placed on public land. The quality of design in relation to subject matter came first and foremost. This conviction resulted in changes between artist's conception and finished product and often produced friction.

With commemorative enterprises, the ACNY faced a dilemma that has continued to this day: the need to weigh its members' tastes—officially representing expertise and the welfare of the "greater good"—against the tastes and desires of a narrower but legitimate public. Although such circumstances often pitted the preferences of the culturally sophisticated against more popular constituencies, the situation was rarely so straightforward. Ultimately beauty and memory, embodied in public monuments, was a function of process and power. The ACNY by no means always won the power struggle.

The discussions here of monuments to ethnic and local heroes will reveal the extent to which the ACNY succeeded in imposing a class- and ethnically inflected taste for moderation, compared to some of the initial submissions. Case studies of the Bolívar, Verazzano, Dante, Salomon, Slocum, Green, and Bronx Spanish-American War memorials will show how the ACNY's actions implicitly challenged and counterbalanced the laissez-faire-ism of the commercial metropolis. Indeed, for better or worse, ACNY members' desire to articulate urban memory in refined and economical terms contributed to diminish idiosyncratic designs and to minimize commemoration of sponsors. Their actions had important consequences for New York City landmarks.

A variety of preoccupations informed ACNY decisions. Engaged in negotiating terms for markers of permanence and memory in a notably impermanent city, the ACNY regarded as crucial the location as well as the forms of memorials. Commission members considered place to be important not only as an aesthetic and geographic experience but also as a catalyst for historical associations, identifying a locale with particular memories or the events that spawned them. Hence, as with mailboxes and drinking fountains, the ACNY assessed memorial designs for specific sites according to whether the memorial seemed to be an "appropriate" expression of urbanism and visual culture. The group took particular interest in the associational and tutelary values that would grow out of the relationship of memorial to site, and that in turn would affect the entire vicinity.

The era between 1898 and World War I is closely identified with southern and eastern European immigration to the United States and with the

Progressive effort to contain, control, and improve the turbulent realm of the social. The period was also marked by concerted attempts to use the visual and performing arts to promote assimilation and Americanization. Public artistic representations of national identity reflected, in varying degrees, the conflict between the national acculturation and the affirmation of ethnic lineage. Some civic works expressed an ideal of old stock Anglo-Americanism, others embraced Old World tradition, and still others, the ideal of the "melting pot," the "cultural fusion and genetic amalgamation" of white ethnic groups into a single American nationalism.[4] The ACNY's engagement with monument proposals, such as that for the Haym Salomon Memorial, was one manifestation of the resulting tensions. So, too, was the ACNY's involvement with colonial revivals and celebrations of the city's Anglo-Dutch heritage, as the ensuing discussion of the Governor's Room and the New York City flag will also suggest. The ACNY's encouragement of an aesthetic of relative minimalism and its discouragement of the idiosyncratic were consistent with some members' desire to advance national ideals of cultural assimilation into a Euro-America with Anglo-Protestant roots. They rejected an expression of nationality or municipal identity in pluralist terms. Art commission members like Robert De Forest and I. N. Phelps Stokes, although often cultural moderates, were deeply invested in this project.[5]

Such attitudes clearly informed the ACNY's work, as the case of the Governor's Room will show, but did not at all indicate the commemorative paths that would ultimately be taken. Memorials, in fact, represented a wide range of organizations and agendas. The ACNY's involvement with their memory enterprises thrust its affiliates into the political fray among a different group of people than those engaged with public buildings. The commission's members were a pragmatic bunch and did not act predictably. As the sections on memorials to "ethnic" and local heroes will indicate, no group or event was sacred. The ACNY was willing to offend just about anyone.

In contrast to the bridges and buildings, memorials, as works of art, offered the ACNY latitude to pull its weight. (From the outset the charter empowered the ACNY to assess both the formal aesthetics and the siting of works of art.) But although the group flexed its muscles, its members usually sought to compromise and ultimately approved many projects that its members believed to be of ambiguous merit. The artist members of ACNY needed future jobs, after all. Museum trustees sought good will from politicians and the mayor. The mayor (as ex officio member of the ACNY) generally did not want to be dragged into fights over "trivial" concerns like memorials (as happened with the proposed Samuel J. Tilden monument).[6] When a project had ramifications for international relations, however, the ACNY knew that the mayor and federal officials would take more than just

a passing interest. As successful businessmen and artists, they were well aware of the need to show flexibility, and this restricted their power.

Commission members had faith in the system; they were in it for the long haul. Hence, as an institutional body, the ACNY acknowledged and accepted the limits of its authority. Acting in accordance with these limitations enabled it to have a more profound and long-lasting impact on memorials and memory in Greater New York. At the same time, their pragmatic approach produced a more homogeneous, less unrestrained, and perhaps even less memorable memorial landscape.

THEORY VERSUS ACNY PRACTICE

The efforts to erect the Heine and the soldiers' and sailors' memorials, discussed in chapter 2, had set off debates about the role of monuments in New York City and about the relationships among democracy, memory, monuments, history, expertise, taste, representation, place, and power. The maneuverings surrounding these two projects were a wake-up call to the city's aspiring sculptors. Commemoration through sculptural memorials was an idea whose time had clearly come, but important questions remained unanswered. Which groups had a legitimate claim to commemoration on public property in a diverse and democratic modern city? Who was worthy of being commemorated? Prior to 1898 no one had ever tried to map out this issue.

Soon after consolidation of the greater city, two sculptors, Karl Bitter and Henry Kirke Bush-Brown, sought to undertake such a task. Bitter (who would serve on the ACNY from 1912 to 1914) and Brown (who would subsequently have dealings with the ACNY over his decorations for Horgan and Slattery's notorious Hall of Records) each published articles about the kind of subjects that deserved sculptural commemoration in New York City and about where they should be placed. Although their ideas varied in the particulars regarding subject and locale, the sculptors' overall conceptions were quite similar. Both called for using "municipal sculpture" as a tool for popular instruction: monuments should represent key events and heroes in the history of the city and nation. Sculptors should strive to celebrate the city's development, growth, and achievements. They should aim to commemorate national ideals, such as liberty and equality, and the heroes who sacrificed their lives in service to them.[7]

Taking a page from advertising men and other advocates of commercial culture in the period, the sculptors argued for the benefits of utilizing the visual culture of memorials to instruct a diverse citizenry by inscribing readily graspable themes in sculptural form so that "he who runs may read." Unlike their counterparts in the commercial sector, however, artists had no

predisposition to cater to mass tastes. They assumed that expert advice on historical and current themes should be solicited to uplift public knowledge, patriotism, and decorum. Both artists laid out conceptions linking key connections among public monuments, municipal and national development, and urban geography—subject and site. Subjects highlighting the Dutch period of the city's development, for example, belonged in Bowling Green; the significance of the Revolutionary War and the Federal periods might be expressed in City Hall Park and environs; Union and Madison Squares were suitable for commemorating the Civil War. For Bitter, the Battery Park area near the aquarium was suitable to celebrate the relationship between land and sea and to celebrate the shipping and commerce so central to the city's identity.[8]

Published in the short-lived reform journal *Municipal Affairs,* the Bitter and Bush-Brown articles bore the editorial stamp of coeditors Milo Maltbie and John DeWitt Warner, the ACNY's key future leaders. Even in 1898–99, the sculptors' essays were consistent with the vision, shared by at least some early ACNY members, for a cohesive expression of civic memory.

Nevertheless, the realities ACNY confronted were very different. No single group could speak for New York City's diverse citizenry. A broad range of organizations and individuals contended that their memories merited claims to special spaces. The ACNY was thus regularly confronted with varied interpretations of how to represent the city and its place within a national historical trajectory. Despite any preconceptions of its members, however, the ACNY had to approach memorials piecemeal. The charter charged the ACNY with approving design and location of plaques, statues, memorials, and monuments but not their subjects. Occasionally, the border between subject and location was rather permeable. The ACNY could affect the outcome by dictating, if not a memorial's subject, then its place, form, accessibility, and cost.

The ACNY would be extremely protective of certain key cultural nodes and historical sites. These places included Battery Park, City Hall Park, Union and Madison Squares, Riverside and Central Parks—also singled out in the Bitter and Bush-Brown programs. In practice, however, the ACNY never really acted, consciously or unwittingly, to implement, through memorials, a vision of civic memory quite so coherent as that which Bitter and Bush-Bush Brown proposed. The process proved to be far messier, even if, in the long run, the commemorative forms themselves were neater and more orderly because of ACNY intervention.

The soldiers' and sailors' memorial was one of the first monument projects to which the newly established ACNY attended (the other was Auguste Bartholdi's *Washington and Lafayette,* approved in 1900 for 114th Street at the intersection of Morningside and Manhattan Avenues).[9] A controversial

holdover from the preconsolidation era, the soldiers' and sailors' memorial presented the ACNY with a variety of challenges, the first of which was simply to conclude successfully the long-running project. This task entailed a second predicament, the question of site, which ACNY predecessors had not been able to resolve. The ACNY's approval of the site choice would also have larger, unspoken implications regarding power and the identity of the city's open spaces.

The soldiers' and sailors' memorial had been put on hold while civic and businessmen's groups argued about its location (see chap. 1). In 1897 Mayor Strong designated the plaza at Fifty-ninth Street and Fifth Avenue as the site for the memorial and delegated architect Bruce Price to hold a limited competition among seven artist-architect teams. The judges (who included the FAF's Russell Sturgis) selected a design by Arthur and Charles Stoughton, a 125-foot column capped by the statue *Victory* by sculptor Frederick Mac-Monnies. But the other members of the 1896 Municipal Art Commission (J. Q. A. Ward and Charles T. Barney) opposed that site and thus began a search for an alternative locale. Meanwhile, Stoughton and Stoughton scrapped their winning design and developed a new one. It was very different from the one on which their selection had been based, but there is no indication that anyone challenged their right to continue as architects or demanded a new competition. The Stoughtons' new design, a collaboration with architect Paul E. M. Duboy, was an elegant, eighty-foot-high cylindrical structure modeled after the Choragic Monument of Lysicrates in Athens (334 BC).[10] But this revised memorial contributed to ongoing difficulties in finding a site.

No sooner had the ACNY begun its official work than it was thrust into the middle of this controversial project. Veterans groups, which had been working for this memorial for close to a decade, wasted no time in approaching the commission. Immediately after the ACNY was formed, in March 1898, the secretary of the Grand Army of the Republic's Soldiers' and Sailors' Memorial Commission (GAR-SSMC), J. A. Goulden, asked for approval for a site at 129th Street and Riverside Drive, at the southern entrance to the viaduct over Manhattan Valley. (The plaza and West Seventy-second Street had been ruled out.) This new site made sense from a symbolic and urbanistic point of view. It would link the accomplishments of the great Civil War general and president Ulysses S. Grant, whose newly completed tomb lay six blocks south, with the sacrifices of ordinary militia and naval men. The memorial would also provide a focal point and ceremonial flourish at the entrance to Riverside Park. The veterans clearly envisioned the site as the beginning of a grand formal monument row dedicated to distinguished American Civil War heroes.[11] To insure that the ACNY grasped the urgency of the request, Goulden let the art commission know that this plan

was heartily endorsed not only by the Grand Army of the Republic and by U.S. naval officers but also by other veteran's' groups, a not-so-subtle signal that the committee hoped that the ACNY would cooperate.[12]

Stoughton and Stoughton's design per se did not pose a problem for the ACNY, but locale was a concern. At issue, at least in part, was surely whether to approve a site that would set the stage for a larger sculptural "master plan," akin to what Bitter and Bush-Brown had proposed, or to allow for contingencies. For the time being, indeterminacy ruled on monument installations. The ACNY was not willing to approve the 129th Street site. Whether out of fear of taking bold action, of upstaging Grant's Tomb, or simply of agreeing to an aesthetically unsuitable site, the ACNY deferred its review of the submission.

Less than two weeks later, the GAR-SSMC returned with a request for a different site, at 127th Street and Riverside Drive, on the "Lawn" of the Claremont Inn (a "popular destination for pleasure drives and promenades").[13] The GAR-SSMC's sought to quell ACNY's concerns about potential overcrowding of the area with war memorials, especially ones that would compete with Grant's Tomb. (Such a concern had blocked the erection of Augustus Saint-Gaudens's memorial to William Tecumseh Sherman.) The veterans contended that their memorial would pose no competition for the tomb, since it was sufficiently far away (1,000 feet north) and totally different in form and composition.[14] The GAR-SSMC claimed that this site would be far more suitable than others considered, including Madison Square and the rocky outcropping known as Mount Tom at West Eighty-third Street and Riverside Park.[15] The Claremont lawn site was level, the GAR-SSMC argued, and thus the monument would be visible from the North River, Riverside Drive, and the park. It would be accessible on foot or by carriage, thus attracting additional visitors to that part of Manhattan. And it was far enough away from any houses on Riverside Drive to allow for clear sightlines. Indeed, sited on one of the "strategic eminences of the city," the memorial would become a crucial landmark, visible from the north, west, and south. "While apparently remote," the GAR-SSMC concluded, "it is a much visited spot."[16] Goulden was prepared, should this aesthetic rationale fail. Asserting veterans' privilege, he warned that since the GAR-SSMC had selected this site, "good reasons must be shown for refusing such a desirable location."[17]

Someone evidently did find good reasons for refusing this location before it came before the ACNY. It seems likely that the Grant family members deemed the site unacceptable for 127th Street—just as they had previously opposed placing the Sherman memorial south of Grant's Tomb. (A nearby memorial to Grant, never realized, was also in the planning stages.)

This left Mount Tom, at Riverside Drive at West Eighty-third Street, as the remaining possibility. The ACNY seemed amenable.[18] This site, however, displeased Stoughton and Stoughton, and they complained to the GAR-SSMC. The physical characteristics of Mount Tom and its environs were too problematic, the architects insisted.[19] If the memorial were placed on this "rocky hill," the hill itself would be obliterated. Moreover, the rapid development of Riverside Drive with six- to nine-story residences also posed problems. The buildings would in effect compete with the vista of the proposed monument when viewed from the south and from the river. "From any part of this field of view the present apartment houses will appear to be either alongside of the monument or behind it," thus "thrusting their large and uninteresting masses into direct competition with the delicate construction, proportions, and color of the monument."[20]

Stoughton and Stoughton recommended, instead, a new site between Eighty-ninth and Ninetieth streets at Riverside Drive, an area that had evidently not been considered previously. Both the GAR-SSMC and the Department of Parks approved this new location in September 1899.[21] With the clients having finally come to an agreement, the art commission prepared to review the project.

Then yet another obstacle arose. Architect Cyrus Eidlitz, representing property owners along Riverside Drive, submitted a petition, arguing that, like Mount Tom, the Eighty-ninth Street site was aesthetically unsuitable for a monumental structure like the soldiers' and sailors' memorial. Many new apartment buildings had gone up along Riverside Drive in recent years. They argued, with disingenuous public spiritedness, that these residences would invariably block views of the monument unless one were either very close to or far from it.[22]

But really the issue of views was launched from the opposite direction. The buildings were very "expensive residences," Eidlitz noted, built with the assumption that "the view would never be obstructed and the park would remain perfectly intact." In a twist that may seem difficult for today's landmarks-conscious generation to comprehend, turn-of-the-century property owners feared that the soldiers' and sailors' memorial would diminish the attractiveness of their dramatic park views and hence detract from rather than enhance their property values.[23] In addition, residents feared the influx of large numbers of veterans and other "sight-seers, without sufficient space to accommodate them," a situation that "cannot fail to be a great injury and injustice to the residents of this portion of the drive," who presumably did not want to have throngs of visitors camping out on what they regarded as their front lawn.[24] Residents needed to be protected from the memorial.

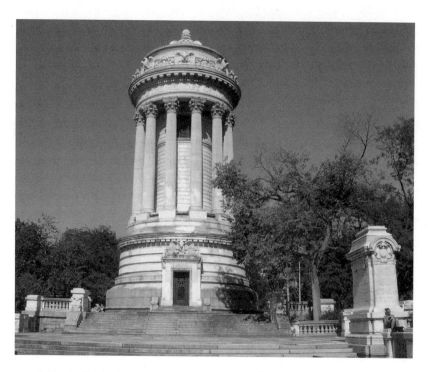

3.1 Soldiers' and Sailors' Memorial Monument, 1902. (Photo by author.)

The ACNY now had to weigh its own aesthetic priorities against those of respected sculptors with a vision (Bitter and Bush-Brown), newly professionalized and activist landscape architects, real estate developers, upscale apartment dwellers, and Civil War veterans. Its decision would have to balance the interests of the local and the immediate with the national and enduring. Approval of the Eighty-ninth Street location might establish associations between Riverside Drive and Civil War memorials: it might transform what the park's designer Frederick Law Olmsted had conceived as a genteel carriage drive into a pilgrimage way and a memorial park. In the end, the ACNY opted to side with the veterans and approved the soldiers' and sailors' memorial, along with a broad esplanade and overlook, at the Eighty-ninth Street site. Governor Theodore Roosevelt laid the cornerstone in December 1900, and the $250,000 monument was dedicated on Memorial Day, 1902 (fig. 3.1).[25]

The soldiers' and sailors' memorial, one of hundreds of Civil War memorials, was the first "sacred" war monument that aroused opposition. The most contentious aspects of the debates had actually taken place before the project came to the ACNY. The commission's process thus became the cen-

ter of deliberations that had already started to jell into consensus. The ACNY clearly sought to balance sensitivity to the interests and influence of veterans and local residents with the need to attend to the developing aesthetics of the growing city. Such a task was not difficult in this instance. The design seemed acceptable, and hence the commission's principal concern, as it was for Stoughton and Stoughton, was finding a harmonious site. Once that happened, the self interests of nearby residents—although couched in the rhetoric of aesthetics in order to stay within the commission's proper purview and deflect criticism of possibly other motives—gave way to pressure for erecting the monument. In this early project, the ACNY had to reconcile opposing factions, quickly learning that its actions would rarely please everyone. Its members may well have realized the practical limitations of plans such as Bitter and Bush-Brown proposed. In actuality, their goal would be less to encourage monument districts than to prevent glutting sought-after places with memorials. While the ACNY continued to keep in mind the ideal of historically appropriate monument sites, it opted for practicality with the soldiers' and sailors' memorial.

ETHNIC HEROES

The ACNY, it will be recalled, had been set up in large part to avoid the pitfalls of having numerous preconsolidation organizational structures dealing with public monuments. The whole point was to improve on the advisory committee to the Park Board and the 1896 Municipal Art Commission. Influential individuals like John Carrère and Elihu Root hoped that the ACNY's configuration would enable its members to resist the kinds of pressures that monument sponsors had placed on predecessors. They anticipated that the ACNY would be more independent, objective, and authoritative. The ACNY's involvement with the profusion of "ethnic hero" monuments tested this vision.

From the outset, the ACNY evaluated public monuments that emanated from New York City's growing importance as a cosmopolitan and international capital. Donations of portrait statues of foreign national heroes became one commonplace strategy in turn-of-the-twentieth-century international relations. Latin American and European nation-states, along with individual citizens, bestowed monuments on major American cities (like New York) to celebrate their countries' alliances with the United States or to symbolize purportedly shared ideals. Still other memorials came as gifts from organizations or individuals representing immigrants and the city's powerful new ethnic constituencies. As with the Heine Memorial, these memorials were deliberate assertions of ethnic presence, pride, and political power.

Perhaps more than any other municipal department, the ACNY repre-
sented the interests of the cultured upper-class Anglo-American establish-
ment. While the ACNY's own advocacy efforts would reflect its presidents'
personal ideals of nationality and municipal identity, as bound up with a
conformist tradition, the ACNY's actions with regard to the memorials of
different ethnic groups proved to be practical. Cognizant of their obligations
as a municipal department, ACNY members acknowledged that turn-of-the-
century Greater New York was a multiethnic city and part of a nation with
global ambitions. A crucial mission for the ACNY was to encourage forms
of commemoration that would suitably acknowledge the new urban reality
of Euro-America: to reconcile its own Anglo-conformism with ideals of cul-
tural integration. Several short case studies shed light on this new political
order, the ways in which urban power was dispersed from the older, Anglo
elites to broader class and ethnic groups and the tensions that accompanied
these circumstances.

Simon Bolívar

The statue of Simon Bolívar was one such project. The soldiers' and sailors'
memorial engaged the commission's attention on a matter of commemoration
and locality that had emerged from a seminal, internal national crisis, the Civil
War. The Simon Bolívar monument highlighted the difficult diplomatic
dimensions of the relationships among commemoration, taste, expertise,
power, and public space as the United States maneuvered on the world stage.

The Bolívar memorial saga began in 1884, when Venezuelan president
Antonio Guzmán Blanco offered to the Board of Commissioners of Central
Park a bronze equestrian monument of Simon Bolívar (1783–1830), the
Venezuelan-born general whose victories over Spain achieved independence
for Venezuela, Columbia, Bolivia, Panama, Ecuador, and Peru. The occasion
was the centennial of Bolívar's birth, but the underlying motivation was to
strengthen its friendships and ties with Venezuela's ally, the United States.
Guzmán sought to identify Bolívar with George Washington and American
republicanism, and in 1883 commissioned a statue of Washington for a cen-
tral plaza in Caracas. The American Bolívar monument would stand as the
symbolic pendant to the Caracas *George Washington*. Bolívar was often de-
scribed as "the George Washington of Latin America."[26]

On their end, federal officials and New York City's powerful merchants had
significant political and economic interests in Venezuela, as with other nations
of Central and South America and the Caribbean. Venezuela's growing dis-
pute with Great Britain over Venezuela's border with British Guiana threat-
ened these enterprises.[27] In their periodic efforts to solicit U.S. assistance in

dealing with Britain, Venezuelans emphasized the common strategic interests and historical experiences of the two republics: quite apart from their mutually advantageous trade relationship, the two nations had—in the era of Bolívar and Washington—liberated themselves from colonial rule. Even in the present, Venezuela still struggled to fend off a powerful adversary, Great Britain, with whose aggressions the United States was certainly familiar.[28]

The Simón Bolívar statue was intended to be a tangible expression of this Venezuelan–U.S. alliance. There was a problem with it, however. As the *New York Times* characterized it in March 1884, the awkwardly angular equestrian group, by South American sculptor Rafael de la Cova, was "an aesthetic calamity. . . . aggressively bad" (fig. 3.2).[29] The Venezuelan government voiced "indignation," at the negative reception, and after additional deliberation about this "delicate matter," the park commissioners agreed to "sink their aversion" and accepted the statue for a grove just inside Central Park, near West Eighty-third Street.[30] The Bolívar monument came to epitomize the embarrassing state of the art of commemoration in New York City. The aesthetic derisions continued over the next decade.

In 1896, Venezuela sought to remedy its monument problem and to reaffirm ties with the United States, a growing world power. In gratitude for U.S. intervention that helped to avert military intervention by Great Britain in the Guiana border dispute, the Venezuelan government offered U.S. Secretary of State Richard Olney (whose interpretation of the Monroe Doctrine resulted in the successful U.S. resolution of the dispute) a new Simon Bolívar statue to replace the much-maligned de la Cova version. (The Venezuelans also requested that the new equestrian statue be relocated to a more prominent site.)[31] Italian sculptor Giovanni Turini (1841–99) would design the replacement. The new statue would be a modified replica of an equestrian Bolívar monument, by Turini's own master, Adamo Tadolini (1788–1868), which stood in the Plaza Bolívar in Caracas.[32]

Olney informed the New York City officials that they would once again be the beneficiary of a Venezuelan gift. The municipality could go through its regular review procedures, but from the federal perspective the statue was a fait accompli. The Board of Parks Commissioners referred the matter to the National Sculpture Society (NSS), which, as we saw in chapter 1, had been delegated to advise the board on statue matters before the passage of the 1896 "French" bill. The NSS recommended keeping the same location. Then, in August 1897, the NSS, having reviewed the clay model of the new Bolívar monument, contended that it "failed to reach the standard of artistic excellence entitling it to a place in the parks" and that it should not be accepted. (The NSS's resentments about the quality of New York's monuments, already high, were no doubt stirred further by the fact that, from their

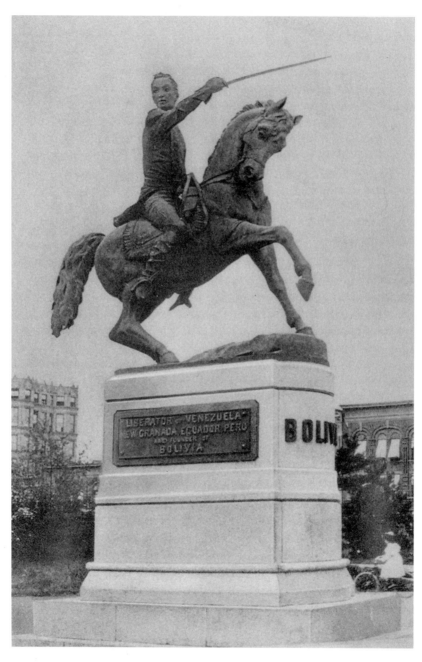

3.2 Rafael de la Cova, Simon Bolívar monument, formerly in Central Park, 1884. (From John Sanford Saltus, *Statues of New York* [New York, Putnam: 1923].)

members' perspective, the majority of these inferior works were by foreign artists, at the very point when American sculptors were struggling to obtain public commissions for themselves.) "Discussion" ensued between the NSS and Turini, and the latter revised his work.[33] By the time he had finished, or thought he had, the new ACNY had come into the picture.

In November 1898 Turini requested that the ACNY review his newly completed plaster model.[34] Sculptor member Daniel Chester French served as intermediary. Clearly, French was unimpressed, asking ACNY president Charles T. Barney whether there was "evidence" that the Venezuelan government had truly commissioned Turini and wondering how the work had come to be bestowed on New York City when it had been donated to the federal government. French intimated that some shady dealing had taken place, noting that Turini had told him that Secretary of State Olney's brother, a lawyer, had the sculptor's contract.[35]

Sensitive to the diplomatic and political ramifications of the project, and of the ACNY's role, at a time when the United States had just fought a war in the Caribbean, French seemed to be trying to offer Turini advice on making improvements. Tired of spending so much time, and still dissatisfied with the statue, French recommended to Turini that he seek help from someone else, "a certain [unnamed] sculptor of ability."[36] Turini would not be paid until the ACNY approved his work and needed money "badly." He was "ready to do anything" the ACNY required, French noted, and "begged me to give him a line that he could send to the authorities in Venezuela" to reassure them that the ACNY would eventually accept the Bolívar monument.[37]

Turini made the suggested changes and French continued to "attend to the case." By late April 1899 he reported that, although the Bolívar monument was "still certainly a pretty bad statue," it would probably pass muster "with the general public" and that the ACNY would be "pardoned for accepting it. It is greatly improved."[38] French, a consummate diplomat in his own field, knew well the importance of appearances and when to compromise. This was just such an occasion. He was willing to bend, acknowledging that there were instances where the experts' perception of lack of merit could be based on formal or technical criteria that might be imperceptible to the layman. The benefits of approving a project already in process before the commission was established outweighed the importance of sticking to "principle." Thus French in effect gave the go-ahead for the art commission to approve the second Bolívar monument, which it did on 24 May 1899.[39]

This monument, however, like many others subsequently approved and disapproved, would never be put into place. Turini died in August 1899 from heart disease, exacerbated, his widow charged, by "worry over the delayed payment" for the Bolívar monument."[40] The Venezuelans evidently agreed

with French that the new equestrian, like the old one, was "a pretty bad statue." Turini's death, combined with a rising anti-Americanism after the ascendance to the Venezuelan presidency of Cipriano Castro, enabled the Venezuelans to cut their losses. The old statue was removed from Central Park on 20 June 1899. An empty pedestal stood on Bolívar Hill.[41] Over a decade later, the Venezuelan government decided to renew its efforts and held an international competition for yet another Bolívar monument. In October 1916 Venezuelan officials informed Secretary of State Robert Lansing that the Venezuelans would be erecting a new Bolívar monument on the site "held in reserve for that purpose in Central Park . . . for over thirty years."[42] This time the selection of the sculptor—an American, Sally James Farnham—was a canny one: Farnham became one of only three women sculptors to have a public monument placed on city property. On 12 November 1917, the art commission approved Farnham's preliminary drawings for a monument for Bolivar Hill (the ACNY did not consider an alternative site). Farnham received final approval in 1919, and the memorial was dedicated on 19 April 1921 (fig. 3.3).[43]

The case of the Bolívar monument illustrates the important role individual artist members played on the ACNY, and the discrepancy between commissioners' private views and dealings and the public, official actions of the group as recorded in the press or in minutes. Because of his genteel family background, artistic experience, and comprehension of the diplomatic stakes, Daniel Chester French proved to be a vital figure in the earliest ACNY phases of the Bolívar monument undertaking. Through his assistance, the ACNY managed to conclude this troubled holdover project and to keep its problems with Turini sufficiently quiet to avoid conveying an impression that the ACNY had caved in to pressure by approving his "pretty bad" statue. The good press continued when the Farnham equestrian was dedicated. The *New York Times,* for example, did not mention the existence of two previous Bolívar statues (whose whereabouts are now unknown). Only Farnham's artistry would be highlighted for public memory, along with Bolívar's heroism and the enduring friendship of the United States and Venezuela.

The Bolívar statues called attention to New York's importance as a hemispheric metropolis. Memorials to Giovanni Verazzano, Dante Alighieri, William the Silent of the Netherlands, and Haym Salomon, submitted for ACNY review between 1906 and the Depression, accentuated Greater New York's centrality as a city of immigrants. Each project articulated an ideal of civic memory linked to "heritage." For the publics that sponsored them, monuments expressed civic pride; they would also facilitate assimilation by reconciling dualities of ethnic and national affiliation.[44] Through hero memorials, each community involved sought, literally and figuratively, to assert its place

3.3 Sally James Farnham, Simon Bolívar monument, 1918. (Collection of the Art Commission of the City of New York, Exhibition file 954-D.)

in the metropolis. With large interests at stake, sponsors regarded the placement of their memorials as crucial symbols of their power and status.

Members of the ACNY were acutely aware of these agendas, and did not entirely approve of them. They were unquestionably unsympathetic when encountering what they perceived to be vulgar self-promotion. While such objections inflected their decision-making, both consciously and unconsciously,

such matters were rarely discussed on the record. Instead, debates over site and the problem of aesthetic excess became the field of struggle. The memorials to Verazzano and Dante exemplified such controversies, as well as the ongoing schisms and compromises among ACNY members, representing traditional and staid Protestant cultural elites and professionals, and a new class of successful, entrepreneurial immigrant businessmen.

Verazzano and Dante

The Bolívar memorial was the gift of a nation. In contrast, the principle sponsor of Verazzano and Dante projects was an individual notorious newspaper publisher, Carlo Barsotti (1850–1927). The realization of the two monuments hinged on Barsotti's dedication and drive, combined with a ready willingness to accuse his opponents of anti-immigrant bigotry.

Born in Pisa, Barsotti came to the United States in 1872. The young immigrant worked his way up from poverty to become a successful businessman, writer, and editor, founding the Italian American paper *Il Progresso Italo-Americano* in 1880. That achievement hinged on Barsotti's talents in building up and maintaining a loyal readership, in good part through ongoing and impassioned campaigns on behalf of Italian causes. Barsotti believed that this task demanded a broader awareness in the United States of the Italian presence and of Italian contributions to civilization in general and to American nationhood in particular. To this end, in 1889 Barsotti had pioneered a new kind of public relations enterprise, sponsoring large urban monument projects as a means of asserting ethnic pride and, by doing so, promoting awareness and circulation of his newspaper. He called on readers in New York and abroad to contribute to public subscription campaigns to fund new monuments for his adopted city. Barsotti was the mastermind behind statues of Columbus (1889–92, Columbus Circle, and mentioned briefly in chap. 1), Garibaldi (1888, Washington Square Park), and Verdi (1906, Broadway and Seventy-third Street). His successes inspired his fellow publishers William Randolph Hearst and Joseph Pulitzer to engage in similar ventures in 1898 and 1911.[45]

The Verazzano memorial was Barsotti's effort to set the historical record straight, in reaction to what he considered the ethnic bias of the Hudson-Fulton celebration of 1909. That extravaganza was planned in New York City to commemorate the three-hundredth anniversary of Dutch-commissioned navigator Henry Hudson's exploration of what became the Hudson River and the upcoming hundredth anniversary (in 1911) of Robert Fulton's demonstration of the steamboat. The event was marked by pageants, exhibitions of colonial American painting and decorative arts at the Metropolitan Museum

of Art, parades with elaborate floats celebrating New York history, massive flotillas down the Hudson River, and the erection of temporary statues of old New Yorkers like Hudson and Abraham De Peyster. The celebration, which reaffirmed the city's Anglo-Dutch and early national heritage, was a clear-cut response to the massive immigration from Southern and Eastern Europe, exemplified, of course, by men like Barsotti.[46] Barsotti was well aware of the ethnic implications of the Hudson-Fulton event and regarded the celebrations as a slight.

Barsotti reminded New Yorkers that gentleman-navigator Giovanni da Verazzano had seen the Hudson River nearly eighty years before Hudson. He sought to insert priority into the midst of the Hudson-Fulton celebration by initiating a public subscription for a Verazzano memorial in the months leading up it.[47] English-language newspapers, which resented the self-promotional tactics of their rival, conveyed their disapproval through disparaging comments about *Il Progresso*'s vulgar pushiness in trying to upstage Hudson and Fulton.[48] Undeterred, Barsotti, pressed ahead. He convinced Italian sculptor Ettore Ximenes to design the monument and contacted the ACNY about bringing it in for review for a site he had chosen in City Hall Park. Barsotti then used his political connections to have notice of the Verazzano memorial's impending dedication inserted into the Hudson-Fulton program.[49]

Since the 1890s, City Hall Park had been a contested site, representing to some politicians a desirable piece of prime real estate and location for new public buildings. Civic activists and historic preservationists had successfully staved off new development by arguing that the park was hallowed ground, as the site of the old Anglo-Dutch Commons and of the architectural "gem," City Hall. The park's "sacred" civic character was bolstered further through the erection, in 1893, of Frederick MacMonnies's famed Nathan Hale memorial, funded by the Sons of the American Revolution. Various groups had sought to erect other structures ever since, particularly memorials that ostensibly were in keeping with the park's civic-historical associations.

De Forest, then president of the ACNY, was clearly not happy with the situation. The Verazzano memorial was one of many proposals that came before the commission, seeking explicitly to link the accomplishments and ethnic/national identity of their hero to the civic memories signified by the park, the "cradle of liberty" and the seat of New York's government and power. The Verazzano enterprise came at a moment when the commission, De Forest in particular, was engaged in a restoration of the Governor's Room in City Hall (discussed later in this chapter) to its "original" colonial-Federal state. As president of the Metropolitan Museum of Art as well, he was a central participant in the Hudson-Fulton celebrations, spearheading the organization of

an unprecedented exhibition of early American painting and decorative arts that would became the basis for the formation of the museum's American Wing. Based on his circumspect comments to the New York papers, De Forest clearly anticipated that negative public opinion would help to quash the Verazzano monument and that the project would just go away.[50] It did not go away, however, and on 20 July 1909, ACNY's assistant secretary, John Quincy Adams, warned sculptor member Herbert Adams (no relation) that he expected the Verazzano project to be "a difficult submission to deal with, as they are quite determined to have it in the most conspicuous site in the City . . . and are in a great hurry."[51] Noting his familiarity with Ximenes and his work, Adams acknowledged that they would have a "hard nut to crack."[52] Nevertheless, when it came to the actual submission, the commission had no difficulty turning it down on the grounds that they could not approve of the "location of any additional statues in City Hall Park."[53]

Although rebuffed, the Verazzano committee returned to the ACNY and proposed two other sites: Bowling Green, facing Broadway, and Riverside Park, north of Grant's Tomb, the same area rejected for the soldiers' and sailors' memorial. Commission members were being pressured to move quickly; Barsotti wanted the monument dedicated by 1 October, in time for the celebration. Site had been a problem for the ACNY's monument committee, but Herbert Adams also did not appreciate being rushed and raised another point of concern, one that the ACNY would encounter with other projects.

According to Adams, the artist's sketches had provided inadequate information. The submission was insufficiently prepared and did not follow the instructions necessary to enable the art commission committee to assess the design, even though commissioners had made a special site visit ahead of time. Now the work was being prepared for casting, and Adams's committee was compelled to make a site visit to the Roman Bronze Works foundry in Greenpoint, Brooklyn, to enable the sculptor to respond to any criticisms. Based on his previous experience, however, Herbert Adams expressed fear "that after we spend half a day getting there that we will find the pieces scattered about, and no provisions made for seeing the whole scheme or even the parts in a good light."[54] Inexpert handling of such mundane matters might seem trivial in the larger scheme of things, but in Adams's view carelessness and inattention to detail were often symptomatic of larger deficiencies. Such difficulties would signal to ACNY members that they could not assume that the final artwork would be well executed or aesthetically compelling.

Adams's concerns were evidently alleviated on seeing the design—a commanding five-foot-high, waist-length bust of Verazzano, mounted on a tall pedestal at whose base stood an open book of history, led by a female alle-

3.4 Ettore Ximenes, Giovanni da Verazzano monument, 1909. (Collection of the Art Commission of the City of New York, Exhibition file 436-E.)

gorical rendition of "Right, holding a torch in her left hand, a sword in the right" (asserting that by right New York should belong to the Italians). The ACNY approved the memorial on 14 September 1909 (fig. 3.4), along with the Battery Park location. To insure that the Barsotti committee did not revisit the site question, however, the art commission disapproved for the record a group of eleven other potential sites listed on the submission form.[55]

Thus, through persistence, Barsotti succeeded in securing a more desirable and symbolically charged site than many might have imagined and in inscribing the Italian presence into one of the prime memory spaces of Lower Manhattan. The monument was dedicated on 6 October 1909, with the proceedings incorporated into the official report of the Hudson-Fulton celebration, just as Barsotti had envisioned.[56]

The ACNY could certainly live with the Ximenes Verazzano memorial, but the problem, from its members' perspective, was that its addition to the list of Barsotti-sponsored monuments to distinguished Italians was apparently not enough to satisfy the publisher. In May 1910, to prepare for May 1911 celebrations of the fiftieth anniversary of Italy as "a united kingdom" and to honor further the Italian influence on Western civilization, Barsotti—claiming to be responding to the enthusiastic recommendations of the New York branch of the Dante Alighieri Society, the Italian Chamber of Commerce, and the Italian ambassador—initiated a new campaign: a monument to Dante, that great "poet, philosopher, and patriot." Barsotti contributed $4,000 of seed money and purportedly received an additional $1,000 overnight. With additional support from the Italian embassy in Washington, D.C., and from the Italian parliament, a committee formed, and the campaign gained momentum. "The emigrants of North America will erect the statue to the glory of the Latin race, to him, 'whose only bounds are love and light.'"[57]

Barsotti's committee brought in Ettore Ximenes once again to design the new monument. There were certainly many precedents for single sculptors being represented by more than one public monument in New York City (notably, Americans John Quincy Adams Ward, Augustus Saint-Gaudens, Daniel Chester French, and Karl Bitter and Frenchman Auguste Bartholdi). However, when commission members were confronted by Ximenes's new design, they were not convinced that he deserved to join the ranks of these prominent artists.

From the ACNY's point of view, there had been nothing particularly distinctive about the design submitted for the $12,000 Dante monument in July 1912, except, perhaps, its size—fifty feet from top to base—and its ornateness. In Ximenes's sketch models, a bronze statue of Dante would stand atop a tapered granite pedestal with a projecting tapered extension to which one ascended by stairs (fig. 3.5). A monumental and elaborate high-relief narrative of scenes from the *Divine Comedy* extended around the upper portions of the plinth. Above these figures was another base with tall pedestal, capped by an obelisk, in front of which stood the massive statue of Dante, surmounted by an eagle bearing a large laurel leaf. A five-pointed star, symbol of the kingdom of Italy, crowned the obelisk.

3.5 Ettore Ximenes, Dante Alighieri monument, disapproved 2 July 1912. (Collection of the Art Commission of the City of New York, Exhibition file 674-B.)

The Comitato Nazionale Italiano initially had Times Square in mind, but by the time they submitted their plans to the ACNY, in July 1912, they had changed their request to either the northern end of Morningside Park, the northern end of St. Nicholas Park (extending in 1916 from about West 128th and 142nd streets between St. Nicholas Terrace and St. Nicholas Avenue), or the southern end of Colonial Park (running from West 146th to 155th streets, between Bradhurst and Edgecombe Avenues). These three were all large expanses in Italian neighborhoods in Harlem that would offer better opportunities for uninterrupted views of the massive monument than the congested Times Square area. The art commissioners, having examined Ximenes's model, concluded that the "architectural composition" would not work in any of these locations; although they were agreeable to considering the possibility of Colonial Park provided that the artist rethink the design with that specific site in mind, the ACNY nonetheless disapproved the submission.[58]

The ACNY members put no specific criticisms into the record, but it is clear from the final design and the commission's views on other projects that they would have considered the Dante memorial too overblown. The monumental obelisk underscored the design problems. Although traditionally a symbol of eternal life and utilized as a tribute to fallen heroes, as was clearly intended here, the obelisk also served as a symbol of Papal authority.[59] These symbolic associations with Catholicism and imperialism were surely not lost on ACNY members, mostly old stock Protestants. Here, the "baroque" aesthetic of ornateness, which in Catholicism celebrated God's glory, clashed with the more restrained aesthetic of the Protestant tradition.[60] No one explicitly articulated objections in these terms, but visually the changes that ultimately made the monument approvable are striking. The alterations, undertaken at the ACNY's behest, reveal that American public sculpture was actually less influenced by French and Italian Beaux-Arts styles than has often been suggested.

Barsotti and his editors and supporters, incensed by the ACNY's rejection, were not acquiescent. Infuriated that New York's purported art experts would question the merits of the work of a distinguished artist, they accused the ACNY of playing politics rather than exercising aesthetic judgment. Barsotti accused the commission of jingoism for objecting to the Italian star. In both the Italian American and English language press, others contended that the commission's decision was reflective of multiple prejudices. "Is this verdict a conscious and disinterested one?" asked Henry De Benedictis.

> It surely cannot be! It may happen, possibly, that the subject is distasteful; there may exist some disinclination to praise foreign artists; or perhaps a lack of sympathy with Italians in general. . . . Well and

good: Italians can understand and tolerate your antipathy, even if they cannot control your feeling!

But, when your avowed "reason of rejection" assumes the form of an *artistic censure* (to cover ill concealed feelings), it seems to me that the judgment and exclusiveness are proofs of disloyalty and hypocrisy against which we, Italians, in a body must protest!

Would you not far better have declared honestly: "we don't want Italian works of art here!"[61]

The ACNY may not have wanted Italian works of art, although it appears more likely that their objections lay in what they believed was the elaborate and calculating manner in which "Italian-ness" was being articulated. In rejecting the design, for example, the commission also requested further information, in the resubmission, about the specific inscription planned for the monument.[62] The request grew out of the fact that Barsotti had a penchant for self-advertisement. The inscription for the base of the Columbus Monument, for example, acknowledged Barsotti and *Il Progresso Italo-Americano* in prominent capitol letters. Such actions seemed inconsistent with the selfless civic enterprise Barsotti claimed to be undertaking on behalf of New Yorkers. In fact, Barsotti did indeed want his name on the shaft of the Dante memorial as donor recognition; this raised the hackles of a number of commentators, especially rival Italian-language newspapers that accused Barsotti of self-promotion at their expense.[63]

Further problems arose. Despite the commission's clear-cut reservations about the current status of the project, Ximenes had completed the monument and shipped it to the United States; it sat in 230 crates on a pier in Hoboken, New Jersey. Barsotti may have believed that the ACNY would have difficulty refusing the work once it was already there in the United States, but the submission did not move forward.[64] In April 1913, events came to a head when the Hamburg-American shipping line (which presumably needed the space) ordered the 230 crates, containing the granite portion of the Dante monument, removed from its pier. Newspapers picked up the story, embarrassing the sculptor. Ongoing personal tensions between Manhattan parks commissioner, Charles Stover, and Department of Parks' landscape architect, Charles Downing Lay—here, regarding Stover's willingness to consider a site in Morningside Park—delayed matters further. (The landscape architect had authority to veto a submission.)[65] An attempt to resubmit the design to the art commission was withdrawn after parks authorities noted explicitly that they found the granite portions of the monument to be unsatisfactory.[66]

In 1914 Ximenes revised the design, eliminating the obelisk and star and reconfiguring the lines of the base, thus reducing the size by sixteen feet, to

a total height of thirty-four feet (with a pedestal eighteen feet high by thirteen feet wide). The ACNY committee seemed inclined to accept this design for a site just south of 137th Street between St. Nicholas and Edgecombe Avenues. However, concerns that Barsotti still intended the monument to serve as an advertising vehicle for *Il Progresso* continued to circulate in the rival local Italian-language newspaper *Giornale Italiano.* Parks Commissioner Stover thus insisted that the lettering in any inscription of Barsotti's name on the pedestal be smaller in size than the inscription for Dante himself.[67]

The parks department took possession of the monument, and the ACNY gave the design preliminary approval in October 1914.[68] Nevertheless, the statue and *Il Progresso* continued to be the object of much dissension among Italian Americans themselves. Barsotti's rivals charged that his efforts were merely a form of self-aggrandizement. The publisher continually sought to dispel such allegations. The rhetorical flourishes of the counterattacks, published in *Il Progresso* against editors of *Il Giornale,* for example, were downright fanatical: "And those newly arrived to disseminate infamy, to foment discord, to defame anyone and everyone, to maliciously foster the greatest insult spat in the face of the Fatherland, these 'sons of nobody,' leaping for joy like inhuman satyrs on the flesh of an innocent maiden deflowered by their horrendous libidinousness, they have the presumption to term 'undesirables' all those who score the offense done to the Fatherland [the offense being the commission's rejection of the statue], who are revolted by the yelling rabble."[69]

World War I put a stop to it. The Comitato Nazionale Italiano Verazzano-Colombo-Dante Alighieri did not return with the model and drawings for final approval until seven years later, on 30 June 1921. Now the sponsors, listed simply but all-embracingly as "Citizens of Italian descent," requested a "relocation" from the site originally approved to a more central location in a triangle at Sixty-third Street and Columbus Avenue. (The appeal for a change of locale was no doubt prompted by the fact that African Americans were moving into the formerly Italian Manhattanville neighborhood originally approved.) The estimated cost had arisen from $12,000 to $20,000.[70]

An ACNY committee disapproved the site for the memorial "as designed."[71] Two weeks later, however, a new ACNY committee approved both the location and an alternative design. Although there was no explanation for these circumstances, it seems likely that a judicious president De Forest decided that it was time to sign off on the project. Ximenes had made many aesthetic concessions with the understanding that the Dante Memorial would ultimately be approved; the ACNY would be ill-advised to hold it up any further. Hence De Forest selected a new committee, consisting of men who would compromise. The new monument had a vastly pared down, monumentally austere pedestal, designed by the prominent firm Warren and

Wetmore (architects of Grand Central Station). The ACNY conditioned its approval on the "future submission of a full-size model of the bronze ornament on the pedestal and full-size drawings of the inscriptions." The monument's sponsors submitted the text of the inscription through New York Congressman Fiorello La Guardia, thus using the weight of his office to pressure the ACNY to approve this remaining portion.[72] Taking no chances, the committee also saw to it that the Dante Memorial was completed and dedicated before the year was out (fig. 3.6). It was the last of the Barsotti-sponsored monuments in New York City. (Barsotti died 30 March 1927 at the age of seventy-seven.)[73]

For all of the obstacles he encountered from art experts and regulators, Barsotti still managed to achieve his commemorative goals, with four statues in New York City to his credit. The presence of the ACNY significantly altered the designs of the Dante Memorial, but did little to thwart Barsotti's overall efforts. Like the Heine Memorial Committee, Barsotti effectively exerted political pressure by challenging the distinction between disinterested aesthetic judgment and ethnic bias. Like a number of other memorial sponsors, he also succeeded through persistence and sheer force of personality. Personal ambition contributed to a "fatigue factor," which also played a part in the ACNY's eventual acceptance of the Verazzano and Dante commemorations; ACNY members, even though they rotated on and off, grew tired of dealing with Barsotti and Ximenes for so many years. This mundane human aspect cannot be underestimated. And, no one could argue that Dante did not deserve a monument.

Memorials to "Hebrews"

Ethnic politics, personality, and fatigue: several of these same factors would come into play with memorials to eminent "Hebrews" (as Jews were typically characterized at the turn of the twentieth century). The outcomes, however, turned out very differently than with the Heine, Bolívar, Verazzano, and Dante memorials. When Jews were the subjects and the donors, persistent efforts to erect memorials as representations of ethnic pride and assimilation were much less successful. The Heine Memorial process had pitted Jewish and non-Jewish German Americans against influential urban arts professionals but had resulted in a monument. An 1899 sculptural memorial to philanthropists Baron Maurice and Baroness Clara de Hirsch, spearheaded by the non-Jewish *New York Times* art critic Charles de Kay in an explicit attempt to counter the negative emotions spawned by the Heine affair, was broached with the new ACNY vice president Augustus Healy but never actually submitted for ACNY review.[74] De Kay was at pains to reassure Healy

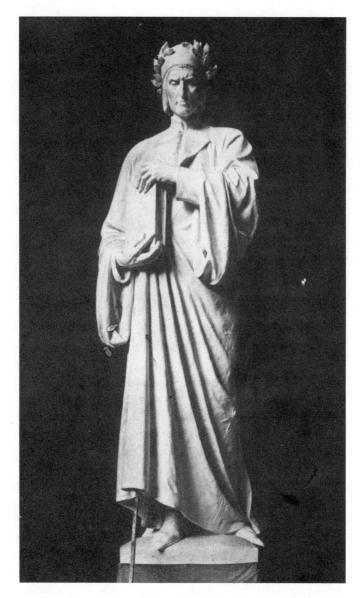

3.6 Ettore Ximenes, Dante Alighieri statue, 1921. (Collection of the Art Com-
 mission of the City of New York, Exhibition file 674-C.)

that—in implicit contrast to the Heine—men of "character" were involved
with the project. The memorial idea had not even originated among Jews, de
Kay pointed out but, rather, among disinterested Gentile sponsors such as
General Thomas L. James. Yet the committee also included upstanding "He-
brews," such as Edward Lauterbach, Rabbi Gustav Gottheil, and James H.

Hoffman; representing respected, "uptown" German Jews, these names would lend legitimacy to the enterprise. The memorial would highlight the correspondence between Jewishness, nationality, and municipal identity and citizenship; it would show that Americans, unlike Europeans, were not in fact prejudiced toward Jews, especially "good" German Jews who were not using their largesse to advance sectarian or commercial causes.[75]

Disagreements among insiders and critics over (Protestant) sculptor George Bissell's design, which included relief portraits of the philanthropists, initially delayed the project. Subsequently, the enterprise was effectively killed after it was vocally denounced by banker and close de Hirsch associate Jacob Schiff, who considered distinctly ill-advised and vulgar the attempt to commemorate the notoriously reticent de Hirsch so visibly.[76] A 1913 campaign to commemorate department store magnate Isidore Straus and his wife Ida, who died in the sinking of the *Titanic,* fared better. A memorial committee, which included future art commissioner Felix M. Warburg, mollified the professionals by sponsoring a competition under NSS auspices. The committee placated wealthy German Jews and the ACNY by establishing competition rules that would invariably produce a design of discretion and good taste, avoiding "loud" or "spectacular features." In keeping with that requirement, competition winners Evarts Tracy and Augustus Lukeman—notably also not Jewish—rendered a simple design, with reflecting pool, exedra, and pedestal, atop of which reclined an elegant allegorical statue of a young woman gazing into the water and titled simply *Memory.* The ACNY approved the project on the first submission.[77]

Resentments did bubble beneath the surface. Arguing for the need to "control" the "monumental and memorial historia" [*sic*] overtaking the city, Carl F. Pilat, landscape architect for the Department of Parks, complained to Parks Commissioner Cabot Ward about the extent to which public lands with "old names and associations" were now being given over to lesser worthies (or so he implied), many of whom happened to be Jewish businessmen. "Greeley Square is often referred to as Gimbel Square; the Plaza at 59th Street and Fifth Avenue will probably be named Pulitzer Plaza because of the Memorial Fountain; and the little park in Bloomingdale Square at 106th Street and Broadway has recently been changed from Schuyler Park to Straus Park." Significant New York locales should not be named for department store magnates or for crass self-promotion. Memorials should be devoted to men whose "distinguished deeds, thoughts, or lives" were in fact the "real and lasting monuments to them." "The erection of a visible memorial" would then be merely a material embodiment of such actual accomplishments. Such memorials, moreover, "should be an expression of appreciation on the part of the *public.*" "It should not be possible for the descendents of

a man to erect a memorial on public lands just because they are so fortunate as to be able to afford it."[78]

Pilat's comments were not centered solely on the actions and influence of Jews. In general, he noted, the city should not be doling out its property indiscriminately or there would be no property left for distinguished future heroes. Pilat objected also to an apparent and widespread assumption on the part of monument sponsors that if private groups and individuals paid for the sculptural portion of a memorial that the city would pay for landscaping, setting, maintenance, and even sometimes the architectural portion of the project. Jewish names appeared prominently in his comments, nonetheless reflecting the truth—that Jews had had an impact on New York's public spaces since the turn of the century—and the myth—that Jews happened to be among the worst offenders when it came to appropriating city property for their own interests.

Pilat's views, tinged with nostalgia and anti-Semitism, were shared by many upstanding New Yorkers. Given the pervasiveness of such sentiments, it was unsurprising that in 1924, in the aftermath of legislation that had effectively cut off Eastern European Jewish immigration, the ACNY managed to dispose of a proposed memorial to impresario Oscar Hammerstein (1846–1919). In 1924 Thomas Gillen, "representing the theatrical profession," proposed to Mayor John F. Hylan to erect a statue of Hammerstein on Broadway between Forty-third and Forty-fourth streets. Gillen reassured the mayor that the property owners in the area were very happy with the idea, implicitly pressuring Hylan by informing him that area merchants desired the work. Hylan, who was not about to touch the matter individually, passed it on to the Board of Estimate, which had jurisdiction over land-use issues. To cover itself, the board in turn asked the ACNY its opinion of the idea.[79] Then-president De Forest responded predictably in bureaucratic terms that the commission could not make a judgment without having an actual design to evaluate. Nevertheless, picking up on the subtle signals the board had sent in referring the project to him, De Forest managed to discourage the statue idea by commenting that that Times Square location was "an important one," a locale that would seem like a "possible site for some monument of significance to the public at large." Hammerstein was clearly not such a cause, and hence the site should not be utilized for "a statue such as that referred to."[80]

In 1924, a proposed monument to a Jewish purveyor of popular entertainments might be easily dismissed. But circumstances that same year surrounding a proposed memorial to a Revolutionary-era Jewish patriot, Haym Salomon, proved to be far more complicated; they evoked the same qualms Pilat had voiced ten years earlier but were still pervasive among "old stock"

New Yorkers about privatizing public space and allowing old British and Dutch names, places, and historical associations to disappear. For the ACNY, the project tested the limits of their jurisdiction and their capacity to shape public understanding of America's history.

Haym Salomon

In November 1924, art commission assistant secretary and architect Henry Rutgers Marshall wrote to inform the commission's aging president De Forest that an organization called the Federation of Polish Hebrews of America, one of the largest of the *farbanden* of *landsmanshaftn* active during this period, was planning to sponsor for Madison Square a memorial " 'to the memory of Haym Salomon, the great and well-known patriot and financier who during the Revolution did so much for our beloved country.' "[81] Salomon's reputation rested on his role as the reputed "financier" of the American Revolution. According to historian Beth Wenger, Salomon, "well-known as a financial broker within the Philadelphia community," had been called on by the superintendent of finance, Robert Morris, at the onset of the American Revolution, to help obtain funding for the Revolutionary cause. Morris's diaries indicate that Salomon succeeded admirably in "raising funds and negotiating bills of exchange with several foreign governments."[82] Although hardly the only Jew involved in such an enterprise, Salomon's adeptness earned him particular distinction. Distinction, however, evolved into myth, as the stories passed down through the ages (with the help of Salomon's family) asserted that Salomon had financed the Revolution single-handedly and personally, that these activities had left him debt-ridden and impoverished, and that neither he nor his family had ever been compensated. Historians now consider these assertions to be greatly exaggerated, but Salomon supporters at the time, convinced of the veracity of the legends, drew on them as the basis for their memorial campaign.

In proposing a Haym Salomon memorial for New York City, the Federation of Polish Jews was following up on an unsuccessful 1910 attempt to commemorate Salomon in the District of Columbia, an enterprise complicated by the fact that Salomon's role in American history had never been clarified.[83] The federation's efforts were specifically prompted by the 1922 legislation cutting off immigration into the United States and the concomitant anti-Jewish sentiments that had accompanied it. In sponsoring a memorial to a Polish Jew whose activities had been crucial for the emergence of the nation, the sponsors hoped to redress historical amnesia, to position Polish Jews within the national "heritage," and to impress on Americans that Polish Jewish immigrants now on U.S. shores were (or could be) good, loyal

citizens. Such actions would help to "close the mouths of those who are in the habit of utilizing every occasion to sling mud upon the immigrant."[84]

From Marshall's perspective, however, the matter coming before the commission differed little from that of the attempt to honor Oscar Hammerstein or Dante. "I find that Mr. Salomon's name is not a familiar one to the public at large in New York," he wrote De Forest, "nor is his name mentioned in standard works on the history of the Revolutionary period." Nevertheless, "the gentlemen concerned will not be satisfied with something small and modest but wish to erect a monument that will attract attention and perpetuate the memory of a man whose name is now almost forgotten, but who, in their view, was closely bound up with the Revolutionary cause."[85] Marshall suggested that such a monument might be more appropriate for Philadelphia, but the federation would have none of it. They wanted the city with the greatest Jewish population. Marshall's coded rhetoric would have been perfectly obvious to De Forest: the aggressive Jewish ethnics wanted to appropriate a central locale in midtown Manhattan and erect a big and ostentatious monument to some nobody. Should the art commission be approving for the city's major spaces monuments to "relatively obscure individuals whose lives have no significance for the city?"[86]

De Forest reminded Marshall that the matter of the subject was not the issue for the ACNY, at least not for the record. But, he responded, it certainly might be within the purview of the commission to consider the appropriateness of the particular aesthetic treatment of *that* subject especially when assessed for a specific locale, such as Madison Square.[87] Thus the commission might in fact find that a proposed monument might not be suitable for the site in question.

Meanwhile, the Federation of Polish Jews pressed ahead. They sponsored a competition, selecting as winner Aaron J. Goodelman, a Jewish sculptor with avowedly socialist sympathies. His memorial (see sketch, fig. 3.7) consisted of a proposed ten-foot bronze statue of a slightly stooping Salomon in period costume, "representing the dignified self-sacrifice of the man imbued with the freedom of the spirit, the desire to assist the downtrodden." The statue stood atop a tall granite pedestal adorned by low reliefs and flanked by American eagles at all four corners. The pedestal, in turn, stood atop a tall granite platform with exedra stone seating on its northern, eastern, and western sides. Steps of rapidly diminishing size ascended the southern end of the pedestal. Goodelman also planned for four reliefs—"Liberty, Patriotism, Peace . . . and Immigration"—for each corner of the pedestal base. To further affirm the Jewish claim to place, the sculptor developed the "architectural principle of the base" (its plan) using the "motif" of the Star of David.[88]

3.7 Aaron Goodelman, model for Haym Salomon Memorial, disapproved 9 June 1925. (Collection of the Art Commission of the City of New York, Exhibition file 1344-E.)

The federation proposed a location inside Madison Square Park, between Fifth and Madison avenues, a few yards north of Twenty-third Street, between the statues of Civil War–era statesmen William Seward and Roscoe Conkling. Parks Commissioner Francis D. Gallatin evidently did not want to touch this political hot potato and approved the project for that site. The Department of Parks submitted the Goodelman design to the ACNY in early June, and the commission disapproved it without offering an explanation for the record.[89] Given the design, however, and comparing the circumstances to those of the Verazzano and Dante memorials, it is not hard to imagine how the commissioners might have disapproved the monument on aesthetic grounds. Quite apart from the fact that the commissioners probably would

have considered the overtly "Jewish" claims to place to be objectionable, they likely responded negatively to the piecemeal conception of the composition. The monument had all the requisite parts—statue, pedestal, seating, platform, and so on—but those parts lacked a sense of seamless unity; the seams were all too evident, in fact, thus endowing the work with a fragmented quality. Given the displeasure with the design, the commission probably also felt that its proposed location would both detract from the views of the Conkling and Seward memorials and from the sightlines north into the park.

The ACNY undoubtedly relayed its aesthetic objections to Goodelman and the federation. Within a month, the federation submitted a new design by one of the competition's four runners-up, Anton Schaaf. Schaaf, like Goodelman, was not one of the nation's leading sculptors, but he was making a name for himself in the New York area through his World War I memorials, doughboy statues in particular.[90] Significantly, Schaaf was not Jewish. He submitted two designs, and ACNY members viewed mock-ups in Madison Square to determine which version they preferred. One design consisted of a bronze statue of Salomon atop a block pedestal set against a rectangular slab with a two-columned inscription above two low-relief allegorical figures representing Liberty and Memory. The second was consistent with the kind of restrained composition that the ACNY preferred. The statue of Salomon stood atop a low block pedestal several feet in front of a curved stone exedra with seating designed by architect Eric Gugler. A block letter inscription bearing the name of Haim Salomon would adorn the front of the pedestal. Simple descriptives, "Revolutionary, Patriot, Financier, & Philanthropist," would be inscribed on the exedra wall (fig. 3.8).[91]

Although the process seemed to be moving forward, the commissioners remained uneasy. I. N. Phelps Stokes (fig. 4.1) was especially concerned. A professional architect, Stokes had dedicated much of his life to studying New York's history, especially the colonial period, and had published a multivolume *Iconography of Manhattan Island;* to this day, it remains an authoritative reference on the city's history and visual culture. The lack of substantiated evidence about Salomon's credentials or the nature of his service to the government bothered Stokes, as it did commission secretary Henry Rutgers Marshall. In August 1925, in his capacity as New York Public Library trustee, Stokes wrote to Victor H. Paltsis, head of the New York Public Library's Manuscript Division, a "distinguished authority" on the early American period, and a researcher for Stokes's *Iconography.*[92] Stokes told him that the federation intended to place a memorial in "one of the best locations remaining" in Madison Square. He also relayed the ACNY's doubt as to whether Salomon qualified as a man of such "great distinction" that he deserved to be commemorated in such an important location. Stokes focused on historical

3.8 Anton Schaaf, model for Haym Salomon Memorial, approved 12 September 1928. (Collection of
the Art Commission of the City of New York, Exhibition file 1344-T.)

issues, and there is no evidence that he was explicitly motivated by ethnic
bias. He commented, for example, that "a cursory examination of the docu-
ments in the library seemed to show that, although his family had repeatedly
urged their claims for reimbursement, no reimbursement had ever been
made. This, of course, is not positive proof that they should not have been
made."[93] The ACNY's unwillingness to give Salomon the benefit of the
doubt was driven somewhat by inherent ethnic and class prejudices (with
the federation's actions perceived as vulgar and pushy); in fact, however, the
ACNY had taken similar stances with when considering memorials to non-
Jews—Verrazano and Samuel J. Tilden, for example.

Paltsis put Stokes in contact with C. Worthington Ford of the Massachu-
setts Historical Society, author of an earlier attack on the Salomon legend.
Asked to offer his assessment of Salomon's importance, Ford insisted that
"no proof was found that he advanced money to the Continental Congress,
otherwise than as a purely business transaction." Articulating his findings in
a manner that recapitulated the stereotype of the Jewish moneylender (an
alien presence interested only in profit making), Ford stated that he saw "no
reason for connection of Haym Salomon's name with the nation's history

(even if "purely business" was an integral part of the nation's history). The only recognition he deserved was as an "estimable merchant."[94] Ford drew a dichotomy between business interests and patriotic interests, but during the revolutionary period such motives were neither clear-cut nor mutually exclusive. Ford's observations, echoed by other historians, and grounded in a long tradition of anti-Semitism, assumed that Jews were only in it for the money and thus disqualified for "patriot" status, while "real" Americans like Robert Morris operated in accord with a different, more selfless set of patriotic values. In fact, both Jews and Gentiles of the revolutionary period operated from a mixture of fiduciary and patriotic motives.

Armed with Ford's findings, the ACNY committee assigned to review the project (sculptor Adolph A. Weinman, De Witt Lockman, and I. N. Phelps Stokes) disapproved the submission on 12 September 1925 in an unusually lengthy committee report that quoted from Ford's letter (without attribution). The ACNY as a whole accepted their recommendations.[95] Aware of the "delicacy" of the matter (as De Forest put it to his commissioners), and seeking to avoid antagonizing the uptown German-Jewish elite, De Forest immediately wrote Louis Marshall (no relation to Henry Rutgers Marshall), founder of the American Jewish Committee, president of the American Joint Relief Distribution Committee, and like De Forest, a prominent lawyer, to explain the ACNY's concerns and actions.[96]

Louis Marshall, while affirming that Salomon had helped the revolutionary cause (and gratuitously acknowledging the prominent banking [and social] credentials of Salomon's late grandson, whom he assumed De Forest had known), agreed with the ACNY that the significance of Haym Salomon had not been proven and probably never would be. Concurring with the ACNY's committee report, Marshall applied the same additional burden of proof (one that had not been applied to Robert Morris), drawing the distinction between Salomon's actions as a "private individual" (i.e., whose actions were taken out of purely personal business interests) and as a "public man" (whose services were undertaken in selfless public-spiritedness). Marshall also contended that space ought not to be given over in Madison Square without some more "reasonably clear proof" being provided to justify Salomon's national significance. De Forest notified the committee of Marshall's response, indicating that the information was "illustrative of the delicacy of the situation as it may possibly come up in the future."[97]

The Salomon memorial committee returned to the ACNY in 1928. They requested a site in Lincoln Square, at Broadway and Sixty-sixth Street, three blocks north of the new Dante statue, an area filled with hotels, theaters, and automobile dealerships. Edward McCartan, sculptor member of the ACNY's new Salomon committee, asked De Forest (still president) whether the

ACNY ought now to consider the merits of the proposed hero in question, Haym Salomon. McCartan wondered, hypothetically, if a major artist like Augustus Saint-Gaudens had executed a statue of an undeserving subject, would the ACNY be obligated to approve it?[98] Did aesthetics trump subject matter in the ACNY's reviews of memorials? The answer, from De Forest's vantage point, was yes. Anxious to move on, De Forest reiterated his 1925 assertion that there was no question that the "function of the art commission does not extend to passing on the merits of persons to be memorialized by statues. . . . Our jurisdiction, however, as to location does involve the determining whether or not the statue of a particular person deserves a particular location." The Salomon statue, De Forest opined, does not deserve "a prominent location, except on much clearer proof than we have of his Revolutionary importance." Then, De Forest capitulated: "But if the statue is of artistic merit," he concluded, "we should give it some location."[99] Having been sent the signal to allow the project to move forward, the McCartan committee agreed to recommend approval, and on 13 September 1928, the ACNY capitulated and gave preliminary approval to the now-anticipated $75,000 memorial.[100]

At this point the project passed out of the ACNY's jurisdiction, but the approval did not resolve the memorial conflict. Instead, the terms of debate shifted from aesthetics to Jewish identity politics: who had the right to lay claim to "American" Jewish identity. New York City's Jewish leaders were bitterly divided over the question of Haym Salomon's historical role and significance. They were also gravely concerned about the broader implications of the motives and actions of the Federation of Polish Jews. There could be potentially negative ramifications in erecting a memorial to a Jew who was, according to Louis Marshall (reiterating a reviled and pervasive stereotype), "only a moneylender," especially since this had been a memorial specifically conceived to highlight the centrality of one class of Jews—Polish Jews—over all other groups.[101] A new phase of the controversy began when a historian for the American Jewish Historical Society, Max Kohler, challenged as spurious the research methods and findings of those retained by the Salomon supporters to legitimate Salomon's place in history.[102] The federation also aroused the ire of banker Felix Warburg, who had actually served on the ACNY committee that had approved the memorial in 1928; Warburg learned that the federation was listing his name in a manner that insinuated that he supported the memorial when in fact he did not. Several other prominent establishment Jews made similar objections, demanding that their names be excised from any lists of supporters or contributors.[103]

These challenges and others, combined with the onset of the Depression, threw the federation's fundraising efforts into disarray. In contrast to Barsotti's

enterprise, the federation had not raised much money up front, especially not before attaining ACNY approval for the site. The deadline for erecting the monument in New York City lapsed. Although Tygel succeeded in seeing a Salomon memorial erected in Chicago in 1941 (depicting him with Robert Morris and George Washington), no Haym Salomon memorial was realized in the city of New York.[104]

William the Silent and the Netherlands Memorial

The Bolívar, Verazzano, and Dante memorials, with their troubled combination of patronage, political, and aesthetic issues, placed special diplomatic burdens on the ACNY and hence on the limits of municipal authority over public space. Yet even relatively simple projects were not necessarily adequate expressions of international good will. Nor did it necessarily matter whether a monument's sponsor could summon up a connection to the city's Dutch heritage. The Dutch learned this for a fact in the 1920s, when their efforts to contribute memorials to New York City were politely rebuffed. In 1924 the Holland Society attempted to donate to the city a large statue of William the Silent, the "Father of the Dutch republic and chief of state after the Dutch War of Independence." William, said the society's spokesman, represented "the spirit of those citizens of the Dutch Republic who conceived the idea of founding the settlement of the New Netherlands and the town of New Amsterdam, now the City of New York."[105] "As descendents in the male line of those citizens of the Dutch Republic who prior to the year 1675 settled on these shores," the Holland Society felt it made sense for "their great hero" to "adorn some public space." They convinced Parks Commissioner Gallatin to erect the larger-than-life-size portrait statue temporarily on the mall in Central Park so that the ACNY could view it as a prelude to official acceptance. Gallatin quickly learned, however, that many on the ACNY opposed placing the statue permanently on the mall, and thus withdrew the formal submission.[106] Although no explanation for the objection exists on the record, ACNY members most likely argued that the mall was already overpopulated with undistinguished portrait statues, and the William the Silent memorial would not have enhanced it.

H. R. Marshall, the ACNY's assistant secretary, acted to avert any public embarrassment, informing De Forest that Judge Reeder had suggested that Rutgers College, an institution with Dutch origins, might take the statue. The timing was right, as the university had just inaugurated a new president (John M. Thomas). A William the Silent statue would be a nice new and very visible gift, tying the university to its Dutch legacy at the height of the fashion for colonial revivals. Marshall urged De Forest to initiate this possibility,

3.9 Lodewyk Royer, William the Silent memorial, 1924, Rutgers University, New Brunswick, N.J. (Photo by Philip J. Pauly.)

since one of De Forest's close colleagues (A. T. Clearwater) was involved with the Holland Society and was also a Rutgers trustee. Finding a good home for the statue would allay any diplomatic and personal embarrassments. With De Forest's and Clearwater's encouragement, the Rutgers board of trustees unanimously approved the acquisition of the statue for their campus (fig. 3.9).[107]

With William the Silent statue safely shipped off to New Jersey, that crisis was averted. But a new offer in October 1925, the Netherlands memorial flagpole, became another point of contention. The Dutch government offered the flagpole in honor of the three-hundredth anniversary of the founding of the city. They originally requested a site at Fifty-ninth Street and Fifth Avenue, at the entrance to Central Park, but the commissioner of parks would not support that application, so they selected a site on the western side of Battery Park. The Battery Park locale made sense from a historical standpoint (the area was the locale of Dutch settlement), but the ACNY was concerned about the monumental size of the proposed pole and about its relationship to the old Castle Clinton and disapproved the submission.[108]

The commissioners did not reject the pole outright. They recommended a different site within the park, on an axis with Bridge Street, and requested that the pole be reduced in height. The Dutch were indignant, arguing that the commission's preferred locale would prevent the flag from being seen from the water. They insisted on retaining the original site and, further, that the city, in appreciation for the gift, should "bear the expenses of the foundation and of the placing of the pole."[109] The Dutch ambassador threatened to withdraw the project if the ACNY could not see fit to capitulate—the implication being that such action could have damaging consequences for the city and federal government. An irritated De Forest was unyielding, stating politely that while the ACNY was willing to adjust the location of the pole so that it could be seen from the water, it was unwilling to accept the site originally requested and that if the Dutch therefore wanted to withdraw, they were certainly free to do so.[110] The minister capitulated, and the commission accepted the memorial flagpole (fig. 3.10). The incident, however, was an additional example of the political pressures brought to bear on the ACNY and of the importance of a strong president. Indeed, De Forest's long tenure and advancing age contributed both to his relative remoteness from the day-to-day process and his ability effectively to cut through the minutia to keep an eye on larger priorities.

Memorials to Bolívar, Verazzano, Dante, and Dutch tradition highlighted New York's centrality as an international city, tied to republican and liberationist traditions, to the great humanist cultures and civilizations, and to the city's "ancient" heritage and connections. But as we have seen, the memory of the city's old Dutch order was not sacrosanct. Neither were Anglo-Saxon aspirations to embody collective memories, in search of a "usable past." In both 1906 and 1910 the ACNY rejected a memorial statue of a seated Daniel D. Tompkins (1744–1825), three-time governor of New York State and vice president under James Monroe from 1817 to 1825.[111] A proposed $50,000 bronze statue of Walt Whitman by Jo Davidson (fig. 3.11) that the New York Authors' Club submitted for a site in Battery Park at the height of

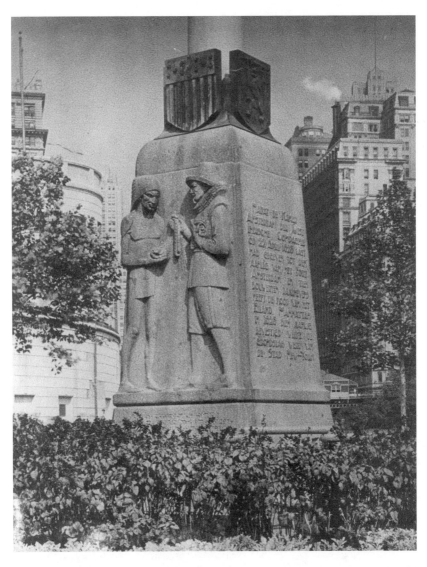

3.10 A. Van Gynde, sculptor, and Dirk Rosenberg, architect, Netherlands Memorial, 1925. (Photo by author.)

the revival of Whitman's popularity was also disapproved. The authors' group evidently later broached the idea with Parks Commissioner Robert Moses, but he was uninterested, and the group never returned to the ACNY. Instead they approached philanthropist Mary Harriman (wife of railroad magnate E. H. Harriman), who donated the statue to Harriman State Park, where it was dedicated in 1941.[112]

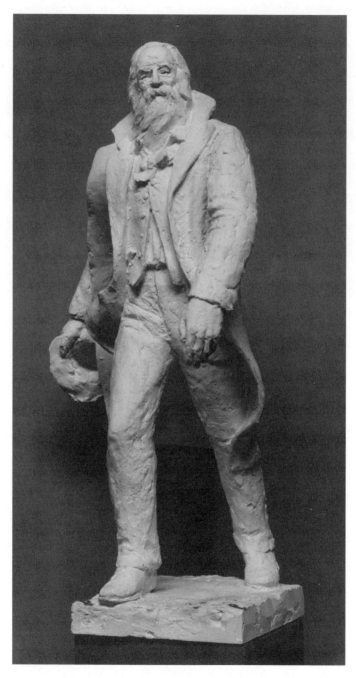

3.11 Jo Davidson, model for Walt Whitman statue, 1926. (Collection of the Art
Commission of the City of New York, Exhibition file 1410-D.)

LOCAL MEMORY

Tragedy, death, and sacrifice were aspects of daily life in the city. Prior to the mid-nineteenth century, cemetery monuments had been considered adequate for private expressions of grief. Occasionally, the circumstances of a death or the lessons offered by the life of the deceased spurred citizens to commemorate local people and events through public monuments. Many such memorials were proposed for parks or other municipal sites and, hence, came before the ACNY.

As the case of the Haym Salomon memorial indicates, the ACNY periodically clashed with memorial sponsors about the historical or civic worthiness of a memorial's subject. In the cases that follow, those of the Slocum Memorial, the Andrew H. Green Memorial, and the Bronx Spanish-American War Memorial, the ACNY had no inherent quarrel with the merits of the subjects but was unwilling to accept the modes of interpreting local memory. In all three instances the problems centered on ACNY perceptions of formal excess. Projects moved forward when the sponsors agreed to adopt (class- and culturally inflected) aesthetic solutions that the ACNY regarded as less elaborate and more dignified. Success, in the long run, was mixed. Review by the ACNY of the memorials to the *Slocum* steamboat tragedy and to Andrew H. Green resulted in drastically pared-down new monuments. In the Bronx, World War I changed the political climate in which both aesthetic debates and the final memorial took shape. All told, these circumstances produced local memories with which few New Yorkers now are familiar.

Slocum Memorial

The Slocum Memorial did not commemorate war, liberty, or national heroism but, rather, grief over a ghastly, preventable tragedy. On 15 June 1904, the steamboat *General Slocum,* chartered to ferry parishioners of *Kleindeutschland*'s Saint Marks Lutheran Church to a picnic at Eaton's Neck, Long Island—caught fire as it headed north up the East River. The captain, inattentive to the severity of the problem, did not turn his ship back to shore until it was too late; winds whipped up walls of oil-fed flames, engulfing the passengers in fire. The disaster took at least 1,031 lives, with many people jumping into the river as they burned to their deaths.[113] The horrific event, one of the worst disasters in the history of New York City, devastated the well-established and tight-knit German American immigrant community of the Lower East Side.

The ACNY's involvement with the project was an example of how its members engaged with aesthetic issues on a local project related to a specific

3.12 Sculptor unknown, Slocum Memorial Fountain, disapproved 9 January 1906. (Collection of the Art Commission of the City of New York Exhibition file 195-C.)

ethnic constituency in a particular neighborhood—although the catastrophe reverberated city-wide. On 26 December 1905, the Sympathy Society of German Women of New York (one of the many benevolent and mutual aid societies and *Vereine* that served to distinguish New York's distinctive German community and culture) submitted, through the Department of Parks, a design for a Slocum memorial fountain, designed by a carver from Middle Village in Queens.[114] The fountain was proposed for Tompkins Square Park, the heart of *Kleindeutschland* (fig. 3.12).

The monument consisted of a horizontal block on a low podium, with leaf-shaped scrolls at each end. The scrolls ostensibly connected the central section, flanked by squat piers, to the lower side sections—a device seen in its ideal form in Leon Battista Alberti's *Santa Maria Novella* (1456–70) in Florence (completed ca. 1575–84), and the 1568 facade for the church of Il Gesù in Rome by Giacomo Vignola (and Giacomo della Porta). The rectangular portion of the structure was capped by a scrolled entablature, in whose pediment was inscribed, in large block letters, a credit to the donor society (ERECTED BY SYMPATHY SOCIETY VEREIN DEUTSCHER FRAUEN). A horizontal fountain projected out from the central rectangle; its backing consisted of two large carved dolphins surrounding a large scallop shell flanked by spandrels carved with leaves. On the face of the fountain block would be

mounted a bronze low-relief panel, depicting a woman and two children watching from the shore the burning of the *Slocum*.

Asked to approve a design marked by the kind of visual exuberance and ornateness that they generally hated, the ACNY members were confronted with a potential dilemma: how to separate their empathy for the victims from possibly having to render a negative judgment. In the end, the ACNY determined that the city's aesthetic welfare took priority over the emotional needs of the Sympathy Society of German Women of New York or the ego of a designer who was unfamiliar to them. They disapproved the memorial.[115] The committee report explained that both the particular location and the design posed problems. The proposed site was only twenty feet away from another drinking fountain; they recommended moving the new monument to stand on axis with the center of Tompkins Square Park. As for the design itself, ACNY committee chairman John J. Boyle (a sculptor) recommended that "the bronze panel in front be omitted entirely. As sculpture," he wrote, mincing no words, "it is inadequate; as an ornament or enrichment, it in no way helps the design." Boyle recommended that the artist eliminate the ornamental spandrels and let "the ornamentation be concentrated on the dolphins and the shell as in the present design they are much too joyous."[116]

The Sympathy Society, though no doubt displeased, subsequently took drastic steps to insure that their memorial would be realized. The initial designer was replaced with an "insider," Bruno Zimm, an academically trained protégé of prominent German American sculptor Karl Bitter. Zimm shifted the axis to the vertical, tightened the design, and simplified the details (fig. 3.13). Most notably, he enlarged the image of the young spectators, changing the medium to marble and making it an integral and central component of the overall monument. The donor inscription was also moved from obverse to the back and deemphasized. The ACNY immediately approved this revised design and illustrated the *Slocum* memorial in its annual report of 1910 as a before-and-after case study.[117]

Commission members believed that insisting on their expertise and aesthetic convictions would insure that the memorial would in fact pay proper respect to the *Slocum* disaster victims. That the sponsoring group consisted of ethnic women surely helped the commissioners muster up the wherewithal forcefully to assert their opinions, along with the fact that the monument was local and relatively modest in size and scope. In the end, the results justified the additional effort. Zimm's pared-down memorial was designed to concentrate viewer attention, inspire the imagination, and enhance the commemoration process in a way that the earlier cluttered, lighthearted, and visually distracting group of images and shapes could not. The ACNY's os-

3.13 Bruno Zimm, Slocum Memorial, 1906. (Photo by author.)

tensibly "universal-metropolitan" aesthetic, honed through education and an imbued sense of class distinction, supplanted the "neighborhood aesthetic" expressed by local artists and constituencies with less familiarity or experience with such tastes and the distinctions borne of them. For a time, at least, the Slocum Memorial became a neighborhood shrine, creating a new

sense of place and small comfort for those who came to Tompkins Square Park to mourn the *Slocum* victims.

Although the ACNY disputed the aesthetic acceptability of the Slocum monument's original placement, the choice of Tompkins Square Park in the heart of *Kleindeutschland* was never questioned. In terms of both locale and patronage, the Slocum Memorial was inextricably bound up with the New York German community. The English-speaking press treated the disaster as a local, neighborhood tragedy. Nevertheless, the ACNY insisted that the aesthetics of a memorial on municipal property should have a broader appeal and significance.

Andrew H. Green

The ACNY sought to implement ideals of aesthetic civic temperance fairly consistently and did not hesitate to disapprove a design its members deemed out of place. Even the city's cultural, economic, and political elites encountered obstacles, however, when attempting to commemorate individual lives as part of municipal history.

In July 1915, a group calling itself the Andrew H. Green Memorial Association submitted to the art commission a grandiose scheme for a large pylon by Charles Lamb to commemorate the lawyer, businessman, and civic activist Andrew Haswell Green (1820–1903). Green had played a leading role in the development of many of the city's parks (most notably, Central Park) and in the formation of the Metropolitan Museum of Art and the American Museum of Natural History. He was also a key architect of plans to merge the counties of Kings, Queens, Richmond, the Bronx, and Manhattan into a single metropolis.[118] A monument would thus commemorate the forging of the greater city and Green's crucial role in developing it. The symbolism would be brought home by erecting the memorial just outside Central Park at 110th Street and Seventh Avenue (fig. 3.14).[119] Much as ACNY members recognized and appreciated Green's accomplishments, however, they evidently felt that the pylon was too large and would block views into the park and down Seventh Avenue, and they rejected it.

In December 1915 Lamb submitted a new conception, consisting of four limestone entrance piers for the same locale. The same art commission committee gave preliminary approval but stipulated that the columns on the tall but thinned-down pylon be eliminated and the architectural details restudied. Yet again, presumably because of the war, lack of funding, and changing configurations of Central Park, the project was put on hold. When Lamb returned to the commission in 1923, his revised memorial, submitted for preliminary approval, was far more modest, having been shrunk down to a simple

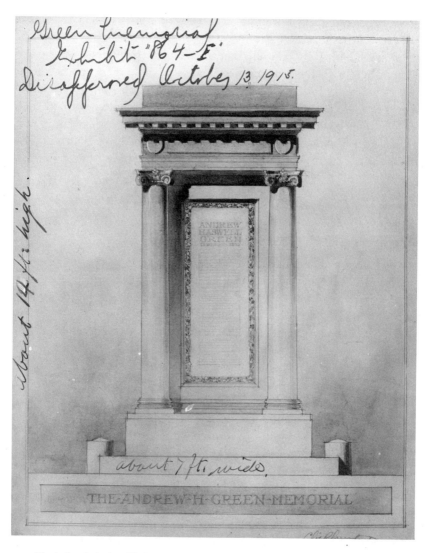

3.14 Charles Lamb, Andrew H. Green Memorial, disapproved 13 October 1915. (Collection of the Art Commission of the City of New York, Exhibition file 364-F.)

memorial "seat" of Indiana limestone, encircled by American elm trees symbolizing the "five boroughs of the Greater City" (fig. 3.15). Now the commission's concerns centered on practical matters, such as the durability of the materials and the jointing of the stone. The committee recommended approval (swayed undoubtedly by the presence of the secretary/treasurer of the Green Memorial Committee, Edward Hagaman Hall, a former colleague of Green's in forming the American Scenic and Historic Landscape Commission who

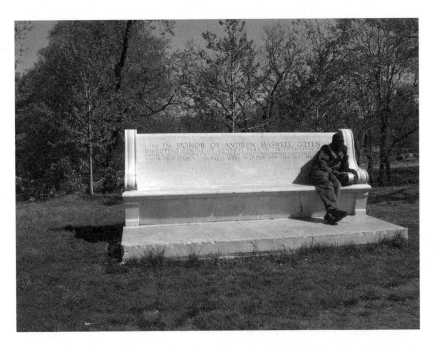

3.15 John V. Van Pelt, Andrew H. Green Memorial, 1928, Central Park (106th Street). (Photo by author.)

would become assistant secretary of the art commission four years later) but called for using a stronger material than limestone.[120] The design, though, underwent another reconfiguration, and the Andrew H. Green memorial bench was not approved for the final time until July 1927.[121] In the time that had passed between initial conception and approval, however, the art commission views had come full circle, with the certificate of approval now noting that the commissioners hoped for erection, down the line, of "a more important monument which the Commission feels Mr. Green's memory deserves."[122]

Bronx Spanish-American War Memorial

Neighborhood insiders also encountered difficulties. In the Bronx, in 1900, the local board of improvements approved a design for an elaborate memorial to the Spanish-American War dead.[123] It looked like a layered wedding cake with the bow of a ship (an allusion to the battleship *Maine,* whose destruction in Havana harbor had been the impetus for the United States' declaration of war against Spain [fig. 3.16]). Fundraising stalled, however, and when the design was submitted to the ACNY in 1916, it was much reduced

3.16 Bronx war memorial, model, disapproved, 1901. (Collection of the Art Commission of the City of New York, Correspondence file 40.)

3.17 Bronx Spanish-American War Memorial, 1918. (Photo by author.) Pedestal is inscribed "To the Brave Men of Bronx Borough Who Gave Their Lives This Memorial is Dedicated A.D. 1913."

in scope and scale; it now consisted of a pink Milford granite column, a bronze tablet, cannons, and cannonballs and was intended to stand in a grassy isle of safety at the intersection of Third and Lincoln Avenues and 137th street (fig. 3.17). Bronx borough president, Douglas Mathewson, went to the art commission to request an informal review, perhaps anticipating problems. He did not wish to undertake street and traffic reconstructions if the project was unacceptable from the start.[124]

From the ACNY's perspective, the project was, indeed, unacceptable from the start. Architect Albert E. Davis (who had also designed the Board of Trade building immediately behind the proposed design) was quite determined, however, and hence the project came before the commission. It disapproved the memorial on the grounds that there were already two dozen light poles in the near vicinity and that the additional column produced an overly cluttered environment. Further, the ACNY contended that the column was not exactly a meaningfully designed artwork, created especially for that occasion and site but, rather, one that was simply "taken from some building and given to them."[125]

The Bronx Chamber of Commerce was livid, challenging the right of Manhattan elite outsiders to second-guess the neighborhood's wishes without giving residents and businesses a hearing. A Chamber of Commerce publication sought to put additional pressure on the ACNY, using photographs to drive home the point that the commission's decisions on matters Bronx were arbitrary and the consequence of simple prejudice. Had not the commission already approved arrangements of columns similar to the one being proposed in the Bronx for Manhattan's plaza south of Fifty-ninth Street?[126] The columns cited bounded the site of the new (1916) Pulitzer Fountain, but the reference to Fifty-ninth Street was also intended to recall art officials' previous actions, circa 1899, with respect to the plaza, the soldiers' and sailors' memorial, and the Heine Memorial, circumstances in which disapprovals had offended Germans, veterans, and subsequently, Bronx politicians.

For Bronx officials, some of whom had also been involved with the Heine Memorial controversy, the Spanish-American War memorial was a question of home rule. They refused to stand by while outsiders denied them the right to represent their constituencies, who demanded an opportunity to honor veterans and express their patriotism. The Bronx borough president took action, calling on his supervising engineer, Louis Haffen, the former borough president who had been removed from office and who no doubt bore grudges. All parties tried to push the ACNY committee to accept the project, but its members refused. The still publicity-conscious De Forest, tiring of the affair although somewhat removed from it, expressed his reservations

to Assistant Secretary Adams that perhaps the commission was seeking "too much perfection" and was being "unwisely finicky." [127] The committee members in question, however, clearly regarded the design as ridiculous, and the local politicians' and advocates' bullying tactics as obnoxious. They refused on principle to cave in.[128]

Two years later, however, in the midst of World War I enthusiasms, the sponsors succeeded by appealing through flag waving. Edward W. Curley, alderman for the twenty-eighth district, told Henry Bruckner, borough president, that "the Art Commission is meeting with very unfavorable comment of the patriotic citizens of my district." Accusations about lack of patriotism was a burden that De Forest clearly did not want the ACNY to bear; he intervened. He appointed a new committee to review the Spanish-American War memorial, and in May 1918 they approved it.[129] The Heine Memorial, mailboxes, and fourteen years of experience had taught De Forest that in select instances, especially involving confrontations with veterans and local elected officials (especially outside Manhattan), the ACNY had to defer to the popular will in order to operate authoritatively in the long run.

REPRESENTING CITY GOVERNMENT

Memorials to the *General Slocum,* the Spanish-American War, and to Andrew H. Green commemorated individuals associated with notable episodes in New York City history: the tragic destruction of families and of a neighborhood; New Yorker's sacrifices on behalf of oppressed peoples and imperial ideals; the formidable achievements of one civic leader, along with mistaken identity and murder in the expanding metropolis (Green was shot on Park Avenue by a deranged man who mistook him for someone else). The aspirations of these memorials were relatively localized. On other occasions, the ACNY evaluated enterprises intended to highlight more extended if imprecise visions of municipal significance. Like the memorial to Andrew H. Green, these projects were sponsored by the city's civic, artistic, and political leaders. They proved to be no less contentious, placing ACNY members in the awkward position of challenging one of their own. The case of *Civic Virtue,* for example, pitted the ACNY's interests against those of not only several of the city's mayors but also long-time social and professional colleagues.

Memorials to upstanding and patriotic citizens, as we have seen, were often fraught with tension, misunderstanding, and nasty politics. Frederick MacMonnies's *Civic Virtue* (fig. 3.18), a project that one might have anticipated would be impervious to such problems, was in fact no exception. *Civic Virtue* was an unmitigated disaster from the outset. A monumental statue

3.18 Frederick MacMonnies, *Civic Virtue,* 1922 (presently on Queens Boulevard at entrance to Union Turnpike). (Photo by author.)

and fountain, *Civic Virtue* put the art commission in a major political and professional bind, all the more because it was a rare municipally sponsored commission, doled out by the mayor. The monument was quite literally and deliberately meant to represent the city. The challenge for the ACNY was how to prevent the project from becoming a major embarrassment.

This troubled monument had its inception in 1891, when Mrs. Angelina Crane bequeathed $52,000 to the City of New York to erect a drinking fountain. (Certainly, given the sum, such a fountain would be beyond the scope of anything that the American Society for the Prevention of Cruelty to Animals [ASPCA] could have imagined.) Delays ensued on resolution of the Crane estate, and the city did not receive the money until 1908. Mayor George McClellan, Jr., took charge of administering the funds and, without consultation, bestowed the commission on the sculptor Frederick MacMonnies, a celebrated artist who had just completed a District of Columbia memorial to the mayor's father, George McClellan Sr. For personal and professional reasons, MacMonnies took his time, and in 1914 Parks Commissioner Cabot Ward wrote MacMonnies to insist that he complete the work. MacMonnies submitted a design to Ward in October 1914. His fifty-seven-foot-high scheme, which would replace the smaller "Victorian" Calvert Vaux fountain in the southeastern corner of City Hall Park, consisted of a twenty-eight-foot-wide series of fountain basins with decorative jets and overflows and a monumental sculptural personification of Civic Virtue, a male Virtue astride a "siren vice" ensnared "in her own nets." [130]

When the ACNY committee assigned to the project (Karl Bitter, John A. Mitchell, Frank L. Babbott) met to examine the sketches, its members were displeased. The work struck them as altogether too large. A memo from Parks Commissioner Ward (who by law gave his approval after preliminary and before final approval) corroborated the objections. He considered the base, on which the statue was to stand, too small in proportion to the statue and the basins below. The basins themselves seemed to him "rather monotonous." But then again, it was a little hard to tell, since the work overall was too sketchy to discern any of the details. Ward complained, further, that MacMonnies had overemphasized the frontal (southern) view rather than making it appeal as a figure in the round. "There is nothing in the back of the group to excite interest," he continued. In addition, the male figure seemed too large in scale in relation to the proposed surroundings—City Hall in particular. Then Ward equivocated: "I like the idea of the group; the subject is simple, dignified, and sculptural." The problem was that the actual execution of the design was as yet unacceptable. [131] Commission committee chair Bitter wrote to MacMonnies to convince him to revise the design before submitting it, but the sculptor, under time pressure and unwilling to accept criticism, went ahead with the submission. Hence the ACNY was put in the awkward position of disapproving the work of a renowned sculptor and colleague. [132]

MacMonnies's designs were not only unsatisfactory to Ward and the ACNY; even MacMonnies's subsequent collaborator, architect Thomas Has-

tings (who had previously teamed up with the sculptor during the McClellan and Gaynor administrations), was dismissive. Noting that MacMonnies had asked him for assistance, Hastings stated, "I do not wonder that the designs were not approved. It is too evident that Mr. MacMonnies tried to do his own architecture." Hastings asked Ward's permission to help, assuring that he would do his best to "do a simple thing, in harmony with the city hall."[133]

Ward asked De Forest if it would be all right for Hastings to intervene. A letter ghostwritten by John Q. Adams for the ailing De Forest responded that the ACNY could not make that decision but that "personally" he thought it a good idea. Ward also asked for the reasons for the commission's 30 November 1914 disapproval, but was told that the meetings of the commission were "executive and private" and that Adams could not divulge the content of deliberations unless the committee issued a report, which it had not. Adams noted that the ACNY had discussed the matter with MacMonnies. The artist himself was not kept in the dark.[134] In such circumstances, the ACNY found it advantageous to draw distinctions between committee discourse, private conversations among individuals, and ACNY meetings, which were official public actions.

MacMonnies continued to work on the design, with Hastings joining in. In early July 1917, the Department of Parks prepared to submit the fountain portion for preliminary approval for a meeting on 31 July. As of the 24 July, however, the model was still not ready. De Forest notified Ward that if he did not have a model completed that he should withdraw the submission; otherwise the ACNY, asked to review an incomplete submission, would have to disapprove it. De Forest urged Ward to take the former action because, although everyone involved would understand why that disapproval action would have to be taken, others, "after seeing the model . . . might not so understand it." In other words, the press might assume that the art commission was disapproving the aesthetics of the work.[135]

Those bothersome matters continued. On 15 December 1915, several commissioners continued to object to the monument's size. "The whole thing seems to me too big," commented architect member William Boring, before MacMonnies and Hastings entered the room. "It is very enormous." Yet once the architect and sculptor were present, the commissioners, trying to be polite, danced around the issue. "It is certainly a very beautiful design," said Boring in the artists' presence. "It still looks to me a little big in size."[136] No one insisted that MacMonnies and Hastings alter the size. The two had a distinguished track record, ties to powerful politicians, and a contract. In the end, Ward suggested that the best way to handle the situation was to lower the grade of the pavement, which could be done at a nominal cost because

the paving was in very bad condition and a complete repaving of the area was necessary anyway.[137]

Ultimately, in October 1919 Hastings and MacMonnies submitted new proposals. The ACNY requested to see a silhouette mock-up in situ. Although still not satisfied with the proposal, they nonetheless approved it. In 1921 Democratic mayor John Hylan and Republican Board of Aldermen president Fiorello La Guardia, discovering the problems and costs associated with the yet-incomplete monument, challenged the ACNY to explain the causes for the delay. The politicians' assumption, perhaps spurred on by the comments of the new parks commissioner, Gallatin, or of Hastings, was that the ACNY had caused the obstacles and added expense. De Forest wrote Hylan and LaGuardia to explain the delays—most of which, he insisted, were not the ACNY's fault—and pointed out that the ACNY, in critiquing the scale and other aspects of the work, was merely looking out for the city's interests.[138] Neither politician was persuaded, especially after they faced the public's ridicule when *Civic Virtue* was actually unveiled in 1922. At this point the critique of the work's aesthetic features became the least of the monument's problems.[139]

For the ACNY, in contrast to the public, the iconography and treatment of the subject matter were not the problem but, rather, the delays and the overbearing scale. The difficulties were all the more acute because of MacMonnies's prominent reputation and his ties to the administration of former mayor McClellan. Hesitant to offend professional colleagues MacMonnies and Hastings, ACNY members dithered. The commission's failure to act forcefully on its instincts and demand more radical modifications was a miscalculation. In this instance, the ACNY's weak stand contributed to a monumentally unflattering image of the city that undermined its credibility in 1922, and later, as we shall see in chapter 4, when Fiorello LaGuardia became New York City mayor.

CURATING AND CREATING A MUNICIPAL IMAGE

The ACNY's involvement with memorials was one way it sought to shape civic memory, an enterprise in which, as we have seen, individual members and staff were heavily invested. Engagement with memorials also demonstrated the department's official limitations. In accordance with the city charter, as mentioned, the ACNY could neither initiate projects nor pass judgment on the inherent worthiness of a memorial subject when another municipal department submitted a project for review. Commission members were obligated to attend to the design merits, leaving others free to put forth conflict-

ing images of municipal identity. The ACNY's members endeavored to do what they could to control matters, while working within a framework that was, by mandate, essentially reactive and negative.

There were times, however, when the ACNY articulated what its members believed was a consistent municipal image and collective memory, seeking to convey loyalty to a politically "disinterested" ideal through means other than statues or memorials. Members and staff of the ACNY first sought to express such standards through the redecoration of the Governor's Room in City Hall. In turn, commissioners anticipated that developing a city flag and seal would serve as an instrument for public edification, civic allegiance, and pride. The flag would impart these principles through decorative symbols and a refined aesthetic that would evoke New York's colonial and Federal past and that—notably—would not occupy public space.

Governor's Room

During the early presidency of Robert De Forest, the ACNY took decisive steps to restore the image of the municipality to one associated with ideals presumably held by his forebearers. By eventually accepting the importance of "ethnic" structures and monuments, commissioners acknowledged that the meaning of the metropolis was to some degree bound up with the accommodation and acculturation of immigrants. But they also believed that the urban future had to be grounded on familiarity with the city's history and sociocultural origins; New York's modest and formally reserved (Protestant) landmarks embodied the spirit of that past. De Forest, although a cultural moderate, was especially invested in this enterprise. He was a major sponsor of the colonial revival. He was a collector of early American furniture and decorative arts and one of the central administrators for the upcoming Hudson-Fulton celebration of 1909 (as chairman of the Committee on Art Exhibits for the celebration), which commemorated the early American period contemporaneous with the construction of the Governor's Room. The Governor's Room (along with the efforts to restore other portions of City Hall) was part of this endeavor.[140]

In this instance, the ACNY was able to exploit its authority as curator of City Hall and of the city's art collection to initiate a project over which it would clearly have supervision. The Governor's Room was a large reception hall and portrait gallery on the southern end of the city hall building. Although it is unclear that the room was originally conceived as such when first designed, beginning around 1814 it came to be reserved for the governor when he visited the city.

De Forest and (unsurprisingly) John Quincy Adams determined to restore the Governor's Room to its original glory, even though no one was clear about what that original glory was, or cared that a restoration had just been completed in 1905. Although the ACNY had approved those earlier plans, the enterprise (undertaken by the firm Bernstein and Bernstein) included "muchly painted" red walls and garish decorations like gilt and silver chandeliers. It was widely condemned.[141] John Ahearn, Manhattan's borough president, and De Forest, supported by many of the city's newspapers, City Beautiful advocates, and certainly by the ACNY, hoped to dismantle an interior design job that had clearly been a Tammany boondoggle, one presumably engineered by the city's "ethnic" interests. Ahearn retained McKim, Mead, and White, renowned for their work in the classical and colonial revival styles, to redesign the Governor's Room. When objections from the Controller forced Ahearn to drop the plans, the city's private establishment clearly decided to take charge and to bring in one of its own "tasteful" decorators to refashion the room as more of a museum and less of a gaudy party chamber. In this instance, however, representation for the private and public sphere were one and the same.

Adamant that the room be restored once more or less to its Federal-period style, De Forest prevailed on Margaret Olivia Sage (philanthropist and widow of industrialist Russell Sage), for whom he served as family lawyer and adviser. De Forest persuaded Sage to have the Russell Sage Foundation—of which De Forest was president—donate $25,000 for the new restoration. Using private rather than municipal funds, De Forest could override any potential objections by the controller that a new restoration on the heels of another would be extravagant. Moreover, because the funds were private, donated by a corporation of which he was president, De Forest could insure that the ACNY would oversee the selection of the architect and the development of plans.

When given an opportunity to shape memories rather than just react to them, the ACNY preferred the city's old-stock traditions. Sage retained Grosvenor Atterbury, designer of Forest Hills Gardens, a project also underwritten by the Sage Foundation.[142] De Forest and Sage knew that Atterbury would treat the room, with its extensive collection of historic portraits, with appropriate reverence. It would be revitalized as a museum (somewhat like a satellite of the Metropolitan Museum of Art), in keeping with one of its early functions as a portrait gallery and an attraction for tourists.[143] Like the Hudson-Fulton celebration, preparations for which coincided with the restoration, the Governor's Room would serve as an instructional resource: an incarnation of the city's history, it would inspire civic pride and education and serve, incidentally, as a gracious space for public rituals and entertainments.

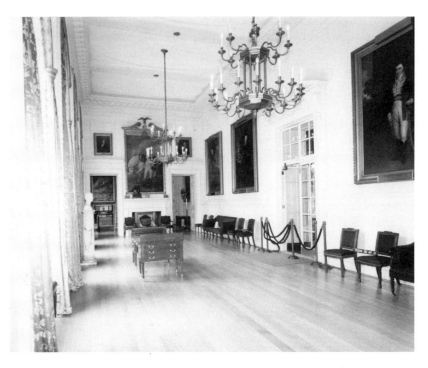

3.19 Central hall, New York Governor's Room, City Hall, ca. 1950. (Collection of the Art Commission of the City of New York.)

Donor, architect, and ACNY endeavored to recreate an authentic sense of place, one that was bound up, as well, with urban tourism and expansion.

Working under ACNY supervision and with the commissioners' enthusiastic support, Atterbury certainly succeeded, in their minds at least, in bringing the Governor's Room back into alignment with the spirit of the chamber's "original" restraint and purity. This would be in keeping with the Anglo-American heritage that the upcoming Hudson-Fulton celebration was committed to celebrating, a tradition of which City Hall was regarded as prime exemplar. As Mary Beth Betts has made clear, however, the reconstruction of the room's original design and purpose was a fiction. The Governor's Room had not been originally associated with the governor or designed for paintings. The original plans included only one room, not the three with which Atterbury was working. Atterbury's restoration (fig. 3.19) evoked the spirit, not the letter, of the room's original plan.[144]

With the Atterbury restoration, the ACNY succeeded in establishing, in built form, an "invented tradition." The Atterbury plans came to set the standard; his Governor's Room became the *ur*-room—evoking the civic lessons and traditions of Federal-era New York—that all subsequent restorations of

the Governor's Room would emulate, at least until the 2003 restoration by interior designer Jamie Drake. Atterbury's discrete decorations were a response to the excesses of the 1905 restoration, and projects like the Slocum and Verazzano memorials, which had paid tribute to the city's diversity.

Thus the ACNY extended its enterprise to preservation of the past, to formulate an image of the city that would be conceived as memory in the name of history and tradition. With the help of private funds, municipal identity within the seat of government would be bound up with the memories of distinguished men portrayed in paint in the Governor's Room and overseen by the ACNY.

The City Flag

Like the Governor's Room, a new city flag represented an attempt to align the city's heritage with that of the national heritage at a time when the continued influx of immigrants from southern and eastern Europe raised concerns about New York's future. To some, New York City was becoming a mongrel city. It seemed to be losing ground; New York had, after all, lost to Chicago in its bid to host the World's Columbian Exposition of 1893, an event signaling a national "coming of age" and imperial presence. Other major expositions marking major national events had been held in urban "provinces": Buffalo (1901) and St. Louis (1904). The Hudson-Fulton celebration of 1909 was New York City's way of tapping into the Anglo-Dutch legacy. This was a desire underscored by the fact that the two dates being commemorated, conflating the ventures of Hudson and Fulton, were previously unconnected. The New Yorkers on the Hudson-Fulton celebration commission hoped to assert the city's centrality to national development and civilization and its contributions to technological, commercial, and cultural progress, both nationally and internationally.[145]

The city flag idea was initiated by lawyer John B. Pine in the wake of the Hudson-Fulton celebration fervor, in the hope of inspiring civic loyalty among schoolchildren, immigrants, and other New Yorkers. A flag that would "suggest [the city's] origin and history and fitly symbolize the 'great abstract idea' of the ideal city" could help to unify diverse local ethnic and class constituencies and to assert a common ground in the face of mass immigration and its potentially fractious politics.[146] A flag would provide an "emblem which would symbolize the civic unity of [the city's] people and perpetuate the historic tradition of its foundation."[147]

Pine was a former corporation counsel under Mayor Seth Low and a former art commissioner, hence a member of the Art Commission Associates,

composed of former ACNY members.[148] Although interested in prodding the city to develop a flag, Pine knew that there was no point in his initiating the project personally. He thus suggested the idea at an associates' dinner in January 1914 and convinced them to take it on as a project, since the ACNY itself could not initiate a design. The city, he pointed out, did have a flag— "a white field bearing the seal of the city in dark blue"—but this was of rather "dubious origin."[149] Pine proposed a flag that would embrace the city's Anglo-Dutch histories by using the same colors—orange, white, and blue—as the flag of the United Netherlands in 1626, with the city seal in the center—"an inheritance from English occupation, as modified at the time of the Revolution by the substitution of an American eagle as the crest in place of a ducal coronet."[150]

The associates were enthusiastic, contending further that the city should also develop a restoration of the city's "ancient corporate seal" ("which, through careless usage, had become a caricature of the original design"), thereby bestowing on the city the imprimatur of tradition and antiquity.[151] The associates formed a committee that consisted of Pine, I. N. Phelps Stokes, Richard Townley Haines Halsey, and Francis T. Jones, all men of "old stock" pedigree who shared a reverence and intense scholarly engagement with America's past.[152] The group undertook research on the colors and iconography of the flag and seal and their adoption under the Dutch and English. The key players in the flag's development were Stokes, Victor H. Paltsis (subsequently Stokes's researcher on the Salomon memorial), and Edward Hagaman Hall (a founder of the American Scenic and Historic Preservation Association and a future assistant secretary of the ACNY), all men with expertise on early New York City history and direct personal involvement in its various reconstructions. They and other advocates regarded the design of a flag as a "distinctive advance in the cultivation of civic pride."[153] The group developed a design that combined allusions to and symbols of both empires. Thus the colonizers were taken by the colonized as symbols of liberation—a meshing of these representations into a singular, distinctive image evoking the history of New York. The design was a graphic and iconographic amalgam. "The colors are Dutch," noted a leaflet distributed to schoolchildren. "The seal is English, the eagle [replacing the English crown of the old seal] is distinctively American, but the flag as such is the flag of our City."[154]

The Greater New York flag consisted of three equal vertical bands of orange, white, and blue, with the latter closest to the flagstaff. Its seal was inscribed in blue on the middle, white band. The committee sought colors that would approximate those of the Dutch flag. The flag, however, was not intended to be a reproduction but, rather, "distinctly a New York flag"

3.20 Flag of the City of New York. (City of New York flag used with permission of the City of New York.)

(fig. 3.20).[155] The reconstruction was, in effect, a reiteration of the academic artistic process of imitation, drawing on the past to create something new.

The associates committee selected up-and-coming sculptor Paul Manship (1886–1966) to redesign the new city seal in a manner that would be "historically accurate and correct," a variation of the corporate seal of New York City as adopted by the Common Council 1686, "with the alteration adopted 16 March 1784."[156] Manship's conception, incorporating a beaver, flour barrel, and windmill, affirmed the city's centrality in commerce and industry.[157]

Under ACNY auspices, the associates presented the flag and seal to the Board of Aldermen on 23 March 1915. The aldermen accepted the flag, although they were not uniformly enthusiastic. (A representative from the Bronx threatened to vote against it.) Problems arose when, prior to the aldermanic hearings, the press mistakenly reported that the city was adopting the Dutch flag of 1626 as its own flag, "the same as the banner that first floated over the island of Manhattan." A fight thus ensued over the question of historical accuracy.[158]

Press assertions that the new flag was like the one Henry Hudson used raised the hackles of members of the New-York Historical Society (NYHS). This band of patrician New Yorkers of antiquarian leanings had long seen

themselves as the proper arbiters of the city's heritage by virtue of their descent from the original patroons and other old families. The NYHS was invited to testify at the aldermanic hearing; however, as so often happened within the convoluted circuitry of city government, notification of the meeting arrived late. Unaware that a hearing was taking place, the NYHS representative did not show up. Irked at being left out of the loop, the NYHS's Gerard Beekman wrote the ACNY to complain, especially since, from his perspective, and from what he learned from the newspapers, the flag that purported to be historically accurate was not, particularly with respect to how the colors were arranged.[159] In Beekman's view, those experts dedicated to archiving documents pertaining to New York City's earliest history should have been consulted; instead it was the bureaucratic upstarts and a new rival cultural institution, the New York Public Library, who were heard. The society, Beekman would note subsequently, was of "such ancient standing" and had collected "such invaluable data relating to the history of New York, that an attack upon its accuracy in historical matters is in effect an attack of the City Government and upon the city itself."[160]

The New York newspapers, catching the story from Beekman and his cohorts, now began reporting that the flag was found to be "historically false." Pine responded acerbically in a letter to the *New York Times* that the flag was not intended to be a literal reconstruction. "The Historical Society's criticism of the city's official flag . . . shows such a misunderstanding on the part of the society that one might suppose Rip Van Winkle was only half awake." Beekman complained in a letter to Mayor John Mitchel, who in turn asked the ACNY to defend itself.[161]

The ACNY's assistant secretary, John Quincy Adams, explained the problem of the timing, reassured Mitchel that the Pine letter was a "personal matter," that he did not speak on behalf of the ACNY, and that the commission had never criticized the New-York Historical Society. Indeed, Adams pointed out, the Art Commission Associates itself, which Pine represented, was not a city department. Even so, the historical society's objections were based on misinformation. The flag was a new and distinctive design especially for the city of New York, not a deliberate reconstruction.[162] Mitchell dropped the matter and on 24 June 1915 — designated as the 250th anniversary of the "installation" of the first mayor and Board of Aldermen — the ordinance adopting the flag and the "re-adopted" seal went into effect. The events were celebrated through an elaborate flag-raising ceremony, long-winded evocations of the city's history in prose, poems, and song (notably, *The Orange, White and Blue* by Victor Herbert), and a reception in the Governor's Room.[163]

The city flag was an occasion for affirming an ideal of heritage, celebrating a historical consciousness that had gained momentum with the

Hudson-Fulton celebration and the Governor's Room. That fervor culminated early in 1924 with the opening of the American Wing in the Metropolitan Museum of Art after the museum had acquired the facade of the old Assay Building, thanks to I. N. Phelps Stokes and the ACNY.[164] For Pine, the flag would have "a distinctive educational value as a symbol and would tend to develop civic patriotism, representing loyalty to the City as the national flag represents loyalty to the Country."[165]

The desire for a city flag was not just an expression of idle antiquarianism. While the flag idea grew out of a broader Progressive spirit of historical consciousness and expressed ideals of education and reform in the wake of massive immigration, by 1915 it had acquired greater resonance as a symbol of civic unity and loyalty. A city with its own distinctive flag was a city to be reckoned with. The flag, wrote Pine, was "emblematic of the courage and independence which repelled the tyranny of Spain and founded the Dutch Republic, and which gave to New York as its birthright free government, free speech, free commerce, free schools, and free religion." "This flag is no mere decoration," Pine continued. Its colors "perpetuate a great tradition." It symbolized "liberty and law" and "the basic idea of civil government which the founders brought to us and which is our priceless heritage."[166] By rallying around the city flag, New Yorkers, new and old, could also demonstrate their patriotism and Americanism. The flag was an assertion that New York was not some city of aliens but, rather, a unique and spirited place that formed an integral part of the national fabric. Such concerns took on additional resonance with the onset of war in Europe, where the atrocities flamed a sense of patriotism.[167]

The city flag was another commemorative initiative that took advantage of the ACNY's peculiar status within municipal government. Along with the Governor's Room, the flag underscored the fact that ACNY members, unpaid and, in several cases, appointed by outside institutions, acted as representatives of private-sector groups and organizations on the city's behalf but not as municipal representatives. As individuals, ACNY members and former members drew on their connections within the private realm to sponsor choice initiatives.

THE ART COMMISSION AND COMMEMORATION IN MODERNIZING NEW YORK

The art commission stood in a unique position as aesthetic gatekeeper at a moment when public cultures of commemoration in New York City converged as never before in the form of monuments. Again and again, the art commission imposed its collective aesthetic will on the city and its inhabitants.

Consequently, as the changes between conception and execution in the cases of the Dante, Slocum, and Green memorials reveal, the city of New York ended up signifying its identity very differently than might otherwise have been the case.

As we saw in chapter 2, the development of the ACNY was aligned, to some degree, with the civic impulse known as the City Beautiful movement—an enterprise influenced in its planning and design aspirations by the achievements of London, Paris, Rome, and Vienna. Yet to a certain extent as well, the ACNY's actions in fact contributed to a Greater New York City that resembled none other than itself. This occurred despite the recommendations of other bodies appointed by the mayor like George B. McClellan's New York City Improvement Commission, which in 1905 proposed broader general planning schemes with the City Beautiful aesthetic clearly in mind.[168] Individual commission members, especially the sculptors, had ample exposure to the public artistic achievements of European cities and their lavish manifestations of outdoor sculpture, but clearly they felt that narrative and ornamental plenitude was inappropriate for the Manhattan grid and most of the specific locales within it. The ACNY's decisions regarding memorials suggests, then, that even art-world constituents with conservative and academic aesthetic preferences were not united on the merits of the more ornate European Beaux-Arts or American City Beautiful aesthetics. Overall, commission members preferred monuments with discursive and aesthetic subtlety, believing commemorative expression to be more compelling when something was left to the viewers' imagination. Hence the projects with whose sponsorship the commission was more directly involved—the Governor's Room and the city flag and seal—were notably less literal embodiments of collective memory than were sculptural monuments.

Prevented by the charter from initiating its own monuments and dissatisfied with the quality of the few monuments projects—like *Civic Virtue*—sponsored by the city itself, the ACNY worked to configure urban memory in plain and straightforward terms on other memorial projects. The ACNY imposed these preferences, often, as we have seen, to the chagrin of applicants. Even so, the ACNY of these years ultimately accepted monument projects more often than not. The commission had power, but its authority remained circumscribed. The ACNY's proceedings, as both part of city government, though somewhat peripheral to it, generated tensions, arising from the gap between members' sensibilities concerning the art of retrospection and their ultimate actions. As a body, the ACNY had to work constructively with multiple constituencies, sometimes needing to compromise in order to function and survive organizationally. The ACNY's powers were such that it could define "aesthetic" for an environment in the broadest possible terms,

hindering development to the point where a project ultimately lost momentum, support, and even sponsorship, as with the Salomon memorial. But although the ACNY had the final vote to approve or disapprove a design, it infrequently halted projects completely except when they already had problems and lacked strong outside support.

The ACNY's authority with respect to commemoration remained subject to significant constraint because of both the charter mandates and broader political challenges. In both class affiliation and tastes, ACNY members might be a throwback to older days when cultivated gentlemen dominated New York City in cultural spheres. They were called Swallowtails (because of their predilection for long frock coats), and many were members of the mercantile-gentleman elite who entered politics after successful professional careers. These men nonetheless operated within a public political sphere dominated by Tammany Democrats, who were responsive to the emotional pleas of a wide array of ethnic groups and other constituencies who sought representation through monuments.[169] Individual and group constituents were conscious of their prerogatives and tended to be extremely persistent. The ACNY locked horns with many groups during the process of review and insisted on results that—from the sponsors' and artists' point of view—sometimes eviscerated the original conception. Nevertheless, the ACNY usually sought to encourage and frequently achieved what was in their view an acceptable outcome.

Commission members strongly identified with efforts to promote awareness of the city's Anglo-Dutch tradition. Contrary to what one might expect, however, given the visibility and cultural influence of the older elites, when it came to sculptural monuments that presence was relatively limited. Indeed, from the ACNY's standpoint, as we have seen, no one was exempt. In its dealings on memorials and commemoration, the commission would have occasion to upset just about everyone. (A memorial to Samuel J. Tilden, for example, proposed in 1905—before the contentious Dante memorial—was not completed until 1926.) As men with strong commitments to philanthropy, low-income housing, settlement house work, race relations, social reform, and detailed historical investigation of life and place in Manhattan—De Forest and Stokes accepted, if sometimes reluctantly, the right of New Yorkers to forge ties to their city through timeless commemoration. To be sure, the most engaged players on the ACNY, including De Forest, Stokes, Marshall, Hall, and Herbert and John Quincy Adams sought to insure that the commission's own contributions to the city's "commemorative infrastructure" would be unambiguous reminders and reconstructions of simpler days before the city's population became diverse and assertive and its politics and culture so multifaceted and contested. Nonetheless, by 1929 a multitude of

different groups—Italians, Poles, the French, Germans, the Irish, the Dutch, and Jews—made a notable commemorative imprint on the city's public spaces. Memory, in New York City, was born of negotiation and concession.

The art commission entered the fray with a clear conception of what kind of work was appropriate for representing memory in New York City and where it should stand, as well as what was not suitable. Guided by a forceful and venerable president, whose tenure effectively coincided with the memorial fever, the commission managed to jigger the geographic locations of proposed memorials to result in what they believed would be a more coherent statement. By 1930, Manhattan's major parks and most desirable central open spaces below 125th Street (with the exception of Thirty-fourth Street and Park Avenue) were virtually all accounted for.

Yet significantly, as we have seen, the ACNY did not follow, in its deliberations, recommendations urged early in the century by Bitter and Bush-Brown and, subsequently (1911), by parks landscape architect Charles Downing Lay that commemorative monuments be distributed within specific geographic and historical "districts." Lay, for example, suggested that "military and naval heroes" go on Riverside Drive below 130th Street, with "heroes of peace and monuments to the workers in the city service, as police and firemen," above; he also recommended that some districts be designated by "nationality," with memorials to Italians, for example, grouped in the area around Columbus Circle.[170] Members of the ACNY preferred to take a flexible, politically expedient stance. They idealized traditions of Anglo-Americanism but accepted the melting-pot idea rather than Lay's multiculturalism. Conceivably they also believed that following the other route risked bypassing a potentially meritorious work that for one reason or another did not fit into a broader conceptual scheme. Rather than operating according to a prescribed vision of the city, the ACNY reviewed projects on their individual merits, assessing "appropriateness" primarily along formal aesthetic lines. Such a tack, while still consistent with the ideal of visual culture discussed in chapter 2, made for a less cohesive or comprehensive vision of the city, one that enabled an ongoing process of reenvisioning its appearance.

By 1929 New York was filled with monuments to achievement, creativity, intelligence, sacrifice, state power, national unity, and political sagacity, a commemorative legacy that was reasonably, if not entirely, representative of the city's diversity. Nevertheless, by the 1930s, even the state became unconvinced that public arts offered an adequately representative and inclusive vision and embarked on a mission to supply new public art. The artistic consequences, and the ACNY's involvement with those projects, will be part of the following chapter's focus.

CULTURE WARS

U ntil the end of World War I, the ACNY had engaged in empire building more or less effectively. From the 1920s into the 1960s, the fabric of authority began to fray. Controversies initially arose over bureaucratic turf and urban park terrain, then expanded into broader battles over public culture and representation in civic affairs. In carrying on the traditions of the early twentieth-century Progressive movements, the ACNY confronted a rising artistic populism and radicalism, new forms of activist government, and formidable politicians.

This chapter will explore the ACNY's shifting fortunes during this period, epitomized by the work of its genteel president, architect and historian-collector Isaac Newton Phelps Stokes (1929–38; fig. 4.1). Much of the discussion will center on Stokes, a figure who emerged from a John Singer Sargent portrait to confront forces like Robert Moses, Fiorello La Guardia, and Ben Shahn as they sought to reconfigure public art, the urban design process, and the ACNY itself.[1] Moses was generally willing to comply with ACNY values and standards in the abstract but often defied its procedures. La Guardia sought unsuccessfully to bully Stokes into transforming the ACNY into a more active, initiatory body. With the emergence of the federally funded New Deal art programs, Stokes and the ACNY confronted a younger generation of artists—many of whom were aesthetically progressive and politically radical. They had a different vision of public art: as a form of work relief and social commentary at a time of mass unemployment and as an instrument of revolution. Against the political odds, Stokes extended the ACNY's powers. A presidential successor to Stokes, architect William Adams Delano, had the connections and wherewithal to extend the Stokes legacy. The lack of a high-profile civic cultural leadership, both within the ACNY and outside, diminished the agency's powers, visibility, and influence by the early 1960s.

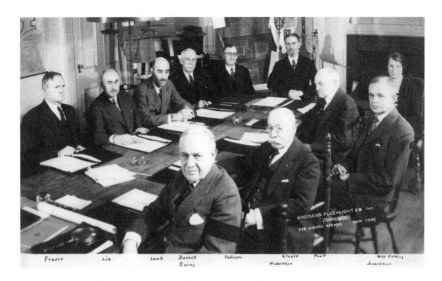

4.1 Art commission boardroom, with art commission members, ca. 1933–34. Art commission members (*from left*): James Earle Fraser, Jonas Lie, William F. Lamb, Frank L. Babbott (*top*), Thomas Ewing (*bottom*), A. Everett Peterson (executive secretary), George W. Wickersham (*bottom*), I. N. Phelps Stokes (*top*), George D. Pratt, Francis Boardman, Bessie E. Fielding. (Collection of the Art Commission of the City of New York, Exhibition file 7–85.)

Political scientists Wallace S. Sayre and Herbert Kaufman, in their remarkable study *Governing New York City,* described the ACNY in 1960 as one of ten "overhead" agencies, "engaged in making decisions governing the behavior and the decisions of other agencies, decisions which are important stakes in the political contest for all the major participants." Because the "line agencies"—"administrative agencies in direct contact with all or part of the populace that perform the regulator, enforcement, and service functions of government"—were "compelled to share their decision-making with each overhead agency," the latter were "important centers of power and influence in the city's politics."[2] Sayre and Kaufman's characterization of the relationship and distinction between overhead and line agencies is apt and relevant to the ACNY's activities in the earlier part of the decades on which this chapter concentrates.

The ACNY's role as an overhead agency put it into conflict with other, line agencies (or, more accurately for the time period, departments), like the Department of Parks, which were charged with getting things done. The ACNY could carry out its review and regulatory activities only as long as those departments, and the individuals in charge of them, were willing to negotiate and compromise. Departments like parks had their

own problems and concerns, but in the early decades of the twentieth century they were generally willing to be accommodating to the ACNY's recommendations.

By the 1920s, as New York City's functions and operations were expanding, the goals and interests of the ACNY and the departments that submitted projects to it for review started to diverge. Oversight became an ever more politicized, competitive process. During the Depression, the earlier balances of power were realigned as the result of unprecedented federal government intervention and power and the establishment of new municipal, state, and interstate authorities. Faced with multiple and overwhelming challenges to the standards of its members, the ACNY was put on the defensive. Mayors, for whom the ACNY was intended to do service and who previously had been friendly or at least indifferent, periodically became adversaries. In the 1930s, the ACNY's intrinsic structural weaknesses came to the surface. These problems, exacerbated by personal, class, ethnic, and professional tensions between Stokes and La Guardia, threatened the ACNY's existence. Although the immediate problems were resolved in the political arena, cultural differences and organizational weaknesses remained.

From the 1940s into the 1960s, continued expansion of the city's bureaucracies resulted in fragmented agendas and dilution of authority among the ACNY's core supporters and nongovernmental constituents, like the Municipal Art Society. The ACNY sought to invigorate its image during this period but had limited latitude within which to do so. The ACNY's greatest strengths lay within the realms of preservation, an area within which it acted forcefully and successfully. Stokes and his successors, Edward Blum and William Adams Delano, also collaborated with sometime adversary Robert Moses to manage memorials and landscapes within the complex and highly charged spheres of Cold War public culture. However, the ACNY's socio-professional makeup became increasingly at odds with the preponderantly Democratic municipal government's desire to appeal to broad affiliations that cut across the five boroughs. Its involvement in large-scale development projects became more restricted and piecemeal.

The division of interests that surfaced during the postwar period culminated in the mid-1960s. The commission's membership and deliberations were affected by the city's design agendas as well as its politics, driven by preoccupations with race, ethnicity, and liberal counterculture. Yet the very strength, independence, and longevity of the ACNY's elite social networks, together with a recognition on the part of the city's mayors that the ACNY ultimately represented mayoral power and objectives (even while paying lip service to the powerful Board of Estimate), ultimately enabled the ACNY to endure.

PARKS PROBLEMS

Process Matters

Up through the First World War, civic art enterprises in New York City had hinged on coalitions of progressive Republicans and independent Democrats. Frequently allied with good government efforts, these groups aspired to implement successfully the Greater New York Charter. Tammany Democrats who toed the party line, and who saw their natural constituencies as working-class Irish, Italians, and Germans, tended to be antagonistic toward beautification projects initiated by and for the wealthier professional classes from which ACNY members were drawn. The art commission had had backing during the reform administrations of George B. McClellan (1904–9), William J. Gaynor (1910–13), and John Purroy Mitchel (1914–17). The Tammany administrations of John Hylan (1918–25), James J. Walker (1926–32), John McKee (1932), and John P. O'Brien (1933), displaying stronger class antagonisms, were decidedly less supportive. Like Robert Van Wyck at the turn of the century, Hylan and Walker sought to gain points with their working-class constituencies by playing off the latter's ostensible interests against those of the civic establishment types. During the period between the two World Wars, neighborhood party functionaries disdained the citywide, charter-mandated art review board. They wanted to undertake large capital projects, dispense patronage, and complete the projects while in power to improve the city and reap political credit. The ACNY, whose members engaged in public service precisely in order to curb expedient approaches to urban design, was committed to being included in the process, which after all, was mandated by law. Yet in the late 1920s under De Forest the ACNY took a passive and inconsistent stance toward officials who ignored the charter by circumventing ACNY review. The political antagonisms manifested themselves especially in the actions of the Department of Parks.

The interests of the ACNY had long coincided with those of the parks not only because the commission was involved with monuments and other structures but also because the input of the Department of Parks' landscape architect was crucial in assessing park design and park grounds. In Manhattan, for example, the ACNY, the commissioner of parks, and the parks landscape architect, although not always in agreement, were often allied on matters regarding monuments and sites and interacted fairly cordially during negotiations over City Hall Park, the Maine Memorial, the Pulitzer Fountain, the Tilden Memorial, and *Civic Virtue,* among other instances.[3]

This relationship began to break down during Jimmy Walker's administration in 1929. Commissioners learned that customary procedures were

being bypassed. According to Gregory Gilmartin, Walker's commissioner of parks, Walter Herrick, was his friend's "most trusted" bagman.[4] Regarding the ACNY's concerns as trivial, Herrick took a cavalier attitude toward the rules, as the commissioners learned to their dismay in the case of Union Square Park.

Opened in 1831, Union Square Park had initially been a manicured green space lying amid the theaters, concert halls, and mansions in the surrounding neighborhood. The park became a favored site for monuments in the decades following the Civil War. The neighborhood became depressed in the early years of the twentieth century but was nonetheless the site of a bustling commercial, artistic, and intellectual community; development began once again soon after World War I. Artists and urban groups like the MAS regarded Union Square Park as having special civic significance. The ACNY had long taken interest in the park and, in particular, in protecting it from what members regarded as additional, inappropriate sculptural encroachments. Nevertheless, the park's character continued to change. It became a center for workers in the needle trades and a popular locale for labor rallies and protests; the May Day parades wound up there. The square was "like London's Hyde Park Corner, with many small knots of people engaged in emotional political debates."[5]

In 1926 the Department of Parks brought to the ACNY plans for a gigantic flagstaff with a large base decorated with bronze relief sculptures, ostensibly commemorating the 150th anniversary of the signing of the Declaration of Independence. The so-called Liberty Memorial, funded by Tammany Hall, was subsequently dedicated to recently deceased Democratic party boss Charles Murphy. Art commission members had had their run-ins with Murphy and could not have been enthusiastic about the shifted purpose to which the memorial was dedicated. Nevertheless, the ACNY approved the model for the flagpole's base and sculptural reliefs.[6] As it transpired, however, the Department of Parks had bigger plans: a large-scale renovation of Union Square Park. The department did not inform the ACNY about its elaborate new scheme until it was too late to make substantive changes.

I. N. Phelps Stokes, the New York Public Library's representative on the ACNY, was becoming increasingly concerned about the conduct of the commissioner of parks toward the ACNY. Stokes had served on the ACNY since 1911 (with hiatuses between 1913 and 1916 and 1918 and 1921), long enough to witness a change of attitude and approach.[7] De Forest remained president, but his health was deteriorating. Apprehensive that the ACNY was losing its influence among city officials, Stokes became increasingly outspoken. From 1928 on, he would effectively become ACNY leader; he was elected president in 1929 after De Forest's retirement, remaining in office until 1938. Stokes was

a crucial actor within the world of New York taste politics. A few words on his background are thus in order.

Isaac Newton Phelps Stokes (1867–1944) was the scion of two old-stock families, Phelps and Stokes, long involved with urban philanthropy, particularly African American education and housing. The oldest of nine children, Stokes received his B.A from Harvard and briefly attended the School of Architecture at Columbia University and then the École des Beaux-Arts in Paris. At the urging of colleagues, Stokes soon became involved with housing reform, winning a competition to design the new University Settlement House in New York City and assisting Lawrence Veiller and Robert De Forest in drafting the 1901 Tenement House Law. Together with architectural partner John Mead Howells (son of novelist William Dean Howells), Stokes engaged in a successful architectural career. In the early decades of the twentieth century, his firm, Howells and Stokes, received important commissions for banks, insurance buildings, and other corporate structures in New York City and elsewhere.[8] As historian Max Page has observed, Stokes's career was very much bound up with service, accumulation, development, and speculation. Even while advocating "radical" new powers for government in the areas of municipal planning and low-income housing, he remained wary of too much state control and endorsed "some merging of government and private initiative."[9]

Stokes worked hard to move the city forward but was also pulled by the past. He amassed an extraordinary collection of prints and maps of old New York, documenting many of the places that were undergoing change as the consequence of his activities and those of others like him. Stokes used his collections as the basis for a massive research project, culminating in an extraordinary six-volume chronology of the development of New York's built environment, *The Iconography of Manhattan Island.*

The *Iconography* revealed Stokes to be a man obsessed with detail. He was not one to gloss over particulars either in his historical work or in his work on the ACNY. Hence when Stokes learned, in 1928, that the Department of Parks was undertaking a large-scale renovation of Union Square Park, he notified ACNY president De Forest and the MAS and insisted that the Department of Parks insure that the ACNY would be brought into the process to review the plan's specifics.

Union Square Park

Approved by the Board of Estimate in June 1929, the Department of Parks plans for Union Square called for elevation of the park grade and a relandscaping. The work, done in conjunction with a major subway reconstruction

underneath Union Square, involved removing and relocating of the statuary adjacent to and inside the park. Henry Kirke Brown's statue of George Washington, which had stood below the southern end of the park, would be moved into the south end of the park, facing Broadway. Bartholdi's statue of Lafayette would be moved from the southern end of the park itself to "the center of the east side of the park," between Fifteenth and Sixteenth streets. The huge flagpole would be placed dead center.[10]

The ACNY had approved none of these plans, although by law they were supposed to assess them. From Stokes's point of view this circumvention was a travesty, and he was determined not to let Tammany officials make a mockery of ACNY as an institution. Even if the designs were a fait accompli, it was imperative that the ACNY be consulted: from Stokes's perspective, process was as important as the end product, if not more so. That process needed to begin. By 1929, "the entire Square has been reduced to the condition of a plowed field, and all statues, fountains, trees, etc. removed," Stokes complained to De Forest.[11] The MAS, newspapers, and other groups were starting to complain about the current state of the park. The situation was "causing much comment," wrote Stokes, "and I am constantly asked whether the Art Commission does not propose to do something to protect the city's interests."[12] The MAS and ACNY needed to act swiftly to put a stop to the work, he insisted.

De Forest, by 1929 somewhat disengaged from the ACNY's affairs (he would retire in October of that year), seemed disinclined to get upset about the matter. He did contact Parks Commissioner Herrick, however. Herrick feigned ignorance and promised to provide blueprints, implying in any event that the redesign was a done deal.[13] Herrick proceeded to send them but not in a regular submission form. In effect, he was attempting to get a de facto, unofficial approval, circumventing the process by which every one else was expected to abide.[14] Assistant Secretary Edward Hagaman Hall of the ACNY, who had studied the Herrick plans, recommended that the ACNY essentially just try to cut its losses. Hall told De Forest that the proposed relocation of Henry Kirke Brown's 1859 George Washington statue to the axis of Broadway, the "most prominent site in the park," made adequate sense. He disagreed with the objection that the Washington statue was being subordinated to "those of lesser reputation," namely, the Lincoln and Lafayette memorials. Intimating that for the ACNY to engage in battle with Herrick at this point could weaken its stature, Hall suggested that perhaps the ACNY consider acting formally just on the materials submitted to it. If it voted approval it would resolve a "somewhat delicate situation and save the prestige of the Commission."[15] In other words, Hall felt it would behoove the ACNY to give in on the larger reconstruction project that it normally should have reviewed.

De Forest and Hall, both laymen, might be satisfied to give the Union Square Park designers the benefit of the doubt, but Stokes would have none of it. Disagreeing with Hall, he argued that the ACNY was losing credibility and power because it did not speak out. ACNY members had become fearful that offending Tammany politicians would result in having "its powers curtailed" or "suppressed altogether." [16] Stokes believed that the ACNY's timidity would do it just as much harm.

Deciding that De Forest was too passive and removed from the process, Stokes took matters into his own hands. He protested to Herrick that his submission was incomplete, with no section drawings or other data "essential to an intelligent judgment by this Commission," and insisted that Herrick adhere to the charter. Stokes also persuaded influential colleagues to press Herrick to consult the ACNY. [17]

Herrick finally paid lip service to the process. He submitted the park layout designs to the ACNY, which approved them in late 1929. The large flagpole and base received ACNY approval the following May (fig. 4.2), but these sanctions did nothing to speed up construction. [18] Nine months later, the park was still in disarray, and the ACNY began to receive complaints about the mess. Stokes, now president, again took action, objecting to Herrick that the work was not being executed as approved and criticizing the slow pace of construction. [19] The work was finally completed in 1932, but from a public relations and organizational standpoint the damage had been done. The outspoken state senator Nathan Straus declared the newly completed park an "eyesore," its stone wall an "incredible monstrosity." The embarrassment of the renovation put the ACNY in a bad light, undermining its authority. Its approval of the Union Square Park designs had apparently done little to improve them or affirm the merits of the ACNY's review process. It also sent up a red flag to Stokes, president of ACNY as of late 1929, that cooperative relations with the Department of Parks could no longer be taken for granted. [20]

After the Union Square debacle Herrick continued to bypass ACNY jurisdiction, not only over park designs but also over the disposition of the city's monument collection. Herrick and Stokes began sniping. When in March 1932 Stokes objected to removal of a statue of Civil War general Daniel Butterfield and the developing of Claremont Park without prior ACNY approval, Herrick retorted that Stokes was being "unduly solicitous in regard to the prerogatives of the Art Commission." "I know of no provision of the charter which prevents the Park Commissioner from removing any statue in any of the parks under his supervision." The only time Herrick needed permission from the board, he continued, was if he wanted to relocate a statue to another position. Stokes sent Herrick the relevant section of

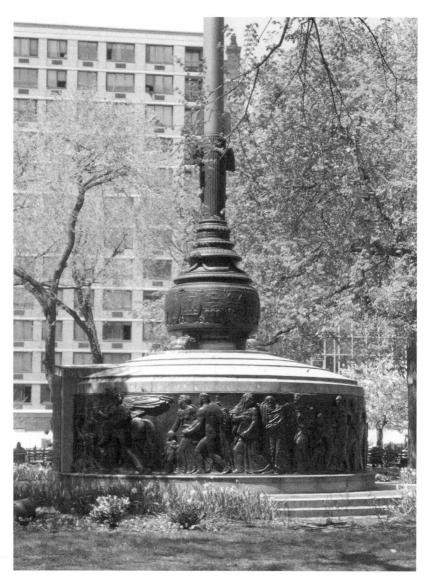

4.2 Anthony De Francisi, sculptor, and Perry Coke Smith, architect, Charles F. Murphy Memorial
 Flagpole, 1926 (dedicated 1930), center Union Square Park, looking west. (Photo by author). The
 bronze allegorical reliefs in this photograph depict the evolution of civilization under democratic
 rule. The opposite side of the base (invisible here), depicts civilization under tyrannical rule.

the charter regarding its jurisdiction over monuments.[21] Herrick, noting his familiarity with the charter, insisted that "the part which refers to removals means permanent removals and not temporary ones. Certainly the Legislature never expected us to annoy the Art Commission whenever a piece of statuary or work of art had to be temporarily removed or repaired." He also reminded Stokes that the cost was being defrayed by John D. Rockefeller, Jr., an implicit warning not to do anything that would jeopardize the project's funding and progress.[22]

Stokes would not budge, assuring Herrick that "the Art Commission will not be annoyed by your submission to it of *any* matters which it believes to be within its jurisdiction" and recited the charter section, chapter and verse.[23] "The ordinary dictionary meaning of the work 'remove,'" he wrote, contemptuously, "is to take off or away from the place occupied, to convey to another place, to change the situation of." "If the Butterfield statue was taken down and moved to a storage place, either before or after you had determined what should be done with it, after the work of improving the Park area had been completed, it was certainly removed in some way, and the approval of the Art Commission should therefore have been secured." As for the fact that Rockefeller was footing the bill, this was irrelevant. Again Stokes scored Herrick for handicapping the process by not bringing it before the ACNY until it was, in effect, too late.[24]

Athletics versus Landscape Art

The Department of Parks kept defying the ACNY, and Stokes kept up the pressure for the department to adhere to the letter of the law. Matters deteriorated further under John J. Sheehy, parks commissioner for the borough of Manhattan under interim mayor John P. O'Brien (a Tammanyite who replaced Jimmy Walker after that playboy's forced resignation). Sheehy, a boss from the city's Fifteenth Assembly ("Silk Stocking") district, had little sympathy for the beautification agendas of Stokes and his colleagues and had no intention of allowing his activities to be scrutinized by an art board.[25] In 1932 Stokes sent Sheehy a memorandum outlining the various recent parks projects underway that had not yet been submitted to the ACNY. In addition to Union Square, they included Riis Park in Queens, the work on the old reservoir in Central Park, and designs for Marine Park, Brooklyn.[26] Months later, Stokes felt compelled to write Mayor O'Brien, with irony, that perhaps his new parks commissioner was uninformed about the ACNY's duties and jurisdiction, since Sheehy had not responded to Stokes's inquiries.[27] For Tammany officials, Stokes was a patrician fingernail scraping the blackboard.

In 1933 Stokes and Sheehy locked horns over a plan for the site of the former Catskill reservoir in Central Park. For over a decade, civic and neighborhood groups, artists, park advocates, World War I soldiers' families, and city officials had debated the merits of using this acreage for a Beaux-Arts war memorial, green space, or active recreation. Sheehy was determined to push forward plans that would give "the public," as he put it, "the fullest possible use of the parks."[28] For Sheehy, this meant transforming the lower reservoir into playgrounds and athletic fields with baseball diamonds and pits for broad jumping.

The plans elicited outright class antagonisms. Numerous elite civic groups protested the plan, contending that Central Park should remain quiet green spaces. Ball fields would draw loud and boisterous crowds from the city's poorer neighborhoods. Active recreation, opponents declared, was at odds with "park purposes." Their objections had an aesthetic component as well. Opponents deemed the rectilinear, function-driven Sheehy plan as crass and haphazard, ill-composed and jarring within the context of the curvilinear, pastoral Olmstedian contours of the Central Park landscape. Advocates of the athletic facilities, many of whom were lower-income residents of the far East Side, disagreed with civic arts groups' conception of "park purposes" and sided with Sheehy. Their concern was athletics, not aesthetics. Longstanding resentments on the part of these constituencies began to surface and were inflamed by the mutually prejudiced statements voiced by both sets of alliances.[29]

Though the ACNY had not been directly involved in the early stages of the controversy, Stokes was appalled by Sheehy's attacks on civic groups (calling them "dictators" who had only the concerns of the wealthy in mind) as well as by the plans themselves. He was determined to try to put a stop to Sheehy's plans for the park.[30] Writing to Sheehy, he pointed out that the ACNY had refrained from weighing in because it was duty bound not to "take sides" on a matter until a plan had been submitted to it. To date, this had not happened. Sheehy could not start his Central Park project legally until he had obtained ACNY permission, which he had not done. Presumably he did not plan to do so either, given his pronouncements in the *Daily News* that ACNY members were "removable at the mayor's pleasure" and that the commission's "nose is sadly vulnerable." Perhaps, Stokes acknowledged, the ACNY had been too passive on the issue of appropriate use.[31] Perhaps it was time for the ACNY to take a stand on the project regardless of whether Sheehy formally submitted it for review.

Such action was not necessary. Ignoring Stokes and the opposition, Sheehy continued with his ball field plans. In late 1933, however, the power

struggle was resolved in favor of the ACNY and civic groups when Fusion candidate Fiorello H. La Guardia was elected to the mayor's office with the backing of the editors and publishers of the *New York Times* and Nathan Straus, Jr., all of whom strongly opposed Sheehy's stance. (Iphigene Ochs Sulzberger, daughter of *New York Times* publisher Adolph Ochs, had helped lead that opposition.) La Guardia, not surprisingly, declared himself against the ball fields.[32]

La Guardia selected as his parks commissioner Robert Moses (1888–1981). Moses, who had deferred in his own mayoral aspirations to La Guardia, in return negotiated a legislative deal, backed by La Guardia, to become New York City's first citywide park commissioner. Moses's appointment boded well for the ACNY. Unlike Sheehy, he was, to a certain extent, one of "them," a serious Yale man, an assimilated German Jew (like Felix Warburg, ACNY member from 1927 to 1932, who had devoted his early career to Progressive reform causes), and a good-government Republican with a proven reputation as a successful, can-do developer of tastefully designed and tightly managed parks and public works projects. Early Moses projects like Jones Beach and the Northern State Parkway were notable for design, materials, and attention to details. Moses had significantly expanded the New York State parks system. His Jones Beach project of 1929, which included park houses, parking lots, bathhouses, and attendants in uniform, had won him accolades worldwide. These accomplishments surely appealed to Stokes, an Ivy Leaguer with experience in big development, artful building, and public service. (Moses had received his Ph.D. from Columbia, where Stokes had dropped out of the architecture school.) Stokes anticipated a positive relationship between Moses and the ACNY.[33]

Stokes's hopes were realized in many cases but by no means in all of them. Moses understood the values of the civic establishment. He more or less shared the ACNY's aesthetic preferences for "classical" simplicity and formal cohesion and accepted the fact that, as commissioner of parks, he operated within a bureaucracy. Twenty years Stokes's junior, however, Moses was used to operating within a managerial environment that followed principles of efficiency. He submitted projects for ACNY review, but when the end results were either the same as the initial proposal or when the proposed changes were not to his liking, he grew impatient. He thus utilized the ACNY selectively when he felt that ACNY input suited his needs, as will be seen with the memorials to victims of the Nazis.

Awaiting word on Moses's ideas for the lower reservoir site, which they assumed would be compatible with La Guardia's stand against Sheehy's plans, ACNY members hoped that they had turned a new corner. Things

looked promising; Stokes thus backed off, assured that "a suitable plan" would "ultimately be presented to the Art Commission for its consideration and action."[34] Civic groups also anticipated that the battles that had held up previous development of the lower reservoir site were unlikely to happen under Moses, whom they trusted to take the reins of the city's parks.[35]

Indeed, in mid-1934 Moses brought the lower reservoir debates to an end, with a plan for a great lawn that followed along the basic lines of an old American Society of Landscape Architects design but also included more playground and recreational space, not for baseball but for less strenuous pursuits like croquet, shuffleboard, and lawn bowling.[36] Moses also hired the prominent Aymar Embury II as his consulting architect and as Department of Parks liaison to the ACNY. The Department of Parks also seemed to be making submissions to the commission—with Bryant Park redesigns, for example.[37]

By mid-1934, however, the honeymoon period was over, when commissioners again became aware of projects that the Department of Parks was undertaking or completing without having submitted them for approval. Still insistent on a public review for public works, Stokes resumed his protests. He wrote a series of missives to General Superintendent W. Earle Anderson of the Department of Parks and to Moses, reminding them that the commission could not "properly consider nor wisely act on submissions for buildings in parks, the general plans for which have not been submitted to it, or are not in its files"—circumstances that had occurred with a fieldhouse project for Chrocheron Park (Bayside), Queens, and other projects.[38]

Moses's action regarding the ACNY has to be understood in the context of the new federal presence, for which Mayor La Guardia was partly responsible (along with many others). Using his long-time political connections with President Franklin Roosevelt, La Guardia helped to secure federal funding that put 68,000 unemployed men and women to work on park refurbishment in 1933. Thousands more were employed on public construction projects. In December 1933, the formation of the Civil Works Administration and its Public Works of Art project, administered in New York City by Juliana Force, resulted in creation of hundreds of new public buildings, parks, and works of art for the city.

Moses had a stake in seeing that public works projects were implemented on time, within budget, and according to his standards of quality. The more projects that could be pushed through, the more funding and additional projects could be garnered. He could understand why ACNY should review art projects, as we shall see, but an occasional comfort station or park—evidently such details were not always worth getting bogged down in aesthetic review. Stokes and other art commissioners did not see things that way.[39]

THE ART COMMISSION
AND THE GREAT DEPRESSION

Staking Claim to Art Work

The early years of the Depression had seen a paucity of ACNY submissions, largely because the funds for new projects had dried up but partly, as well, because of the lack of cooperation from Herrick and Sheehy. With the formation of the federal emergency relief and construction programs, the number of municipal art and building projects increased markedly. Heedful of the fact that the ACNY would have to act expeditiously and efficiently on the multitude of new submissions in order have its function taken seriously, Stokes acted decisively. He reminded city commissioners that they were obligated to submit for review projects assisted by federally funded emergency labor, just as they would any other project on municipal property. He also set up a process that enabled projects to receive an immediate review, making it more difficult to use excuses about time constraints to bypass requirements.

Normally the ACNY met officially once a month, with committees convening separately and informally to review individual projects for recommendation to the whole committee. Stokes now appointed a committee of himself, commission architect member William Lamb, and lay member Thomas Ewing "to consider designs for emergency construction, which cannot await action at the regular monthly meetings of the Commission."[40] The committee promised a decision within forty-eight hours, and it met weekly for what Stokes described as "a considerable interval.[41] Stokes had taken similar measures after the establishment of the Public Works of Art Project (PWAP) resulted in a ballooning number of submissions—from 69 in 1932 to 227 in 1934 and 341 in 1937.[42] To "cooperate to the fullest extent," Stokes again appointed emergency committees on painting, sculpture, and architecture, which offered decisions within forty-eight hours.[43] The ACNY thus sought to demonstrate just how committed its members were to the review process and to insuring that work done by artists on relief be of the highest quality. With so many new and untested artists involved in the federal art projects as part of the New Deal, Stokes was not about to let bureaucrats render final judgment on artistic excellence.

Most municipal departments cooperated, and consequently the process became clearly "a strain." The committees undoubtedly turned a blind eye to certain questionable designs, although, as we shall see—they generally did not do so. Stokes bent over backward to insure that the process would continue to operate according to the standards and expectations at play under any prior circumstances. For this reason, Stokes and other commissioners

were chagrined to learn that Moses and his staff were still bypassing the ACNY or submitting projects too late for the ACNY to recommend substantive changes.[44]

Stokes and his cohorts strongly believed that all projects were crucial and should undergo review, no matter how seemingly trivial. In cases like comfort stations, for example, many ACNY members felt parks could do better. Hence Commissioner Edward Blum (Brooklyn Institute representative) wrote Moses to complain about "the little brick power houses—often called 'Sears Roebuck comfort stations' in the various city playgrounds." "May I suggest to prescribe to the designers of the Park Department vitamins A, B, C, and D for a more varied diet. While it may not attract more users, these pavilions may be made more decorous—with the help of vines, shrubs, and trees to fade them out."[45]

Moses, in contrast, believed that review of certain forms of utilitarian structures was bureaucratic overkill, a waste of time. He was confident that he had dotted his i's and crossed his t's on the matter of meshing good design with programmatic needs and security concerns (avoiding vandalism). On the matter of the comfort stations, he responded that parks had studied the issue a great deal and that the design was necessary "in order to combine an efficient workable floor plan with a well proportioned and attractive elevation. The plan must first of all permit an ease of operation and ease of maintenance. . . . extremely important due to our limited budget." Storage space was needed, plus a heating plant. Vandalism was also a major concern, and thus gutters and leaders were put inside, which "does not permit of an overhanging roof that would materially assist in the proportion of the structure." Responding to the vines idea, he wrote "it is not honest practice to cover up architectural mistakes with spinach [vines in the parks parlance] and, of course, we are not anything if not honest. The spinach, of course, contains some of the vitamins that you recommend, and I am going to pass that suggestion on to the staff."[46]

Moses could charm, but he could also be extremely nasty, as in the exchanges over major projects like the West Side Plan, which included development of the Miller Highway and the surrounding environs of Riverside Park, and the East River Drive. In both cases, he attempted to avoid ACNY involvement. This effort failed, but he succeeded in holding off review until very late in the process, which made it very difficult for the commission to insist on any major changes. When they did make suggestions, such as the incorporation of underpasses between Corlears Hook and Fourteenth Street on the East River Drive, Moses responded to Stokes: "I am in complete disagreement with you on this subject, which I do not believe comes under the scope of your authority. There is nothing in the Charter or in common sense

which gives the Art Commission the power to dictate whether or not there shall be facilities of this kind, and let me add quite frankly that I don't think you know what you are talking about."[47]

In general, Moses's relations with individual ACNY members remained cordial; he was collaborating or negotiating with a number of them on various projects. (For example, both he and Edward Blum, president of Abraham and Straus Department Store as well as an ACNY member, were very involved with development of the Brooklyn Civic Center in downtown Brooklyn, a complex that included municipal courthouses that the ACNY had to approve.)[48] Nevertheless, during Moses's virtually unstoppable path to power over the built environment and public works, his actions vis-à-vis the ACNY remained extremely variable, as we shall see.

Mayoral Relations

Moses's ambivalence toward the ACNY, following in the path of the park commissioners preceding him, was also an outgrowth of the troubled relations between the ACNY and Mayor Fiorello La Guardia. In contrast to the dismissive indifference of the post–World War I Tammany mayors, La Guardia began his first term overtly hostile toward the ACNY, especially the tall, courtly Stokes. Stokes's old-school attention to detail and respect for process would send Mayor La Guardia over the edge. La Guardia was out for change, and the ACNY represented much that he wanted to change. The interactions among La Guardia, Stokes, and the ACNY represented the uncertainties of the ACNY's work and future at a key moment of cultural transition in the municipality.

La Guardia's resentments toward the ACNY predated his tenure as mayor. In 1921, as president of the Board of Alderman, he had worked, on behalf of Carlo Barsotti and his memorial committee, to expedite ACNY approval of the controversial Dante Memorial. Undertaking this task at a moment of severe duress (his wife and daughter were dying of tuberculosis, and he was running for election), La Guardia surely harbored negative associations with these negotiations. La Guardia was also aggravated by the expenses incurred on MacMonnies's *Civic Virtue,* a monument he and many others ridiculed and for whose presence he blamed the ACNY. The mayor's uneasiness with ACNY members, rooted in class and ethnic differences, further fueled his antagonism. To some extent La Guardia's treatment of Stokes was retaliation for all of the snubs that the short, stocky Italian American had endured from the patrician New York establishment.[49]

La Guardia entered office with a vision of what an art commission should do. He envisioned a municipal art committee that would put the force and

funds of the public sector behind the development of new artistic projects and programs, enterprises that would extend beyond the scope of the then-current federally sponsored public works and Works Progress Administration projects and would include new ventures and structures like an opera house, municipal art center, and high school of music.[50] La Guardia wanted a committee that acted, a line agency that would initiate projects, and he was willing to help such a committee acquire more power. Noticing the paintings in City Hall, for example, La Guardia had his secretary inquire of Stokes whether they might perhaps need cleaning; maybe this would provide work for unemployed artists through the Civil Works Administration. (Whether unemployed artists would have the qualifications necessary properly to restore the city's large collection of portraits was not at all clear.)[51] According to Stokes, La Guardia directed that the first ACNY meeting of his administration be held in his office.[52] In a reversal of mayoral precedent, La Guardia actually used his prerogative as an ex officio member of the ACNY and attended some ACNY meetings. Clearly he was examining all municipal operations and possibilities. What he learned in his ACNY experiences did not at all please him.

Stokes tried to impress La Guardia by highlighting formality, rules, and rituals. La Guardia was not one for ceremony. At their initial meeting, after Stokes had explained to the mayor the "jurisdiction, principles, duties, and procedure" of the commission, La Guardia joked that as he had crossed the threshold of City Hall he had been "confronted by an angry group of well-fed cockroaches." Noting the commission's oversight of City Hall, La Guardia expressed his surprise that "conditions had been allowed to reach such a pass as to permit the existence of so deplorable a situation" and directed Stokes to take measures to "preclude the possibility of its continuance." Stokes tried to run with the irony. He responded that the commission's duties did not extend to "housekeeping matters" but agreed to appoint eminent attorney and lay member George Wickersham as "a committee of one to investigate the matter."[53]

The levity ended there. La Guardia wanted to develop big schemes. Stokes, far more caught up with mundane matters of immediate concern for current ACNY operations, pressed La Guardia about appointing much-needed new commissioners (whose presence was necessary in order to achieve a quorum), particularly, the necessity of reappointing painter member Jonas Lie. Lie chaired the committee charged with approving the painting submissions of the New York Regional Committee of the Public Works of Art Project (one of the federally funded arts programs), and Stokes felt that it would benefit the city, the committee, and the smooth operations of the ACNY to have Lie continue.[54]

Stokes's requests fell on deaf ears.[55] In March 1934, only two months after taking office, La Guardia wrote to Stokes:

> Frankness requires me to state that I am not at all satisfied with the present Art Commission, or in agreement with its policies. From our conference it seems to me that you gentlemen are living on a memory of the past. I am concerned with the future. The commission, as I have observed it, seems to lack initiative and energy. While impressed with its dignity, I was disappointed in its accomplishments.
>
> I will appreciate it if you will bring this letter to the attention of your colleagues at one of your formal and most solemn meetings.[56]

Stokes tried to respond, noting that by law the ACNY had no powers of initiative and that, if it did, it would be impossible to obtain the caliber of people to serve pro bono that it presently did (because the job would be too time consuming). Commenting on La Guardia's insult that ACNY'ers lived in the past, Stokes stated, turning around La Guardia's statement, "It is true that we are not so much interested in the past or in the future as in the present." Perhaps the mayor had not adequately acquainted himself with the specifics of the commission's work, Stokes wrote; and surely, had the mayor read the several ACNY reports Stokes had given him, he would be convinced of the commission's accomplishments, all the many projects the ACNY had reviewed and improved.[57]

Stokes's manner and approach, serious and well intentioned but insufficiently obsequious, simply dug the ACNY into a larger hole. Rather than expressing interest in La Guardia's proposals to make the ACNY more active, Stokes continued to resist and to highlight the status quo, writing again (after he received no response to requests to make an appointment) that "the charter does not confer upon the Art Commission any powers of initiative, nor any police powers."[58] Stokes pointed out that power of initiation would need to come from the Mayor's Committee on City Planning and department heads and that an initiating board needed to be composed of "paid professional members" who worked full time and had more staff. This would require an appropriation some twenty times that of the ACNY's. Stokes also offered a perspective that had been voiced as early as 1913. A review body could not both "initiate ideas and definite plans and pass upon the same judicially."[59]

When La Guardia, in a gesture that indicated his engagement with the ACNY's activities, asked the members to hold its meetings in his second floor office, Stokes refused, instead of responding positively and accommodating immediately. He reminded La Guardia that the displays and exhibit materials

were very bulky and unwieldy; it would be difficult to haul them up and down the narrow and circular set of stairs from the third floor.[60] Instead of detailing the ACNY's actions, project accomplishments, and initiatives, Stokes told La Guardia about the ACNY's many meetings and site visits.[61] When Manhattan borough president and custodian of public buildings Samuel Levy attempted to install a gate at La Guardia's end of the City Hall "to keep out cranks who pester the police detail guarding the executive offices," the ACNY, as the aesthetic custodians of City Hall disapproved it, creating further antipathy.[62] New security constraints were needed to protect a flamboyant, highly accessible mayor in a tension-filled economic climate in a very public building, especially in the wake of the 1933 murder of Chicago's mayor, Anton Cermak. Subsequently apprised of this, the ACNY ultimately backed down, with the proviso that any barrier conform to the period style of the building.

These encounters increasingly grated on La Guardia's nerves. As the year went on, the relationship continued to deteriorate, with Stokes seemingly helpless to ameliorate matters. La Guardia took to the press, disdaining the commission's "highbrow" or "top hat" procedures and complaining that the ACNY was useless because it never initiated projects like his proposed Municipal Art Committee.[63] It was too stodgy and niggling.

Stokes's efforts to explain the commission's situation were for naught. La Guardia, anxious to implement his own vision and impatient with Stokes's purported inability to think beyond the box, complained to the press about the recalcitrance and "pomposity of the Art Commission."[64] The *Tribune* quoted La Guardia ostensibly mimicking the group: "Why Mr. Mayor . . . we haven't time to take the initiative. We have little time to do anything but exercise our veto power on unworthy projects."[65] "They've got to get a new motor—a supercharger and gear it way up if they want to keep pace of the development of art in this administration. You notice I have not appointed anyone at all to this commission."[66] Although the ACNY secretary always notified the mayor of upcoming meetings, La Guardia nonetheless directed his law secretary to request notification. The tone put the ACNY on the defensive by implying that it was remiss and that La Guardia somehow did not receive information.[67]

Stokes was sincerely perplexed. He responded to the press in a polite and appeasing fashion. La Guardia had attended various ACNY meetings, he noted; he had asked questions, been offered explanations, seen the hard work commissioners had put in, and even offered his assistance in insuring a quorum (which, of course, was difficult to achieve because of the mayor's unwillingness to fill open positions). "That's why I can't understand his attitude now," said Stokes. "It might be some little thing that has caused him to make

an impulsive statement. The next time I get down the hall I shall talk it over with him and I know we will straighten it out," he reassured the reporter, trying to downplay the problem.[68]

Low (the former mayor) and Warner (the early ACNY president) saw eye-to-eye. The venerable ACNY president De Forest earned respect and accommodated. Stokes seemed inept at playing the political game. He was certainly able to negotiate and compromise, but to La Guardia it did not appear that way. Led by Stokes, the ACNY insisted on trying to display integrity, stick to their aesthetic convictions, and do their job, apolitically, as they believed they were charged to do it. The ACNY members' refusal to let La Guardia "win the battle" infuriated the mayor, even though he was winning the war. Privately, La Guardia mocked Stokes and his patrician mannerisms.[69] With a newly formed Charter Revision Commission having recently begun deliberations, La Guardia made it known that he was considering urging that body to eliminate the ACNY.

The standoff continued until July 1935, when La Guardia abruptly asserted that he "could take it" and admitted to his critics that he had been remiss in not appointing the new members to the ACNY. By early August he had made three appointments: John Erskine, novelist, professor, and musician, as lay member, Ernest Peixotto as painter, and C. Paul Jennewein, sculptor.[70] Instead of recounting all the terrible things the ACNY had done, the press, obviously with the mayor's encouragement, began printing lengthy and complimentary accounts of the ACNY's accomplishments.[71] Indeed, Stokes in his memoir proclaimed happily that he and the mayor became "staunch friends" after La Guardia's first year in office, with Stokes calling La Guardia by his pet name "Little Flower" and La Guardia nicknaming Stokes "old pomposity."[72]

Stokes feigned ignorance concerning the reason for La Guardia's change of heart. Gregory F. Gilmartin has pointed to a viable explanation, provided by Stokes's close friend Charles Culp Burlingham (1858–1959). The details explain the change of course and highlight the peculiar, personal, and contingent nature of the relationships among urban politics, aesthetics, publicity, and public policy during the La Guardia years.

As a former head of the New York Bar who had used his considerable influence among Fusion leaders to secure La Guardia's candidacy and election, Burlingham had La Guardia's ear. Some years later Burlingham recalled that La Guardia described a meeting that Stokes and La Guardia attended. The mayor joked about how he had imitated and poked fun at Stokes; La Guardia then pointed out to Burlingham that he had mimicked Stokes on other occasions and started doing it again. After La Guardia had gone on "this way for awhile," Burlingham recollected, he told the mayor of Stokes's

sad personal circumstances. Stokes's beloved wife Edith Minturn Stokes had been struck down by a series of strokes and was confined to her bed, lifeless and unresponsive. Convinced that she could nonetheless hear him and would gradually respond, Stokes went to her side several times a day to read and talk to her.[73] "'Fiorello,' Burlingham inquired of La Guardia, 'did you know that man's wife has been unable to recognize him for four or five years and he has never left her more than two or three hours at a time.'" La Guardia, who as a younger man had been devastated by the loss of his first wife and his daughter to tuberculosis, uttered to Burlingham: "'That's the way it was with my wife.' That's the only time he ever spoke of his first wife, who was a beautiful Italian," Burlingham concluded. "But he was always nice to Stokes after that."[74]

The recollections of the savvy Stokes and the nonagenarian Burlingham are surely only part of the story. Their personal accounts provided a sentimental ending to the story of the Stokes–La Guardia confrontations. More significant, the anecdote helped to burnish the reputation of the scrappy and sometimes irascible mayor. The change in La Guardia's behavior was undoubtedly also due to some maneuvering behind the scenes. Stokes was a shrewder player in the La Guardia political world than the mayor may have credited him for. In this instance, while La Guardia talked about eliminating the ACNY, Stokes was already taking initiatives to increase its muscle.

In June 1934, while under fire from Mayor La Guardia, Stokes had begun a lobbying campaign to insure the commission's future, to clarify and expand its jurisdiction, and to extend its membership. He had already developed specific proposals and called on his old associates to help promote them. Telegraphing his friend, sculptor and former art commissioner Herbert Adams, Stokes urged the National Sculpture Society to urge the Charter Revision Commission to expand the ACNY's powers to include oversight of the repair and maintenance of monuments.[75] He then drafted a proposed charter revision that sought to modify the provision that "no work of art shall become the property" of the city without review by the ACNY, by clarifying the definition of "work of art": in his view, the wording should include not only approaches but also "lay-out, lines, grades, plotting, etc.," to insure that landscape designs and site decisions would have to be part of the review. To prevent a department from proceeding without ACNY approval (as the Department of Parks had done frequently), Stokes also sought a provision that no final bills would be paid on a project until the ACNY provided a final certification of approval in writing.[76]

Stokes also utilized his political connections, turning to distinguished colleagues who were staunch La Guardia allies and on whose support the mayor depended. After consulting with lawyer, civil service expert, and "old friend"

Samuel H. Ordway, Stokes contacted high-ranking members of the Charter Revision Commission, like its vice president, Judge Samuel Seabury, to inform him about the proposed revisions and the ACNY members' belief that the board should be "continued as an independent body," with the mayor still an ex officio member. Stokes sought to communicate that La Guardia's political bullying would not sway the commissioners' resolve to render an objective judgment.[77] Ordway contacted the counsel for the Charter Revision Commission and reported to Stokes on a "very satisfactory" conference, which left him assured that the provision would be included.[78] Ordway then contacted the Citizens Union, which agreed to write on the ACNY's behalf. Stokes in turn wrote to the chairman of the Charter Revision Commission, Al Smith (later governor), as well as to every member of the commission to persuade them to adopt the proposed revisions.[79]

La Guardia, assuredly pressured by allies and close advisers like Seabury and Burlingham, was pragmatic enough to be persuaded that it could be advantageous to have a body of ostensibly independent citizens willing to take the blame for unpopular artistic decisions, thus leaving the mayor free to deal with more pressing matters. Having formed his Municipal Art Committee in 1935, La Guardia could now move forward on his desired municipal cultural enterprises and reap full and positive credit. These events, combined with the personal motivations mentioned earlier—may have contributed to his sudden moderation of tone. La Guardia backed off. Even so, the Charter Revision Commission's membership would be altered before the new charter finally came into effect in 1937; allies like Smith and Seabury had resigned.[80] The ACNY would thus have to wait and hope that Stokes's efforts in ACNY's behalf would ultimately succeed.

KEEPING BAD ART OUT OF TOWN

The Art Commission and the Federal Art Projects

Although La Guardia stopped his attacks on Stokes and the ACNY after midyear 1935, the status of the ACNY under the revised charter remained uncertain. Charter revisions would not be concluded until 1937, and much could occur in the meantime. Thus between 1935 and 1937 the ACNY still faced the question of survival, much less its improvement or expansion. One route was to be inconspicuous and not incite controversy. The other was to prove the ACNY's centrality and civic contributions by adhering to its aesthetic convictions and taking stands on the merits of its work, no matter what the consequence. Stokes and his colleagues chose the second option, the path of greater resistance.

La Guardia wanted the ACNY to do more. When it came to the federally funded art projects initiated during the Depression, the ACNY had often been urged to do less. New debates took place, as ACNY members struggled to maintain the commission's authority while reconciling their aesthetic ideologies and expectations with the new and more radical social and artistic agendas of the federal projects.

The New Deal art and building programs had started in New York City as an outgrowth of the close ties between President Franklin Roosevelt and First Lady Eleanor Roosevelt and the cross section of elite New Yorkers who embraced liberal politics.[81] When the city's corporation counsel determined that projects that stood on municipal property had to be reviewed by the ACNY, submissions began pouring in. The ACNY reviewed airports, terminals, parks, bridges, playgrounds, pools, roadways, piers, signage, schools, courthouses, and other public construction projects funded through the Treasury Emergency Relief Administration, Civil Works Administration (which financed new construction of public works), and the Works Progress Administration (WPA), which put the unemployed to work on public projects. It evaluated murals, public sculptures, monument conservations, mosaics, and other designs sponsored by the Public Works of Art Project (PWAP), a temporary, pilot art employment program established in 1933, and by the Treasury Section of Painting and Sculpture (1934–39), subsequently known as the Section of Fine Arts of the Public Buildings Administration of the Federal Works Agency (1939–43). The Federal Art Project (FAP) and the Treasury Relief Art Project, both funded through the WPA beginning in 1935 and administered regionally, offered artists financial assistance by awarding stipends to create murals and architectural sculpture and monuments to decorate schools, prisons, hospitals, courthouses, and other public buildings.[82] At its height, over 2,320 New York artists worked for the WPA. The ACNY reviewed more than two hundred murals between 1934 and 1937 alone.[83]

The New Deal projects raised procedural, pragmatic, and aesthetic challenges. Like La Guardia, federal art and building project administrators wanted to get work done. Each project entailed complicated time and economic constraints and bureaucratic obstacles, both nationally and locally. Projects engaged regional and neighborhood politicians, administrators, citizens, and artists, architects, and contractors in tests of will. New York project administrators had a great deal of autonomy but, ultimately, had to answer to federal officials and insure that procedures were appropriately followed— just as twenty years earlier ACNY members were not subject to quite the same kinds of pressures. Although they sought to be accommodating, they took a somewhat different approach to both the process and time frame. Problems arose because the ACNY's concerns—to "keep bad art out of

town" as lay member John Erskine put it bluntly—were often at odds with the goals of the federal projects: to provide meaningful work and, secondarily, civic enhancement.[84]

Erskine's strong words were indicative of the taste, generational, and class differences that swayed the commissioners during the Depression. In 1935, the majority of commissioners were "elder statesmen." Stokes had served on the ACNY for twenty-eight years.[85] In the 1930s, the training and aesthetic proclivities of ACNY members were far more conservative than those of many of New York's numerous and younger artistic constituencies. Jonas Lie (1880–1940) and Ernest Peixotto (1869–1940), painter members from 1932 to 1935 and from 1935 to 1937, respectively, had begun careers at the turn of the century, working in an academic-naturalist style. Sculptor members James Earle Fraser (1876–1953) and his successor C. Paul Jennewein (1890–1978) were also trained in a traditional, academic manner that put a premium on evocations of classicism. Louis V. Ledoux (1880–1948) was a poet of florid verse, as well as a leading authority on and collector of Japanese prints.[86] Luke Vincent Lockwood was a historian and collector of colonial American furniture and decorative arts. Jennewein and architect member William F. Lamb (of the firm Shreve, Lamb, and Harmon) were working in the more fashionable art deco neoclassical styles: Jennewein, in eagle reliefs for the city's Federal Building (1935), Lamb for the Empire State Building, and Lamb's successor, Wallace Harrison, for Rockefeller Center. Although some commissioners, Lie especially, had extremist conservative views, the majority were not inherently averse to "modern" art. But many members of the ACNY were disturbed by the populist ideology underlying the New Deal art programs: allegedly assigning artwork for labor's sake, without regard for "high" aesthetic standards, whether or not the artist had competed for the commission.

These convictions prompted some commission members to disapprove projects they regarded as unconscionably poor or sloppy. Such actions infuriated officials, including La Guardia (who, along with Moses, could take much credit for federal dollars flowing into the city), as well as the artists and architects.[87] As we have seen, the solution for Moses, who had authority over many of the construction projects, was to avoid submitting them consistently for ACNY review. From the perspective of the commissioners, experience had shown that work by designers that Moses hired would at least generally uphold their standards; while work done for other municipal departments could be far more problematic.[88]

Architect member Wallace Harrison (1895–1981), in particular, acquired a reputation as an obstructionist, especially on school buildings. Harrison was well acquainted with school construction problems, having been an associate architect for the Board of Education's Bureau of Construction and

Maintenance.[89] "I can't sign this certificate because of the very bad stone work on the job," he wrote ACNY's assistant secretary, Everett Peterson. "I can conceive of no possible action of the Art Commission which could approve such workmanship."[90]

Harrison also rejected designs for a new $2,800,000 William Howard Taft High School (Morris Avenue and 172[nd] Street, the Bronx), arguing that the structure simply duplicated what he considered to be an unfortunate design for Lafayette School in Brooklyn. He contended that the architect was simply churning out cookie-cutter schools. The proposed structure, he added, was supposed to be placed at the top of a hill in such a way that a viewer looking toward it would merely see the rather undignified vista of the back end of the gymnasium.[91] Harrison was pounded by members of the Board of Education and the neighborhood, which sorely needed the new school. But he had one member of the administration behind him on this issue; as Deputy Mayor Henry H. Curran wrote the ACNY, "Will you please not weaken in your rejection of plans for new public schools of the Sears-Roebuck, standardized, identical or ossified variety."[92] The ACNY approved the school only after the Board of Education hired a new architect, Eric Kebbon, who came up with what ACNY members regarded as a preferable design that took into account the "community, the site, the space available," and "general construction" issues. "The days of standardization are over," Kebbon assured the press.[93]

Harrison was not the only challenger. His successor, Archibald Manning Brown, vehemently opposed the approval of the Nightingale Cancer Hospital, part of the Columbia Presbyterian complex in upper Manhattan, despite the fact that the project was a priority initiative for Mayor La Guardia. Brown believed that the building "did not fit the site" and that a triangular court formed by "two long wings" was "too narrow, too dark, and would be extremely ugly, seen from the main approach to the building."[94] Brown urged architect James Gamble Rogers to make certain changes that would have involved revising the deed between the city and the hospital. The parties refused, and the ACNY ultimately capitulated, unwilling to alienate the mayor or hinder completion of such a politically and medically important project.[95]

MURALS

With painting, distinctiveness rather than standardization caused troubles. Mural painting came to the fore as a public art form during the Depression, in ways that it never had earlier. Commission members believed that New Deal murals truly validated their mission. The ACNY reviewed 241 federally sponsored mural projects between 1934 and 1937 alone.[96] With many murals

funded under PWAP as relief projects, the commissioners found themselves faced with several dilemmas. They were forced to assess large numbers of projects whose creators had been selected because they were unemployed rather than because of their artistic track record or the excellence of their works. Thus the ACNY received, in Erskine's words, many "ghastly" mural submissions from "untrained talent." "We had," he recalled brusquely, "a front seat at the tragedy which the W.P.A. programs were enacting."[97]

The outcome of this clash of interests was almost inevitable. Some artists and administrators felt that the ACNY adopted an air of pompous superiority, summarily disapproving many of the earliest projects.[98] So, taking precautions against further diminishing its precarious reputation under the La Guardia administration, Stokes urged ACNY to display a more sympathetic and compromising attitude. Casting the circumstances in the best possible light, Stokes observed in his 1937 report to the mayor that "a greater degree of care on the part of project officials, the artists' added experience, and the encouragement and constructive criticism of the painter members of the Commission, have caused a very marked improvement in quality." "Of late the Commission has rarely found it necessary to disapprove designs, although," he averred, "it has often suggested radical changes.[99]

The ACNY brought the discriminating eyes of cultivated private professionals and art connoisseurs to the WPA-FAP projects but kept the greater good in mind. They occasionally vacillated or backtracked in circumstances where the negative impact of their aesthetic decrees may not have seemed worth the aggravation. In other cases, when racial sensitivities were at play, the ACNY clearly felt it had to take a forceful stand.

Race and Courthouse Murals

Where murals for the New York County Courthouse, Harlem Civil Court, and Riker's Island were involved, the ACNY had to grapple not with differences of style, composition, or color but, rather, with elusive questions about the nature of public art. Should municipal public art be allowed deliberately to offend its viewers? For "old pomposities" like Stokes, committed to a communitarian perspective, the answer was decidedly negative. When the questions grew out of projects arousing community protest over racial insensitivity, in particular, the ACNY intervened and mediated.

In the case of the Harlem Civil Courthouse at 170 East 121st Street, for example, lay member Louis Ledoux represented the ACNY in deliberations with New York Federal Art Project officials and the Manhattan borough president over a mural panel, *Exploitation of Labor,* by David Karfunkle, for the third-floor courtroom. The National Association for the Advancement of

4-3 David Karfunkle, sketch for *Exploitation of Labor*, Harlem Civil Courthouse, disapproved 14 July 1936. (Collection of the Art Commission of City of New York, Exhibition File 1926-K, negative of photostat.)

Colored People (NAACP), the Urban League, and Charles H. Lynch, alderman for the local (nineteenth) district all criticized the painting as offensive. Karfunkle, expressing the left-wing outlook of numerous artists working for the WPA-FAP, attempted to make a statement about the oppression of labor and the intermingled interests of black and white workers. In the upper right-hand side of the preliminary sketch, submitted to the ACNY (fig. 4.3), a black man whipped a group of black (African) and white (Jewish) slaves, under the watchful eye of an Egyptian overseer; to the left, a black man and a white man toiled on a monumental sculpture. More significant, Karfunkle evoked the possibility of interracial love by depicting a black woman, at center, pleading to the Pharaoh for mercy for the white man, who was presumably her husband. From the NAACP's probable (although unstated) point of view, putting class above race, combined with the touchy theme of cross-ethnic and interrracial relationships, was taking matters too far.

Ledoux concurred that the mural was a problem, and Karfunkle was asked to modify his designs and resubmit them for approval. Ledoux presided over a subsequent meeting (11 July 1936) that NAACP and the Urban League representatives attended. Ledoux told Karfunkle that the mural was "replete" with "historical inaccuracies" and that he would need to submit a new design. Concerned about the repercussions, regional WPA-FAP administrator Audrey McMahon proposed to assign another artist to the project. Ultimately, however, Karfunkle was kept on; the panel was "covered in burlap" while he undertook revisions.[100] In the final panel (fig. 4.4), approved by the ACNY in November 1936, the painter shifted the dominant theme from labor to racial oppression, highlighted by altering the kneeling husband's skin color from light to dark. By transforming the man from white to black, Karfunkle avoided introducing the explosive issue of interracial sex—which no one ever mentioned explicitly in the press or archival records—and emphasized instead the centrality of the black family as a true, racially defined unit.

The ACNY's actions were consistent with the sensitive old-line conformist outlook of its president and many of its members. Given Stokes's personal and family involvement with philanthropic enterprises dedicated to improving African American housing and education, the NAACP/Urban League request for revisions would have made sense. Quite apart from the personal sympathies of individual ACNY members, the sympathetic response of the municipal and WPA officials undoubtedly had a pragmatic, political dimension. Only eight months earlier, in March 1935, riots by residents devastated Harlem in the wake of a mistaken rumor that police had shot and killed a young Puerto Rican shoplifter. (In fact he had merely been arrested.) The destruction alerted officials to the degree of anger and frustration among black Harlemites. The La Guardia administration, which like its predecessors

4.4 David Karfunkle, *Exploitation of Labor,* Harlem Civil Courthouse, 1936. (Collection of the Art Commission of City of New York, Exhibition file 1926-M).

had never especially reached out to African Americans, now made such relationships a priority. The events explain the fears on the part of moderate groups like the NAACP and Urban League that the Karfunkle murals' themes would get them into trouble. Moreover, the sensitivity of the issues at hand explains why neither the press nor the archival records provided a specific account of the community's actual objections. In light of events, the ACNY and WPA-FAP officials readily saw the merits of public art that promoted the moderate agendas of black respectability and the integrity of Harlem. In the wake of the riots, white officials sought to accommodate the black establishment and deny that they supported the agenda of the radicals, who were also suspected of having incited the riots.[101]

The NAACP and the Urban League had good reason to be wary about public representations of African Americans. In early December 1936, Borough President Samuel Levy received vehement complaints from members of the Harlem clergy, the executive director of the Harlem YMCA, and an assistant district attorney. The subject was Anthony Pusterla's rotunda murals for the New York County Courthouse on Centre Street, completed under the auspices of the WPA and on the verge of being considered for the

4.5 Antonio Pusterla, United States Constitution and Emancipation, detail from dome mural, *Law through the Ages*, New York County Courthouse, 1936. (Collection of the Art Commission of City of New York, Exhibition file 739-BO.)

ACNY's final approval. The mural consisted of six sections, each representing "a period of the codifiers of the law from the earliest known law-givers to the present." Its background included a frieze "showing the evolution of the races during the various periods." In the extreme right-hand corner of the frieze in the section representing the U.S. Constitution and emancipation, Pusterla had included a caricatured grinning black boy grasping a large piece of watermelon (fig. 4.5).[102] The protesters insisted that the image was not "dignified enough for a mural" and was not "representative of the Negro race," and called for its removal.

The ACNY's painter member, Ernest Peixotto, was brought in to resolve the issue. Although Peixotto publicly insisted that the artist had not meant to convey "malicious intent" in painting the watermelon boy, he also averred that the figure could "very easily be eliminated." Soon after, at a meeting of Peixotto, Pusterla, and several representatives from the Harlem community, Pusterla agreed to replace the boy with the image of Frederick Douglass. An embarrassed WPA official put the issue to the press that "no disrespect for the Negro had been intended" but, rather, that the figure had been included for "'levity,' to brighten up the solemn picture."[103] The Harlem paper the

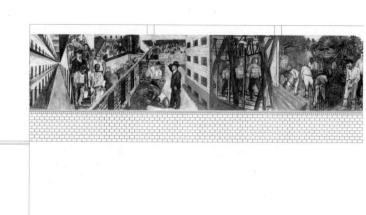

4.6 Ben Shahn, unfinished mural study for the Rikers Island Penitentiary, 1934–35. Reconstruction by Deborah Martin Kao; computer imaging by Michelle Tarnsey, Kao Design Group, 1999. (Courtesy of the Harvard University Art Museums, copyright President and Fellows of Harvard College.)

Amsterdam News acknowledged the "levity" of the situation and the stupidity of Pusterla's actions by recounting the story of the "Watermelon Mural" in a rhetoric of irony.[104] But the ingrained racial insensitivity of the day was such that even the most liberal of establishment art world and editorial representatives were not willing or able to acknowledge the true cause for offense. The headline in the *Tribune* story that discussed the controversy, "Negro Eating Watermelon Ruled off WPA Mural as Frivolous," avoided completely the issue of racial inequality and the slur conveyed by the stereotype.[105]

Rikers Island Penitentiary

With the courthouses, many New Yorkers agreed that the ACNY's requests for an adjustment of mural imagery were in good taste. The ACNY regarded minorities as a viable part of the public that deserved to be uplifted; when it

came to racially dubious murals, the commission's "pomposity" served a just cause. On another side, many of the same ACNY members were willing to risk charges of censorship on a project they believed to be socially subversive. The "bad art" that the ACNY sought to drive out in this instance was Ben Shahn's proposed murals for Rikers Island Penitentiary (1935; fig. 4.6). Here the ACNY again found itself confronted with the dilemma of provocative government public art. But whereas Pusterla's "watermelon boy" represented a disturbingly common point of view, the question raised by Shahn's mural became whether government-sponsored art should advocate antiestablishmentarian perspectives. In this instance, ACNY members ultimately decided that WPA-FAP ideals, emphasizing art as experience and as a vehicle of social liberation, were both disingenuous and extremist.

Shahn and painter Lou Block were no strangers to controversy. An avowed Socialist with ties to the Communist Party, Shahn had long painted and photographed images that protested the oppressions and injustices of the state. As collaborators on Diego Rivera's controversial Rockefeller Center murals, summarily destroyed (at the direction of Nelson Rockefeller) after Rivera refused to remove an unscripted depiction of Lenin, both were

familiar with the tactics of provocation and its potential consequences. Indeed, the censorious and destructive responses to Shahn's work often served to reinforce the very assertions of capitalist coercion that were the thematic core of his art.

Shahn and Block's project, initiated in the summer of 1933, gave no hint of any especially problematic content. Block wrote to the deputy commissioner for the New York City Department of Corrections proposing a mural "dealing with the progress of penology, from the earliest era research would disclose, through the present," and culminating in depictions of "plans" that the deputy commissioner and other corrections administrators envisioned "for the future." [106] In fact such a theme, evoking a diachronic and evolutionary trajectory often seen in Progressive-era murals, was an approach to subject matter with which many art observers were familiar.

Over the next year, the artists continued to lobby the Department of Corrections, as well as engineers and architects in the process of designing a new penitentiary on Rikers Island, informing them that the project could be funded with monies from the Temporary Emergency Relief Administration. In May 1934 Mayor La Guardia, along with his newly appointed commissioner of corrections, Austin H. MacCormick, approved the preliminary proposal for the mural project. An advocate for prison reform, MacCormick saw the project as contributing to his program not only by providing "socially conscious" images that would instruct and uplift prisoners but also by employing them in the project, thus engaging them in dignified, industrious labor and thereby contributing to rehabilitation. [107]

Subsequently, however, Shahn and Block abandoned their original linear emphasis. Block developed a design for a different section of the prison. Shahn modified his design program, instead offering a more comparative and contemporary message, consistent with the social realist concerns of much socially committed painting of the day. The designs sought to highlight social conditions and enterprises (like unemployment and poverty) that contributed to crime and to draw attention to ignorant and ineffective forms of penal justice and contrasted an "unenlightened" inhumane system (with police lineups and chain gangs, for example) with a "utopian," reformed prison system (with depictions of prison reformers, proper medical facilities, and inmates engaged in studying and productive work). [108] The orientation of the project thus shifted from an emphasis on progress to one of critique and revelation.

As art historian Deborah Martin Kao has shown, the panels would line a corridor leading to and from the prison chapel. The paintings celebrated reforms planned for Rikers, based in part on Shahn's photographs of a different reform prison in New Hampton, New York.

In January 1935 Shahn affixed his cartoons for the project on the corridor walls of the new penitentiary for ACNY review. On 14 February the commission disapproved it.[109] In the eyes of some observers, their actions represented art censorship, based on inappropriate reasoning that was beyond the ACNY's proper purview. Discussions of the mural story, generally sympathetic to Shahn and his art, have glossed over the question of why the ACNY responded as it did, pointing simply to the artistic conservatism of Stokes and especially of painter member Jonas Lie. Whether the ACNY's actions were, in hindsight, misguided, it is nonetheless important to understand the rationale behind their actions, especially in relation to the ACNY's dealings with the Harlem and New York County Courthouse murals.

From Lie and Stokes's point of view, Shahn's mural was bad art. They found the designs poorly articulated and rendered, too overtly dogmatic, and above all (although they did not state this outright), politically repugnant and potentially inflammatory. In contrasting the horrors of the old system and the vision of the new, Shahn's painting appeared to have generated several fundamental problems for Lie and other ACNY members. First of all, Shahn had sought to contrast the bad conditions of the old system with a more enlightened and humane prison, but Rikers was a new prison, and while reforms were planned for it, it was not clear that the experiment would bear fruit. Prisoners would encounter Shahn's view of the oppressive older stages, but one drawback was that enlightened conditions had not yet become a reality at Rikers. The cycle was ostensibly intended for visitors, but prisoners would also have seen on a daily basis murals that would be a constant reminder of their own lack of freedom. Rather than providing a vision of reform and uplift, the paintings highlighted the gap between ideal and reality.

From the ACNY standpoint, this artistic perspective made little sense. As with the Harlem murals, context and the subject's public also mattered. It was not just that they considered Shahn's vision to be false but that they also believed it had the potential to foment disillusionment, discontent, and disorder among prisoners—criminals who might not read the mural in its totality or find their current conditions living up to those pictured for Rikers. The vision and goals of prison reform put forth by Shahn was not a consensual one, moreover. Administrators like MacCormick believed in humane treatment—productive labor, training, and rehabilitation of prisoners—to prevent recidivism. Conservatives dissented from this more liberal approach, believing that the individual, not the system, was the problem; they were unconvinced that reform measures were the most suitable methods of rehabilitation or that hardened criminals were even capable or deserving of being reformed. Informed by such opinions, Lie and Stokes were not persuaded that prisoners were the sort of people who really ought to be encouraged (or priv-

ileged) to engage in debate about the nature of prisons, criminality, reform, and their relations to society, the matters probed by Shahn's proposed murals.

All of these concerns likely informed Lie's and the ACNY's decision to disapprove Shahn's murals. Finding it impossible to draw rigid lines of separation between form and "antisocial" content, and believing that "crude" paintings reminding prisoners of their misfortunes and fates would only serve to rile them, the ACNY, following Lie's lead, extended its powers of aesthetic review to include assessment of Shahn's murals' aesthetic and psychological appropriateness for their prison setting. For this reason they disapproved the murals as public art. Stokes recalled that he could not bring himself to approve Shahn's "sordid" depictions, "painted in the crudest and most blatant and offensive modernistic style," "contrasting the horrors of the old with the scarcely less repulsive new methods of punishment in our prisons."[110]

Shahn and his numerous supporters within the worlds of art and labor were infuriated with the commission's actions, which they contended were tantamount to police suppression. Although some of the more seasoned leftists must have anticipated that problems might arise with an artist like Shahn (and indeed, may have anticipated a good opportunity here to thumb their noses at the establishment), many nonetheless were shocked, especially in the wake of the destruction of Diego Rivera's murals just two years earlier. Lie—who as president of the National Academy of Design was reviled by many leftist artists for his virulent conservatism, outspoken calls to "whitewash" New Deal mural painting, and his support for the destruction of Diego Rivera's murals for Rockefeller Center—received special condemnation. A series of attacks ensued in the art magazines and called for overhauling of the ACNY to "be replaced by one elected by a democratic vote of delegates representing all the organized bodies of artists of New York City, a Commission which will truly represent the artists, which will be aware of the problems confronting artists, and capable of judging art on its own merits."[111]

Although initially favoring the murals, MacCormick was unnerved by the controversy and the accusation that the murals were psychologically unfit for prison populations. He brought in a psychologist to take a survey among a group of prisoners, selected as "representative," to see how they responded to the murals. The survey had four questions that asked what the prisoners thought of the murals and how they thought others would react. The majority (ninety-seven) responded favorably, although twenty-two were "indifferent" and ten unfavorable; thirty-one did not respond.[112] Stokes was incredulous. Such behavior underscored for him all the more the threat to standards represented by the twinning of social consciousness and self-expression embraced by the New Deal art projects, artists on the left, and now, apparently municipal bureaucrats. "From this exhibition of intelligence

I am wondering whether our mayor will feel that the 'favorable majority' of these gentlemen have qualified for appointment to membership on the Art Commission." [113] This project reinforced his convictions, and those of ACNY members like Lie and Erskine, that this official municipal body was essential: New York needed its art commission to insure that offensive, poorly crafted art—be it pictures that derided or otherwise injured reasonable citizens or that fomented disorder and empowered criminals over experts as art connoisseurs—would not represent the city's aspirations.

The Artists Union and other Shahn supporters remained outraged by the ACNY's decision, highlighting its class dimensions and condemning the commission as narrow-minded oppressors, representative of conventionalism and creaky obsolescence. Like La Guardia in 1934, they, too, began agitating to restructure the ACNY, to make it more representative of and responsive to artists. In 1935–36, the height of the labor movement and of the influence of the Communist Popular Front, the artists' protests were very visible. The city was in the midst of preparing for charter reform; thus with artists on the left adding their voices to the mix of the ACNY opposition, the ACNY's future was uncertain. Notably, however, La Guardia remained relatively silent on the matter, and for better or worse, MacCormick by 1937 seemed to have decided that the commission was right—or so he said. [114] Shahn's Rikers Island project was never realized.

Self-Preservation

The ACNY was beleaguered by these events, but other experiences had a more positive outcome for the institution. Stokes's regulatory activism ultimately bore fruit, from members' points of view. Contemplation of the Artists Union's proposals appeared to send La Guardia over to the ACNY's side. Perhaps La Guardia became persuaded in mid-1935 of what Stokes—and Carrère, Root, Warner, and De Forest before him had argued all along. La Guardia may have surmised that eliminating the ACNY or transforming it from a regulatory body to an initiating committee, appointed by the mayor, had potentially dangerous consequences. With the mayor constantly subjected to intense political pressure, an initiating agency risked being corrupted or co-opted by artists on the radical left (the outcome sought by the Artists Union) or some other extremist group. Without some form of autonomous patrician monitoring, as was built into the current ACNY structure, the mayor might well lose independence, not acquire more power; and surely, then, the city's beauty and culture would be undermined as well.

The Harlem, Rikers Island, and WPA-FAP controversies more generally confirmed the belief among members of the reform political establishment

that the ACNY as currently configured was good for New York. The outcome was that in 1937, the charter, far from eliminating the ACNY, extended its powers, adding a landscape architect to its membership and codifying its authority as curator of the city's art collections and as guardians of New York City's "heritage." Having succeeded in protecting the ACNY legacy as he envisioned it, the vindicated Stokes retired in 1938.

WARTIME NEW YORK AND ITS AFTERMATH

With the city's attention and economy focused on the war effort between 1939 and 1945, the ACNY acted on a fairly "light schedule," reviewing projects like signage, plaques, pedestrian bridges, and the remainder of the WPA murals.[115] The work could not have been overly time consuming, for busy IBM CEO Thomas J. Watson saw fit to serve as lay member during this period.[116] At the same time, the war put the ACNY on guard against a feared new threat: Nazi bombs.

At the urging of Assistant Secretary Georg Lober (himself a professionally active academic sculptor) and clerk Betty Fielding, the ACNY found an augmented role in insuring that the city's art collection would be properly protected. In 1942, the ACNY recommended to Parks Commissioner Moses that "the statues of Hale, Farragut and Sherman be boxed and that the boxes be protected by sandbags for greater safety during the war period."[117] Such measures were deemed preferable to the alternative fate, suffered by a numbers of Civil War cannons and cannonballs that were melted down as scrap for the war enterprise.[118] The ACNY's staff coordinated the removal of the City Hall portraits to Whitemarsh Hall ("the 150-room residence of the late Edward Stotesbury, near Chestnut Hill, Pennsylvania"), where they were hidden away with artworks from the Metropolitan Museum of Art.[119]

The ACNY was helpless to prevent the usurpation of the Governor's Room for Grover Whalen's Office of Civilian Defense volunteers. To the chagrin of the ACNY, already engaged in battle with La Guardia over proposed select modernizations of the City Hall interior, the Office of Civilian Defense "pushed the beautiful old furnishings into one corner and had spread themselves over the remainder of the room," and workers reportedly wiped "their pens on the window draperies" and left "cigarettes and chewing gum on the picture frames."[120] After the war the ACNY embarked on a new phase of its ongoing public relations campaign to claim the Governor's Room as a historic museum. The power struggles and small stage the ACNY occupied in wartime, however, would be underscored by events that occurred afterward.

Under Stokes's successor, Blum, the ACNY was relatively low key, engaging in relatively little activity compared to that of earlier years. After World

War II, with the ascension to the presidency of ACNY by William Adams Delano, a well-connected architect in the older Stokes tradition, the commission stood on relatively firm ground.

Delano (1874–1960), who studied at Yale (BA) and Columbia University School of Architecture, worked as a draughtsman for Carrère and Hastings before setting up his own firm with Chester Aldrich in 1903. Delano and Aldrich became renowned for their neo-Georgian and colonial style clubs and elegant city and country residences. Architect and planner for many major federal and civic structures (including the Federal Triangle plan and the post office, and the Japanese Embassy in Washington, D.C., the American Embassy in Paris, and the Marine Air Terminal at La Guardia Airport), Delano served on the national Commission of Fine Arts from 1924 to 1928, on the U.S. Treasury's Board of Architectural Consultants from 1927 to 1932, and on the National Capital Park and Planning Commission from 1929 to 1946. He served on the ACNY from 1939 to 1954 as New York Public Library representative. Delano knew how to maneuver in artistic and political worlds and, like Stokes, had ties to influential men, like the Rockefellers and Roosevelts.[121]

For the twenty years following Stokes's retirement, the ACNY's relations with Moses, not the mayor, would shape its agendas and activity. Stokes's legacy was such that the ACNY could fight a dynamic figure like Moses and occasionally persuade him to cooperate. Under Delano's leadership, the ACNY remained sufficiently empowered to take on big issues in the form of Moses's proposed Battery Bridge and Castle Clinton. These struggles, centering on parks, structures, landmarks, and national security, enabled the ACNY to assert its position as the bureaucratic authority of last resort on matters of preserving municipal property.

Battery Bridge

In January 1939 Moses proposed a bridge, extending from Battery Park to Hamilton Avenue in Brooklyn, to link lower Manhattan with the terminus of a planned new elevated highway (which became the Brooklyn-Queens Expressway). Moses had originally proposed a tunnel but switched to the more monumental bridge idea at the last minute, contending that it would be less expensive.[122] He proposed the bridge plan in the context of a redesign of Battery Park. There, three large piers would support a low causeway leading to the bridge; the causeway would connect to an extension of the West Side Highway.[123] Battery Park had long been associated with the Anglo-Dutch era of New York City's history. It had become a favored site of memory and was populated with monuments (like the Verrazano statue), but the

park itself was not deemed special. However, the bridge elicited a huge out-
cry from civic groups, fearful of the impact of traffic and of the hulking piers
and roadways that would cut a swathe through Lower Manhattan. As head
of the Triborough Bridge and Tunnel Authority and member of the new
City Planning Commission (established in 1938), Moses wielded all his
power to move the project forward. The opposition, including influential
figures like Manhattan borough president Stanley Isaacs, Regional Plan As-
sociation president George McAneny, and lawyer, preservationist, and ac-
tivist Albert Bard, seemed helpless to stop him.[124]

In desperation, civic, planning, and good government groups pressed the
ACNY for a hearing. Arguing that the ACNY was empowered to put a stop
to the bridge, they sought to take advantage of the elite, narrow structures of
operations from an earlier era and to corral the ACNY, an ostensibly impar-
tial body, in support of their cause. The attempts were unsuccessful. The
New York City corporation counsel determined that because the Narrows
passage was crucial to the city's security, the project was under U.S. War De-
partment jurisdiction, and hence the ACNY was forced to review the Battery
Park designs independent of the bridge.[125] The War Department, however,
ultimately put a halt to the bridge project, citing security concerns. In the
end, as Robert Caro has shown, the personal ties between reformer Charles
Culp Burlingham and Franklin and Eleanor Roosevelt proved to be crucial
in influencing this decision.[126] The ACNY had been unable to alter the
course of events, but the vote of confidence was helpful in steeling member
resolve in its subsequent battles with Moses.

Castle Clinton

The ACNY, under Delano's stewardship, pitted its ideals of an older, "civic"
New York against Moses's modern metropolis of efficiency. Still smarting
from his losses over the Battery Bridge, Moses was determined to reconfigure
Battery Park and Lower Manhattan. He presented a plan for Battery Park
to the ACNY in 1939. This design, reviewed separately from the bridge, was
approved.[127] But a proposal to tear down the popular aquarium, housed
in the historic old fort Castle Clinton (fig. 4.7; constructed as West Battery
during the War of 1812), once again put Moses on a collision course with
civic groups.[128] In February 1941, he declared Castle Clinton "obsolete."
Anticipating that his bridge would require that the building be demolished
anyway, he announced plans to demolish Castle Clinton and to build a
modern, new aquarium. Despite heated public protest, Moses closed the
aquarium, cordoned off the park, and in 1942 began demolition of Castle

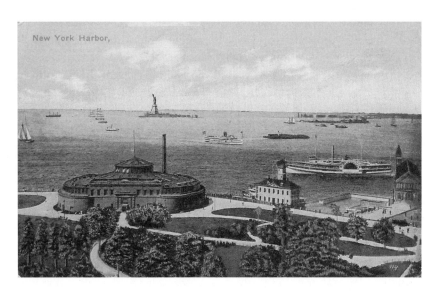

New York Harbor,

4.7 New York Aquarium (Castle Clinton), postcard, circa 1920. (Collection of author.)

Clinton.[129] In 1947, however, Moses was forced to face off with the new ACNY president over prioritizing fish culture versus material culture.

Mustering up all the forces of the established civic organizations, Delano embarked on an extensive campaign to save Castle Clinton, thus positioning the ACNY squarely at the center of the preservation battle. Although initially hesitant, Delano had been prodded to insist on extending the parameters of the commission's jurisdiction to include the protection of historic structures on municipal property. He argued that Castle Clinton—as a work of art— could not be destroyed or "relocated" without ACNY approval.[130] Moses, with the Board of Estimate on his side, authorized demolition contracts. Delano refused to be defeated and worked on lobbying Congress. Moses started to demolish the building anyway. A lawsuit was successfully brought against him in State Supreme Court, which issued an injunction to stop work. Moses appealed. Ultimately, however, Delano and others convinced President Harry S. Truman to declare Castle Clinton a National Landmark.[131] Truman's actions removed Castle Clinton from the ACNY's hands but also from Moses's. Delano's activism thus helped the ACNY consolidate its position as guardian of New York City's building heritage in the years before the establishment of the New York City Landmarks Preservation Commission.[132]

That curatorial role was bolstered during the Cold War, another period of vigilance around City Hall.[133] In 1950 the commission successfully fended off a renewed attempt, on the part of the Office of Civil Defense, to usurp

the Governor's Room as "supplementary quarters" for Civil Defense office staff. After the notorious World War II experiences in which Office of Civilian Defense workers "seriously damaged historic objects," Delano and sculptor member Wheeler Williams were determined to prevent the room from being used as anything other than a museum.[134] By 1955, the commission had effectively sealed off the room as a site of mundane bureaucratic activity and established its reputation as a "hallowed" "historical shrine" (fig. 3.19).[135] The commission, in turn, had now gained positive repute as the "watchdog of the city's art."[136]

COLD WARS

Good Neighbor Monuments

The canny Moses fought the ACNY's authority but was also aware that he could use that authority to his advantage, especially when it came to monuments. In the case of the José de San Martín memorial (fig. 4.8), for example, Moses pressed the ACNY for help with a monument he deemed aesthetically and politically troublesome. In 1949 ACNY members became participants in the ongoing enterprise, stepped up since the onset of World War II and the passage of the Act of Havana, of consolidating diplomatic ties with Latin America.[137] New York urban space again became a crucial stage for acting out symbolic gestures of U.S.-South American friendship in an effort to keep those countries out of the Communist orbit.

As a part of that venture, city officials, responding to a move begun in 1939, undertook a series of reconfigurations of urban space, symbology, and memory to highlight hemispheric trade and friendship. In 1945, for example, Sixth Avenue was renamed Avenue of the Americas. In turn, the Argentinean government offered the city a replica of a statue of its great "liberator," José de San Martín, intended to complement that of Sally James Farnham's Simon Bolívar memorial (fig. 3.4), already standing in Central Park. Mayor William O'Dwyer, responding to requests from the Argentinean and Venezuelan governments, proposed a plan to place the San Martín memorial in a park at West Fourth Street and Avenue of the Americas. It would cap the end of the boulevard. The Bolívar statue would be moved from Eighty-second Street to the north side of West Fifty-ninth Street (Central Park South) and the re-named Sixth Avenue to culminate the vista at the north end.[138] Moses, who had since 1941 been resisting pressure to develop some kind of Latin American Hall of Fame at the Bolívar memorial's West Eighty-second Street site inside Central Park, was happy to entertain the concept of moving the statue to the park's southern end. As was often his practice, he immediately and

4.8 Louis Joseph Daumas, José de San Martín monument, dedicated 25 May 1951, Central Park South
at Avenue of the Americas. (Photo by author.)

without consultation signed contracts to begin the work. Only then did the
parks department submit the projects to the ACNY. The ACNY, angered at
not being consulted first and displeased with the particulars of the statue's
relation to its proposed site, disapproved the design.[139] Although the disap-
proval caused friction between the ACNY and Moses, O'Dwyer was more

conciliatory. In November 1949, the ACNY approved a revised plan to place both the Bolívar and the San Martín statues on a new, relandscaped site at Central Park South and Avenue of the Americas.[140] Thus after a showdown, all parties came to a resolution.

Jewish Martyrs' Memorials

Moses and the ACNY stood on common ground when it came to the complex situation of post–World War II memorials to Jewish victims of Nazi genocide. Here, the commission and Moses joined together to protect in very delicate and sensitive circumstances what they believed were the city's interests against politically influential and vocal Jewish constituents. The ACNY-Moses alliance, combined with ideological divisions between Moses and memorial sponsors and among Jews themselves, created profound and irreconcilable differences that proved the endeavor's undoing.

In 1947 a committee headed by Polish News Agency editor A. L. Lerner and textile manufacturer Ira Rogosin commissioned sculptor Jo Davidson and architect Ely Jacques Kahn to develop plans for a memorial to the forty thousand victims of the Warsaw Ghetto uprising.[141] Moses made a tentative agreement to place a fifty-by-fifty-foot granite and bronze memorial in Riverside Park at Eighty-fourth Street. In a ceremony 17 October 1947, the memorial group laid a simple square cornerstone on the promenade, where it can still be seen today. From that point onward, the project became in Moses's words, "the subject of seemingly endless discussion and controversy," most of which was "private and off the record."[142] Also off the record, the dispute was integrally bound up with Moses's own standing as a wealthy and assimilated German Jew who had succeeded within the worlds of the cultural and political elite, dominated by white Protestants, by disassociating himself from any overt "Jewish" identity.

Davidson developed a model, depicting "the last of the survivors in the Warsaw citadel." It consisted of a fifteen-foot bronze figure on a forty-foot base. Moses characterized the work to Delano as "a pretty bloody and terrifying business, and obviously a conception that could not be approved."[143] In Moses's (and Delano's) view, restraint should be exercised in public memorials with the city's imprimatur. Identifying with a then-prevalent centrist "Judeo-Christian" ideal of nationality, Moses could not relate to the anguish conveyed by the proposed memorial's subject, style, and scale.

As it happened, the memorial committee was not happy with Davidson's designs either, and "bitter arguments" ensued. Moses intervened, telling the memorial committee to pay Davidson and start again.[144] The group proceeded to solicit new designs from sculptors William Zorach and Chaim

4.9 Ivan Mestrovic, sculptor, and Erich Mendelsohn, architect, proposed Memorial to Six Million Jews of Europe, 1951. (Collection of the Art Commission of the City of New York, Exhibition file 2875-A4).

Gross and architects Percival Goodman and Erich Mendelsohn. "In the course of the months that followed," Moses recalled, "all sorts of fantastic and even pathetic drawings were shown to us."[145] Goodman contended that the committee had selected his idea in October 1949 (and a *New York Times* article corroborated this) but dropped him when Moses objected to the "severe modern lines" of the scheme, a plaza with a stone pylon and huge menorah, which would "tower" sixty feet above the Henry Hudson Parkway. Moses objected to the design not merely because of its severity but also because of its size; he feared that a gigantic monument would distract parkway drivers and cause accidents.[146]

The committee ultimately gave the commission to Mendelsohn and sculptor Ivan Mestrovic. Their design (fig. 4.9) called for a platform with stairs leading to a second platform at the end of which was an enclosing wall surmounted by two eighty-foot high tablets with the Ten Commandments, bordered on the long side by a hundred-foot bas-relief of figures, representing "the struggle of humankind to fulfill the Commandments," and "urged on by a giant" sculptural rendering of the biblical Moses.[147] Robert Moses was concerned about the pylons' height and the fact that the Ten Commandments

inscription was in Hebrew. He urged Mestrovic to reduce the scale from eighty to seventy feet, but the sculptor insisted that change of scale would destroy the design. Moses told the memorial committee that the inscription was "too inflammatory" and edited it. He also urged the group to include "a quotation from the Sermon on the Mount relating to the Ten Commandments" to give the memorial a broader Judeo-Christian appeal. The sponsors "flatly refused" to do so.[148]

Delano, ACNY president at the time, had similar concerns. Indeed, at ACNY's meeting of 9 July 1951, the commission had a tie vote on the memorial. They asked to see a model to gauge bulk and dimensions and asked for a reduction in scale.[149] Delano and Moses conferred privately and collegially, in a manner that intimated a personal friendship, about what actions should be taken. Moses averred that "in light of the entire history, I am firmly of the opinion that we should all approve the present design, subject possibly to a further reduction of height."[150] Evidently concurring, Delano pushed the commission a week later to approve the resubmitted designs, now retitled the American Memorial to the Six Million Jews in Europe (referring to the holocaust).[151] He then issued a statement, pointing out several concerns: first, that the inscriptions would "arouse controversy and very likely, race feeling" and, second, that many "so-called Christians" as well as Jews were familiar with and abided by the Ten Commandments and thus that "they might better be inscribed in English than Hebrew."[152] Delano's suggestion that the Ten Commandments be inscribed in English presented difficulties, to say the least. As many Jews and Christians were well aware, interpretation of the Ten Commandments varied depending on whether the version used was Catholic or Protestant. (The second commandment in the Protestant King James version, which admonishes that "thou shalt not make unto thee any graven image" [Deut. 5:4] is not included in the Catholic Ten Commandments.) Seemingly unaware of this troublesome issue, Delano then pointed to his principal, architectural objection to the memorial: that the tablets of the law were too tall and looked "unstable." This was unsuitable for a "great and enduring" monument.[153]

Two months later, however, more problems arose. Memorial sponsors and Moses remained divided, as did the Jewish groups themselves. Rogosin reported to Moses that the committee refused to include a New Testament inscription as he had demanded.[154] The inscription that Moses insisted be changed was never altered, and he threatened to annul his earlier approval. When Moses subsequently learned that the committee had never paid Davidson for his work, he was even more infuriated and withdrew the approval. "It would take more superlatives than I could muster to tell you how

disgusted I am with this entire subject," Moses informed one of the committee members.[155]

Moses's decision rendered the ACNY's approval moot. The memorial committee denied it owed Davidson any back pay. Davidson's lawyers disagreed.[156] Mendelsohn was equally chagrined when Moses told him of the problem, telling Moses that he "sincerely" deplored "this unfortunate situation." He refused to be further involved with the project until the situation was resolved. Although Davidson's estate (the sculptor died in 1953) came to an agreement with the memorial committee and the claim was dropped, the entire process nonetheless continued in free fall.[157]

Memorial proponents regrouped some twelve years later. In 1964, two ostensibly different groups submitted new proposals to the ACNY, both for the same site and by the same artist. The first was a memorial to "the self-inflicted martyrdom of Shmuel Artur Zygelboim," who in 1943 committed suicide in London to draw attention to the world's unresponsiveness to the plight of the Jews in Poland (fig. 4.10). Resonating with the then-recent (11 June 1963) self-immolation of Vietnamese monk Thich Quang Duc in Saigon, the bronze Zygelboim memorial was a contorted, expressionist figure of a man tilted to the side with his arms flung out, "calling to humanity for rescue," his lower extremities engulfed in thorns and flames—"all of it extremely strained," as the submission form described it.[158] The second, a memorial to the Six Million Jewish Martyrs and Heroes of the Holocaust (fig. 4.11), consisted of two forty-by-twenty-six-foot wide concrete scrolls with "episodes of Jewish Martyrdom and heroism" carved with wall inscriptions listing names of "infamous Nazi concentration camps and places of Jewish heroic resistance." The artist, Nathan Rapoport, had created memorials to Warsaw Ghetto resistance in Warsaw, Yad Vashem, and Philadelphia.[159]

An ACNY committee made up of sculptor Eleanor Platt, architect James Marsden Fitch, and notably, Edward Blum rejected both memorials: the Zygenboim because it showed, in Platt's words, " 'so tragic a posture' that 'it might distress children in the park'"; the scrolls, for being "excessively and unnecessarily large." "Construction of the monuments "would set a highly regrettable precedent," she stated (evidently unaware of the Heine and Slocum memorials), potentially providing "an opening for 'other special groups' that wanted to erect memorials on public land." Specifically, Platt wrote, "The figure is depicted in so tragic a posture that it does not seem appropriate for location on park land intended for recreation and relaxation. . . . It does not seem desirable to confront children with sculpture of such distressing and horrifying significance, worthy as it might be in a more relevant place. I can reach no other conclusion than that a public park is not a proper place for it."

4.10 Nathan Rapoport, Artur Zygelboim Memorial, disapproved 28 January 1965. (Collection of the Art Commission of the City of New York, Exhibition file 2287-AY.)

4.11 Nathan Rapoport, memorial to Six Million Jewish Martyrs and Heroes of the Holocaust, disapproved 28 January 1965. (Collection of the Art Commission of the City of New York, Exhibition file 2287-AW.)

When asked by the *New York Times* whether this work were not in effect being held to a different standard, since there were other memorials dealing with violent themes, Platt effectively dug herself deeper into a hole by drawing a distinction between the Holocaust events commemorated here and "American history."[160]

Other city memorials, she noted, were generally patriotic and had to do with this country "holding its own. It's American history." Platt's remarks infuriated the *Times* and many Jews, who regarded the atrocities inflicted on the Jews in Europe as in fact integrally bound up with American history.[161] Although not anti-Semitic, Platt regarded the vocal and visible ethnic character and interests that post–Nazi era New York Jews articulated as alien. For many of her class and background, American history was a history still bound up with the Anglo-Dutch past. In 1965, that pervasive mindset was only just beginning to change.

The tenor of Platt's remarks must be understood not merely in relation to ethnic and religious tensions but also urbanistically, in relation to long-standing attitudes toward what constituted "appropriate park purposes." For Platt, it was not just the fact that Jews represented a "special group" but also that she feared the long-term impact of allowing any group or particular constituency to erect a memorial of that scale and style in Riverside Park. As in the late nineteenth century with the Soldiers' and Sailors' Monument, the memorial raised the issue of what parks were for. Were they open spaces, ripe for development as sites of commemoration? Or were they meant to remain basically structured landscapes, organized for active recreation and peaceful leisure? "How would we answer other special groups who wanted to be similarly represented on public land? . . . In an attempt to treat all equally we could well end up with a profusion of such memorials and become responsible for a progressive violation of the basic concepts for park land use."[162]

Platt blundered not only in making remarks that seemed tinged with anti-Semitism and seemed, at the least, insensitive but also in begging the question of the "basic concepts for park land use" at a historical juncture when those concepts were being debated.[163] In 1966, after all, a new parks commissioner, Thomas Hoving, would open the parks up to a host of "special groups," hosting rock concerts, "be-ins," and a range of other untraditional activities that had an impact on park aesthetics. Platt, a New Yorker with traditionalist views of parks advocacy, was less capable of envisioning how the magnitude of the Nazi atrocities might alter the physical and emotional landscape of city parks as secure, serene spaces.

Members of the ACNY committee obviously shared Platt's point of view on parks but were surely aware that politically it was incumbent on them to

4.12 Neil Estern, Memorial to Six Million Jews of Europe, preliminary approval, 13 December 1965. (Collection of the Art Commission of the City of New York, Exhibition file 2875-E3.) Estern sought to impart a universality to the message by depicting in bronze relief the image of Cain and Abel to evoke metaphorically the horror of man killing his brother man. Estern recalled in conversation with the author (10 March 2004) that a rabbi on the memorial committee, an Auschwitz survivor, considered the symbolism to be unacceptable, contending that the Nazis were not men but beasts. According to Estern, the rabbi was so adamant that the committee ultimately could not reach a consensus and its members resigned. At that point, the project fell apart.

approve some memorial somewhere. Indeed, the ACNY did approve a significantly pared down plan by sculptor Neil Estern for a memorial at Lincoln Square, at Broadway and Sixty-sixth Street, across from the new Lincoln Center (fig. 4.12) and, subsequently, an expansive design by Louis Kahn for Battery Park, between Castle Clinton and the Hudson River promenade. The aesthetics of restraint, so prevalent among earlier ACNY members, also prevailed in form, scale, and emotional expression in the post–World War II era.

For memorial sponsors, the ACNY approval proved to be a hollow victory. Aesthetic and political divisions dragged on, outlasting Delano, Moses, and Platt. The ACNY was only one obstacle among the gaggle of fighting groups. Ongoing fractures between Jewish organizations over the intellectual and artistic viability of the designs resulted in the realization of neither one.[164]

THE ACNY IN DECLINE

Bureaucratic Competition

That the ACNY was only one party among many involved in the previous dispute was indicative of the dissolution and fragmentation of its powers and purview during the third quarter of the century. The commission continued to scrutinize a wide array of projects—hospitals, schools, parks, bridges, tunnels, plants, libraries, health centers, and piers—but addressed them in isolation, with little authority to engage with broader visions and agendas.[165] Hence while the ACNY continued to improve on individual works, the commission's cumulative impact became less obvious.

By 1960, the ACNY's voice in urban design affairs had been weakened by the consolidation of power within some large agencies, combined with a fragmentation and flagging of influence among some of the ACNY's core supporters and constituencies among nongovernmental organizations (like the MAS). Delegation of power to public-private authorities altered the scope of the commission's work and the political picture. The sweeping jurisdiction of the public authorities—a product of the Depression era—meant that the ACNY was not brought in to review of some of the city's major projects. The Moses-run Triborough Bridge and Tunnel Authority was but one of several special government agencies (like the New York City Housing Authority and the New York City Transit Authority) empowered to bypass standard city review processes.[166] With his hand in most of the major government organizations of the postwar era, the increasingly unstoppable Moses continued to push through the projects—and designs—that he wanted.

Expansion in other areas in the city bureaucracy also had the effect of usurping additional aspects of the ACNY's domain.[167] Over time, the Department of City Planning had become increasingly powerful—thanks in part to Moses's role as a commissioner on that board. Taking on the broader view of regional development, the Department of City Planning now dealt officially with areas of action (such as land use) with which the ACNY had dealt informally before and which it hoped to continue to oversee at the turn of the twentieth century.[168]

The ACNY lost traction in the realm of landmarks as well. On 19 April 1965—in the wake of the destruction of McKim, Mead, and White's Pennsylvania Station—the passage of a Landmarks Preservation Commission Law vested official authority for preservation in an unpaid eleven-member board with subsequent enforcement capabilities and real political clout. The new agency, established to designate private properties as well as the municipal

built environment, usurped to a certain extent the ACNY's role as guardians of New York City architectural heritage. The ACNY nonetheless continued its oversight role on sculpture conservation projects (see app. A).[169]

By the early 1960s, with no strong president or presence and with much less direct contact with the mayor, the commission, as Parks Commissioner August Heckscher (a lay member of the ACNY from 1959 to 1962) recalled, was a bit at sea. The ACNY continued with the same reviews it had always done, but its detail-oriented scrutiny of city building elevations, as opposed to a hands-on implementation of its ostensible status as oversight agency, seemed to relegate it to a more marginal place within city government. According to Heckscher, the ACNY operated, moreover, under intimidation, and simply did the mayor and Moses's bidding when it came to development. Members concerned themselves with elements like plaques and artwork (as was their mission) but were powerless to act on significant structures that represented "the major portion of buildings in the City."[170] In addition to the virtually autonomous authorities, "powerful" "moneyed" bureaucracies like the Board of Education pushed through mediocre designs for schools, and the commission would approve the plans for fear of reprisal (such as, presumably, being circumvented or eliminated).[171] The ACNY gave approvals, as well, for dubious design and land use projects in the early 1960s, like the proposed modernist glass Huntington Hartford Pavilion Café for the southeast end of Central Park and the tiered, boxy, and contentious Columbia University Gymnasium in Morningside Park. Troubled as the commission members were by the Hartford Pavilion project in particular, they felt pressured and obligated to review the design as discrete, without considering the structure's impact on the aesthetics of the larger landscape setting.[172] In contrast to the days when the ACNY held up construction of the Hell Gate and Henry Hudson Memorial bridges, its power to delay or reject any huge project was limited at best.

As Wallace S. Sayre and Herbert Kaufman observed in their 1960 *Governing New York,* although the charter gave the ACNY "extensive powers as an overhead agency," it also enabled officials to put a check on that authority. The charter stipulated that a given project could go forward if the ACNY did not act on the submission within sixty days. Thus "the sixty day limit on its actions over the great number of submissions is squeezed against the spare time resources of Commission members" and its two full-time staff members. According to Sayre and Kaufman, city officials capitalized on the fact that "what the Commission cannot inspect, it cannot disapprove." If the ACNY's "resources" were consumed "for weeks" by "one major battle," then the other projects left unattended for lack of time and energy would end up going forward.[173]

From the vantage point of line-agency heads, the ACNY was merely a bureaucratic hindrance, an aspect of development and public culture that they preferred to ignore. "I would say it's a sort of gentle influence on public buildings but not really a crucial factor," was Heckscher's blunt assessment. "Still I go around the town and see things and think, good God, I passed that when I was on the Art Commission!" [174] Thus the ACNY's peculiar "liminal" semipublic status worked against it once there was no Stokes or Delano out in front, pressing to publicize the commission's presence and purpose.

By the mid-1960s, the ACNY was in a no-win situation. Its decision-making process had begun to be buffeted by New York's political strife, multiple and conflicting constituencies, the powerful Board of Estimate, and city agencies. Thus the commission was pushed increasingly to the sidelines, except in instances where bureaucrats felt that the power of its opposition could be used on their behalf—as with the case of Moses and the Jewish martyrs' memorial or the proposed Adele Rosenwald Levy playground for Riverside Drive between 102nd and 105th streets (to which the ACNY did give preliminary approval). [175] With these projects, ACNY review served as cover for line-agency commissioners and their agencies, enabling them to avoid or deflect some of the political heat. The ACNY could legitimate the bureaucrats' aesthetic tastes when dealing with political enthusiasts. Such realities had offered a useful lesson to future agency heads like Parks Commissioner Heckscher. In hindsight, he recalled, his work on the ACNY taught him how the city operated. He could use his ACNY experience to his advantage. [176]

Lindsay and Urban Transformation

How the city worked or did not work was a central preoccupation of municipal bureaucrats, politicians, architects, planners, academics, and ordinary citizens during the administration of Republican John V. Lindsay (1966–74). The new mayor, determined to implement reforms in the city's cultural structures as well as in its social and political sectors, undertook to improve the realm of public design. His efforts portended good and bad times for the ACNY. One of Lindsay's proposed methods of solving big problems was to reduce the bureaucracy. To that end, his new commissioner of parks, Thomas Hoving, proposed to swallow up the ACNY and the Department of Cultural Affairs into a single "super agency." Hoving succeeded in incorporating Cultural Affairs (the agency was renamed Parks, Recreation, and Cultural Affairs). The ACNY remained intact, however, because it sustained the power of the mayoralty and because reconfiguring or abolishing the commission would have required a city charter revision—a time-consuming and difficult process that was considered not worth the bother. [177] Hence the

charter continued to empower the ACNY and protect its "independence" as an (overlooked) "oversight" agency (as Kaufman and Sayre described it at the time).

One of Hoving's key reasons for wanting the ACNY under Department of Parks' management was to control its membership. The current commissioners were doing a "creditable job," he stated, but their views on art tended "to be overly traditional."[178] In 1965, for example, the ACNY just barely avoided rejecting Henry Moore's sixteen-foot-high *Reclining Figure* for the northern plaza of Lincoln Center (a project of which Hoving's predecessor Newbold Morris also disapproved). Acknowledging that the commission would not be legislated out of power, Lindsay followed Hoving's recommendation that the membership instead be brought "up to date," to include people who would at least be sympathetic to modernist art and design.[179] Thus, for example, he appointed the expressionist constructivist Seymour Lipton as sculptor member to replace the now-controversial Eleanor Platt.

The young Lindsay (1921–2000), a cultivated Yale-educated former congressman from the Silk Stocking District of the Upper East Side, was committed to improving the design quality of municipal government structures. Soon after taking office he formed, within the Department of City Planning, the Mayor's Task Force on Urban Design, and following that an Urban Design Group that developed recommendations. The goal was to improve the overall quality of submissions and to formulate better rules to attract good architects and strong, modern designs, like the program James Stuart Polshek conceived for bus shelters. Making design excellence an integral part of the urban fabric had a larger mission in mind: to have an ideal built environment that contributed to solving big problems like racial conflict, middle-class white flight, and social alienation.[180]

Lindsay's design groups and task forces took some of the work pressure off the ACNY but, at the same time, rendered its role less significant. The Urban Design Group's mission was consistent with its concerns, but technically speaking, it marginalized the ACNY. Meanwhile, the Urban Design Group's grand plans and recommendations did not materialize to the degree that had been hoped for. A mounting recession strained the city's budget and put a damper on new initiatives. The federal government did not come to the city's rescue as it did during the Depression.[181]

The ACNY had had its problems in the 1920s, but by the 1960s, the agency had become somewhat overwhelmed within the city bureaucracy. Yet because it continued to serve a function for the mayor, the borough presidents, and other municipal officials, they did not see fit to try to legislate the ACNY out of business. Hence the commission continued to carry on with reviews and with tweaking the details of projects, sometimes more productively than at

other times. By the mid-1970s, however, the point at which administration officials could truly appreciate the ACNY's services in improving the cityscape, the city's economic crisis left the commission's volunteer members with little to do. In 1974, the total number of submissions was 190 (many of these federally funded), down from 250 in 1970. With funds for capital projects drastically reduced, many projects were put on hold.[182] In the 1980s, the city returned to financial solvency, but it was afflicted by national travails. New York City's terrain—the locus of ACNY activity—became ideologically and culturally a very different place.

CHAPTER FIVE

RESTRAINT

I arrive at City Hall at 8:25 a.m. by subway. Several other commissioners drive up to the City Hall gates in chauffeured limousines. After clearing security, we climb steep narrow steps to the third floor and the ACNY boardroom. Other art commissioners arrive, and we sip coffee and chat for five minutes, the only relaxation for the next eight or nine hours. The president convenes the business meeting at 8:30, in a private, "executive session." Commission members and staff review potentially problem-laden items on the agenda and receive a heads-up about notable current or upcoming projects. Occasionally animated discussions take place of big visions, initiatives, and events. The president and executive director gently prod us to stick to the agenda.

For a number of years, ACNY public meetings were held in the stately former Board of Estimate chamber on the west side of City Hall's second floor. Commissioners ascended a podium to an enormous semicircular desk with antiquated microphones and rickety leather chairs. Visitors sat in pewlike seats facing the dais. On being introduced by the liaisons for the respective city agency sponsoring the project, the applicants, usually carrying boards, models, and supporting materials, entered a chancel-like area to present their projects to us ACNY members, who stared down on them from on high. Spectators could see the presentation boards only if they climbed the podium and stood behind us. The atmosphere was thus rarified and intimidating. In 2002, Mayor Michael Bloomberg appropriated the Board of Estimate chamber for his open-office mayoral "bullpen," and the ACNY meetings shifted upstairs to the stuffy and overlit but far more intimate boardroom (fig. 4.1).

The meeting format has remained the same, no matter what the venue. The executive director establishes the agenda (which is distributed to commissioners and the public at least a week before the public meeting). When the ACNY president convenes the public meeting, the presentations unfold, typically in fifteen- to thirty-minute intervals (see app. B, sec. 1). Liaison

officials from the various city agencies (typically architects, planners, administrators, and designers in mid- to upper-level positions within) introduce the projects and their applicants, who present background information and the proposed design. Commissioners pepper the applicant with questions about composition, site, and materials. They offer praise, critique, and suggestions for improvements, straining to avoid the temptation to design the project themselves. They seek—not always successfully—to assess the merits of submissions on a case-by-case basis rather than in terms of the broader urban or political implications. Applicants and liaison respond to the questions, defend their design visions and selections, or rationalize the constraints. The back-and-forth continues until the ACNY finishes with questions or the time is up. One commissioner then gathers opinions together into a motion to approve (often with stipulations), disapprove, or table the item. Submissions are presented one after another nonstop, with a half-hour working lunch break.[1] The meetings often run behind schedule, then catch up toward the day's end.

Here is a typical ACNY committee meeting agenda (22 May 2002):

- reconstruction of portions of Prospect Park, Brooklyn;
- consultation with the deputy mayor on selection of colors for the latest renovation of the Governor's Room;
- track and field landscaping on Randall's Island;
- construction of a Victorian food kiosk, restrooms, seating, fencing, and landscaping in a corner of Corporate Park, Staten Island;
- conservatory courtyard paving at the New York Botanical Garden;
- streetscape improvements (replacing curbs and sidewalks along two commercial avenues) in Tottenville, Staten Island;
- the design for a new steel fence in Union Square Park;
- facade renovation of the Brooklyn House of Detention;
- facade renovation of P.S. 1 Museum in Long Island City;
- renovation of a bio-safety laboratory in Manhattan;
- public art for a combined Emergency Medical Service Fire Department station in Staten Island;
- improvements to structures at the Delaware Aqueduct;
- construction of a "froth building" for a water treatment facility;
- a distinctive sidewalk for apparel retailer Jil Sander on Fifty-seventh Street off Madison Avenue; and
- changing an approved granite color and size for a library in Brooklyn's Crown Heights.[2]

These deliberations may appear to be both varied and haphazard; indeed, they tend to be so, in certain ways. The ACNY members who review these

projects for the first time often know practically nothing about their broader circumstances, budgets, and constraints. Little is discussed about them ahead of time; presenters sometimes assume that ACNY members have reviewed the plans in advance, when this is often not the case. From a historian's perspective, the ACNY process may seem to transpire in something of a vacuum.

In total, however, a certain thread of consistency runs through the ACNY's negotiations. The reviews often improve the design of individual projects. They also lend coherence and articulation to the enterprise of representing the municipal built environment at the turn of the twenty-first century. That environment is crucial. New York City is typically associated with its iconic landmarks: the Statue of Liberty, Ellis Island, the Empire State Building, Lever Brothers, the late World Trade Center. But the city's streets and built environment are equally crucial in constituting the urban experience. The ACNY's encounters force a range of authorities and interest groups to arrive at some consensus about what that experience should be like.

How does a modern, democratic New York City become publicly signified while still maintaining as the mediator of the message a body whose mission is to impose authoritative standards? This chapter examines these dilemmas as they played out through the ACNY process in the years between 1982 and 2004, concentrating on the period in which I myself served on the ACNY: April 1998 through September 2003. These years coincided with the shift in viewpoint from the authoritarian populism of Mayor Rudolph Giuliani to the elitist moderation of Mayor Michael Bloomberg. The examples discussed here are by no means exhaustive. Rather, they represent those that I recall most vividly because they related to my work as a professional historian. For comparative purposes I have also chosen topics that parallel those of earlier chapters.

Centering on select structures and the corresponding politics of process, I offer a concrete view of the differing approaches of the two administrations. More significant, attention to the projects considered or produced during this time allows me to compare an era dominated by indisputable, classical standards and the postsixties, postmodern climate in which aesthetic canons, considered socially constructed and arbitrary, became culturally suspect. The ACNY's sense of mission, underscored by the educated upperclass backgrounds of many of its members, has impelled it to negotiate gaps among cultivated, art world perspectives, bureaucratic perspectives, and popular tastes—conflicts that resonate broadly within American society.

Some observers certainly questioned the relevance of the ACNY, an institutional outgrowth of the Progressive Era, to New York's public built environment a century later. I will argue that despite mixed successes, the

ACNY has continued to play an important role within municipal government. From 1980 into the present day, it has served as a detail-oriented force of moderation, a vehicle of restraint in a world of urban design occasionally marked by willfulness, shortsightedness, generalization, and commercial and political exigency. In this chapter I focus on the ACNY's activities in this regard and conclude with a look at the commission's involvement with post-9/11 New York City. First, a brief overview of the previous two decades will help put recent developments into perspective.

THE ACNY AS MAYORAL AGENCY

The ACNY underwent a notable change in status during the mayoral administration of Edward I. Koch. After the fiscal doldrums of the mid-1970s, New York City in the 1980s experienced an economic upturn, enabling city officials to undertake many new initiatives. The revitalization of the city and the ACNY went hand in hand. In contrast to the indifference or hostility displayed by New York City's Tammany mayors since 1916, Koch, a Greenwich Village Democrat (with a strong interest in the arts) who had triumphed over the Tammany machine, wholeheartedly embraced the ACNY's mission; he regarded it as an ally, a branch of the mayor's office. Thus the ACNY entered into a new phase of enhanced mayoral support and reliance on its services to improve and enrich municipal design programs.

Just as in the Low (1902–3) and La Guardia (1934–45) administrations, the mayor's endorsement was decisive. Sympathetic to the notion of professional cultural expertise, Koch sent out a directive to the heads of city agencies, instructing them to abide by the charter and submit projects to the ACNY in a timely manner. He also extended the ACNY's purview, requesting the public authorities (like the Battery Park City Authority and Metropolitan Transit Authority), which as autonomous corporations operated independently of the constraints imposed on municipal agencies, also to submit their artistic and construction designs to the ACNY for courtesy review.[3] (A courtesy review meant that although the authorities legally did not have to follow ACNY recommendations, they were strongly encouraged to do so.)

Equally significant, Koch initiated a notable gender shift in constituting the ACNY's upper-level staff. From its beginnings through the 1960s, the commission staff and membership had been, in keeping with the dominant culture, predominantly male. From 1979 onward, the staff became all female. Confident of their abilities, Koch delegated much authority to these new administrators, and they in turn extended considerably the ACNY's scope and

operations. In 1979 ACNY staff renewed its attempt to survey the city's mural, sculpture, and portrait collections, a task former Assistant Secretary John Quincy Adams had begun sixty years earlier.[4] In 1982, the agency inaugurated an annual event, the Art Commission Design Awards. With Mayor Koch as host, the ceremony validated ACNY-designated notions of "quality" in municipal design, by celebrating the best submissions to the ACNY in a given calendar year.

In 1983 Koch appointed Patricia E. Harris to succeed Annette Kuhn as the ACNY's administrator. Harris, a former assistant to Congressman Koch, an assistant to the deputy mayor from 1979 to 1982, and for a brief interval an assistant to the mayor for federal affairs, has been described as being "like a daughter" to the mayor.[5] During Harris's tenure (1983–90), the ACNY underwent further expansion in objectives, scope, and staffing. It continued to engage in enterprises of classification, documentation, and preservation of the sort initiated circa 1900 but with the more deliberate goal of public outreach. Through Harris, as well, the ACNY assumed a new role, not only as municipal design review board and curator but also as educator. Harris instituted a student internship program, thus extending the ACNY's influence into area schools and universities. Training interns cost the office staff time, but the city benefited in turn from alliances with educational institutions and the low-cost student labor. Capitalizing on burgeoning interest in "heritage" and landmark preservation, the commission cataloged and opened up its extensive archive and photographic collections. Drawing on data from its new art surveys, it published (in collaboration with the Municipal Art Society) a guidebook to Manhattan's outdoor sculpture.[6] Its staff developed exhibitions and acquired supervision of a gallery in the old Tweed Courthouse, behind City Hall on Chambers Street. Cumulatively these initiatives broadened the ACNY's visibility and relationships with municipal agencies, schools, and other urban institutions.[7]

All of these new initiatives demanded additional resources. Under Koch, the ACNY expanded its staff from two to twelve, although the majority of these new employees were supported by private funding. Koch's encouragement of and his close ties with Harris were clearly crucial to the ACNY's reinvigorated role and stature. The Harris connection would be decisive as well eighteen years later, when she became deputy mayor for administration under Mayor Michael R. Bloomberg.

The feminization of the ACNY staff, followed more gradually by a comparable development among the ranks of ACNY members, reflected larger national trends in the post-Vietnam era: the broadened opportunities for women and, eventually, for blacks and Latinos.[8] It also represented the feminization of the arts throughout the twentieth century. The diversified makeup

of the commission continued under the mayoral administration of David N. Dinkins. In keeping with his vision of an integrated and multicultural city, the Dinkins administration appointed two African-American ACNY members, hired the commission's first black executive director, and placed Hispanics on the staff.[9] The commitment to diversification continued, although with far less fervor, during the Rudolph W. Giuliani mayoral administration (1993– 2001). The overall move toward feminization also continued but served to undermine the commission's authority within the lingering, predominantly male culture of upper-stratum New York government and politics during the Giuliani era.

New York City's social and economic elites had always been the prevailing influence in the ACNY. The broadening diversity among commission members in the second half of the twentieth century, particularly in the 1980s and 1990s, reflected the expanding parameters of the nation's elites—not just to include women but, by the 1920s, Jews, German, Italian, and Irish Americans, just as, nationally, new groups were being assimilated and the influence of Anglo-Americans was diminishing in the culture more broadly.[10] The changes in commission membership also represented a gradual decline of patrician influence. Back in 1966, John Lindsay had claimed he would initiate such a development, insisting that he would purportedly "break" away from the tradition of selecting ACNY members from the ranks of the Century Association (then a bastion of white, Anglo-American male Ivy Leaguers). According to former art commissioner August Heckscher, however, the club put Lindsay up for membership, and subsequently he continued the tradition of Century Association appointees.[11]

While ACNY members continued to have ties to old families and old wealth, elite domination decidedly weakened under Mayors Dinkins, Giuliani, and Bloomberg. As in earlier years, most recent appointees (mayoral and institutional) came from the ranks of the very wealthy in law, retail, and finance; by the turn of the twenty-first century, the interests of large-scale private-sector real estate development were increasingly represented.[12]

Some links to the old Anglo-American aristocracy continued. The majority of recent ACNY members, however, lacked the social ties, name recognition, and political clout of such predecessors as Robert W. De Forest, I. N. Phelps Stokes, Felix Warburg, George W. Wickersham, Rodman Gilder, Thomas J. Watson, or Brooke Astor.[13] In some instances, politics, not social pedigree, was the determining factor in obtaining an appointment. The appointment of a public university professor like me, someone with no social connections to speak of, bespeaks the ACNY's broadened and attenuated elite identity and the shifting position of the older cultural elites within city demographics and power.

This partial diversification within the ACNY facilitated interactions and collaborations with the many new individuals and groups participating in the urban design process from the 1980s on into the present. This, of course, was a part of the same phenomenon that contributed to the ascendance of racially, ethnically, and economically varied new communities—local and citywide—that emerged as sponsors, advocates, critics, creators, and publics. Thus ACNY meetings became more of a forum for citizen and organizational participation and comment, occasionally enabling numerous opinions to circulate. The ACNY reviewed increasing numbers of projects that catered to the needs and desires of local neighborhood or communities of interests. The board approved the majority of these projects with few problems. But as had been the case since 1900, especially during the New Deal's WPA, ACNY members occasionally found submissions aesthetically problematic and disapproved or delayed them. These deliberations periodically generated tensions that some opponents of the commission's membership imputed to have class and racial dimensions. Hence the task of recommending improvements, especially on local projects in the "outer boroughs," became even more complicated and politically charged than in previous decades.

IT'S GIULIANI TIME

Presidents in Search of Power

During the Giuliani administration, the tensions among people with political power, professional expertise, and elite cultural capital made the ACNY's work difficult, especially during the mayor's second term (1998–2001). The administration professed an interest in art, proposing a variety of projects that ACNY members often deemed preposterous. In reality, the mayor was disdainful of the ACNY and what it represented. The commission's staff would thus struggle to maintain communications with the mayor's office, and the board itself was usually unable to stop the projects that were most egregious (from its members' point of view) or even to improve them. Nevertheless, by simply showing up, posing questions, and challenging some of these official artistic enterprises, the ACNY represented a check on the administration's unbridled enthusiasms.

Giuliani, for all his law-and-order posturing, regarded the city's century-old "art police" as a threat and an impediment to the authority of his administration. The mayor's representatives worked to fill open ACNY slots either with Giuliani's allies and political supporters or with middle-income education and design professionals (like myself, architect Jean Parker Phifer, and

landscape architect Donald Walsh, appointed in 1998), who came with no political baggage and were presumably deemed unlikely to rock the boat.[14]

The administration also swept house. Deborah Bershad, the ACNY's art history–trained archivist, was promoted to replace Dinkins appointee Vivien Warfield as executive director. Jean Rather—wife of CBS anchorman Dan Rather—was appointed as the painter member. Reba White Williams—a City University Graduate Center Ph.D. in art history, a Harvard MBA, a serious print collector, and a major donor to the Giuliani campaign—joined the ACNY as a second lay member.[15] She had been an executive at the management company Alliance Capital (where her husband was CEO). The mayor appointed Bud Konheim, the CEO of fashion house Nicole Miller and a major fundraiser for both Giuliani mayoral campaigns, as a mayor's representative. Subsequently Michael Geller, Democratic Party district leader for the Forty-fifth Assembly District in South Brooklyn, replaced Konheim as mayor's representative, and Konheim became a lay member. Geller, however, rarely attended meetings, an indication of the low priority given to this position. In December 1997, commission members elected Williams president. The ACNY's landscape architect and previous president (Nicholas Quennell) and its architect (Lo Yi Chan), Dinkins appointees, were both forced out. Suzanne L. Randolph, a designer and art consultant and an ACNY lay member appointed by Mayor Dinkins, quit in protest.

Thus by the beginning of its second term (1998), the Giuliani administration had corralled the ACNY's power. Giuliani vested principal authority in the hands of litigator and mayoral confidant Jennifer Raab, who presided as chair of the Landmarks Preservation Commission—a completely separate oversight agency whose powers occasionally overlapped with those of the ACNY. Raab (who would move on to become president of Hunter College in 2001) seemed genuinely to respect professional credentials. Raab may also have correctly surmised that as nobodies, with no clout, the new professional members were not likely to be a source of any trouble for the administration.

Initially, this was certainly the case. At the outset of Giuliani's second term, ACNY president Williams considered herself to be a political insider. The forceful and outspoken executive was more than happy to toe the line as long as she was kept inside those inner circles, along with "friends" and associates like Peter J. Powers, Randy Mastro, and John Dyson, all deputy mayors during the first Giuliani administration (1994–98).[16] For the first six months of 1998, then, Williams was a strong and successful ACNY president. To facilitate the ACNY's functioning as a smoothly running, business-friendly aesthetic review appendage of the mayor's office, Williams reined in her colleagues in an imposing and no-nonsense manner. She ran meetings with drive

and efficiency, like the corporate executive that she was. Williams would seek to charm Raab, liaisons, and others; yet she could also be brusque and churlish toward ACNY members and staff, or anyone else who might cross her. As a member of the Giuliani club, moreover, she operated according to its rules—by intimidation. As with the administration in general, dissent was not acceptable. Those voicing reservations on projects Williams favored (or believed that the administration favored) would be pounced on. From Williams's perspective, decisions had to be made to enforce the will of the administration (meaning the mayor and his advisers). Though assertive and dynamic, she was not a genteel negotiator like predecessors De Forest, Stokes, and Delano. As long as she remained in the administration's good graces, she appeared willing to act in any way she considered necessary to advance the mayor's interests.

At the same time, Williams had strong personal tastes and convictions and stayed true to them. Thus when in summer 1998 she initiated a showdown with Commissioner Henry Stern of the Department of Parks over his illegal installation of flagpoles with yardarms in the city's parks and playgrounds (which I shall discuss later), she forced her ally the mayor to choose sides between herself and his trusted commissioner. Giuliani backed Stern. Marginalized by the mayor and his henchmen, her muscle undermined by the fight with Stern, Williams lost the battle. Infuriated by Stern's disregard for the charter (as indicated, in her view, by his circumvention of the ACNY process), and by the mayor's refusal to back her up, Williams abruptly quit the ACNY in December 1998. This seemingly strong ACNY president turned out to have been a very weak and short-lived one. Characterizing Stern as a scofflaw and a liar, Williams sued him and Giuliani.[17] The lawsuit was settled some months later, but in the eyes of the administration, Williams's actions made her and the ACNY look ridiculous.

Williams's alienation from Giuliani officials diminished the ACNY's authority all the more. A new mayoral representative, investment banker Theodore Shen, had been appointed in late 1998 to replace the never-present Michael Geller. Although diligent and congenial, Shen had no real connection to the mayor or high-level officials. The ACNY staff, down to three people, had to tread ever more cautiously when dealing with the mayor's office, for fear of reprisals if someone made the wrong move. The staff was unable to act forcefully because all actions had to be cleared with the mayor's office, and the deputy mayor with actual oversight responsibilities was essentially incommunicado.[18] In fact, from 1998 onward, the only real liaison between the ACNY and the Giuliani administration was John Dyson, a former deputy mayor for economic development in the mayor's first term, who was now serving, unpaid and unofficially, as a kind of roving ombudsman.

After coming once (in his first year in office), the mayor himself never again attended the art commission's annual design award ceremony. During the second Giuliani administration, the ACNY had become a mayoral agency in name only.

The ACNY's new president (1999–2003), Jean Parker Phifer, a gracious Yale and Columbia University–trained architect in the civic mold of Stokes and Delano, tried to be conciliatory. She worked hard to improve ties with officials like Parks Commissioner Stern and to establish a more expansive vision and activist agenda—ultimately, to little avail. The genial Phifer lacked the political savvy and clout to push the ACNY much beyond the immediate tasks at hand. In the long run, however, Phifer succeeded, more successfully than had Williams, in encouraging better design and a meaningful public dialogue about municipal aesthetics.

Giuliani City

Both in spite of and as a consequence of the lack of administration support, my group had plenty of urgent tasks with which to contend. Principally, of course, the ACNY continued its design review of structures and landscapes for city property. Those projects kept coming, despite a downturn in the economy. Plans ranged from daycare and youth centers in Brooklyn and the Bronx, sheds for the Brooklyn Navy Yard, guardhouses for upstate reservoirs, prison guard passageways on Rikers Island, and bathhouses (for Coney Island, Brooklyn), street-level elevator enclosures for the subway, parking garages, bus terminals, police stations, and neighborhood parks and playgrounds, and multimillion-dollar-budget projects like bridges, water pollution–control treatment plants, ferry terminals (for Manhattan and Staten Island), baseball stadiums (for Brooklyn, Staten Island, and Queens; fig. 5.1), festival amphitheaters (Randall's Island), and Queens family courthouses.[19] Many of these undertakings were mundane and straightforward, requiring only minor adjustments. But numerous other ventures were far more burdensome, requiring numerous presentations and far more time for discussion than could be allotted at any one meeting. In such circumstances, we commissioners also made site visits to evaluate the specifics firsthand.

Individual ACNY members often disagreed on details, but in 2000 as in 1900, the group approached urban design, broadly speaking, with a certain degree of consistency. In recent times, as earlier, the ACNY preferred sophisticated designs—those perceived as simple, bold, and dignified yet complex and thoughtful in conception. Thus a continual preoccupation was to help improve projects we deemed vulgar, overly elaborate, awkwardly proportioned, shoddy in material, badly sited, or otherwise ill-conceived.

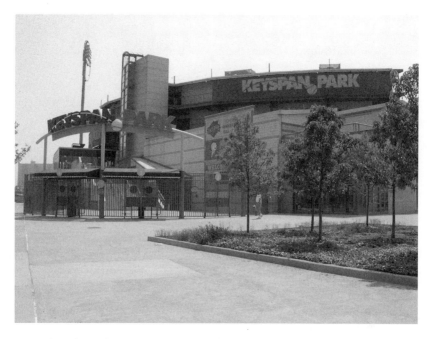

5.1 Jack Gordon, architect, Keyspan Park baseball stadium, 2001, Brooklyn. (Photo by author.)

Many of these structures were destined for the so-called outer boroughs (figs. 5.1, 5.2, 5.6, 5.17). Lay member and Giuliani-insider Bud Konheim put it bluntly several times in executive session: no one in the upper echelons gave a damn about the quality of design outside of Manhattan.[20] When it came to projects in Brooklyn, Queens, Staten Island, and the Bronx, we would press for changes, just as we did in Manhattan. Nevertheless, it seemed to me that a double standard sometimes prevailed. Mostly residents of upscale neighborhoods in Manhattan and Brooklyn, ACNY members tacitly accepted the obvious differences in taste between themselves and residents of the "outer boroughs," and the class and educational divisions they implied.[21] Then under political pressure, the group was more willing to accept in Staten Island or in Tremont what would not be acceptable in Manhattan.

 In addition to conferring on designs actually submitted for review, the Phifer-led ACNY and staff, reliving travails of the 1920s and early 1930s, also found itself protesting a variety of large projects. These included a group of gates at the entrance to Brooklyn's Fulton Street Mall and decorative fencing surrounding Robert Moses Park, along the FDR Drive—constructed without undergoing ACNY review (fig. 5.2). On other occasions, we learned that designers or agencies had just ignored our requests for modifications, actions

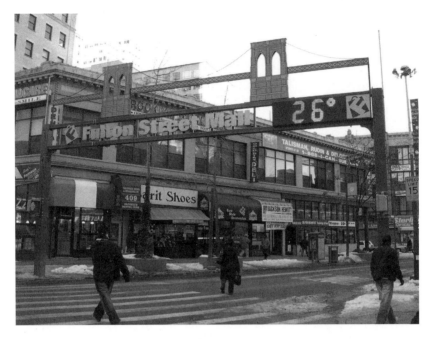

5.2 Fulton Street Mall gate, 2000, Brooklyn. (Photo by author.) In January 2000, the Fulton Street Mall Business Improvement District Chairman Louis Carbonetti, Jr. (a childhood friend of Rudolph Giuliani's and the father of Giuliani Deputy Mayor Anthony Carbonetti), brought in elevation renderings of a gate for Fulton Street Mall by the North Shore Neon Sign Company. Carbonetti requested a conceptual review, meaning that the project had not really been designed yet. Commission members took one look at the drawings (whose specs referred to "Typical truss frame and support columns," "typical signage," and "typical ad boxes") and proclaimed that there was no way this design would be approved. Carbonetti simply ignored the comments. The job is "fast tracked," he informed the commission—a euphemism for saying that the job, far from being in the conceptual stages, was virtually under construction. The ACNY, few of whose members had ever seen the Fulton Mall, agreed to make a site visit. That visit did not change anyone's mind, but Carbonetti had no intention of being stopped. Soon after the site visit, a gateway with large, flat, and crudely rendered cut-outs of the Brooklyn Bridge (to give the place "identity," said Carbonetti) and a shopping bag logo appeared virtually overnight. The ACNY and neighbors complained. The mayor's office simply looked the other way. After Giuliani left office, Carbonetti was indicted (on other charges) and removed from his post.

that agency commissioners and administration officials condoned and at times encouraged.

The Giuliani administration's contempt for the ACNY was patently evident when it came to matters of public "art." Mayoral officials proposed a variety of monuments, presented "informally," in committee meetings; the attitude was that installation was a foregone conclusion. Such actions were consistent with past mayoral interventions in monument matters, such as

when Mayor George B. McClellan handpicked Frederick MacMonnies to execute the troubled *Civic Virtue* (discussed in chap. 3). Indeed, most of us considered Giuliani's schemes to be especially unfortunate.

An example of what we were confronted with was a replica of the famed antique statue of Marcus Aurelius (from the Campidoglio, Rome), a gift from Giuliani friend and mayor of Rome, Francesco Rutelli. Italian-American Friendship Association director Mico Licastro presented the proposal to the ACNY (in committee) on behalf of Rutelli and the Giuliani administration. Licastro informed us that while mindful of the city's rich past, Rutelli also wanted to show that there existed, as well, a modern Italy, situated in Rome. The presence of a Marcus Aurelius statue in the political heart of New York City would signify both this link between antiquity and modernity and the friendship between the two "sister" cities. The fourteen-foot reproduction (with pedestal, twenty-two feet) would be installed by 2 June 2000, the Italian national day. We learned that the Italians wanted the equestrian statue to stand near City Hall, but other possibilities mentioned were Foley Square, Central Park (behind the Metropolitan Museum of Art), and the Manhattan entrance to the Brooklyn Bridge (apparently the suggestion of Mayor Giuliani). A subsequent recommendation, submitted to the ACNY, would have placed the Marcus Aurelius statue in what is now Millennium Park, on Park Row between Ann and Beekman streets. Up for the ACNY's discussion was whether the New York copy would have the same design for the base as the Roman version or whether it should have a new base, designed to suit its setting (in terms of size). Another pressing question was whether the old Roman inscription should be maintained or whether there should be a new, more "up-to-date" inscription.

The ACNY broached these matters quite reluctantly. The very notion of commissioning a replica for a city with so many living artists struck us as an aesthetic and political absurdity, but the tacit assumption was that this statue was a mayoral priority and that the ACNY would of course approve it. Thus commissioners were greatly relieved when Rutelli left office in early 2001 to run for prime minister of Italy and the project was abandoned.[22]

Mayor George McClellan, Jr., chose an allegorical evocation of municipal grandeur. Mayor Giuliani's colleagues preferred portrait statues of popular heroes: Frank Sinatra (planned to have music piped out of it); marathon organizer Fred Lebow (whose statue—thanks to a runner/official "close to the mayor"—was sited "temporarily" in bushes northeast of Tavern on the Green in Central Park but pulled out for the marathon); and Theodore Roosevelt, a proposed statue whose image, derived from a photograph of him in mid-sentence during a stump speech, would have adorned Park Row had it been ever been completed. This monument proposal pitted the values of the

academic and elite worlds of high art against more traditionalist, middle-brow tastes of powerful, educated men.

In an ACNY conceptual review, John P. "Fipp" Avlon, the mayor's young speechwriter, presented a stiff, "realistic" bronze statue of Roosevelt, destined for the same Park Row locale as the ill-fated Marcus Aurelius sculpture. City Hall Park and vicinity had statues of Benjamin Franklin, Nathan Hale, and Revolutionary era heroes, with the Horace Greeley monument north of City Hall representing the nineteenth century, Avlon asserted. What better way to evoke the twentieth century, he exclaimed, than to erect a monument to the only president to have been born in New York City? Commission members observed that a stately but now-deemed politically incorrect 1940 monument to Roosevelt (by James Earle Fraser), already stood at the entrance the American Museum of Natural History and badly needed conservation. Rather than fashioning a second Roosevelt statue, might it not be preferable to use the centennial as an opportunity to restore the one already there, and to reflect on Roosevelt's life and career in a more complex fashion?

Avlon responded that the city certainly "had plans" to restore Fraser's Roosevelt memorial but that the latter represented Roosevelt "the Hunter." The administration wanted to represent him as "New Yorker" (as if two statues were thus needed to evoke the dual dimensions of an individual's personality and achievement). When I asked whether the administration might instead participate in the Percent for Art program (see app. B, sec. 2) so as to at least raise the possibility of a less literal interpretation, Avlon stated that they would not be entertaining alternate options. One day later, 11 September 2001, the Roosevelt monument subject became moot.[23]

Park "Art"

Few of the Giuliani administration monument initiatives came to pass, thankfully, but the legacy of the Giuliani years would live on through the many new and redesigned parks and playgrounds carried out during the boom economy that coincided with his second term. In fact the frustrations with the administration's monument proposals have to be understood in light of the wars being waged over the art being installed in the city's parks. Some of these park art debates centered on the site, scale, form, and iconography of out-sized new works, such as the Nobel Monument (fig. 5.3). Other disputes centered on park designers' overinclusion of what Metropolitan Museum trustee member Joyce Menschel termed "visual clutter" and on the increasingly prevalent "dumbing down" of art and history in various park design programs (figs. 5.4, 5.5).[24]

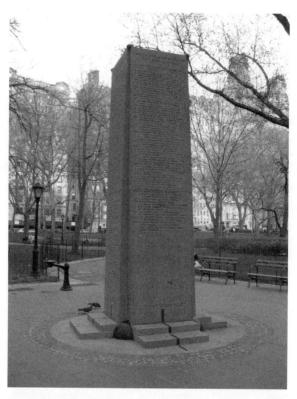

5.3 Sivert Lindblom, Nobel Monument, 2003, Theodore Roosevelt Park, Eightieth Street near Columbus Avenue, Manhattan. (Photo by author.) Like the Barsotti-sponsored monuments of the turn of the twentieth century, the Nobel Monument had political and diplomatic origins. Funded by the Swedish pharmaceuticals corporation Merck and presented to the Department of Parks and Recreation (DPR) in 2001 by the Swedish Consul General's office, the monument was intended to celebrate American recipients of the Nobel Prize to generate good will in both the New World metropolis and the homeland. Commissioner Stern of the DPR sought to place the monument on Central Park West south of Eighty-first Street, adjacent to the American Museum of Natural History. His rationale was that since Theodore Roosevelt had been the first American Nobel Prize recipient, the memorial should stand near the museum's Theodore Roosevelt Memorial wing. The Landmarks Preservation Commission (which reviewed the work because it would stand next to a designated landmark) disapproved the site; so did the ACNY, contending that the scale was too monumental for that locale and would block the view corridor to the museum. The ACNY and LPC also considered Lindblom's initial design to be overly classical, old-fashioned, and unimaginative. Neighborhood groups like the Friends of Theodore Roosevelt Park also opposed the monument. Some took umbrage at the idea of honoring the inventor of dynamite. The Department of Parks and Recreation subsequently chose a square in Theodore Roosevelt Park just west of museum, and the sculptor revised and simplified his design. The landmarks commission signed off on the new site and design. The ACNY did not. The majority felt that the monument (eighteen feet tall, then reduced to seventeen) was much too large. Commission president Phifer professed to like the "minimalist" vocabulary, but I countered that the monument's minimalism was slick and disingenuous. Although intended to celebrate U.S. Nobel Prize winners, the monument's visual rhetoric, with its list of names, was elegiac and funereal. It appropriated a certain high modernist vocabulary, for purposes that failed to signify what these elements had typically served to evoke: open-endedness, aspiration to the infinite, a sense of consciousness about scale and the body. I lost my battle. The sculptor refused to make additional changes to the height, and most other commission members were indifferent. Under intense pressure to approve the monument before Commissioner Stern left office at the end of 2001, a quorum of the ACNY approved construction of the Nobel Monument in November of that year.

5.4 George Vellonakis, Department of Parks, designer, City Hall Park decorative paving design, 1999. (Photo by author.) This decorative etched-granite circle at the southern end of City Hall Park was completed as part of a $30 million renovation. In summer 1999 the ACNY and LPC were summoned to review the design and informed that the paving had to be completed by October. The art commission was involved because the project was ostensibly a work of art, the LPC, because City Hall Park is a scenic landmark. The thirty-foot circular pavement includes scenes from the crucial phases of the park's history around the perimeter, in the form of etched-granite translations of period engravings and photographs. Set between each image are lengthy descriptive texts, composed by Mayor Giuliani's speechwriter. Farther inside the circle, corresponding to each image, pie-shaped sections with "base maps" depict the evolution of the park. The design was to evoke the history of the park and create a sense of place. The ACNY and LPC argued that visually and conceptually the design was far too chaotic. Some voiced concern about the legibility of finely drawn linear images when translated and etched into black polished granite. Both commissions also objected to the choice of materials but were told they had already been ordered. On learning this, LPC washed its hands of the "art" project. The ACNY continued to expend a great deal of time agonizing over the design and inscriptions. Vellonakis's plan sought to render place history comprehensible, controllable, subject to a mythifying vision, but his methods oversimplified the tensions, contradictions, complexities, and debates that history entails. The story of the "history," of the park in the present, for example, was simply a bloated public relations statement. In the end, most all suggestions for revisions went ignored. Presently, the paving is surrounded by signage that warns Use Caution When Wet, admonitions that the ACNY and LPC could have easily predicted.

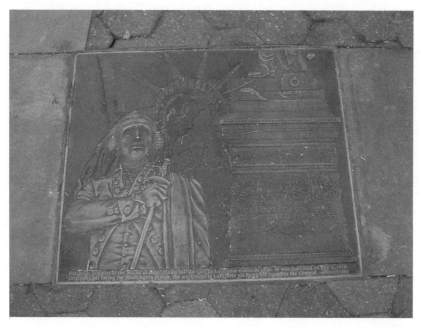

5.5 Gregg Lefevre, bronze plaque depicting the Lafayette statue and Statue of Liberty by Frederic Au-
guste Bartholdi, 2002, Union Square Park at Union Square West, Manhattan. (Photo by author.)
This plaque was one element in an elaborate and controversial reconfiguration of Union Square
Park, a project reviewed by the art commission between 2000 and 2002. The Union of Needle-
trades, Industrial and Textile Employees (a successor to the ILGWU) sponsored five bronze
plaques by Lefevre to commemorate the labor histories associated with Union Square. Project
manager and DPR landscape architect Laurence Mauro elaborated on the plaque idea, commis-
sioning Lefevre to design twenty plaques chronicling Union Square Park history. The project
scope also included two large bronze relief maps of Union Square Park in the years 1833 and 1872
and two-and-one-half-by-three-foot bands, each eighteen feet apart and each inscribed with one
year from 1843 to 1870, to be set into the stone and encircle the park's perimeter. The idea, in ef-
fect, was to turn the park into a memorial, a landscape that would represent "history." The ACNY
vigorously debated the merits of this project. I led the opposition, arguing that while it was laud-
able to commemorate the park's history, twenty plaques plus a timeline were overkill. More
significant, the plaques were neither compelling art nor accurate history. As with the City Hall
Park paving pattern, Lefevre's designs, with their emphasis on little vignettes and simple, collage-
like images, conveyed little of history's complexity. The images and statements were literal and
crude "translations" of engravings and photographs; such translations in bronze did not them-
selves constitute art. I contended that this bronze montage, highlighting Auguste Bartholdi's role
as sculptor of Union Square Park's Lafayette memorial, was ineffectively composed and lacked
nuance and compelling significance. Lefevre was sincere and dedicated to his artistic mission, but
his approach trivialized history. Although many of the commissioners agreed with me, no one
else wanted to go so far as to disapprove the project, especially after Lefevre revised some of his
compositions.

Administration projects close to the heart of one powerful individual, commissioner of the Department of Parks and Recreation (DPR), Henry J. Stern, caused the greatest consternation. Park plantings and overall landscaping were, apart from an occasional awkwardly composed comfort station or an absence of evergreens, usually quite satisfactory. The artistic schemes proposed to complement these landscapes, however, and the agency's ways of implementing them, were another matter altogether. Some of the ACNY's biggest battles arose over what we perceived as DPR's simplification, trivialization, and misrepresentation of history—and as the degradation of aesthetic standards in the decorative components of park designs citywide. Numerous DPR projects (along with some others discussed in this chapter), were marked by clashes over expertise, influence, identity, place, and memory, articulated through the discourse of aesthetics.

As a historian, I had a great stake in these issues. For me, paradoxically the run-ins with Stern generated some of the most compelling discussions about the role of art in parks, the nature of beauty in urban public places, the question of taste and its relation to authority, and the appropriate modes of representing municipal identity and power. At the same time however, I, like Reba Williams, took strong exception to Stern's actions, believing that he was abusing his authority to ridiculous extremes.

Stern (1935–), a graduate of Harvard Law School, was the ultimate insider, having served as a first deputy commissioner of consumer affairs, city councilman, and commissioner of parks under Mayor Ed Koch and head of the Citizens Union. In 1994, Giuliani reappointed Stern to his old job as commissioner of parks, after Stern, along with his close associate Robert F. Wagner, Jr., threw their political weight behind Giuliani in the 1993 mayoral campaign.[25] Stern, one of the few Giuliani commissioners allowed to speak for himself, was given a very long leash. The energetic commissioner expanded the number of new parks. Whenever possible, he lay claim to open spaces on new construction projects, even when they were undertaken by other agencies, like the Department of Design and Construction. He installed a "Greenstreets" project, putting plantings in empty street triangles when the local community groups agreed to care for them. He applied George Kelling and James Q. Wilson's influential "broken window" theory to the parks, making the DPR maple leaf logo ubiquitous to assert DPR supervision and authority (fig. 5.6).[26]

In the Giuliani administration Stern soon acquired a reputation as a maverick, a puckish eccentric, dressing up in funny hats and costumes and with his golden retriever in tow on official park business. He gave himself the "Parks Name" of "Starquest" and bestowed similar titles on the agency's employees and on influential outsiders. He turned ceremonies into infantilizing spectacles; attendees of the Heine Memorial's rededication, for example, were

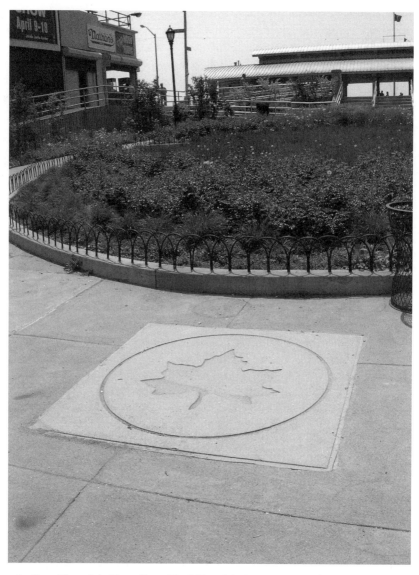

5.6 Sign with maple leaf logo, Coney Island, New York City Department of Parks and Recreation, 2004. (Photo by author.)

urged to recite en masse Joyce Kilmer's famous poem "Trees." Stern also cultivated the media, especially the *New York Times* and local television stations. The press lavished attention on him and glossed over the more questionable aspects of his tenure—which from my point of view included exploitation of power when it came to park aesthetics.[27] In 1995, when a newly reappointed

Stern announced the formation of the Association for the Promotion of Animals in Art, the *Times* covered the pronouncement with bemusement. By 1997, however, Commissioner Stern essentially decreed as a new DPR "standard" that any new DPR park or playground project had to include animal "art" and put himself in charge of determining what basic form that art should take.[28]

Animals had of late become a lucrative public art trend.[29] A popular tourism-oriented exhibition called Cows on Parade, for example, drew widespread attention when mounted in New York City in summer 2000. Touted by its sponsors as "the world's largest public art event," the display consisted of over one hundred, life-size fiberglass cows, each decorated by a different artist and placed on the street. The cows were then auctioned off, with a portion of the proceeds going to charity. The concept, initiated in Zurich in 1998, meshed well with Henry Stern's fanciful animal art agenda; numerous Cow Parade cows were displayed in the city's parks, mostly in Manhattan.

Animal art, according to Commissioner Stern, was supposed to inject a bit of "whimsy," into the tough and gritty city. We art commissioners had a different point of view. In New York City, such whimsy, when it was not temporary, came at a cost. The objects were often cheaply and shoddily rendered items from mail-order catalogs. These items, when actually submitted for approval, were characterized with the utmost seriousness by the unfortunate in-house or consultant architects (who had to present them to incredulous ACNY members), as popular art and as expressions of place.

I considered the rationales for the supposed connection to place as highly questionable and, just as often, absurd. A group of mail-order Holstein cows were proposed in conjunction with a reconstruction of a golf concession in Flushing Meadows Park because the Borden's Milk pavilion had occupied that site in the 1939 World's Fair.[30] Dog bones and a crudely rendered concrete Dalmatian were introduced for a fence and dog run in the newly reconstructed Madison Square Park. I had extreme difficulty maintaining my composure during this presentation, and when shown "decorative" imprints of chicken, hen, and pigs feet, along with onion features, for "Vidalia Farm Park" in the Bronx.[31] The ACNY turned down designs for an eight-foot-high bronze baseball with a dragonfly on it for a group of baseball diamonds in Juniper Valley Park, Queens; multicolored donkeys, commemorating a local Democratic politician, for a fence in a newly redesigned park in northern Queens (figs. 5.7, 5.8); and a procession of elephants and camels (invoking Aida) to decorate the tops of the fence surrounding the Verdi Monument on Broadway and Seventy-third Street.[32] A bronze dog was proposed as "play equipment" for the Lower East Side's Seward Park because Seward had been involved in the purchase of Alaska and there was another dog there besides Balto who had

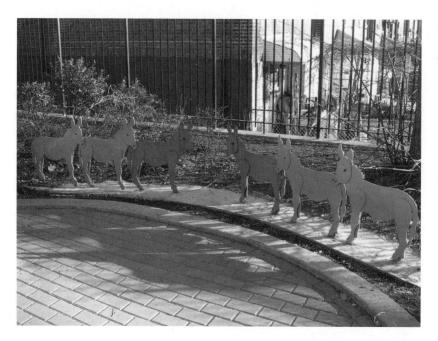

5.7 Donkeys, 2000, Nathan Weidenbaum Park, Queens. (Photo by author.) In the (private) business meeting, I dismissed the proposed laser-cut donkey silhouettes as an "asinine" idea. When informed that the donkey imagery referred to the late local Democratic Party activist Nathan Weidenbaum, Metropolitan Museum representative Joyce Menschel stated in the public meeting, aptly and not without irony, "Let's not inject politics into the Parks." The park's designer said that the community board had specifically asked for donkeys and camels. The ACNY approved the design, without the donkeys, suggesting that DPR install a plaque describing the importance of Mr. Weidenbaum rather than just displaying symbols of his party affiliation.

5.8 Camel spray shower, 2000, Nathan Weidenbaum Park, Queens. (Photo by author.) When shown plans for this spray shower, ACNY members noted that camels were not typically associated with fountains; Joyce Menschel mused that perhaps the association with camels and fountains derived from the fact that camels spit.

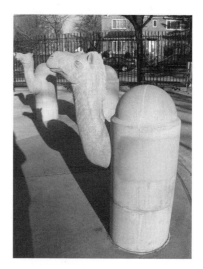

5.9 Shelley Smith Curtiss, Togo memorial, 1999, William H. Seward Park, East Broadway, Canal Street, and Essex Street, Manhattan. (Photo by author.) The Seward Park project was a major reconstruction, with new paving and curbs, fences, gates, benches, picnic tables, play units, spray shower, drinking fountains, plantings, and lighting. The DPR's in-house designer, Chris Crowley, proposed to install the husky pictured here to evoke the memory of the forty-eight pound Siberian husky, Togo, the lead dog for Norwegian-born Leonhard Seppala's Serum Run to Nome, Alaska, in 1925—a trip that saved Nome's residents from a diphtheria epidemic. When asked what this had to do with William Seward (the park's namesake), Crowley responded that another husky, Balto, who ran the second leg of the Serum Run, had been given most of the credit, with a statue, for example, erected in Central Park. Crowley (and clearly Commissioner Stern) now wanted to give Togo his due. Thus, the connection between Togo and William Seward was an association with Alaska. The husky had, in fact, nothing to do with Seward himself. "It's supposed to be whimsical," argued ACNY/DPR liaison Frances McGuire, when I challenged the inclusion of the dog as not suitably conveying the serious and important causes (of emancipation and imperialism) associated with the name William Seward. "It's not supposed to be *art*, it's supposed to be children's play equipment." The commission approved all aspects of the park's redesign except the husky. The DPR installed it anyway. It abuts the southern perimeter fence, a convenient place for dogs to relieve themselves.

saved Americans but who had not received proper credit (fig. 5.9).[33] We disapproved that proposal, but the figure was placed there illegally, as were three cookie-cutter silhouettes of Dalmatians intended as a "memorial" to firefighter Louis Valentino in Brooklyn's Carroll Park. Mike Browne, DPR project manager, proposed a twenty-foot high bison for the quintessentially urban Greeley Square because Horace Greeley was known for his pronouncement "go west, young man."[34]

These were just a few of the numerous astonishing historical contortions, presented in the guise of art that Stern's beleaguered employees brought to the ACNY for review over a four-year period. Individually, such whimsical conceptions may have seemed charming and amusing, but I feared that cumulatively they would lead to a standardization that would homogenize and trivialize place and history, even though ostensibly motivated by place and memory. Other commission members, although not as caught up with the intellectual issues as I was, were nonetheless in agreement that these items were both ridiculous and ugly. Could New York City not do better?

As absurdities, signifying nothing—these parks art products became, for me at least, rife with meaning. In hindsight, they were transformed into ironies, parodies that both highlighted the folly of the design review process and underscored its significance as a forum for negotiating in the public sphere the meanings of municipal art and their relation to power and taste hierarchies in the metropolis. While engaged in the process, however, the art commissioners and staff found it difficult to view circumstances that way. We viewed these projects with deadly seriousness because of their cumulative negative impact on the aesthetic quality of life in New York City and because of the misuse of power such works represented, not to mention the circumventions of the law—a "whimsical" lesson for the city's children. Commission members sought to restrain the number and designs of these decorations to prevent one individual from inflicting his idiosyncratic vision on millions of others.

PROCESS, POLITICS, AND PUBLIC RELATIONS

Williams, Phifer, and others of us faltered in trying to exert influence through high-stakes political brinksmanship with Stern over animal art and in the infamous yardarm debate. Incorporated by administrative fiat into capital projects submitted (and often not submitted) by DPR for ACNY review, yardarms highlighted the permeability of the borders between aesthetics and politics in the public sector.

Seeking to put down his personal stamp like the legendary Robert Moses, Commissioner Stern decreed in 1997 that yardarms—flagpoles with the American flag and crossbars bearing the flags of the city and of the parks department (fig. 5.10)—would serve as a marker of municipal presence in all city parks—along with large maple leaf logos and other abundant forms of signage. Stern wanted to treat yardarms, along with maple leaves, as a "park standard" that would promote his agency. To those who questioned Stern's choice, he offered a rationalization. Yardarms, he insisted, would help deter

5.10 Yardarm, Tompkins Square Park, Manhattan, photographed 2004. (Photo by author.) On hearing incorrect rumors that the ACNY sought to prevent construction of flagpoles bearing American flags, a group of World War II veterans came to protest in one of the ACNY's public meetings. Lay member Bud Konheim took pains to reassure them that yardarm crossbars were the problem, not the American flag, contending that as a war veteran and former Marine he had fought for his country, "not for the Parks Department!"

vandalism and crime because they signified that someone was paying attention: that the city was watching over the park. His claim seemed consistent with Giuliani's security-oriented administration.

The ACNY did not question this rationale, just the visual effects. On many occasions we took the position that the yardarms diminished the aesthetic appeal of parks. Many of them blocked vistas; some were placed within groups of trees and detracted from their natural beauty. For example, a yardarm at Litchfield Mansion, the A. J. Davis landmark that serves as the Brooklyn headquarters of the DPR in Prospect Park, was installed so that it abutted the building's front wall and windows. Two giant yardarms were installed in Cadman Plaza Park in Brooklyn and in Stuyvesant Park in Manhattan. The Cadman Plaza yardarms, dubbed the "Siamese twins," stood within several hundred feet of a large grove of trees with which they competed for attention; here as elsewhere, the yardarm crossbars created a distracting effect. In other locales, flags became twisted in tree branches. Some yardarms were placed on war memorial flagpoles, detracting, in our view,

from the somber commemorative purpose. Painter member Jean Rather objected that ill-placed yardarm installations, or those with torn and filthy flags, conveyed a disrespectful attitude toward the American flag.[35] Konheim asserted that yardarms belonged only in nautical contexts.

Believing these crossbar elements to be obtrusive, the ACNY under Williams sought to review the yardarms on a case-by-case basis. Instead, however, yardarms cropped up in parks throughout the city, with neither staff nor ACNY members ever seeing submissions for them. A summer 1998 revelation that 750 yardarms had been installed without ACNY (or LPC) approval in the city's parks throughout the five boroughs, at a cost of more than $3 million, set off the chain of events that, as mentioned earlier, prompted Williams to quit.

The Williams lawsuit was ultimately settled, with Stern agreeing to remove a few of the yardarms the commission had requested, but he followed up minimally, as we ascertained when surveying neighborhoods for yardarm infractions. The commission pressed to have yardarms removed and grilled DPR designers about whether new ones had been slipped into plans for new or renovated parks and playgrounds. (In fact, yardarms were often included, depicted as small dots on project working drawings.) Williams's successor, Phifer, sought to be conciliatory toward Stern. Stern feigned collegiality but sidestepped her completely. The ACNY developed a set of guidelines for installing flagpoles and yardarms on flagpoles, but Stern essentially ignored them.[36] "We wanted to promote the [Parks] Department with this symbol," Stern reminisced in February 2004, "so we put up 800 yardarms in parks all over the city with our flag and the city flag on the cross-bar. The president of the art commission objected, but we did it anyway, because I knew they would never give us permission. As Mayor Bloomberg once said, 'Ask forgiveness, not permission.'"[37]

From the perspective of Stern, the administrator-politician, the ACNY was just an obstacle, a group of stodgy aristocrats. His priority was articulating DPR authority and his own, concerns that superseded fusty obsessions with aesthetic details. Stern had the advantage of having New York City press behind him. The press covered the controversies as entertainment, making the ACNY, of course, look obsessed with trivia.

In hindsight, we had clearly picked the wrong cause. The interagency power struggle spiraled out of control. An ACNY vote calling for removal of an ill-placed flagpole with a bizarre three-pronged yardarm (Asser Levy Park, Twenty-third Street and FDR Drive) was distorted by rumors that the ACNY opposed any installation of the American flag on city property. Suddenly, aged World War II veterans, donning their old army caps, trooped into an ACNY public meeting to testify about how much the American flag meant to them

and to urge us to change our minds about allowing the American flag to fly. In front of these men, a high-level DPR official accused the ACNY of being unpatriotic (an assertion to which the normally agreeable. Rather took strong exception), acknowledging later that this was said "in the heat of the moment."[38] A raucous band of Catholic war veterans descended on us during a site visit to Staten Island, accusing the ACNY of being elitist, antiveteran, and anti-Christian ("because [yardarms] are shaped like a cross!" shouted one woman).[39] The controversy came to a head when City Councilman James Oddo (R-Brooklyn/Staten Island), angered by our singling out for removal a yardarm in his district (Staats Circle, Staten Island), initiated a bill to abolish the ACNY and have DPR and the Department of City Planning absorb its duties.[40] The Giuliani administration's efforts to abolish an institution that questioned its policies and preferences were clearly gaining momentum.

Members of the ACNY scrambled, talking points in hand, to try to offset the damage, but we alone could not have succeeded. In the midst of the political crisis, the century-old bipartisan goo-goo alliances sprang back into action. Well-connected officials of the MAS, FAF, and Art Commission Associates (alumni of the art commission), groups with long histories of dealing with municipal politicians, were not about to allow what they saw as opportunism, cynicism, and abuse of power subvert a mechanism for independent aesthetic oversight. (Very few city council members were actually familiar with the ACNY's role in city government.) The civic organizations, joined by individual supporters, initiated letter, fax, and phone call campaigns, urging the mayor to preserve the ACNY.

These actions weakened the administration's resolve. Perhaps influenced by the support of eminences like attorney Whitney North Seymour, Jr., Giuliani's former boss and a former ACNY member, the mayor took no action.[41] Without his backing, the eradication attempts in the city council fizzled out. Phifer and Executive Director Bershad negotiated with Oddo, and tensions were quelled. A subgroup of former ACNY members nevertheless formed the Friends of the Art Commission to establish a base of political support should such "initiatives" revive. The events underscored (as they had in 1934) the fragility of the semipublic ACNY's power when political forces—and especially the mayor—were belligerent. At the same time, the crisis showed the overall resilience of the agency and the solidity of the charter. Such circumstances also illuminate the importance of organized lobbying in the formation of public policy.

For the ACNY, an immediate crisis had passed, but a sense of threat remained imminent. The heavy-handed tactics of the administration and city council succeeded in temporarily diluting our effectiveness. The ACNY was "toothless," in the words of one former bureaucrat, for fear of being snuffed

out. But with the long-term picture in mind, we on the ACNY deemed it better to lie low until a new administration came into office.

MICHAEL BLOOMBERG

The succeeding mayor—financial services and media entrepreneur (and art collector) Michael Bloomberg—had a very different management style. Bloomberg embraced expertise and delegation of authority, an outlook that extended to urban design matters as well. He had hired Patricia E. Harris, ACNY's former director under Koch, as manager of the Corporate Communications Department for his media empire Bloomberg LP. Now, as mayor, Bloomberg appointed her as deputy mayor of administration. A coterie of female professionals who had worked as ACNY staff under Harris during the Koch era also returned to City Hall under Bloomberg.

Bloomberg and Harris made clear the new administration's renewed support of the ACNY. Given Harris's previous involvement with the ACNY, it was hardly surprising that she and Bloomberg sought to utilize its powers to enhance the public realm and to benefit their administration. The change of attitude became immediately apparent. In 2002, the mayor returned to hosting the ACNY's Annual Design Awards, an event that Giuliani shunned throughout most of his administration. Bloomberg also reinstituted and presided over the Doris Freedman Awards for Excellence in Public Art, an event initiated in the Koch administration and extended under Dinkins but that languished under the Giuliani administration. Whereas Giuliani had deputized an unpaid and rarely accessible former official, John Dyson, to serve as a liaison to the ACNY, Deputy Mayor Harris consulted directly with art commissioners and staff on initiatives important to her (like the Governor's Room).[42] Bloomberg himself announced his administration's commitment to design excellence, directing his agency heads to comply with the charter and submit all of their permanent projects to the ACNY. Tensions between the DPR and the ACNY were largely put aside as the new commissioner of parks and recreation, Adrian Benepe, set a more conciliatory tone. Under a new term limits law, the membership of the city council had undergone an unprecedented turnover, and members backed off, preoccupied with their own learning curve and aware that the new mayor now endorsed the ACNY.[43]

Unlike Giuliani, the astute Bloomberg and Harris made real use of the mayor's representative. They recognized that bringing the ACNY into their fold would enable their administration to achieve desired goals with much less effort and resistance. They brought in as a commissioner a professional,

art consultant Nancy Rosen, who had both real expertise and prior experience working with Harris and in whom they clearly had full confidence. They delegated Rosen to act as a true agent on behalf of the mayor's interests and tastes in the realm of public design. Throughout her tenure on the ACNY, Rosen utilized her abilities to sway decisions on large projects or targeted initiatives in a direction the administration sought to take.

There were both advantages and disadvantages to this state of affairs. On the negative side, Rosen's influence weakened the strength of the ACNY president, the elected officer with ostensibly more immunity from political pressure. To the extent that the mayor's representative served as an actual envoy, it was just as difficult for the ACNY to obstruct or alter big projects as it had been under the previous administration. This was especially true for projects (like the 2002–4 redevelopment of Columbus Circle) in which Daniel Doctoroff, deputy mayor for economic development, and Amanda Burden, commissioner of city planning, had a stake. At the same time, Bloomberg officials never used threats or bullying tactics. They achieved their goals through negotiation, by including the ACNY in the process. Debate, dissent, and modifications were actually possible. Representatives of the ACNY were free to battle openly even if they lost the war.

Moreover, the Bloomberg administration utilized the ACNY's influence not for political aggrandizement but rather to benefit New York City at large. Through the ACNY, the mayor reclaimed the authority of a civic-minded city government over the municipal public sphere, an orientation relinquished by Giuliani. Bloomberg—via Harris—reenlisted the ACNY to restrain, in general, the onslaught of aesthetically and commercially overdetermined images and designs, like distinctive sidewalks, way-finding signage, and streetscapes. This power proved to be crucial at a moment when, more than ever, the boundaries between the public realm and private-sector interests were literally becoming far less distinguishable, especially when it came to the streets.

PUBLIC AMENITIES, PRIVATE ENTERPRISE, AND MUNICIPAL CONTROL

From its beginning, the ACNY had grappled with the problem of the overloaded streetscape. Throughout the century, commissioners struggled to find an appropriate balance among public welfare and quality of life, special interests, and aesthetics. The ACNY circa 1900 had rejected proposals for lighting, mailboxes, and animal drinking fountains. At midcentury, lighting and traffic safety signage became matters of attention. Newsstands, pay telephones, and bus shelters were additional concerns after World War II. Commission

meetings at the end of the twentieth century focused on a new erosion of municipal public space, with increasing incursions of private-sector groups onto the streetscape.

Privatization of civic spaces occurred through a number of different types of projects. Individuals sought to improve their homes by extending fences, gardens, stoops, and trash/recycling areas onto public byways.[44] More often, initiatives came from developers, local businesses, and global corporations, newsstand operators, telephone companies, and Business Improvement Districts (BIDs), all of whom believed that they offered important services.

Empowered by the city (community boards, City Planning Commission, city council, and the mayor) to charge commercial property owners in the specific area special assessments for making improvements, BIDs had a major impact. Dan Biederman, a founder and president of the Bryant Park Restoration Corporation (established 1980), Grand Central Partnership (1988), and the Thirty-fourth Street Partnership (1989), undertook such initiatives as the restoration of Bryant Park and introduced new programs of informational signage, street furniture, security patrols, and other capitol improvements. Although Rudolph Giuliani himself was personally hostile toward Biederman and reduced both his power and that of the BIDs, the business-friendly climate thrived under the Giuliani administration.[45] Business Improvement Districts multiplied throughout New York in the late 1990s; influenced by the midtown BIDs, many of them developed streetscape improvement programs.

The city's embrace of these private-sector initiatives often produced positive results, especially in midtown Manhattan (where Biederman made good design a priority), but also contributed to one unsettling trend. Increasingly, individuals and organizations sought to lay claim to public space and create something ostensibly "imaginative," to impose their personal tastes onto the public landscape. The ACNY's task was to try to sort out how much idiosyncrasy was too much. What was the appropriate balance between public and private? What degree and form of private intervention should be acceptable, and by whom? When did an interest group formed by a range of constituencies constitute the public?

For the ACNY, who reviewed hundreds of proposals, the notion of "something imaginative" became something of a cliché: more often than not, it translated into a design that seemed to be glaringly jarring and inordinately "busy" and in which the parts did not cohere. It was within this context that the ACNY operated most noticeably as art police. Much of the our time was spent trying to convince people that sometimes the simple and unimaginative worked better, that busywork was not necessarily urban art or an amenity.

Commercial enterprise, local groups, and individuals have always been involved in the shaping of public spaces. But in the recent present, the city and

the ACNY had become far more receptive and accommodating than ever before to the pressure of private interests. Distinctive sidewalks, phone enclosures, and newsstands highlight in specific ways the commercial influence in public space, the centrality of the tourist economy and culture, and the integral connection between these concerns and a burgeoning material culture of "urban memory." Streetscape projects in Brooklyn and Harlem show the ACNY's engagement with different types of "public-private partnerships" (to use a phrase especially in vogue in the late 1990s), in which municipal agencies teamed up with nonprofit groups, local elected officials, and businessmen to shape a sense of "place" and memory celebrating ethnic and racial identity. As with mayoral initiatives, these street design projects highlighted tensions arising from the diverging agendas among these government agencies and from weighing the priorities and powers of collaborating public and private interests against those of a peculiar public entity like the ACNY.

In Search of Distinction

One understated but unifying marker of the New York City street has been its light gray or sand-colored concrete sidewalks, divided into squares. Efforts to depart from that civic standard proliferated during the late 1990s in the form of "distinctive sidewalks." Popular since beginning of the late 1970s, distinctive sidewalks are those whose patterns or materials depart from the New York City Department of Transportation standard (concrete or bluestone, scored into five-by-five-foot squares that run perpendicular to the curb) to evoke an aura of "class" and to distinguish one particular structure from its urban surroundings.[46]

Distinctive sidewalk requests to the ACNY proliferated during the Giuliani era. Some requests came from individual owners of East Side Manhattan townhouses seeking more elegant brick or patterned concrete entranceways; some came from Manhattan houses of worship, for example, the Transfiguration Catholic Church on Mosco Street in Chinatown and the Holy Family Church at 315 East Forty-seventh Street. The majority of proposals came from owners of midtown hotels and developers of corporate office buildings (fig. 5.11), many of whom favored pink or charcoal-colored granites and more intricate scoring patterns.[47] The burden was on the applicant to justify the need for such a sidewalk, but at the same time the DOT, which sponsored the submissions, exercised little discrimination. It was simpler to hold the ACNY responsible for the decision.

Commission members were not keen on distinctive sidewalks, considering them a capitulation to private-sector desires for conspicuous individualism, a special favor bestowed at the expense of the streetscape's unity. As with other

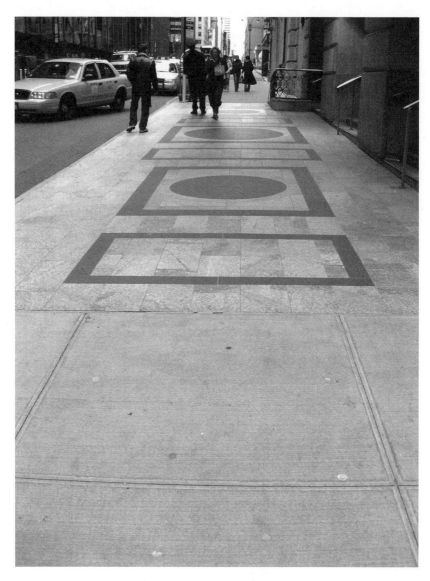

5.11 Distinctive sidewalk, Inter-Continental Hotel—the Barclay, New York, 2002, 111 East Forty-
eighth Street, Manhattan, 2002. (Photo by author.) The Barclay hotel proposed an elaborate geo-
metric pattern "carpet treatment," of three granites (cambrian, stony creek, new arctic white) to
mark its new marquee. The art commission requested that the design be simplified. This photo-
graph shows the revised pattern.

types of projects, the commission emphasized restraint, requesting simplification of patterns that seemed overly distracting. In theory, the ACNY was inclined to approve distinctive sidewalks only if they did not overly disrupt the visual continuity of the block as a whole. During the Giuliani administration, however, and especially during Williams's tenure, there was an unspoken assumption that such distinctive sidewalk requests ought to be looked on favorably and evaluated according to intrinsic aesthetic merits, not in relation to any bigger picture—as long as the proposed sidewalk did not pose a "trip hazard" for pedestrians. The city government clearly seemed to be receptive to the use of the streets for promotional purposes, portrayed as "place history" (fig. 5.12). The question was often not "whether?" but "how much?" There were limits, however. When it came to the use of gaudy designs, or sidewalks for blatant advertising purposes—such as when Kaufmans, the army-navy store, proposed a camouflage "woodland pattern"—the ACNY disapproved them.[48]

Given this ostensible receptivity, it was no wonder that, by 2002, developers for large new residential buildings also began to submit distinctive sidewalk proposals. By this time, however, the climate had changed. Under Bloomberg, the ACNY was encouraged to take a broader, more urbanistic stance on the sidewalk issue, approving only relatively unobtrusive designs that were crucial for the viability of the business and that did not break up the visual continuity of the overall streetscape. Requests for residential buildings were generally not approved because, as mayor's representative Rosen put it, there was no justification for co-opting the public realm for the benefit of private interests.

Pay Telephones

At the turn of the twenty-first century, the ACNY continued its enterprise, ongoing since its founding, of negotiating the design and scale of street furniture, with the goal of maintaining visual harmony and special flow and minimizing "visual clutter." This was a difficult task, what with commercial amenities like distinctive sidewalks, newsstands, and pay telephones adding to the mix of urban utilities taking up space on the sidewalk. Phone enclosures, circa 2000, presented particular challenges, all the more so because the design plans were linked to the incorporation of large-scale advertising panels from which the city reaped profits. Although the ACNY hoped to extend the parameters of its jurisdiction to include location, the Department of Information Technology and Telecommunications (DOITT) and the administration made it clear that the ACNY could assess only the basic design. Neither location nor the issue of advertising could be part of the equation.[49]

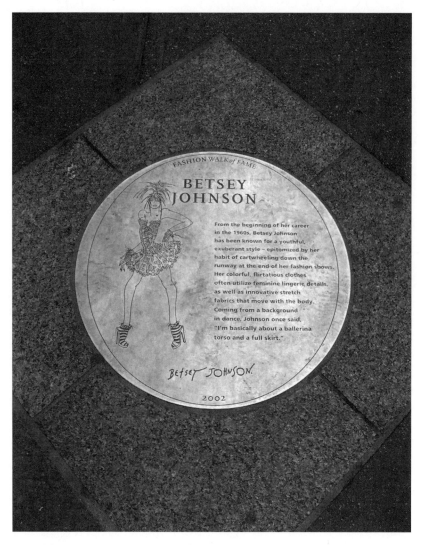

5.12 Medallion from Fashion Walk of Fame, Johansson and Walcavage, designers, 1999, Seventh Avenue, between Forty-first and Thirty-fourth streets, Fashion Center, Manhattan. (Photo by Philip J. Pauly.) In January 1999 the Fashion Center BID and Johansson and Walcavage submitted designs for a proposed Fashion Walk of Fame, for Seventh Avenue between Forty-first and Thirty-fourth streets. Two-foot-square decorative medallions embedded in the sidewalks each honor a notable fashion designer by including an original fashion sketch, the designer's signature, and BID identification. The ACNY voiced concern about designers' occasionally fleeting reputations. The commission accepted the plaques but rejected as blatantly promotional a plan for "donor recognition" for project underwriters Macy's Department Store and *New York Magazine,* in the form of inscriptions rendered in the respective fonts of their company logos. The compromise was to allow one recognition plaque at each end of the walk, with donor names in small inconspicuous letters.

Thus all that the ACNY could do within these confines was to operate as the city's aesthetic conscience, to try to obtain the most appealing and least intrusive design possible. All the more frustrating, from our standpoint, even the most compelling solution—a sleek dark blue modern phone kiosk submitted as a prototype by the Thirty-fourth Street Partnership (fig. 5.13)—came to naught because the big telephone companies like Verizon did not support it. Verizon had its own plans, developing an outsized enclosure to support advertising panels, with a pay telephone inside (fig. 5.14). The ACNY meetings provided a forum for deliberations on the part of the ACNY, DOITT, telecommunications corporations, BIDs, and, to a lesser extent, community boards and advocacy groups. The discussions concerned the relationships among private and public interests, street aesthetics, commerce, and communication on the twenty-first-century city sidewalk. But on matters of money and big utilities, restraint was a matter of tweaking details.

Newsstands

Like telephones, newsstands were also a major public aesthetic preoccupation in New York circa 2000. In contrast to the situation with telephone enclosures, however, the ACNY hoped to determine the placement and appearance of individual newsstands. Our actions on newsstands were based on the notion that civic identity, expressed partly via the aesthetics of public streetscape, could take priority over individual and corporate interests.

Quintessentially New York City fixtures since the early twentieth century, newsstands were basically boxlike sheds with awnings, often abutting or adjacent to subway stations. Occasional efforts were made to improve their appearance in the late twentieth century; the Public Art Fund held a competition for new designs, but the resulting structures deteriorated because of shoddy materials and poor maintenance. In 1996, Deputy Mayor Fran Reiter championed plans for a coordinated street furniture initiative under a twenty-year city-wide franchise. A group of leading architectural and design firms would compete to undertake the designs. After dithering about whether to give out contracts to single firms or several contracts for different neighborhoods or different types or fixtures and designs, Mayor Giuliani lost enthusiasm for the idea, and a moratorium ensued on the construction of newsstands.[50] The average newsstand remained a ramshackle-looking affair.

In 1999, the administration began to lift the moratorium, and proposals for new newsstands began to trickle into the ACNY. Some commissioners opposed the new newsstands on principle, contending that they diverted business from other stands and from magazine stores that paid significant rent and taxes. The Newsstand Operators Association contended that such arguments

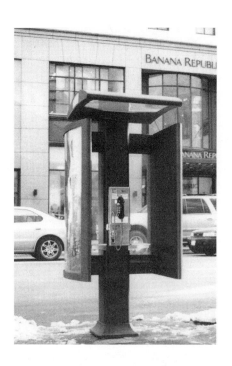

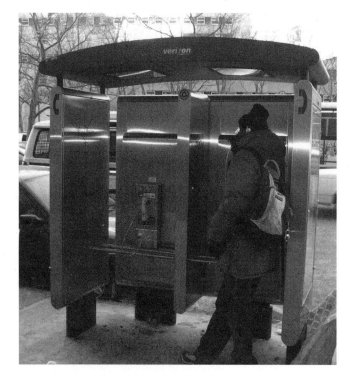

5.13 Thirty-fourth Street Partnership prototype telephone kiosk, Igacio Ciocchini, designer, Thirty-fourth Street between Sixth and Fifth avenues, south side. (Photo by author.) The conspicuous rectangular box telephone booths of Superman fame had all but disappeared from the streets of New York by the 1980s, a victim of rising vandalism. After the 1984 breakup of the AT&T corporation, a variety of independent phone companies each began installing their own phone structures, and the city relinquished much of its oversight on upkeep and aesthetics. A 1988 franchise with Bell Atlantic permitted advertisements on the booths. By 1999, New York City received 26 percent of the revenues from telephone enclosure advertising, along with 10 percent of the gross income from coin in phones on the curb. With much to gain from the proliferation of telephones and their advertising panels, the Giuliani administration's new Department of Information Technology and Telecommunications (DOITT) took a lenient position on telephone franchising. The ACNY could not review applications for public pay telephone permits. Its members could only weigh in on new designs, most of which were deemed unacceptable. Graffiti and stickers on the booths—signs of shoddy maintenance—did not help, nor did the fact that many companies placed unapproved designs on the streets. The Thirty-fourth Street Improvement District, a Manhattan BID, developed its own telephone design, shown here: a sleek dark blue modern kiosk by in-house designer Igacio Ciocchini. The enclosures included the requisite advertising panels, well-integrated into the structure. The ACNY singled out the design in its 2000 Design Awards, but the BID nonetheless failed to convince phone companies to adopt it. One reason was cost; another, according to Verizon, (the largest of the city's telephone service providers), was that the convex shape of the Thirty-fourth Street prototype was unacceptable to the advertisers because it obstructed views of the ads from afar.

5.14 Verizon phone enclosure, 2002, Montague Street near Pierrepont Street, Brooklyn. (Photo by author.) One additional reason that Verizon did not support the Thirty-fourth Street Partnership's phone initiative (see also fig. 5.13) was that the corporation was developing its own design. An initial scheme, reviewed in 1999, struck ACNY members as overly large, bulky in proportion, and self-promotional, with excessive display of the Verizon logo. Verizon returned with the "slimmed down" version seen here. The ACNY approved it on 11 November 2002 after the corporation counsel ruled that the question of advertising was part of a franchise agreement between DOITT and Verizon and outside ACNY jurisdiction. Civic and community groups protested the size of the enclosure and its commercialism, but their objections came too late in the game to have an impact on the vote. The mayor's office, city council, city budget office, and the telecommunications industries thus played a central role in shaping the municipal streetscape at the turn of the twenty-first century.

were not valid, and the New York City Law Department agreed, instructing us to stick just to aesthetic review; the Department of Consumer Affairs (DCA) and the New York City Department of Transportation (DOT) would ostensibly deal with the other issues. Beyond insuring that a newsstand application met the basic size and minimal safety requirements, however, the DCA and DOT in fact imposed few standards. For example, they did not require that an architect had to design it.[51] Thus while laissez-faire design ruled the day, neither the ACNY nor many community activists could live with it.

The proliferation and poor condition of the older newsstands had irritated some BIDs, businesses, activist groups and individual residents, especially on Manhattan's Upper West Side.[52] These critics objected to the stands' unkempt, unattractive appearance, exacerbated by storage box and refrigerator add-ons that protruded onto the sidewalk; they also contended that the stands hindered pedestrian movement and caused congestion. Advocates like

Newsstand Operations Association counsel Robert Bookman, on the other side, argued that newsstands offered an important public service and contributed to public safety by being a constant presence on the streets. Some ACNY members were not so convinced.

Mindful that newsstands faced community and business opposition and that the ACNY would not approve new stands unless they looked better, the Newsstand Operators Association worked with architect James Garretson of Offsite Technologies (who had created an award-winning newsstand design in 1993) to develop a new design. Throughout 1999 the congenial and accommodating Garretson came to the ACNY for conceptual reviews, and he modified his designs in response to ACNY recommendations. The ACNY subsequently approved the preliminary and final design for a newsstand that would serve as a prototype (fig. 5.15).[53]

Adoption of the Garretson prototype did not mean that an application for a specific locale would be automatically accepted. Wary about the failure of DCA oversight, the ACNY resolved to review the newsstands case-by-case to account for how location would affect view corridors or the surrounding built environment. Several commissioners voiced particular apprehension about how the most desirable sites for newsstands were often high-traffic districts, where "street clutter" and congestion issues were necessarily most troublesome.[54] Occasionally remarks would unwittingly betray the confidence born of class. Objecting to a proposal to install a newsstand on the east side of Fifth Avenue, just south of Fifty-seventh Street, one commissioner, an Upper East Side resident inquired: "Can't people just run into the Plaza to buy their paper?"

Hence the ACNY approved some newsstands, not others. These procedures have remained in place.

Meanwhile, in summer and fall 2003, the Bloomberg administration and city council revived efforts to establish a coordinated street furniture program. In October 2003, the city council approved a bill that would make newsstands part of a "megafranchise." A new newsstand design would be developed, one that would allow advertising to be incorporated. Under the new arrangement, the franchise holder would replace old newsstands with the new design and would pay the city $400 million over twenty years in exchange for "exclusive advertising rights."[55] The ACNY will review the new newsstand design prototype but, as with the telephones, cannot have a say on the advertising panels that are to be part of the package. How this reality will affect the evaluation of new newsstands in new locations—as street furniture or "visual clutter"—remains to be seen. For the time being, however, at least with newsstands, the ACNY has managed to define municipal aesthetics in terms of place as well as structure.

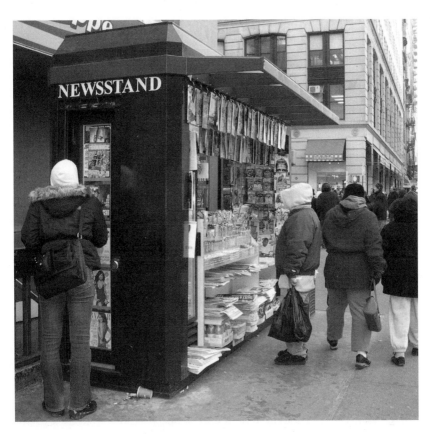

5.15 Newsstand, James Garretson, Offsite Technologies, designer, Twenty-third Street east of Park Avenue South. (Photo by author.) Garretson produced a thoughtful red and green design (1999), but the cheap paint and metal gauge utilized on some of the new newsstands proved unable to withstand graffiti and everyday wear and tear. The ACNY insisted that better maintenance would be necessary for future approvals. Applications for newsstands, which typically come from individuals (many of them South Asian immigrants), first go to the Department of Consumer Affairs (DCA), and then to the DOT. If the stand is to be installed within 350 feet of a park, then the DPR has authority over its placement and franchise arrangements. Property owners cannot prevent DCA from accepting a newsstand application for the sidewalks fronting their property, despite the fact that the stands affect pedestrian and street traffic, local businesses, and quality of life in front of their buildings.

Streetscapes, Communities, Identity, Memory

Distinctive sidewalks, newsstands, and telephones highlight tug-of-wars between private and public factions over the gradual encroachment of commercial or private interests on municipal property. Several streetscape projects in Queens, Brooklyn, and Harlem, combining the efforts of the city's Economic Development Corporation (EDC), local redevelopment corporations and

BIDs, environmental and graphic designers, architects, and citizens, were more comprehensive and intricate enterprises that also meshed public and private interests. These programs were intended to enrich and lend coherence to the area through coordinated designs for sidewalks and street furniture. They were also meant to establish a distinctive place "image" or "identity" that would instill local pride, attract tourism, and thereby boost the economic fortunes of the neighborhood or district.[56]

With the streetscape projects, the ACNY negotiated with these local coalitions to modify features that we found to be jarring, overpatterned, or iconographically questionable. Two concerns were at issue: How much decoration was too much? And who should have the right to claim public space in the name of identity and how? The ACNY exerted a conservative pressure to maintain continuity with elite or cultured traditions of high art that conceive of design as a vehicle for articulating a common culture. The assumption undergirding many of our comments was that such practices were not grounded in parochial concepts of racial, ethnic, religious, or military affiliation but, rather, articulated most effectively through high modernist aesthetics and aspirations to the timeless, favoring either sophisticated compositional complexity or spareness of form in the service of unity.

Using streetscape projects and design to evoke images of urban culture and place was not new to the 1990s. The "unified streetscape" was a basic City Beautiful conception. The introduction of corporate-type "marketing features" was a throwback to the 1970s and 1980s. In the early 1970s, for example, logos and insignia—graphic design and public relations symbols used for some time in the corporate sector—were utilized to enhance community redevelopment, pride, and ideals of urban identity rooted in place. In 1976, kiosks, "marker signs," and "trailblazers" (banners) established a "Heritage Trail" for lower Manhattan as a historic district that encouraged tourism. In 1979 the ACNY approved a redevelopment of Flatbush Avenue, Brooklyn, that included distinctive sidewalks and crosswalks, plantings, and an "identifying" logo—a flat green tree (fig. 5.16).[57]

Streetscape development seeking to establish neighborhood identities became increasingly trendy. Seemingly nothing was omitted: benches, bollards, crosswalks, trash receptacles, lighting fixtures, banners, kiosks, plaques, wayfinding signage, distinctive sidewalks, and other amenities. Between 1998 and 2002, for example, the ACNY reviewed elaborate streetscape plans for lower Manhattan and for Columbus and Frederick Douglass Circles, 110th Street in Harlem, Fifth Avenue (Sunset Park), Flatbush Junction, and Empire Boulevard in Brooklyn, and the Flushing and Jamaica districts in Queens. Many of these projects were situated near large mass transit hubs and funded by federal monies obtained through the Intermodal Surface Transportation Efficiency

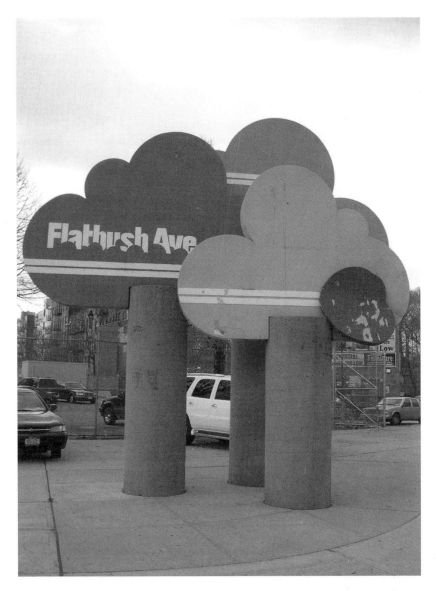

5.16 Logo Tree, 1979, intersection of Flatbush Avenue and Empire Boulevard, Brooklyn. (Photo by author.)

Act of 1991 (ISTEA), which authorizes federal highway and transit funding programs. The ISTEA system sponsored planning ventures as strategies for improving transportation and investment in a given district. The U.S. Department of Transportation dispensed large sums of money with an eye to drawing in as many constituencies as possible. The streetscape ventures were

one outgrowth of this investment in a community-based process, although it remains unclear whether or how they would ultimately realize the ISTEA mission.[58] Some ACNY members believed that the abundance of signage and other visual features of these projects seemed gratuitous, even excessive, a means of insuring that all ISTEA monies were visibly expended. Hence ACNY reviews of street reconstructions and signage programs focused intensively on just trying to simplify them.

Signage as an instrument of place marking and place making in New York City dated back to the eighteenth century. Much of this signage was commercial in nature and served to advertise and mark places of business; its contribution to the experience of place in most locales was largely inadvertent, although the role of signage in the formation of Times Square's identity was renowned worldwide by the twentieth century. The municipality contributed street and regulatory signage for controlling and clarifying the streets. The ACNY, as we have seen, had been involved in efforts to make coherence out of chaos since its earliest years.

Way-finding signage was a popular trend in twenty-first century "visual culture," promoting an ideal of the city as legible image, as sign. Reviewing the plans for the Downtown Flushing Pedestrian Project in Queens, I wondered whether an overusage of features and signage (fig. 5.17) might diminish a sense of place instead of enhancing it.[59] People would no longer be encouraged to "make" their way; individual choices and corporeal experiences were being deemphasized. Instead, way-finding was now defining and representing places *for* people.[60] The ACNY sought to tone down some of the more excessive manifestations of this outlook but was hard-pressed to put an end to it.

Spaces of Identity

Some efforts to create a sense of "place" through streetscape projects laid claim to neighborhood identity and memory in racial and ethnic terms. Streetscape projects at Flatbush Junction (Flatbush Avenue at Hillel Place and Nostrand Avenue), at Flatbush Avenue and Empire Boulevard, and in Harlem were just such enterprises, as were a number of submissions to the ACNY for plaques and memorials. These projects brought forth an additional, more controversial matter with which the ACNY grappled in its pursuit of aesthetic moderation: whether and how one group, representing itself as *the* voice of a community, ought to portray its history, agendas, and images in shaping municipal public space.

The Brooklyn and Harlem projects involved us in exchanges on these questions and urban design logistics more generally with community activists, politicians, municipal agency officials, and architectural and planning

5.17 Construction of Downtown Flushing Pedestrian Project, Thirty-seventh Avenue and Thirty-ninth Avenue near Main Street, Flushing Queens, 1999–2000. (Courtesy of Chermayeff and Geismar; Collection of the Art Commission of the City of New York, Exhibition file 6181.) For the Downtown Flushing Pedestrian Project, the project team (Department of City Planning, Saratoga Landscape Architects, and Chermayeff and Geismar, graphic designers) planned new lighting, benches, a patterned sidewalk, signage, a collage-style mosaic mural for a small pedestrian passageway, and parking lot gateway finials designed as "public art." The project also included copious amounts of signage, which, we were told, paradoxically would "alleviate visual clutter" and add "a public presence." (Committee meeting, 22 March 2000.) The city planning team also sought to promote the area as a tourist destination by developing the Freedom Trail, which would highlight Flushing's significance as the "birthplace of religious freedom" and the center of immigrant life. To that end, the Flushing group also proposed new sidewalk medallions, stanchions, pedestrian lighting, trail routes, and colored banding in the crosswalks to mark sixteen historic sites, some of which no longer existed. Chermayeff and Geismar's designs for signage were sleekly modern and elegant. The polished spherical logo, symbolizing the 1964 World's Fair Unisphere in Flushing Meadows-Corona Park, contributed to a look that struck me as more appropriate for a corporate plaza than for a bustling ethnic neighborhood in Queens.

professionals. As with the Flushing program, they raised concerns about scale, materials, detail, and visual excess. The programs also generated debate about racialized urban iconography. In Flatbush Junction and Empire Boulevard, for example, neighborhoods where many residents and business owners were West Indian and black, the firm of Johansson & Walcavage (Flatbush Junction) and Urban Architectural Initiatives (Empire Boulevard) sought to lend distinction to the neighborhood by developing an aesthetic that they contended signified Caribbeanness. Several commissioners challenged this concept vociferously, but the ACNY ultimately did not turn it

CAMPUS

HILLEL PLACE

KENILWORTH PLACE

5.18 Construction of Flatbush Junction sidewalk amenities, Flatbush Avenue between Farragut Road
 and Avenue H, and Nostrand Avenue between Glenwood Road and Avenue H, and Hillel
 Place between Flatbush Avenue and Campus Road, Brooklyn; Johansson and Walcavage, Land-
 scape Architects, 1998. (Courtesy of Johansson and Walcavage, Landscape Architects; Collection
 of the Art Commission of the City of New York, Exhibition files 6089-A, -B, -D.) For this
 streetscape project near Brooklyn College, the landscape architect Donna Walcavage developed a
 brightly colored palette whose vibrancy she likened to an Afro-Caribbean aesthetic and to Times
 Square. Johansson and Walcavage intended to use bright yellows, oranges, and reds for the ban-
 ners, kiosks, tall pylon gateways, chairs, trash receptacles, and other features. The designers also
 planned to include multicolored, diagonally patterned distinctive sidewalks. This plan depicts
 Hillel Place, leading to Brooklyn College, with a pattern of yellow brick zigzagging down the
 street. Commission members responded that the scheme proposed too much and urged the de-
 signers to reduce the numbers of large streetscape elements (such as the tall pylons) and simplify
 the street patterns so as to reinforce the lines of the street rather than distract from them. Lay mem-
 ber Konheim strongly objected to the interpretation of a Caribbean aesthetic, arguing that it was
 inaccurate and patronizing. Johannsen and Walcavage reduced their color palette from three to
 two colors and simplified the street and sidewalk patterns. The basic Afro-Caribbean concept re-
 mained intact however, and the commission granted preliminary approval in March 1999. (As of
 summer 2005, construction on the project had not begun.)

down (fig. 5.18).[61] An ambitious project to celebrate the 110th Street corridor along Central Park as the "gateway to Harlem" through new sidewalks, plantings, and lighting fixtures was driven by some similar desires to articulate the history and traditions of a public place in racial terms. This enterprise, a pilot project of the nonprofit group Cityscape Institute, aroused more public controversy.[62] The objections arose partly because the design team was trying to design a completely new type of light fixture (fig. 5.19)—a process fraught with bureaucratic and aesthetic complexities—and partly because the team sought to evoke Harlem's "heritage" by incorporating photographic and text plaques into the pedestal base of the light pole.[63]

An ACNY public meeting turned into a debate over the 110th Street Corridor project, especially the plaques. The ACNY and others opposed the plaque concept. Our concern was that approving them would set a bad precedent: neighborhoods elsewhere would want to try something similar, and little plaques would start to crop up on light poles all over the city. Some feared that the plaques would be defaced and then, for lack of funds to replace them, would be supplanted by advertising. A third reservation pertained to the plaques' appearance. I asked what sources were to be used for the images, and how these would look when translated into the monochromatic dark green color proposed for the light poles. Preservation organizations questioned the historical and ideological overtones and implications of the commemorative statement: plaques devoted solely to African-American heroes delimited Harlem's identity solely in racial terms, as a black neighborhood, when historically the neighborhood had also been dominated by Irish, Italian and Jewish immigrants. The plaques provided a limited conception of Harlem, and of black Harlem at that. Others, notably Harlem historian and preservationist Michael Henry Adams, contended that the plaque plan would "Disney-fy" or theme-park Harlem by imaging black celebrities, many of whom had never lived in Harlem, instead of preserving actual places or the histories and memories of the notables who had actually resided along 110th Street.[64]

The negative testimony resonated with ACNY members' own reservations, not made public as forthrightly as by those who testified. Commissioners were also aware, however, that in a city that had little acknowledged the African American presence in public art, many black New Yorkers desired to make their history more visible. The question we asked was whether plaques were the best way to do so. How to balance a community's aspiration to celebrate tradition in a particular manner, with the imperative to uphold high standards of urban beauty and not trivialize local or national history? Other questions persisted. Who spoke for "the community," and why should their tastes be privileged, especially given the number of dissenting voices from the neighborhood?[65]

TYPE 1 — STREET POLE
SCALE 3/8"=1'-0"

TYPE 2 — PEDESTRIAN POLE
SCALE 3/8"=1'-0"

99% SUBMISSION

NEW YORK STATE EMPIRE STATE
DEVELOPMENT CORPORATION

CONTRACT NO.

110TH STREET CORRIDOR IMPROVEMENTS

TYPE 1 — STREET POLE
TYPE 2 — PEDESTRIAN POLE

HARDY HOLZMAN PFEIFFER ASSOCIATES
NEW YORK, NY 10010

5.19 Proposed heritage pole for Harlem Gateway Corridor, Hardy Holzman Pfeiffer, architects, 1999. (Courtesy of Hardy Holzman Pfeiffer; Collection of the Art Commission of the City of New York, Exhibition files 6097-L-O.) Cityscape Institute, working with architects John Fontillas and Hugh Hardy of Hardy Holzman Pfeiffer, developed a new "family" of light fixtures (pedestrian, road, and traffic poles) to provide much-needed illumination for 110th Street. Cityscape Institute, which shepherded the plans through the city bureaucracy, faced numerous obstacles because of the numbers of agencies involved: the DOT, responsible for maintaining the pole and the light; the Landmarks Preservation Commission (LPC), which had an advisory role because 110th Street bordered on the scenic landmark Central Park; and the ACNY, which had principal jurisdiction because the project fell outside a landmark district. Complicating matters, the agencies had different priorities and points of view. Cityscape Institute intended to install the new heritage pole designs on both the north and south sides of this very wide street. The LPC argued that the south side of 110th Street was the culmination of Central Park and, thus, wanted the *B* (pedestrian) pole and bishop's crook pole, standards in historic districts, placed on the park side. The ACNY had to decide whether to concur with the LPC opinion, which would have meant approving three different types of fixtures for the street. The alternative was to approve the heritage pole for both sides. We decided that 110th Street was part of the urban fabric to the north, that it was important to maintain consistency of features, and that it made no sense to approve the *B* and bishop's crook poles on the south and a different fixture on the north side. Commissioners disagreed on whether the heritage pole design was the best choice for a new design. Painter Jean Rather argued that the sharp edges of the spiked flourish on top (an homage to a form found on lamps of turn of the twentieth century) would make people feel threatened and uncomfortable. Others felt that the design, recalling the Beaux-Arts and art nouveau styles, was too ornate and outdated. Menschel wondered how the poles would look once covered with the usual plethora of traffic signs. Where Hardy sought to render, in his words, "texture and robustness" in the lamppost bases, a "strong character with a human scale," a majority of ACNY members found the scale of the bases large and unwieldy. The architects attenuated the base and reduced the scale of the poles, changes that helped to sway opinions in their favor. Commission president Phifer pressed the group successfully to approve the heritage pole rather than to fall back on the familiar.

Given our conflicted responses, the ACNY stalled on the plaque issue. A 12 July 1999 decision granted preliminary approval to the heritage light fixtures, without plaques.[66] The Cityscape team returned in October 2001, requesting the ACNY to approve the plaques. Paradoxically, on this occasion, worn down by the discussions, and confronted with this delicate issue so soon after the shock of the terrorist attacks of 11 September 2001, none of us objected to the plaques. In fact, discussions centered narrowly on the plaques' appearance and material, not on whether they were viable.[67] On reaching consensus about format and materials, we accepted the plaques, thus highlighting the importance of persistent negotiation, liberal attitudes, and happenstance in shaping the built environment of the present day.

For Cityscape Institute, the approval proved to be a Pyrrhic victory. After all of the deliberations, the DOT could not determine that the revised Hardy Holzman Pfeiffer design for the Heritage Pole was actually workable from a maintenance point of view and, thus, refused to approve it at that time. To insure that the project would stay on schedule and thus retain its ISTEA funding, the city and Cityscape Institute moved forward, using the "M" pole, which was already being used on Malcolm X Boulevard and which the ACNY had previously approved as a fallback (fig. 5.20).

The DOT's inaction on the Heritage Pole, bolstered perhaps by the reservations voiced in ACNY deliberations, demonstrated the obstacles facing sweeping new public municipal initiatives undertaken by small private enterprises. This project's vicissitudes reveal the conservatism inherent in the process and the pressures brought on it that can—depending on one's viewpoint—either impede creativity and multicultural inclusiveness or insure that public space retains a measured and reserved nonpartisanship. The ACNY sought to strike a balance between respecting and pleasing local constituencies and maintaining standards that occasionally conflicted with community-devised aesthetic programs. The ACNY consistently sought a middle ground, tempering extreme positions and encouraging a simpler and more "universalist" design solution.

Monuments, Plaques, and City History

Streetscape improvements were large, complex ventures, engaging citizens, neighborhood civic and interest groups, community boards, city agencies, city councilpersons, and representatives of federal government. Deliberations on memorials, plaques, and other commemorative forms involved similar challenges.

The ACNY had reviewed memorials since its inception, of course. Eliminating bad art had been the ACNY's reason for being. It was much harder to

5.20 110th Street, between Fifth Avenue and Malcolm X Boulevard (Lenox Avenue), 2004. (Photo by author.) This view, looking east, shows the *M*-style highway and pedestrian light poles and the distinctive sidewalk "carpet treatment," developed by Ken Smith and Cityscape Institute.

achieve this mandate in the turn-of-the-twenty-first-century political and aesthetic climate. The ACNY sustained its ideal of an aesthetic of restraint, along with challenging intellectual content and a broader civic significance. At the same time, in trying to resolve conflicts of taste, we trod cautiously, demanding less excellence than adequacy. It was now rarely a question of whether a

work of art would be approved but, rather, how much we would request in the way of alterations. The memorial review process revealed the limits of elite authority, especially when compared to its influence a century ago.

Prior to the 1960s, the ACNY had been the gatekeeper between the urban public and private interests, especially those of the contemporary art worlds of New York City. During the second third of the century in particular, the commission sought to protect the public from contemporary developments like modernist or abstract art. The ACNY of the early twenty-first century was a liberal body. With taste preferences cultivated through collecting museum-quality art and being immersed in university and New York art world–validated creation and discourse, we frequently experienced a disconnect between our own aesthetic values and those of memorial sponsors— friends, families, or coworkers of victims of tragic death; local ethnic organizations; and veterans, for example—with very different perspectives. This turn-of-the-century ACNY sought to bridge the gap between the "establishment" elite art worlds of the university, museum, and the multinational corporation, on the one side, and the more localized art-world spaces carved out within the municipal bureaucracy and the neighborhoods, on the other.

Many of the proposed projects, especially those that blue-collar or middle-class sponsors initiated in the outer boroughs, exhibited a traditional and conventional aesthetic that reflected more popular tastes and dominant representational traditions. Thus memorials additionally raised the question of how far we should allow our liberal proclivities to prevail when the group deemed a memorial project aesthetically unacceptable.

At the turn of the twentieth century, with the Slocum Memorial, for example, the ACNY had no compunction about sending the donors of a memorial—the friends and families of victims of that terrible tragedy—back to the drawing board (figs. 3.12, 3.13). Families and survivors had no special influence. In the past, moreover, memorials were intended to celebrate the significance of the life of the hero or a specific event. A century later, many Americans prioritized the memory of the victim for the immediate survivors and "loved ones" rather than to individuals' broader significance or social legacy. Some sponsors sought to empathize with victims by utilizing memorials to replay or evoke a moment of the horror. Memorials acquired a new, therapeutic purpose; they were created to serve as part of a "healing process."

Memory projects such as these differed a great deal from those involving municipal bureaucrats and encounters with designers whose superiors had directed them to push forward specific concepts, such as appending cow and donkey art to evoke the memory of local people and places. In several notable cases, the ACNY sparred with local groups who had emotional investments in their projects and no desire to let experts or bureaucrats interfere

with their conceptions. In these circumstances, the ACNY sought aesthetic revision, moderation, and, ultimately, compromise. Our proceedings represented a republican mediation of unrestrained expression of democratic will and action. At the same time, we commissioners were quite conscious of both the peculiarity and fragility of our authority as select individuals imposing taste as an aggregate and of the need to be cautious in light of the Giuliani-era threats to the agency's survival. Hence the ACNY was willing to push only so far. As a historian of monuments, I found these circumstances frustrating—I would have preferred the group to take a stronger stand. Nevertheless, these concessions were logical within the context of the process.

In the case of a reconstructed pedestal for a monument to Lin Ze Xu in Chinatown (fig. 5.21), for example, debates arose over lengthy inscriptions. The message attempted to link ethnic history to a contemporary antidrug and local political agenda, but we on the ACNY considered it illiterate, politically inflammatory, and anachronistic (see caption). Long lists of individual donor names, proposed for the sides of the pedestal, also became a point of contention.[68] Ultimately the commemorative process boiled down to questions concerning the broader public interest versus that of the ostensible "community." The sponsor implied that the ACNY objections were the result of ethnic bias. We could not determine whether the disagreements were spawned by actual cultural differences between ourselves and the sponsors (a group of Chinatown businessmen and residents), or whether the ACNY was simply succumbing to political manipulation by the Lin Ze Xu Foundation's director. I recommended extensive revisions for inscriptions, some of which were made, but the ACNY—myself included—approved a few of the problematic statements. Our leniency was unnecessary. The donor defaulted on payments to the conservator, and the compromise inscriptions were ultimately never completed.[69]

A different case was that of the memorial to the Third Water Tunnel Workers (Sandhog Memorial) in the Bronx, a series of manhole covers extending out from a medallion map of the New York City water system. Here we negotiated indirectly, through the mediation of the Department of Environmental Protection (DEP), with a constituency of blue-collar municipal workers over differences of taste preference that articulated disparities of class and culture. Each circular manhole cover included the name and death date of one of the twenty-four individuals who perished while constructing the tunnel. When I requested that the birth dates of the individual be provided as well for civic and educational purposes, the DEP designer responded that the Sandhog's union was "adamant" that birth dates not be included, out of a belief that the workers had not died but had merely "passed on" and that the

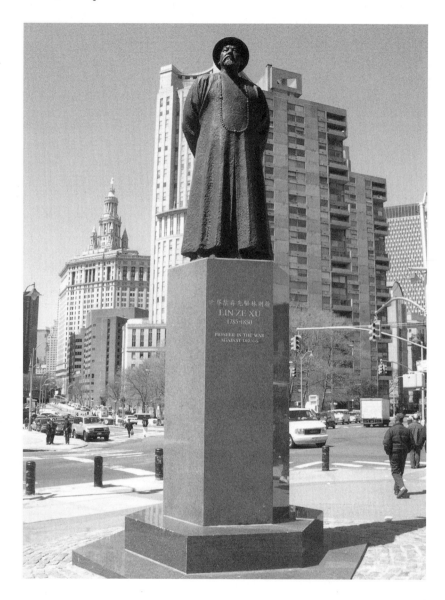

inclusion of both dates rendered the statement too funereal and final. Believing that the name and date approach was already a funereal one, we puzzled over what to consider a suitable amount of information in such a memorial. Given the small scale and relative remoteness of this project, we ultimately decided not to dig in our heels; the issue was not worth a fight.[70]

Memorials provoked disagreements not only between the ACNY and narrow interests, as they always had, but also with, for instance, veterans.

5.21 Lin Ze Xu Memorial, Li Wi Si, sculptor, T. A. Ho and T. C. Ho, architects, Chatham Square, 2000 (pedestal reconstruction). (Photo by author.) This project illustrated the difficulty of trying to demand improvements while also trying to be sensitive to different cultural sensibilities. Originally installed in the 1970s, the Lin Ze Xu statue and its pedestal underwent conservation by the Ottavino firm in 1999. That work went without incident. For the ACNY, the problems began when the sponsor, the Lin Ze Xu Foundation, announced its intention to add to the pedestal a lengthy list of individual donor names and an elaborate "historical" inscription. Department of Design and Construction liaison Michael Cetera introduced the project by explaining that the Chinese bureaucrat Lin Ze Xu, a leader in the resistance to the British during the Opium Wars, was a symbol for an antidrug campaign in Chinatown. The Lin Ze Xu Foundation sought to use the project to promote its commitment to the antidrug effort. The organization in fact wanted to leave one side of the pedestal blank for future donor names, so that it could serve as a fundraising vehicle on an ongoing basis. The ACNY, which had jurisdiction over design and content of plaque and monument inscriptions, had long discouraged extensive donor recognition inscriptions (especially after its encounters with Carlo Barsotti), believing that such methods detracted from the unified appearance of monuments and were basically just self-serving. During several tense encounters, we tried to convince the Lin Ze Xu Foundation president, Steven Wong, to include only the names of the principal sponsoring groups. Wong would have none of it. Donors wanted to put their names "out there," he said, to show drug dealers they were fearless. In publicizing their names, donors were "putting their lives on the line." Putting the names on the pedestal, Wong insisted, was like inscribing on Maya Lin's Vietnam Veterans' Memorial the names of the soldiers who lost their lives. (Veterans of that war might beg to differ.) We commission members sought compromise, suggesting that the list of donor names be placed in the pavement rather than on the pedestal itself. Cetera noted that such an installation would be considered insulting because people would step on it. After much deliberation, everyone agreed that a donor plaque would be incorporated separately onto a low wall behind the statue. The inscriptions were equally problematic. They were anachronistic, asserting that Lin Ze Xu would "forever be remembered as the pioneer of 'SAY NO TO DRUGS'" and that he was also the "first vanguard in the war against drugs." (These phrases dated back to the 1980s era of former First Lady Nancy Reagan but surely not to nineteenth-century China.) The dedications were both repetitious and ungrammatical, even after numerous revisions. Viewers were instructed to "advocate proper attitude by overcoming perverse behaviors. . . . Creating peace and harmony around the world that will shine upon the entire human race." They were also inflammatory, referring, for example, to the "British Navy, in its pirate-like fashion" and the British's "'murder for the sake of money' nature." The ACNY deemed this language unsuitable for a work on municipal property. As the executive director, Deborah Bershad, put it, public monuments on city property should not express an opinion "that could be offensive to another public constituency." The groups continued to talk past each other. The foundation was noncompliant, but we on the art commission were insufficiently forthright and directive. We ultimately approved an abbreviated but still too lengthy inscription, but thankfully, the only portion actually completed is the one pictured here.

Commission members butted heads with the sponsors of a memorial to Staten Islander Matthew J. Buono (1942–68), the thirty-ninth Staten Island resident to be killed in the Vietnam War (fig. 5.22). The memorial design included inscriptions dedicated to Staten Island victims of war. On the sides of the broad granite cylinder were plaques inscribed with the names of the war dead of the Civil War, World War I, World War II, the Korean War, and the Vietnam War. But the community also wanted recognition for all Staten Islanders who had lost their lives in major conflict. Thus they planned to include a plaque

5.22 Matthew J. Buono Monument at Buono Beach, near Alice Austin House, Hylan Boulevard at Edgewater Street, Staten Island, 2000. (Photo by author.)

for the 1991 Persian Gulf War and a separate section for "All Other Wars." In addition, the community wanted a list of all fifty states, and a photograph of Buono etched mechanically in stone.

All of this struck commission members as being excessive. The circular wall would be crowded with names and images, making for an unwieldy design. Expressing concern with the "kitchen sink" approach to war referencing, we suggested that the DPR in-house designer simplify the memorial by removing the Gulf War headings and the gaps left for the future conflicts. We also tried to convince DPR to explore other possibilities for commemorating Buono that, as Jean Parker Phifer put it, might not involve such a "funereal" form of imagery. The applicants did not take kindly to these ideas, nor to the query from one commission member, who asked sardonically whether the wars in Somalia and Grenada were next on the list for inclusion.[71] What constituted an appropriate public commemoration of an individual soldier? What was the relationship between his heroism and broader losses in multiple U.S. wars? The disagreements illustrated the ongoing divide between some middle-class Staten Island residents and the so-called Manhattan elite.

In most instances, conflicts over memorials resulted from the ACNY's desire to see inspiring contemporary art, whereas the schemes actually submitted were, from our perspective, disappointingly conventional and traditionalist. The memorial to the Battle of the Bulge for Wolfe Pond Park, Staten Island, submitted to the ACNY for conceptual review, was exceptionally troubling. The proposed monument, designed by a World War II veteran and Cranbrook-trained architect, Anthony Moody, was meant to evoke the monoliths of 1950s modern classicism and late 1960s minimalism, but the ACNY recoiled at its profusion of graphic logos, insignia, and inscriptions (fig. 5.23). On repeated occasions, ACNY members importuned the designer to cut down on the numbers of logos and simplify the scheme but erred in not being more assertive and forthright. The designer made minor alterations, but it was evident, even from the schematic plans, that he rejected larger changes.

Months went by, and the project did not return. Suddenly, several months into the Bloomberg administration, we learned incidentally that the Battle of the Bulge Memorial had been dedicated during the previous year (in a 16 December 2002 ceremony officiated by then-commissioner Henry Stern), completed illegally without undergoing the necessary further ACNY review. When the ACNY requested that DPR present the finished project for final review in February 2003, we were appalled at the clichéd design, plethora of logos, amateurish composition, and shoddy craftsmanship. Disgusted that the Stern-era DPR had not only circumvented the process but also installed a work so mindbogglingly awful, I made a motion to disapprove. Knowing that Bloomberg, Harris, and the new Parks Commissioner Adrian Benepe had staked a claim on design excellence, the ACNY voted to disapprove the hulking memorial, confident that there would be no political repercussions.[72] The veterans had a memorial, but it would not be part of the city's collection; hence DPR would not be authorized to maintain it.

When responding to memorials we considered problematic, the ACNY acted on the assumption that it was preferable to make the best of a difficult situation and to extract gradual improvements rather than to veto an entire project. The group was rarely in a position to take principled action; the Battle of the Bulge Memorial became a notable exception.

11 SEPTEMBER 2001

The issues at play in the previous circumstances all informed, in crucial ways, the ACNY's discussions in shaping the New York City built environment after 11 September 2001 (hereafter 9/11), when terrorists hijacked four airplanes and crashed two of them into the World Trade Center.[73] The 9/11 cataclysm indelibly altered the Lower Manhattan landscape and generated tremendous

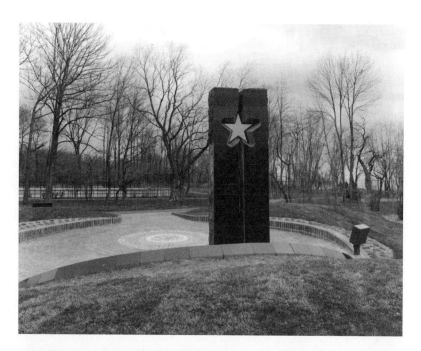

5.23　Battle of the Bulge Veterans' Memorial, south end of Cornelia Avenue, Wolfe's Pond Park, Staten Island, 2002 (disapproved). (Photo by author.)

uncertainty about the city's future. The day-to-day operations of municipal government (much of it based downtown), and rebuilding of Lower Manhattan continued, with disruptions, within a month of the catastrophe.

The ACNY was involved in this unprecedented reconstruction effort in ways that were not substantially different from pre-9/11 practice. Ground Zero, the area destroyed by the hijackers' actions, was not municipal property but was owned by the Port Authority and leased by developer Larry Silverstein. The federal government promised to pay a large part of the rebuilding costs. The state of New York largely controlled the process, especially Governor George Pataki and the Lower Manhattan Development Corporation (LMDC), a public authority. As of early 2004 the ACNY had no direct input on the permanent site reconstruction. During the winter of 2001–2, ACNY Executive Director Bershad and President Phifer participated in several interagency and downtown groups that sought to improve the appearance of downtown while rebuilding was in process; this collaboration was sporadic. The Ground Zero redevelopment process itself was idiosyncratic. The LMDC selected ACNY mayoral representative Nancy Rosen for the Ground Zero memorial jury, but jurors were prohibited from divulging anything about the deliberations, and thus the ACNY had no direct involvement. Otherwise, the art commission's normal practices continued.

In the years following the World Trade Center disaster, the ACNY sought to restrain the extremes of responses to 9/11—from an excessive number of concrete or steel impediments that turned the city into a fortress to excessive personalized funerary-type memorials in public locales and countless decorative and distracting features in reconstructed urban park spaces. The process continued to play out.

Security

New Yorkers and Americans more generally had been preoccupied with security long before 9/11. An $11 million reconstruction of City Hall Park under Giuliani essentially fortified the area. Years before 9/11, bollards (columns of concrete and sometimes steel) were placed near some sidewalk curbs to prevent vehicles from destroying fire hydrants, telephone booths, or other property or from driving up onto the sidewalk. After the terrorist attacks of 2001, the ACNY screened increasing numbers of submissions for security bollards and planters, as well as fencing and guardhouses for vital facilities like reservoirs. Such measures had a significant impact on the New York City landscape, just as they have had in the District of Columbia and in other major cities.

In a study on design and security, Deborah Bershad and James Russell had concluded that many such measures offered a forbidding presence but did little to provide actual security.[74] Following the logic of these findings, a number of commission members expressed hesitation about so much additional "street clutter." Nevertheless, acknowledging a legitimate need for psychological security and deterrence, the ACNY emphasized the desirability of attractive window dressing, urging applicants to make the objects as well-made and as sturdy as possible and to avoid, for example, bollards with plain grey concrete caps, a form of "bunker" aesthetics. In the post-9/11 urban environment especially, when it came to the "aesthetics" of public safety, security would take precedence. The ACNY sought to limit the intrusion of private interests onto public terrain, but its actions on security accepted the need to use public space to protect the public in private buildings.

Parks under Pressure

The ACNY was engaged with the reconstruction of parks in post-9/11 Lower Manhattan. In summer 2003, as part of the larger rebuilding enterprise, Governor George Pataki mandated that within approximately one year's time the DPR create or redesign thirteen downtown parks, drawing on funds from the LMDC. The ACNY carried out numerous reviews of park plans in summer and fall 2003, knowing that the state's time and budgetary pressures were the key determinants.[75] As with many other big projects initiated by high-level municipal government, everyone involved struggled to achieve satisfactory results but often had to compromise. While a process driven by time constraints was more likely to produce a mediocre design, review could still produce notable improvements.

9/11 Memorials

The mass deaths of 9/11 brought commemoration in civic art back to the forefront of discussions, along with the question of who should control and shape memory. An early proposal to address the significance of 9/11 on public ground—another Union Square Park plaque by Gregg Lefevre (see fig. 5.5), a photographic montage commemorating the park as the place where people congregated after the event—struck ACNY as trivial and ungainly. Within a year, 9/11 memorials proposed and approved for Coney Island, Brooklyn, and for Staten Island continued now-familiar trends: the emphasis on victims, families, and survivors and on the transformation of civic terrain into a private mourning ground.

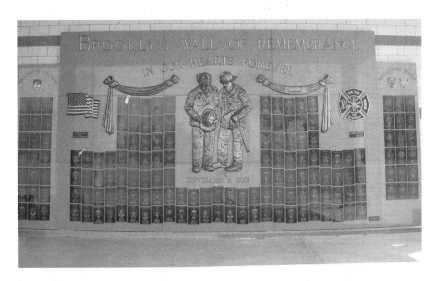

5.24 The Brooklyn Wall of Remembrance, Jamie Lester/Morgantown Monument Sculpture Studio,
sculptor, 2002. (Photo by author.) This Coney Island memorial to 9/11 extended the vulnerable
and exhausted hero iconography evoked by Fred Hart's *Three Fighting Men* sculpture and Glenna
Goodacre's national Vietnam Women's Memorial. The memorial's photographically etched gran-
ite portraits were reminiscent of Italian and Russian cemetery memorials.

In October 2002 we learned that we would be reviewing a memorial for
Coney Island, to honor the 115 firefighters from Brooklyn who died on 9/11.
Because of a series of supposed miscommunications, the work on the memo-
rial had been completed without the ACNY's ever having seen it, but it now
needed the ACNY's blessing (or rubber stamp). With 115 photographically
etched portraits of firefighters, a six-foot bronze relief of two firemen com-
forting each other in mourning, and an oversized inscription denoting the
wall as the "Ebbets Field Wall of Remembrance," the memorial was the kind
of hackneyed, sentimental design that ACNY members personally abhorred
(fig. 5.24). We were particularly dismayed by the choice of site—on the side
of Keyspan Park (the Mets organization's minor league baseball stadium) just
off the Coney Island boardwalk and nowhere near the former site of the
Ebbets Field baseball stadium. Joyce Menschel of the ACNY publicly con-
veyed her indignation at the idea of installing a 9/11 memorial in a place
where people would be carousing and drinking beer. Jean Phifer and I had
expressed similar consternation via e-mail messages. Yet confronting the real-
ity of what such a memorial seemed to mean to so many others, the major-
ity of us individually resolved to let the memorial's advocates prevail. Eu-
phemistically expressing "disappointment" at the lack of opportunity to relay
more constructive suggestions, the ACNY achieved a quorum to approve

5.25 Postcards, Staten Island September 11 Memorial, Masayuki Sono, architect, 2004. (Photo by author.)

the already completed design, minus the confusing "Ebbets Field" inscription.[76] Menschel, able to stand her ground because there was a quorum, voted against it.

A Staten Island 9/11 memorial (2003) posed some similar dilemmas, although the process was more honest. The Staten Island borough president's office held a competition, juried by politicians and victims' family members. The memorial committee paid lip service to expertise by consulting on the program with Percent for Art and ACNY staff in an advisory capacity. The competition winner, Postcards, by Japanese architect Masayuki Sono, included a resin-infused fiberglass structure intended to evoke both the idea of folded postcards, like those sent to absent loved ones (like victims of 9/11), and an eagle-like bird with wings lifted and outstretched, rendered in the Brutalist manner. The structure's inner walls included shelves, carved out at an angle to create a rectangular, "postcard-like" niche for each victim. Each shelf "postcard" had a carved granite silhouette portrait "stamp" of each Staten Island resident killed.[77]

As with the Brooklyn Wall of Remembrance, ACNY members believed that the Postcards memorial was aesthetically timid as well as too personal

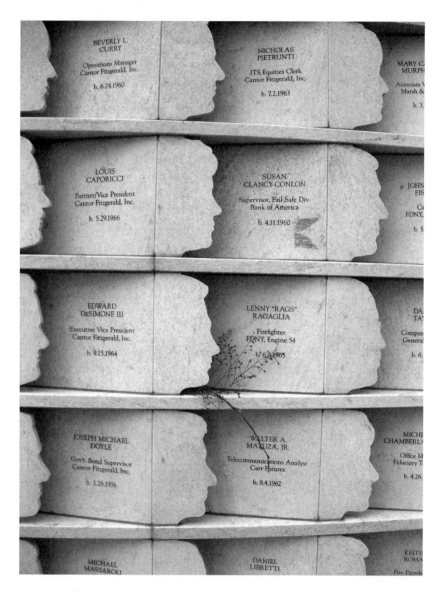

5.26 Postcards memorial, detail, 2004. (Photo by author.)

and funereal. At the same time, we wanted to avoid making public comments that might be interpreted as mean-spirited or insensitive. We therefore first discussed the shortcomings among ourselves in the private, business portion of the meeting. Even so, most of us did relay in the public meeting our concerns about the tension between the personal and the civic, as a reminder of the need for the Postcards memorial to maintain its force beyond

the immediate present. At the same time we acknowledged the unprecedented nature of the event being commemorated and the fact that in this instance many families had no cemetery to visit. Beyond expressing reservations about signification, however, the ACNY tried to move the project forward. Hence much of the discussion focused on the difficulty of rendering all the silhouettes "accurately" (i.e., in a manner that the families could accept and that—to paraphrase ACNY lay member Estrellita Brodsky— would not look "cartoonish").

The other focus of public dialogue was maintenance. As a pilgrimage site, the memorial and especially the small individual shelves would attract numerous "spontaneous memorial" offerings. Did the borough president's office have a plan for how to deal with the objects? ("Not yet.") Had the sponsors accounted for the fact that some visitors would surely use the shelves as ashtrays or insert trash into the openings provided between the silhouette portraits and the memorial? Our subsequent approval of the project stipulated that the participating agencies and organizations develop and budget for an ongoing maintenance plan. The memorial was dedicated in September 2004.

The September 11 attacks were a catastrophe unlike any that New York City or the nation had ever experienced. The ACNY's assessments of these two memorials to the disaster offered challenges like no other. Many of us were unenthusiastic about the basic concepts offered for the memorials and for their formal execution, hence we were confronted with all-or-nothing decisions. At the same time, it was politically and morally impossible for us to render negative judgments. The only solution was to exercise self-restraint and to voice larger reservations, circumspectly, for the public record.

These dealings with memorial plans highlight how the ACNY's role and powers had both changed and remained constant since its inception. They showed, on the one hand, the extent to which the commission had relinquished an authority grounded in expertise and social status that, from the outset, had undergirded its mission. At the same time, it seemed that little had actually changed since the Heine Memorial in controlling the fate of projects outside Manhattan, especially memorials.

Initially, the ACNY's authority had been premised on a City Beautiful vision that conflicted with the realities of New York politics, generated in part by conditions and personalities unique to each borough. Agendas and aesthetic preferences in the Bronx, Queens, Staten Island, and most portions of Brooklyn, along with social class and cultural sensibility, truly differed from those generally shared by Manhattan's political leaders and activists. In turn, the cityscapes were markedly varied. From an aesthetic point of view, parts of New York were, and remain, provincial. Largely representing Manhattan, the urbane cultural center, the ACNY had limited power in these other settings.

Also, when dealing with the other boroughs, some ACNY members displayed less intense interest and had a different set of expectations. So while the ACNY could often curb the authority of individuals, it was less able to influence enterprises with broader constituencies, on which individual commissioners were unable or unwilling to impose their standards.

In sum, commissioners had strong individual convictions about the nature of municipal beauty as visual culture—as a transcendent ideal. But the success and longevity of the art commission has hinged on their willingness to operate cooperatively in the real world—to acknowledge that urban beauty is also an ongoing and inherently political process, governed by fluctuating circumstances.

CONCLUSION

The ACNY was established to improve the welfare of the city as a whole by managing its built environment. To that end, the commission worked to preserve visual coherence, aesthetic richness, and historical gravity and complexity in public art, structures, and landscapes. That mission has continued in the present day, although without the conscious commitment to ideals of social management and patronizing benevolence that New York elites held a century ago.

The art commission has not always been completely successful, yet if its members actually disapproved as many projects as was their inclination, this agency would have been abolished quite some time ago. Keeping larger aims in mind, ACNY members resolved that small changes and incremental improvements were ultimately preferable to no changes at all: eliminating an art commission would give officials and citizens carte blanche to do whatever they liked. Through the ACNY, the city's cultural elites managed to exert a continual, low-level pressure to adopt their values in the realm of public design. Those pressures, brought to bear in ACNY's negotiations and the controversies that they generated, contributed to making a city whose public spaces are more attractive because they embody ideals of civic accountability.

As this book has shown, cooperation and compromise on the part of the commissioners occasionally proved to be more productive than rigid adherence to ideal criteria of judgment. Even though the ACNY's deliberations have not always guaranteed excellence in urban design, at least as defined by its members, they have helped to make people in authority acknowledge that work in the municipal sphere entails a responsibility to a vision of a civic community. The ACNY's ongoing critique of clutter and excess—its rejection of the "cute" in art, architectural, and landscape design and of theme park–style simplifications in plaques and other historical imagery—has reflected an

aspiration that the public realm be life-affirming for all, that it transcend self-indulgence, condescension, special interest, whims, and whimsy.

Aesthetics must continue to play a significant role in shaping the municipal landscape. This study confirms the belief that an agency like the ACNY, despite its shortcomings, provides an essential function. It must continue, even though politicians periodically question its value. Thanks to the resilience of the New York City charter, this institution is likely to endure as long as thoughtful citizens and public officials—especially future mayors and their advisers—are aware of its merits and understand what it can (and cannot) do to make Greater New York even greater.

THE ACNY AND
MONUMENT CONSERVATION

I n chapters 1 and 3 we saw how the ACNY's identity had been bound up with monuments and memorials. In those early years, its responsibilities centered on approving new work. As early as 1920, however, it was widely acknowledged that several of the city's key monuments, including the Washington Arch and the William Tecumseh Sherman Memorial, were in serious disrepair. The charter provisions that prevented works of art from being "removed, relocated or altered in any way" without ACNY approval had informally endowed the commission with responsibility for oversight of the condition of City Hall, its portrait collection, and indeed the entire municipal art collection.[1]

A number of civic organizations believed that the ACNY should have formal oversight of monument conservation, even if other city agencies, like the Department of Parks, were in charge of the actual maintenance. Thus in 1921, President De Forest sought to convince Commissioner of Parks Francis Gallatin to ask for an annual appropriation to maintain and preserve work in his department's jurisdiction, hoping that other department heads would follow that lead.[2] Little money was forthcoming, and in 1927, the Municipal Art Society urged the commission to "institute such procedure as shall be necessary to clean and restore to proper condition the statues owned by the City."[3] In 1928 the National Sculpture Society wrote Mayor Walker that the city's monuments were "without exception . . . caked with dirt, and in danger of serious damage from neglect," and called on the city to have the monuments washed "annually" under "the direction of an expert." Appealing to a politician's logic, they pointed out that the monument restorations offered opportunities for unveilings "with impressive ceremonies" and represented "from the financial point of view alone a substantial municipal investment."[4] Walker passed the letter on to the ACNY, which, not surprisingly, concurred.

The commission became involved in a dispute with the heirs of Joseph Pulitzer, the Fifth Avenue Association, and the Department of Parks over a proposed restoration of the Pulitzer Fountain at Fifty-ninth Street and Fifth Avenue. The process proved to be a nightmare. The city rescinded the appropriation, and it appeared that the conservation enterprise might be jeopardized.[5] In 1934, however, as a result of pressure by the NSS and its ties (and those of Moses) with federal art project administrators like New York regional Public Works of Art director, Juliana Force, the ACNY and Department of Parks embarked on a coordinated plan to survey and restore the city's monuments using WPA manpower.

The 1937 New York City charter revision also codified the commission's authority as curator of the city's public monument collection. Stokes lobbied the Charter Commission extensively for the changes, noting that the repairs undertaken by the city departments themselves (notably the parks department) had been "ill-considered and improperly executed."[6]

Section 854f of the revised charter mandated that the ACNY periodically examine all paintings, sculptures, and monuments belonging to the city, recommend courses of treatment, and exercise "general supervision" over the work. The charter required written approval of the commission on any cleaning, repair, and conservation projects and prevented release of final funds without commission certification that the work was done in accordance with its approval.[7]

The art commission took responsibility for conservation issues through committees, but by the 1970s it became clear that the ACNY needed input from actual conservators. Since the charter did not mandate conservators as a distinct membership category, ACNY's Sculpture and Painting Committee formed a Citizen's Consulting Committee in 1979 to "implement and execute specific projects of conservation and preservation of City art works under the jurisdiction of the Art Commission."[8] The ACNY's current Conservation Advisory Group (CAG) grew out of that committee. Advisory group members presently include conservators for the Metropolitan Museum and Brooklyn Museum of Art, an architectural preservation expert, a sculptor, an art historian, the director of the DPR division of Monuments and Antiquities (when the work stands on parks property), and the head of the MAS's Adopt-a-Monument and Adopt-a-Mural programs. The ACNY deputy director or director of projects coordinates CAG's affairs.

The Conservation Advisory Group oversees the conservations of public works in the city's art collection (generally monuments and murals) and makes recommendations to the ACNY on the treatment proposals submitted for specific projects. It makes recommendations to the ACNY, for example, on the choice of patination (color for bronze conservation projects)

and on the degree of intervention appropriate for conservation of stone monuments or restoration of lost or stolen parts. Occasionally the ACNY makes its own determinations on these issues, and it always decides on relocations or reinstallations, but it relies heavily on CAG recommendations. Through the work of CAG, the ACNY extended its curatorial role over the city's art collection, upholding a mission it had claimed since the turn of the century.

THE APPROVAL AND SELECTION PROCESSES

THE PROCESS

Approvals usually require multiple applicant visits. The ACNY urges applicants to come in at the earliest possible stage so that that staff and commissioners can iron out any potential problems before the project is too far advanced. This rarely happens, however, and if anything, the opposite is the norm; applicants tend to bring in their projects in the later stages of development. For a very large project, the applicants will occasionally be asked to review projects for conceptual approval, meaning that the board reviews schematic designs, with only a few details regarding layout and plan.

The majority of building projects come in for only preliminary and final review. In preliminary review the applicants present maps, drawings, and plans; for final approval, applicants are required to submit a complete set of working drawings and materials samples. The review for final also includes details like light fixtures and signage, including both style and placement. (Floor plans are rarely presented because the commission's jurisdiction does not extend to interiors.) After the ACNY approves a project, the staff issues a certificate of approval, which in theory is needed in order for the city to issue final payments and for the project to move forward.

PERCENT FOR ART

In 1982, Mayor Edward Koch initiated the Percent for Art program, which the city council passed as law. The program began in 1983 within the Department of Cultural Affairs. It called for "one percent of the budget for eligible city-funded construction projects" to be "spent on artwork for city facilities." The Percent for Art program maintains a national slide registry, from which artists are selected for consideration for commissions. A panel that includes art professionals and representatives both from the community and

from the city agency coadministering the project select a design. The project then undergoes a conceptual review by the ACNY, which is not represented in the selection process. The artworks commissioned through the Percent for Art program tend to be more diverse and representative of cosmopolitan trends than art commissioned independently from within the other agencies. The range of styles and quality varies considerably. Public comments by the ACNY on Percent for Art tend, for the most part, to focus on materials and maintenance rather than on issues of style and signification.[1] On limited occasions, however (as occurred from 2003 to 2005), the ACNY expressed openly its reservations about the expressive quality and suitability of the work being commissioned.

In contrast to a century ago, the art commission reviews relatively few public art submissions compared to architecture, landscape, and street furniture. This is in part because both the Department of Education and the Metropolitan Transit Authority have their own art programs, which are not subject to art commission review. In addition, the ACNY does not review the temporary public art projects sponsored by the Public Art Fund—a private organization—even when they stand on city property.

NOTES

INTRODUCTION

1. Zoning laws have of course influenced the appearance of private buildings in general fashion, most notably in New York and Chicago, but this discussion refers as well to other features: parks and playgrounds, streets and street furniture, and works of public art.

2. This question was brilliantly posed by artists Vitaly Komar and Alex Melamid in their "Most Wanted" project, in which they conducted "town meetings" and public opinion polls in several countries to ascertain people's tastes and distastes in painting. They then produced paintings that supposedly jibed with those public opinions, incorporating styles and iconographic motifs that reflected popular preferences. The resulting paintings were absurd pastiches. Hence although ostensibly utilizing and celebrating a democratic populist approach to artistic production, the project highlighted with deadpan irony the cultural vicissitudes of pandering to popular taste. On the project, see Joann Wypijewski, ed., *Painting by Number: Komar and Melamid's Scientific Guide to Art* (New York: Farrar Straus & Giroux, 1997).

3. The ACNY's Web site illustrates the most recent winners of its annual design awards, http://www.nyc.gov/html/artcom/html/design_awards_02.html (February 19, 2004), and includes a list of all Design Award recipients since 2001.

4. Cities in the United States with the oldest art commissions, like Boston (1890, five members), Baltimore (1895, seven members), Los Angeles (1903, seven members), and the National Commission of Fine Arts in the District of Columbia (1910, seven members), have mandates and structures that are comparable to those of New York but review far fewer projects and, in certain cases (like Boston), only public art. Los Angeles, Milwaukee, Mount Vernon, N.Y., New Haven, Conn., and Philadelphia also established monument-oriented art commissions or juries by 1912.

The majority of art and design review agencies were established in the 1970s and especially the 1980s, after the development of federal Art in Public Places and local Percent for Art programs. Many of the agencies oversee the

kinds of initiatives that in New York are administered by the Department of Cultural Affairs and the Department of City Planning. For the data, see Art Commission of the City of New York, *National Directory of Design Review Agencies 1991* (New York: Art Commission of the City of New York, 1991). See also "Proceedings of the First National Conference of Art Commissions," in Art Commission of the City of New York, *Report for the Year 1912* (New York: Art Commission of the City of New York, 1913), 19–37.

5. Although one of three mayoral appointees, I had no affiliation with or loyalties to Mayor Rudolph Giuliani. Indeed, I never met him.

6. John Van Maanen describes three different forms of narrative: realist tales, confessional tales, and impressionist tales. Confessional tales coexist with realist ones but acknowledge the presence of the participant-observer and reflect on the scholars' research process alongside discussions of the culture in question. Impressionist tales are more subjective, self-absorbed, spontaneous, and dramatic in emphasis. This book combines the realist and confessional. See John Van Maanen, *Tales of the Field: On Writing Ethnography* (Chicago: University of Chicago Press, 1988).

CHAPTER ONE

1. "Art worlds," a term coined by sociologist Howard Becker, refers to the concerns, activities, and production systems that resulted in those works deemed "art" (*Art Worlds* [Berkeley: University of California Press, 1982]).

2. An 1886 treatise on police power contended that the private rights of the individual were limited, noting that enjoyment of individual rights invariably demanded "transgression" on the rights of others. Police power, according to Christopher G. Tiedeman, was the imposition by government of "that degree of restraint upon human actions, which is necessary to the uniform and reasonable conservation and enjoyment of private rights." On police power, see Christopher G. Tiedeman, *A Treatise on the Limitations of Police Power in the United States* (St. Louis: F. H. Thomas Law Books, 1886; reprint, New York: Da Capo Press, 1971), 1–2.

3. See Margot Gayle and Michele Cohen, *The Art Commission and the Municipal Art Society Guide to Manhattan's Outdoor Sculpture* (New York: Prentice Hall, 1988), 45, 84, 240–42.

4. Michele H. Bogart, *Public Sculpture and the Civic Ideal in New York City, 1890–1930* (Chicago: University of Chicago Press, 1989; reprint, Washington, D.C.: Smithsonian Institution Press, 1995), 44–46; Caroline Kinder Carr, *Revisiting the White City: American Art at the 1893 World's Fair* (Hanover, N.H.: University Press of New England, 1993); Margaretta M. Lovell, "Picturing 'A City for a Single Summer': Paintings of the World's Columbian Exposition," *Art Bulletin* 78 (March 1996): 40–55; Robert W. Rydell, *All the World's a Fair: Visions of Empire at American International Expositions, 1876–1916* (Chicago: University of Chicago Press, 1984); Kirk Savage, *Standing Soldiers, Kneeling Slaves* (Princeton, N.J.: Princeton University Press, 1997).

5. "Art in Memorial Form," *New York Times,* 23 May 1895, 4.
6. Ibid., 4. The Simon Bolívar Monument is discussed in chap. 3.
7. On the NSS, see Bogart, *Public Sculpture and the Civic Ideal in New York City,* 47–55; on the MAS, see Gregory F. Gilmartin, *Shaping the City: New York and the Municipal Art Society* (New York: Clarkson Potter, 1995), 5–17.
8. Candace Wheeler, "How to Make New York a Beautiful City," in *Addresses Made before the Nineteenth Century Club, 12 March 1895* (New York: Nineteenth Century Club, 1895), 28; "Art Societies and City Parks," *Garden and Forest* 6 (12 July 1893): 291–92. On the Architectural League, see its Web page, http://www.archleague.org/ (accessed 21 August 2002).
9. "New York's Memorial Arch," *New York Times,* 7 January 1894, 4.
10. Editorial, *Real Estate Record and Guide* 45 (1 March 1890): 290. See also Robert A. M. Stern, Thomas Mellins, and David Fishman, *New York, 1880: Architecture and Urbanism in the Gilded Age* (New York: Monacelli Press, 1999), 387.
11. Wheeler, "How to Make New York a Beautiful City," 28. Cited also in Gilmartin, *Shaping the City,* 18.
12. Wheeler, "How to Make New York a Beautiful City," 28.
13. The Board of Parks Commissioners set up the art committee in order to try to restrict the number of statues on the Central Park mall. The board had fended off some twenty statue offers, but an evident move to install a statue of William Marcy Tweed may have been the straw that broke the camel's back. On the committee, see "Report of Committee on Statues in the Park," 25 April 1873, in Frederick Law Olmsted, Jr., and Theodora Kimball, eds., *Forty Years of Landscape Architecture* (New York: G. P. Putnam's Sons, 1928), 489–91; Roy Rosenzweig and Elizabeth Blackmar, *The Park and the People: A History of Central Park* (Ithaca, N.Y.: Cornell University Press, 1992), 332. Stern, Mellins, and Fishman, *New York, 1880,* 98–105, offers an excellent overview of early debates over sculpture in the park. On the Tweed statue, see "Proposed Inscription for the Tweed Statue," *New York Times,* 29 December 1870, 4; "Let us Have More Statues," *New York Times,* 18 January 1871, 2.

 The statue committee's advisory functions were extended to include other parks, including Madison Square. See, for example, "Farragut Statue," *New York Times,* 2 September 1880, 8. The committee remained in operation in 1895; see "The Location of Statues," *New York Times,* 1 May 1895, 1; "Only One Examination Now," *New York Times,* 23 May 1895, 8.
14. Quotations from "Art Notes," *New York Times,* 12 February 1890, 5; see also "Art Notes," *New York Times,* 1 December 1891, 11; "Art Notes," *New York Times,* 6 November 1892, 12; and *Laws Relating to Art Commissions* (New York: Art Commission of the City of New York, May 1914), 5–7. Boston's commission included no artists. Baltimore had followed suit in 1895. See "Better Public Statues for Baltimore," *New York Times,* 4 May 1895, 9.
15. "Statues for the Parks," *New York Times,* 4 April 1895, 16.
16. Ibid.; "Close of Heine Fair," *New York Times,* 25 November 1895, 5; "Would Widen the Street," *New York Times,* 10 October 1896, 9.

17. "New York's Memorial Arch," 4; "Close of Heine Fair," 5. Originally a soldiers' and sailors' memorial was to be placed at the intersection of Twenty-third Street and Broadway or in Battery Park, but the memorial committee subsequently decided on the plaza.

18. On the Columbus, see Bogart, *Public Sculpture and the Civic Ideal in New York City*, 61; "From Italians to America," *New York Times*, 9 July 1890, 8; "Columbian Celebration," *New York Times*, 2 June 1892, 4; "The Statue of Columbus," *New York Times*, 15 September 1892, 4; "The Voyager in Marble," *New York Times*, 13 October 1892, 11.

19. "New York's Memorial Arch," 4; "Close of Heine Fair," 5; "Another Heine Chapter," *New York Times*, 26 January 1896, 11.

20. "Reject Heine Memorial," *New York Times*, 19 November 1895, 8

21. Ibid. See also Jacques Mayer, "The Heine Monument," *New York Times*, 21 November 1895, 4. Mayer, trying to take advantage of the art societies' earlier misguided position, complained that the *Times* had presented a misleading perspective on the NSS, MAS, and FAF take on the issue, that "artistic considerations were not thought of or discussed in any way," and that the "poet's religious and political opinions were the only subjects of discussion."

22. Rosenzweig and Blackmar, *The Park and the People*, 332. On the committee in 1895, see "The Location of Statues," 1; "Only One Examination Now," 8.

23. "In the World of Art," *New York Times*, 24 November 1895, 23.

24. The nonsculptor NSS members included critic Russell Sturgis and author Richard Watson Gilder. In 1893 the board's resolution had designated NSS members Augustus Saint-Gaudens, Daniel Chester French, and John Quincy Adams Ward to serve as a committee to develop a report on the "character and artistic merits of the public statues of the city of New York." The park board of experts resigned in order to defer to the NSS (Charles L. Burns to J. Q. A. Ward, 16 February 1893; Thomas Waterson Wood, Richard Upjohn, and Henry Marquand to City of New York Department of Public Parks Board, 10 March 1893, both in John Quincy Adams Ward Papers, reel 509, frames 8, 39, Archives of American Art [AAA]). See also "Statues for the Parks," 16; "The Location of Statues," 1; "Only One Examination Now," 8; "Reject Heine Memorial," 8; "Another Heine Chapter," 11; Bogart, *Public Sculpture and the Civic Ideal*, 65.

25. Work by Herter included statues of Frederick the Great for the courthouse in Breslau and figures of Naiads for the castle bridge at Potsdam; Herman Von Helmholz, Humboldt University, Berlin, Viktoriapark:"Der seltene Fang"; Hermes, at the Villa Hermes, Vienna ("Statues for the Parks," 16).

26. Ibid. On Ludwig Pietsch, see Wolf Jobst Siedler, "Leipziger Buchmesse: Eine Entdeckung aus der Mitte des 19. Jahrhunderts: Ludwig Pietsch träumt von Berlin," in *Der Tagesspiel Online* (22 March 2000), http://archiv.tagesspiegel.de/archiv/21.03.2000/ak-ku-li-ro-13882.html (accessed 29 July 2005).

27. "A Small Coterie of American Sculptors," *Staats-Zeitung*, cited in *New York Times*, 19 November 1895, 8; "Another Heine Chapter," 11; *New York Times*

Illustrated Magazine, 2 July 1899, 3. Kleindeutschland, also known as Little Germany, was an area of the Lower East Side where many Germans lived. Its boundaries ran from Sixteenth Street to Division and Grand streets and from the Bowery to the East River. See Frederick M. Binder and David M. Reimers, *All Nations under Heaven: An Ethnic and Racial History of New York City* (New York: Columbia University Press, 1995), 82–84.

28. "Reject Heine Memorial," 8; "Increased Success of Heine Fair," *New York Times,* 20 November 1895, 5; "Close of the Heine Fair," 5; "Appeal for the Heine Fountain," *New York Times,* 10 December 1895, 8.

29. Many of them had trained in France, thus raising the specter of another form of bias: longstanding Franco-German antagonisms. Sculptors from the NSS, however, had not in fact fully embraced the picturesque surface treatment and elaborate and dynamic compositional proclivities of the French Beaux-Arts style in outdoor monuments.

30. "Another Heine Chapter," 11; Bogart, *Public Sculpture and the Civic Ideal,* 65. To the charges of nativism, it would also be noted at a later date that New York was a cosmopolitan city and that a proposed monument to Chester A. Arthur had also been rejected (*New York Times,* 26 February 1896, 9).

31. Charles Mulford Robinson, "Improvement in City Life," *Atlantic Monthly* 83 (June 1899): 782.

32. "The Offer Withdrawn," *New York Times,* 13 December 1895, 9; "That Heine Fountain," *New York Times,* 22 January 1896, 4.

33. Both quotations in "That Heine Fountain," 4.

34. Although numerically a majority of the Board of Aldermen were in favor of this plan, a majority of the three-person subcommittee formed to consider the proposal seemed to oppose it. However, a third member, a Democrat, was undecided. See "The Question of a Site," *New York Times,* 25 March 1895, 5; "Increased Success of Heine Fair," 5; Mayer, "The Heine Monument," 4; "The Offer Withdrawn," 9; "Another Heine Chapter," 11; the use of the word "tribunal" is in "The Heine Fountain Again," *New York Times,* 27 February 1896, 4.

35. The bill read:

No statue or piece of sculpture, or work of art of any sort in the nature of a public monument or memorial, shall be erected or placed upon any ground, or in any building belonging to the City of New York, without the approval of the mayor, the president of the Board of Aldermen, the president of the National Sculpture Society, and the president of the Municipal Art Society. But this act shall not be construed as intended to impair the powers now possessed by the Board of Park Commissioners, the Board of Aldermen, or any other civic body holding jurisdiction over public lands or buildings, to refuse its consent to the erection of public monuments or memorials, or to obtain suitable expert opinion upon their artistic merits. ("The Heine Statue Bill Reported," *New York Times,* 5 March 1896, 3)

"Talk on Heine Fountain," *New York Times,* 13 March 1896, 9. These changes were outgrowths of broader shifts within New York State government, away from partisanship and toward an emphasis on planning, administration, and regulation. See Richard L. McCormick, *From Realignment to Reform: Political Change in New York State, 1893–1910* (Ithaca, N.Y., and London: Cornell University Press, 1981), 24–39, 104–64.

36. "The Heine Statue Bill Reported," 3; "Accept Heine Fountain," *New York Times,* 11 March 1896, 9.

37. The mayor, the president of the Parks Board, and even the president of the Board of Aldermen, as well as the NSS and MAS, were all already on record as opposing the acceptance of the Heine Memorial ("Talk on Heine Fountain," 9). The Republicans, of course, did not see the matter as a partisan one. Rather, they sought to implement regulations that they believed would contribute to reforming aesthetic politics and halting public aesthetics driven by politicians.

38. Given the political sensitivity of the circumstances, Mayor Strong decided that he should hold a public hearing on the matter. At that hearing, the prominent attorney Elihu Root testified in favor of the French bill, pointing out that its provisions, in requiring unanimity, would cut down on the number of bad works being erected by individual local groups. Comparing the situation with the acquisitions policies of the Metropolitan Museum of Art, he contended that politicians, merchants, and lawyers were not in the best position to assess critically the aesthetic merits of a work of art; artists and other art experts should be called on. Yet for all his assertions, Root was enough of a political pragmatist to support a measure that would give the mayor and the president of the Board of Aldermen equal power of consent. Root's concern was to implement a bill that would officially vest a portion of that power with artists' groups. His assertions were notable antecedents to those that ultimately paved way for establishment of the art commission. The *New York Times* complained that the French bill was an infringement on home rule ("Talk on Heine Fountain," 9). On Root's role in state legislative politics, see McCormick, *From Realignment to Reform,* 109–12. See also "Heine and Home Rule," *New York Times,* 11 March 1896, 4; "Mayor Approves French Bill," *New York Times,* 14 March 1896, 1; "Against the Heine Fountain," *New York Herald,* 14 March 1896, 1; "Mayor Signs the French Bill," *New York Sun,* 14 March 1896, 1; "Another Heine Chapter," 11; "Heine *Lorelei Fountain,*" *New York Times,* 2 July 1899, 12.

39. "The Plaza to be the Site," *New York Times,* 11 December 1895, 15.

40. Ibid.; "The Monument Fight Again," *New York Times,* 27 December 1895, 9. The council consisted of Perry Belmont, Russell Sturgis, George B. Post, Thomas Hastings, and Walter Cook. The FAF also argued that with water having been struck "on the grounds of the New York Athletic Club, on Sixth Avenue," it would be "impossible to secure a foundation for a monument on the Plaza"—an argument that the east siders claimed was preposterous.

41. "The Monument Fight Again," 9.

42. "Models for a Memorial," *New York Times,* 17 October 1897, 9.
43. "No Monument on the Plaza," *New York Times,* 15 December 1897, 5.
44. "Changes in the Charter," *New York Times,* 13 January 1897, 4; John Quincy Adams, "The Art Commission of the City of New York," *New York Architect* 2 (March 1908): n.p.; Bogart, *Public Sculpture and the Civic Ideal,* 66–67.
45. Adams, "The Art Commission of the City of New York," n.p.
46. Gerald Kurland, *Seth Low* (New York: Twayne, 1971), 77.
47. Philip C. Jessup, *Elihu Root* (New York: Dodd, Mead, 1938), 57.
48. John M. Carrère, "The Art Commission of the City of New York and Its Origins," *New York Architect* 2 (March 1908): 1–2.
49. Jessup, *Elihu Root,* 57.
50. "Art in the New Charter," *New York Sun,* 12 January 1897, 6.
51. "New Charter Hearings," *New York Sun,* 12 January 1897, 5.
52. "Fine Arts and the Charter," *New York Times,* 15 January 1897, 2.
53. "New Charter Hearings," 5.
54. "Fine Arts and the Charter," 2.
55. Fraught with politics, the Board of Health and the departments of sanitation and police were undergoing major changes. The Board of Health was acquiring significant powers during the 1890s. The department continued its traditional efforts to appeal to individuals and to influence individual behaviors, habits, and morals. But developments in bacteriology were leading the department in new directions that included systematic efforts to prevent the spread of disease, less concentration on individual moral behavior, and more systematic, impersonal approaches to the control of disease.

 Colonel George Waring, an appointee of reform Republican Strong, instituted systematic changes in the Department of Sanitation, seeking to inject a sense of professionalism and accountability on the part of each employee. Waring, influenced by the ascendant private sector practice of public relations, organized his departmental affairs in accord with a conception of practice as visual culture. Highly conscious of professional image, he required his men to wear "white wing" uniforms and participate in military-style processions.

 See Joseph Duffy, *A History of Public Health in New York City* (New York: Russell Sage Foundation, 1974), 91–290; on Waring and the Department of Sanitation, see Martin V. Melosi, *Garbage in the Cities: Refuse, Reform, and the Government, 1880–1980* (College Station: Texas A&M University Press, 1981), 50–78, 105–33. See also Jon A. Peterson, "The City Beautiful Movement: Forgotten Origins and Lost Meanings," *Journal of Urban History* 2 (August 1976): 416–28; William H. Wilson, *The City Beautiful Movement* (Baltimore: Johns Hopkins University Press, 1989), 35–52. On the Interstate Commerce Commission, see Richard D. Stone, *The Interstate Commerce Commission and the Railroad Industry: A History of Regulatory Policy* (New York and Westport, Conn.: Praeger, 1991), 6–14. On the police power, see Christopher G. Tiedeman, *A Treatise on the Limitations of Police Power in the United States* (St. Louis: F. H. Thomas Law Books, 1886; reprint, New York: Da Capo Press,

1971), 1–9. See also Edward Alsworth Ross, *Social Control: A Survey of the Foundations of Order* (New York: MacMillan, 1901; reprint, Cleveland, Ohio, and London: Case Western University Press, 1969); Christopher P. Wilson, *Cop Knowledge: Police Power and Cultural Narratives in Twentieth-Century America* (Chicago: University of Chicago Press, 2000), 1–56. See also McCormick, *From Realignment to Reform,* 104–64.

56. June Hargrove, "Shaping the National Image: The Cult of Statues to Great Men in the Third Republic," in *Nationalism in the Visual Arts,* ed. Richard Etlin, Studies in the History of Art (Washington, D.C.: National Gallery of Art, 1991), 49–63; Ruth Butler, *Rodin: The Shape of Genius* (New Haven, Conn.: Yale University Press, 1993), 124–25, 133–34, 237, 240, 245, 248, 319, 427, 432.

57. The Heine Memorial Committee spent the next three years pursuing a place. In May 1896 they announced plans to place the memorial on private land in North Beach. Two years later they were trying for space in a Brooklyn park, where they met protests from the Womens Christian Temperance Union, who objected to the bare-breasted allegorical figures. The commissioner of parks for Brooklyn punted, telling both committee and protesters that the new charter called for an art commission to act on such questions and that "in view of the short time now remaining before that commission shall act it would be better to leave the decision to its members" ("Heine Fountain's New Site," *New York Times,* 25 May 1896, 8; "Heine Statue and Brooklyn," *New York Times,* 11 October 1898, 10).

58. Thomas Reimer, "Maiden in the Park: How the Lorelei Came to the Bronx," *Bronx Historical Society Journal* 37 (Fall 2000): 90. Reimer examines the controversy from the vantage point of the politics of ethnicity within the New York German American community.

59. It is unclear from the sources which municipal department had jurisdiction in the final instance. It appears that the statue was initially accepted by the Department of Public Improvements and then by the borough president, not by the Department of Parks. See "Heine *Lorelei Fountain,*" 12; in an untitled critique of the Lorelei Fountain, Charles de Kay stated merely that the opposition "withdrew its untenable argument that as a monument it is unworthy of a public place, its friends having retired from their demand that it shall occupy one of the few most desirable spots in the city for a memorial" (*New York Times Illustrated Magazine,* 2 July 1899, 3.). (This had happened some years earlier, however.)

Significantly, in 1893 Guggenheimer's firm Guggenheimer, Untermyer & Marshall had come into prominence by "negotiating for the English syndicate that consolidated many of the largest breweries of the United States and brought over $100,000,000 foreign capital into the United States." In other words, there was a close and lucrative relationship between Guggenheimer and George Ehret, the brewer who was one of the principal sponsors of the

memorial. See *Who's Who in New York City and State* (New York: L. R. Hamersly & Co., 1907).

60. The quote about the location on a "conspicuous knoll" can be found in "Heine Memorial Unveiled," *New York Times,* 9 July 1899, 10. On the dedication, see "Lorelei Unveiled with Music Song and Speeches," *World,* 9 July 1899, sec. 2, 1; "Dem freien geist im freien Lande," *New-Yorker Staats-Zeitung,* 9 July 1899, 29; "Kunstplauderei," *New-Yorker Staats-Zeitung,* 9 July 1899, 16; Reimer, "Maiden in the Park," 91–95.

CHAPTER TWO

1. Kenneth T. Jackson, "The Capital of Capitalism: The New York Metropolitan Region, 1890–1940," in *Metropolis, 1890–1940,* ed. Anthony Sutcliffe (Chicago: University of Chicago Press, 1984), 320–21.

2. Thomas Bender has defined public culture as a "contested terrain," in which a multitude of different groups contended and exchanged. "Whether the arena is the city's public space or its social institutions, the prize for the actors is relative influence, legitimacy, and security for the meanings they give to civic life. The result for this collectivity is public culture" (Thomas Bender, *The Unfinished City: New York and the Metropolitan Idea* [New York: The New Press, 2002], 59).

3. This chapter builds on the work of several authors, notably Gregory Gilmartin and Max Page, whose exhaustive studies have already scrutinized New York City's built environment and its relationship to the New York City politics. The focus here is thus less on the general political scene than on the politics of design review (Gregory F. Gilmartin, *Shaping the City: New York and the Municipal Art Society* [New York: Clarkson Potter, 1995]; Max Page, *The Creative Destruction of Manhattan, 1900–1940* [Chicago: University of Chicago Press, 1999]).

4. "Conflict of interest," a key concern in the present day, was not an issue in 1898, when the MAS and ACNY presidents could be one and the same. That influence would persist for many years; the close ties would continue on into the present (Gilmartin, *Shaping the City;* Harvey A. Kantor, "Modern Urban Planning in New York City: Origins and Evolution, 1890–1935" [Ph.D. diss., New York University, 1971], 46, app. D).

The charter stipulated that members of the ACNY would elect the president from within, for a term of one year. Although the charter stated the nature of the ACNY commission membership, it did not specify how the department should operate. Its members soon sought to regularize their activities, adopting by-laws and *Cushing's Manual of Parliamentary Practice* to govern the proceedings. *Cushing's Manual* specified that a president, a secretary, a salaried executive officer, and a particular format for recording minutes. Luther Stearns Cushing, *Cushing's Manual: Rules of Proceeding and Debate in Deliberative Assemblies* (Boston: William J. Reynolds & Co., 1845). The

ACNY also implemented a system where submissions for removals and relocations of works of art would be determined by a committee of the ACNY president and its staff secretary, along with the mayor. The commission would subsequently adopt the committee procedure for making its other determinations (Minutes of the Meeting of the ACNY, 26 March 1898 [hereafter Minutes, . . . ACNY]).

5. Horgan and Slattery were Tammany loyalists, former old-law tenement house architects selected to design armories, firehouses, and other major municipal building projects during the Van Wyck administration. Notorious among the MAS and FAF for charging exorbitant fees and securing a monopoly on Tammany architectural jobs, the firm also became the bane of the ACNY; its members regarded the firm as corrupt and disdained its designs as vulgar and poorly conceived. On Horgan and Slattery, see Gilmartin, *Shaping the City,* 23, 64; Michele H. Bogart, *Public Sculpture and the Civic Ideal in New York City, 1890–1930* (Chicago: University of Chicago Press, 1989; reprint, Washington, D.C.: Smithsonian Institution Press, 1997), 139–48.

6. Kantor, "Modern Urban Planning," 43–46; Gilmartin, *Shaping the City,* 23.

7. Kantor, "Modern Urban Planning," 46; ACNY, *Report* (New York: ACNY, 1914), 13.

8. Thomas Reimer, "Maiden in the Park: How the Lorelei Came to the Bronx," *Bronx County Historical Society Journal* 37 (Fall 2000): 90–91.

9. John De Witt Warner to Seth Low, 29 November 1902, Correspondence File (CF) 295 2/1, ACNY.

10. Minutes, 28 September 1898, 14 March 1898, 1, 7, and 21 May 1898, ACNY. Several meetings were held at the office of Edward Hamilton Bell, for example, at 424 Fifth Avenue, others at 234 Fifth Avenue.

11. "Beauty Commission," in ACNY, *Report 1914,* 13. For "Goo-Goo," see Jonathan Evan Lighter, ed., *The Random House Historical Dictionary of American Slang* (New York: Random House, 1994), 1:930.

12. The 1901 charter abolished the Board of Public Improvements, delegating power on land-use issues to five borough presidents and the Board of Estimate. Warner to Low, 29 November 1902, CF 295 2/1, ACNY; Kantor, "Modern Urban Planning," 47; Gilmartin, *Shaping the City,* 33–34. See also Gerald Benjamin, "Charter," in *The Encyclopedia of New York City,* ed. Kenneth T. Jackson (New Haven, Conn.: Yale University Press, 1995), 202–8.

13. Works of art were defined as "paintings, mural decorations, statues, bas-reliefs, sculptures, monuments, fountains, arches, ornamental gateways," and other structures of a permanent character intended for ornamentation or decoration (*Laws Related to Art Commissions, May 1914* [New York: ACNY, 1914], 5–9).

14. Low to Warner, 4 August 1902; Warner to Low, 30 April 1903, both in CF 295, ACNY.

15. Warner to Low, 29 November 1902, CF 295; Milo Maltbie to Robert W. De Forest, 4 May 1905, CF 54, all in ACNY; *Report of the Art Commission of the City of New York, 1914,* 11. Maltbie did have to justify the need to stay in City Hall,

however, and over the years, municipal officials have attempted unsuccessfully to displace the art commission in order to take over its coveted office space on the third floor.

16. The progressive era, associated with the years between 1890 and 1917, is used to describe a variety of enterprises linked to advocacy of social and political reform. In general, progressives believed in the power of organizations, institutions, professionals, and especially, government to bring about change: notably, regulation of business and consumer protection, tax and educational reforms, and the protection of natural resources. For detailed discussion of civic beautification and planning movements that were part of the enterprise, see Jon A. Peterson, *The Birth of City Planning in the United States, 1840–1917* (Baltimore: Johns Hopkins University Press, 2003).

17. In addition to John De Witt Warner, Henry Rutgers Marshall became architect member and William J. Coombs became a second lay member (Warner to Seth Low, 29 November 1902, CF 295 2/1, ACNY).

18. "Biographical Notices," *Municipal Affairs* 3 (1899): 390–91; Gilmartin, *Shaping the City*, 37–38; Bogart, *Public Sculpture and the Civic Ideal*, 54. See also "Warner, John De Witt," *Biographical Directory of the United States Congress, 1774 to the Present*, http://bioguide.congress.gov/scripts/biodisplay.pl?index=W000153 (accessed 30 October 2002). On *Municipal Affairs*, see William H. Wilson, *The City Beautiful Movement* (Baltimore: Johns Hopkins University Press, 1989), 64; Kantor, "Modern Urban Planning," 60–62.

 Annual reports to the mayor, initiated by Warner, were part of the process of bureaucratization. See Warner to George B. McClellan, 4 June 1904, CF 295/3, ACNY.

19. Gerald Benjamin, "Civil Service," in *Encyclopedia of New York City*, ed. Jackson, 237.

20. On Maltbie, see Howard J. Read, *Defending the Public: Milo R. Maltbie and Utility Regulation in New York* (Pittsburgh: Dorrance Publishing Co., 1998).

21. "It is through this so-called Assistant Secretary that the Commission must ordinarily confer with the public; who, by conference with art, architectural, park or street authorities, must prepare for action matters pending or to be submitted to the Commission or its Sub-Committees. These will frequently involve reports on experiments, visits to other Cities and conference there with officials or Committees—work which, only in exceptional cases and to but a slight degree, it can be expected the Commissioners can personally attend to" ("Qualifications for Assistant Secretary," and John DeWitt Warner to A. Augustus Healy, 27 and 29 March 1902, 5 April 1902; Warner to Municipal Civil Service Commission, 5 April 1902, all in CF 93; Minutes, 1 April 1902, all in ACNY).

22. From this point (1902) forward, a staff of two (assistant secretary and clerk) would manage the day-to-day affairs of the ACNY. Maltbie hired a stenographer, Alice Clark, this time through civil service; her duties included reporting "verbatim the minutes of the meetings of the Art Commission," the "care

of the Exhibits—inscribing and filing. . . . and the stenographic work of the commission" (Maltbie to Alice Clark 24 and 31 October 1902; Clark to Maltbie, 13 May 1904, all in CF 45, ACNY.

23. Warner to Low, 30 July 1902, CF 295, ACNY.

24. Warner worked for perks as well. Pointing out that commissioners undertook many site visits for which they paid out of pocket, for example, Maltbie and Warner requested that the Board of Estimate approve travel reimbursement— a small but noteworthy gesture of appreciation for commissioners' work (it also helped out the artists). The practice of providing travel reimbursements is no longer in effect.

On travel, see Maltbie to Low, 10 July 1902, CF 295, ACNY. On committees, see Warner to Low, 29 November 1902, 30 July 1902, CF 295; Maltbie to Healy, 3 June 1902, CF 93; Maltbie to William R. Willcox, 16 September 1902, CF 309; John Quincy Adams to George Raab, 26 July 1909, CF 923, all in ACNY; I. N. Phelps Stokes to George L. Rives, 3 April 1913, I. N. Phelps Stokes Letter books, 9:112, New-York Historical Society (hereafter NYHS).

25. Warner to Healy, 29 May 1902, CF 93, ACNY.

26. Adams to Raab, 25 July 1909, CF 923, ACNY.

27. Warner to Low, 29 November 1902, CF 295, ACNY. The commission no longer operates this way. Committee meetings involve the full commission but do not require a quorum. The proceedings are tape recorded and are part of the public record.

28. "Suitability," in Maltbie to Willcox, 9 July 1902, CF 309, ACNY.

29. See, for example, Maltbie to Willcox, 16 September 1902; Maltbie to John J. Pallas, 5 April 1904, both in CF 309, ACNY.

30. The commission was extremely demanding in the early years. In 1902, for example, fourteen projects were disapproved and forty-six approved; in 1903, sixty-one were approved and fifty-five disapproved "in whole or in part" (with thirty-five of these designs ultimately revised and resubmitted). In 1905 the ACNY approved seventy-three and disapproved twenty-two submissions in whole or part. The numbers would subsequently fluctuate. In 1909, the ACNY approved 144 projects and disapproved twenty-seven; 115 were approved and twenty disapproved in 1910. In 1927 the ACNY approved 149 projects and disapproved sixty-five; in 1928 the commissioners approved 121 projects and disapproved only seven. Warner to Low, 30 April 1903; Warner to McClellan, 1 January 1904; De Forest to McClellan, 16 January 1906, all in CF 295, ACNY; ACNY, *Condensed Report of the Art Commission of the City of New York for the Years 1930–1937* (New York: ACNY, 1938), 51.

31. "Popular culture," in Charles Mulford Robinson, "Improvement in City Life, III: Aesthetic Progress," *Atlantic Monthly* 83 (June 1899): 771–85, esp. 782; "City Embellishment," in ACNY, "Qualifications for Assistant Secretary," March 27 1902, CF 92, 1/5; the term "Arts of Sight," used by architect and future art commission assistant secretary Henry Rutgers Marshall ("How to Make New York a Beautiful City" [lecture, Nineteenth Century Club, New

York, 1895], 9). On Robinson, see Wilson, *The City Beautiful Movement*, 45–48; and Peterson, *The Birth of City Planning in the United States*, 120–22.

32. For an overview, see Wilson, *The City Beautiful Movement;* Peterson, *The Birth of City Planning in the United States*, 55–223; Peter Hall, "Metropolis, 1890–1940: Challenges and Responses," in *Metropolis, 1890–1940*, ed. Sutcliffe, 26, 40. See also Peter C. Baldwin, *Domesticating the Street: The Reform of Public Space in Hartford, 1850–1930* (Columbus: Ohio State University Press, 1999).

33. See, for example, Charles Mulford Robinson, "Improvement in City Life," 771–85, *Modern Civic Art; or, The City Made Beautiful* (New York: G. P. Putnam's Sons, 1903; reprint, New York: Arno Press, 1970), and "Baltimore Municipal Art Conference," *Municipal Affairs* 3 (December 1899), 706–17. For discussion of the organization of urban architectural practice and theory in Paris, see, for example, David Van Zanten, *Designing Paris: The Architecture of Duban, Labrouste, Duc, and Vaudoyer* (Cambridge, Mass.: MIT, 1987), 126, and *Building Paris: Architectural Institutions and the Transformation of the French Capital, 1830–1870* (Cambridge and New York: Cambridge University Press, 1994).

 Marshall, like Wheeler and Robinson, explicitly linked city beautification and sanitation enterprises; Marshall, "How to Make New York a Beautiful City," 13.

34. Robinson, "Improvement in City Life," 785.

35. The Préfet de la Seine controlled planning, building heights, size, and codes, and even the amount of surface decoration for both public and privately owned structures. In London, the Office of Public Works oversaw national public buildings. See Norma Evanson, *Paris: A Century of Change* (New Haven, Conn.: Yale University Press, 1973), 11–20, 147; M. H. Port, *Imperial London: Civil Government Buildings in London, 1851–1915* (New Haven, Conn.: Yale University Press, 1995), 12–25.

36. At a national conference on art commissions sponsored by the ACNY, architect Henry Rutgers Marshall spoke out against the idea that art commissions should have the power of initiation. The commission, he contended, should be in a position to have absolute veto power over projects it deemed aesthetically ill advised, including those put forward by any future planning commission. He disagreed with planner Frederick Law Olmsted, Jr. (a member of the Commission of Fine Arts in Washington, D.C.) that the ACNY might be a subgroup of a planning commission. "It seems to me most important," he stated, "that the art commission should not in general attempt initiation but should be free at all times to act in relation to any matter presented to it" (ACNY, *Report for the Year 1912* [New York: ACNY, 1913], 27–28).

37. "The Art Commission Halts Many Projects," *New York Times,* 21 August 1906, 7.

38. At this time the dominant vision of city planning focused on beauty and public improvements. A different strain—which arose from the ranks of social

welfare activists, challenged the elitism of City Beautiful advocates, and championed techniques for decreasing population density—became increasingly powerful after 1909.

Since there was yet no planning commission, the MAS, FAF, and others regarded the ACNY as playing a vital role in planning when it came to negotiations with the administration and the Tammany Democrats in municipal bureaucracy. In the subsequent mayoral administrations of George B. McClellan, Jr., William J. Gaynor, and John Purroy Mitchel, several broader but ultimately ineffective enterprises—the New York City Improvement Commission (1904–7) and the Committee on City Plan (1913), for example—were conceived to deal with matters of what would today be dubbed "land use" and would make moot the question of ACNY's involvement in the city planning. Planners would acknowledge the desirability of ACNY contributions in an advisory capacity, but in the long run, the department would have a minimal impact on broader planning schemes. With the exception of monuments, the ACNY purview would not encompass the determination of location or the aesthetic viability of a particular structure for a given site. On the early ACNY involvement with planning initiatives, see Gilmartin, *Shaping the City,* 64; ACNY, *Report for the Year 1912,* 27. On planning and the New York City Improvement Commission, see Peterson, *Origins of City Planning,* 227–45; Gilmartin, *Shaping the City,* 82–86, 90, 92, 94–100; Bogart, *Public Sculpture and the Civic Ideal in New York City,* 69; Kantor, "Modern Urban Planning," 152–64.

39. A committee made up of Henry Rutgers Marshall, painter Frederick Dielman, and Brooklyn Institute trustee A. Augustus Healy recommended disapproval on grounds of design rather than planning, contending that the new elevation was "architecturally out of harmony" with the old county courthouse. Marshall contended a decade later that the rejection stemmed also from concerns about location—the projected impact on the City Hall Park space. The ACNY objections were also bound up with ongoing tensions between the ACNY and the firm of Horgan and Slattery, who had cornered the market on construction projects during the Van Wyck administration, from which the county courthouse extension plans were a holdover. The ACNY's objections expressed, through a rhetoric of aesthetics, objections on the part of the Low administration to the last-minute award of this and other contracts at the end of the Van Wyck administration and concerns about the exorbitant fees to be paid to the firm. The firm's ill-repute was driven home constantly by the *New York Times,* which had editorialized two years earlier that the ACNY would be crucial to prevent the "Horganization and Slatterification" of New York City. On the courthouse, see "Court House Plans Condemned," *New York Times,* 5 March 1901, 8; "Horgan and Slattery Plans Thrown Out," *New York Times,* 28 June 1901, 16; "Court House Alteration," *New York Times,* 8 March 1902, 3; "County Court House Plans Rejected," *New York Times,* 12 June 1902, 16; "Horgan and Slattery Claims," *New York Times,* 21 March 1903, 5; ACNY,

Report for the Year 1912, 30; "Horganization" in "Embellishing the City," *New York Times,* 10 August 1899, 6.

40. Louis J. Haffen to Warner, 1 June 1903, CF 296, ACNY.

41. "Claims Laurels for Courthouse," *New York Times,* 17 March 1905, 3; Gilmartin, *Shaping the City,* 118. Garvin was also architect for a number of the firehouses whose eclecticism ACNY president De Forest would subsequently single out as problematic.

42. Exhibit 82-A, disapproved 16 June 1903, ACNY.

43. Exhibits 82-J–Z, disapproved 15 December 1903, ACNY.

44. Haffen to ACNY, "In Local Boards of Morrisania and Chester, 24th and 25th Districts," n.d. [ca. 1904], CF 296; Committee on the Bronx Borough Court-House to ACNY, 16 June, 1904, exhibition file 82; Albert E. Davis to Francis Key Pendleton, 29 March 1904, CF 185; exhibit 82-AA, approved 23 June 1904—all in ACNY. See also "M. J. Garvin Files Plans," *North Side News,* 21 May 1905, and "New Court House," *Westchester Sentinel,* 21 May 1905, Art Commission (ACNY) Scrapbook 1:4, 7.

45. Haffen to ACNY, "In Local Boards of Morrisania and Chester," CF 296; Committee on the Bronx Borough Court-House to ACNY, 16 June, 1904, exhibition file 82; Davis to Pendleton, 29 March 1904, CF 185; exhibit 82-AA, approved 23 June 1904—all in ACNY. See also "M. J. Garvin Files Plans," *North Side News,* 21 May 1905; and "New Court House," *Westchester Sentinel,* 21 May 1905, ACNY Scrapbook 1904–9: 4, 7.

46. "Claims Laurels for Courthouse," 3; Gilmartin, *Shaping the City,* 118–19. Bluemner (1867–1938) had studied architecture at the Royal Academy in Berlin. He fled Germany for Chicago in 1892. Until he moved from there to New York in 1901, he designed, among other things, for the World's Columbian Exposition in Chicago and an Evanston, Illinois, library (H. Wade White, oral history interview with John Davis Hatch, 1964, Archives of American Art, http://www.aaa.si.edu/oralhist/hatch64.htm [accessed 16 February 2003]).

47. "Claims Laurels for Courthouse," 3.

48. On Bronx courthouse sculpture, see, for example, Adams to Haffen, 22 June 1909, CF 296; exhibits 414-A–C, all in ACNY. On investigations of Haffen, see Gilmartin, *Shaping the City,* 119–20; "The Parks for Public Use," *New York Times,* 4 June 1908, 2; "City Paid $252,118 for a $4300 Marsh," *New York Times,* 24 March 1908, 14.

49. The problem was that no one consulted the art commission before purchasing or otherwise designating land for a given municipal purpose. "The Art Commission is also placed in a difficult situation," De Forest reported to the mayor.

If it has no jurisdiction over the selection of sites, it cannot properly exercise its functions, the question of a proper location being inseparably connected with that of structure. Upon the other hand, if it has jurisdiction, even though the land has been purchased, it is impaled upon one of the

horns of the dilemma by being obliged either to disapprove the site and cause serious financial loss or inconvenience, or to approve the site and assume the responsibility for a serious injury to the artistic character of the building—the very thing it is supposed to safeguard. (De Forest to McClellan, 9 October 1907, CF 295, ACNY)

50. Maltbie to De Forest, 3 April 1905, CF 54, ACNY; De Forest to McClellan, 9 October 1907, CF 295, ACNY.

51. Maltbie to De Forest, 3 April 1905, CF 54, ACNY; De Forest to McClellan, 9 October 1907, CF 295, ACNY.

52. Maltbie to De Forest, 3 April 1905, CF 54, 1/17, ACNY; Warner to William M. Ivins, 5 December 1908, CF 261 7/7, ACNY.

 The commission could not act on projects under $250,000 if the mayor or Board of Aldermen asked it not to. See ACNY, *Report of the Art Commission for 1914*, 10; ACNY, *The Art Commission of the City of New York, 1898–1989* (New York: ACNY, 1989), n.p.

53. De Forest held positions of leadership in the Central Railroad of New Jersey, the New Jersey and New York Railroad Company, the New York and Long Branch Railroad, New York Trust Company, Title Guarantee and Trust Company, and the Metropolitan Life Insurance Company. See Susan L. Klaus, *A Modern Arcadia: Frederick Law Olmsted, Jr., and the Plan for Forest Hills Gardens* (Amherst and Boston: University of Massachusetts Press, 2002), 37–39; Henry J. Carman, "De Forest, Robert Weeks," in *Dictionary of American Biography*, vol. 11, suppl. 1 (New York: Charles Scribner's Sons, 1944), 236–37.

54. On De Forest's involvement with the Metropolitan Museum, see Amelia Peck, "Robert de Forest and the Founding of the American Wing"; and Alice Cooney Frelinghuysen, "Emily Johnston de Forest," both in *Antiques* 157 (January 2000): 176–81, 192–97, respectively.

55. Klaus, *A Modern Arcadia*, 39–40; Bonj Szczygiel, "'City Beautiful' Revisited," *Journal of Urban History* 29 (January 2003): 107–32.

56. McClellan's gripe stemmed from his contention that De Forest had turned down McClellan's offer to stay on as chair of the Tenement House Department. According to McClellan, De Forest subsequently spread the rumor that McClellan ("a corrupt Tammany mayor") had actually removed De Forest from office. Later on, De Forest asked McClellan why he had appointed De Forest's successor, whom he regarded as "an incompetent." When McClellan reminded De Forest that De Forest himself had made the recommendation, De Forest responded: "Oh, you know that one must make recommendations like that, that one doesn't mean" (George B. McClellan, Jr., *The Gentleman and the Tiger* [Philadelphia: Lippincott, 1956], 239).

57. Warner to Low, 9 September 1902, CF 295, ACNY.

 The Brush Electric Light Company held demonstrations of new arc lights in 1880 and soon received permission from the Gas Commission

to erect electric lamps from Fourteenth to Thirty-fourth streets along Broadway. In May 1881, the Board of Aldermen awarded franchises to the Brush Electric Light Company and to the Edison Electric Illuminating Company (incorporated 1880), which had introduced an alternative light source, incandescent lighting. Following numerous competitive struggles between gas and electricity businesses for control of the market, a major restructuring of the electric utility business ensued, with a single corporation, Consolidated Gas, acquiring a controlling interest in the three major firms that supplied virtually all the electricity used in Manhattan and the Bronx.

From 1892 onward, demand for electrical illumination on urban thoroughfares accelerated and brought about new potential for extending the possibilities of public space and night life. Spectacular decorative light displays at the 1893 World's Columbian Exposition in Chicago symbolically celebrated this triumph of electric lighting, as did the concurrent development of new street lighting designs for New York and other cities.

The MAS took a keen interest in lighting. Given this, and the overlap of MAS and art commission membership, it may be that MAS involvement helped to insure acceptable submissions and reduced pressure on the ACNY. Indeed, the designs approved during the ACNY's first two decades have remained mainstays on into the present.

For discussion of the impact of lighting, see William J. Hausman, "Light and Power," in *Encyclopedia of New York City,* ed. Jackson, 674–75; Edwin G. Burrows and Mike Wallace, *Gotham: A History of New York to 1898* (New York: Oxford University Press, 1999), 1063–688; John Jakle, *City Lights: Illuminating the American Night* (Baltimore: Johns Hopkins University Press, 2001); and Gilmartin, *Shaping the City,* 54–57. See also Kevin Walsh, "How to Frame a Crook," *Forgotten New York,* http://www.forgotten-ny.com/LAMPS/newcrooks/framecrooks.html (accessed 28 February 2003); New York City Bureau of Gas and Electricity, *The System Electric Companies: Photographs of Street Lighting Equipment as of November 1, 1934* (New York: New York City Bureau of Gas and Electricity, 1934); E. Leavenworth Elliott, "The New Street Lighting," *American City* 2 (June 1910): 254–59; C. F. Lacombe, "Street Lighting Systems and Fixtures in New York City," *American City* 8 (May 1913): 516–19.

58. Gilmartin, *Shaping the City,* 52.
59. Ibid., 53. For the composite fixture, see Nelson S. Spencer, "Street Signs and Fixtures," *Municipal Affairs* 5 (1901): 734.
60. Exhibits 23-A, 23-B, 13 May 1902, ACNY.
61. Maltbie to Low, 22 March 1902, CF 295, ACNY.
62. Ibid.
63. Warner to Low, 30 July 1902; Low to Warner, 4 August 1902; Warner to Low, 14 August 1902—all in CG 295, ACNY.
64. Exhibits 23-C, 23-D, approved 24 September 1902; exhibits 23-J, 23-L, approved 13 November 1902, ACNY. Gilmartin, *Shaping the City,* 54.

65. "Some Things the Salmagundi Club Might Do to Help the City," ca. 1911, CF 295, ACNY.

66. Chicago and other cities contended with similar issues, which, as in New York, not everyone acknowledged were indeed "problems." See, for example, Perry R. Duis, *Challenging Chicago: Coping with Everyday Life* (Urbana and Chicago: University of Illinois Press, 1998), 30–31.

67. Carl H. Scheele, *A Short History of the Mail Service* (Washington, D.C.: Smithsonian Institution Press, 1970), 124–25, 140–41; Louis F. Van Norman, "The New York Post Office: Its Achievement and Its Needs," *American Monthly Review of Reviews* 33 (1906): 580–91.

68. Ohio dentist Eugene D. Scheble had developed the sheet metal box. In September 1903 the papers broke the news that the general superintendent of the General Delivery System of the USPOD, August W. Machen, had approved the purchase of 2,089 letter boxes of the Scheble design in exchange for receiving kickbacks from the box's manufacturers Maybury and Ellis. (The head of Maybury and Ellis was the mayor of Detroit.) Charging Scheble with being a go-between for Machen and Maybury and Ellis, a grand jury indicted him for conspiracy to defraud the United States.

 For a picture of the Scheble box, see the online exhibition of the Smithsonian's National Postal Museum, "Customers and Communities/Serving the Cities/Street Corner Mailboxes," at http://www.postalmuseum.si.edu/exhibits/2b1d_mailboxes.html (accessed 3 August 2005). On the postal scandals, see "Congressman's Graft in Postal Funds," *New York Times,* 8 March 1903, 3; "Tilloch's Charges in Postal Scandal," *New York Times,* 18 May 1903, 5; "Postal Indictments Tell Startling Story," *New York Times,* 12 September 1903, 1; "Maybury Makes Statement," *New York Times,* 12 September 1903, 2; "Arrest in Postal Scandal," *New York Times,* 13 September 1903, 1; "Postal Frauds Are Laid Bare," *New York Times,* 30 November 1903, 1. See also Wayne E. Fuller, *The American Mail: Enlarger of the Common Life* (Chicago: University of Chicago Press, 1972), 320–25.

69. "Postal Indictments Tell Startling Story," 1.

70. Exhibits 71-A, 71-B, disapproved 28 April 1903, ACNY. Locations were the southeast corner of Broadway and Fulton Street, the southeast corner of Broadway and Canal Street, the northeast corner of Broadway and Bleeker Street, southwest corner of Fifteenth Street and Union Square, the junction of Broadway, Fifth Avenue, and Twenty-fourth streets, and the northwest corner of Broadway and Twenty-eighth Street, all major crossroads.

71. "Cooperation with the Post Office Department and the City Authorities in Reference to a Suitable Design for Street Letter Boxes," 1917, CF 54, ACNY.

72. "Numbers and Mail Boxes," *New York Times,* 6 May 1911, 13; exhibits 71-C–F, approved 14 November 1911. The committee, which reviewed the design on 1 November, consisted of architect C. H. Russell, lay member John Bogart, and Metropolitan Museum trustee Robert W. De Forest. See also "Report of the First Assistant Postmaster General," in Post Office Department, *Annual*

Reports, 1911 (Washington, D. C.: Government Printing Office, 1912), 99; also "Report of the First Assistant Postmaster General," in Post Office Department, *Annual Reports, 1912* (Washington, D. C.: Government Printing Office, 1913), 99–100.

73. This box consisted of a tall rectangle with a projecting cornice-type rim and an upper section "entablature" that bore a horizontal handle. Exhibits 71-G, 71-K, 71-J, disapproved 11 May 1914, ACNY; "Cooperation with the Post Office Department," 2. See "Street Corner Mailboxes," www.postalmuseum.si.edu/exhibits/2b1d_mailboxes.html (accessed 2 August 2005).

74. Exhibits 71-G, 71-K, and 71-J, disapproved 11 May 1914, ACNY; "Cooperation with the Post Office Department," 2; "Scarcity of Mail Boxes in New York streets Blamed on Deadlock with Federal Government," *New York Herald,* 16 February 1913, ACNY Scrapbooks, 1910–13, 236. See also "Street Corner Mailboxes," www.postalmuseum.si.edu/exhibits/2b1d_mailboxes.html (accessed 2 August 2005).

75. "Post Office Has Right to Instal [sic] More Mail Boxes," *Evening Telegram,* 16 December 1916, in Charles Keck Scrapbook, reel D105, frame 131, Charles Keck Papers, Archives of American Art (hereafter CK, AAA).

76. Exhibits 71-L–N, approved 13 October 1915, ACNY.

77. "Cooperation with the Post Office Department," 2. Edgerton to Adams, 27 September 1915, CF 253; exhibits 71-L–N, approved 13 October 1915—all in ACNY.

78. The quoted phrases ("distinctly inferior" and "comparatively inartistic") are from De Forest to John Purroy Mitchel, 27 April 1916, CF 295; "Cooperation with the Post Office Department," 2; Edgerton to Adams, 27 September 1915, CF 253, ACNY; "Mailbox Scarcity Up to Post Office, Mitchel Asserts," *New York World,* 16 December 1916; Franklin Clarkin, "Art's Funny Struggle with the Ugly Mailbox," *Evening Transcript,* 30 December 1916, both in Charles Keck Scrapbook, reel D105, frames 131, 152, CK, AAA.

79. Clarkin, "Art's Funny Struggle with the Ugly Mailbox."

80. "Mayor Blames P.O. for Mail Box Lack," *World,* 16 December 1916, Charles Keck Scrapbook, reel D105, frame 131, CK, AAA.

81. "Cooperation with the Post Office Department," 1; the categorization as "fussy" is in De Forest to Adams, 27 March 1917.

82. Ibid., 2; De Forest to John Purroy Mitchel, 27 April 1916, CF 295; De Forest to Mitchel, 31 March 1917, CF 54, ACNY.

83. Clarkin, "Art's Funny Struggle with the Ugly Mailbox."

84. Ibid.; "Post Office Has Right to Instal [sic] More Mail Boxes"; "Mail Box Scarcity Up to Post Office," *World,* 16 December 1916, all in Charles Keck Scrapbook, reel D105, frames 131, 152, CK, AAA; "Post Office Department—Additional Letter Boxes for the City of New York," *City Record,* 16 January 1917; "Mail Box Demand Stirs Estimate Board," *New York Evening Sun,* January 1917; "A Block to Nearest Post Box," *New York Evening Post,* January 1917—all in ACNY Scrapbooks, 1910–13, 201–2.

85. Clarkin, "Art's Funny Struggle with the Ugly Mailbox."

86. Exhibit 284-A, disapproved 11 June 1907, ACNY.

87. On the history of animal advocacy in the United States, see Diana Beers, "A History of Animal Advocacy in the United States: Social Change, Gender, and Cultural Values, 1865–1975" (Ph.D. diss., Temple University, 1998), 97–99, 108. See also James Turner, *Reckoning with the Beast: Animals, Pain, and Humanity in the Victorian Mind* (Baltimore: Johns Hopkins University Press, 1980).

88. Beers, "History of Animal Advocacy," 125.

89. Maltbie to John P. Haines, 16 September 1902, CF 301, ACNY.

90. Haines to Maltbie, 23 October 1902, CF 301, ACNY.

91. Warner to Haines, 25 October 1902, CF 301, ACNY.

92. "Fountains for Horses," *New York Times,* 5 July 1907; "Fountains for Horses," *New York Herald,* 25 October 1907; "Would Offend Art to Save the Horses," *New York Herald,* 23 July 1907; "Concerning Animals," *Vogue,* 25 July 1907— all in ACNY Scrapbook 1907, 51, 54, 56, 57, 76. Haines to Warner, 22 June 1904, CF 301, ACNY.

93. Alfred Wagstaff to Adams, 15 August 1906; "Competition for Public Drinking Fountains to Be Erected in the City of New York, 1906," both in CF 301, ACNY.

94. General Manager to Maltbie, 21 May 1907, CF 301, ACNY.

95. De Forest to Wagstaff, 16 November 1906, CF 301, ACNY.

96. John J. Boyle, John B. Pine, C. H. Russell, Committee on Fountains to ACNY, 11 April 1908, CF 301, ACNY.

97. De Forest to McClellan, 1 October 1908, CF 295, ACNY.

98. Ibid.

99. Exhibit 286-D, 286-E, approved 10 March 1908; exhibits 286-F, 286-G, approved 14 April 1908, ACNY. The estimated cost of this fountain was $3,000.

100. Exhibits 287-A–G, disapproved 23 July 1907; exhibit 287J-N, disapproved 8 October 1907, ACNY. The committee consisted of sculptor John J. Boyle, Howard Mansfield, and Robert De Forest. Charles Lamb designed the fountain, and Mrs. Helen M. Livingston made the $2000 donation.

101. De Forest to McClellan, 1 October 1908, CF 295, ACNY.

102. "The Triumph of Taste in New York's New Drinking Fountains," *New York Herald,* 24 May 1909, ACNY Scrapbooks, 1904–9, 118; De Forest to McClellan, 1 October 1908, CF 295—all in ACNY.

103. On Dixon, see Al-Tony Gilmore, "Dixon, George," in *Dictionary of American Negro Biography,* eds. Rayford Logan and Michael R. Winston (New York: W. W. Norton, 1982), 180. On boxing, see Steven A. Riess, "In the Ring and Out: Professional Boxing in New York City, 1896–1920," in *Sport in America: New Historical Perspectives,* ed. Donald Spivey (Westport, Conn.: Greenwood Press, 1985), 95–128; Elliot Gorn, *The Manly Art: Bare-Knuckle Fighting in America* (Ithaca, N.Y.: Cornell University Press, 1986), esp. 179–247. On the Dixon Fountain, see exhibition 328-A, 328-B, approved 10 March

1908, ACNY. See also "Will Erect Memorial Fountain to Dixon," *Morning Telegraph,* 16 April 1908; "Fountain in Boxer's Memory," *Evening Mail,* 15 April 1908; "Dixon Is First Boxer to Have a Monument," *New York American,* 17 April 1908, in ACNY Scrapbook 1904–9, 131, 133, ACNY. On the West Village environs, see Gerald W. McFarlane, *Inside Greenwich Village: A New York City Neighborhood, 1898–1918* (Amherst: University of Massachusetts Press, 2001), 36–38.

104. "For Fountain Design," *New York Tribune,* 25 October 1907; "Fountains for Horses," *New York Herald,* 11 July 1907; "Fountains for Horses," *New York Times,* 5 July 1907, ACNY Scrapbook, 1:76, 54, 51, ACNY.

105. By 1922, automobile traffic was such that the art commission was called on to review the first of New York City's traffic signal towers for Fifth Avenue. The elegant designs were approved, with little problem. See Traffic Signal Control Towers, Fifth Avenue at Fourteenth, Twenty-sixth, Thirty-fourth, Thirty-eighth, Forty-second, Fiftieth, and Fifty-seventh streets, exhibits 1100-D–H, approved 16 June 1922. The committee consisted of architect Welles Bosworth, Metropolitan Museum curator R. T. H. Halsey, and William J. Wilgus, chief engineer of the New York Central Railroad and mastermind behind the Grand Central Terminal.

106. On the municipal investment in circulation, see Daniel Bluestone, "The Pushcart Evil," in *The Landscape of Modernity: Essays on New York City, 1900–1940,* ed. David Ward and Olivier Zunz (New York: Russell Sage Foundation, 1992), 287–309.

107. "New Bridge Approaches," *New York Times,* 20 November 1902, 6.

108. ACNY, *Report of the Art Commission, 1914* (New York: ACNY, 1914), 17–18, 20–21; Adams to Arthur Woltersdorf, 26 October 1908, CF 934, ACNY.

109. The ACNY's engagement and difficulties with these designs were bound up with the broader politics of bridge development during the Low and McClellan administrations. These controversies, which are beyond the scope of this chapter, are mapped out in Gilmartin, *Shaping the City,* 121–34, 312–13.

110. See exhibit 281-A–I, disapproved 11 June 1907; Henry Hornbostel to De Forest, 9 January 1908, CF 187; exhibits 281-J–M, approved 13 June 1911—all in ACNY. Gilmartin, *Shaping the City,* 312–13; Tom Buckley, "A Reporter at Large: The Eighth Bridge, *New Yorker,* 14 January 1991, 37–50.

111. Montgomery Schuyler, "Bridges and the Art Commission," *Architectural Record* 22 (December 1907): 469–75; De Forest to McClellan, 1 October 1908, CF 295, ACNY; "That Hudson Bridge," *New York Evening Telegram,* 23 March 1906; "Stevenson Grows Angry," *New York Tribune,* 7 July 1906; "Art Board Rejects Memorial Bridge Plans," *New York Times,* 20 September 1906—all in ACNY Scrapbook 1904–9, 32, 34, 40, ACNY.

112. De Forest to McClellan, 1 October 1908, CF 295, ACNY. On the completion of the bridge, see Robert A. M. Stern, Gregory Gilmartin, and Thomas Mellins, *New York, 1930: Architecture and Urbanism between the Two World Wars* (New York: Rizzoli, 1987), 687–88.

113. De Forest to McClellan, 1 October 1908, CF 295, ACNY.

114. Ibid.; "Little Art in Ferry Plans," *New York Times,* 4 March 1906, 20; "Metz Hectored at City Plans Meeting," *New York Times,* 6 May 1909, 2; exhibition file 194, ACNY; Gilmartin, *Shaping the City,* 108; Robert A. M. Stern, Gregory Gilmartin, and John Massengale, *New York, 1900: Metropolitan Architecture and Urbanism, 1890–1915* (New York: Rizzoli, 1983), 48. On the New York City budget and the problem of financing public works during this period, see Keith D. Revell, *Building Gotham: Civic Culture and Public Policy in New York City, 1898–1938* (Baltimore: Johns Hopkins University Press, 2003), 143–69.

115. "Stevenson Grows Angry," *New York Tribune,* 7 July 1906.

116. On pier shed design, see Kevin Bone, "Horizontal City: Architecture and Construction in the Port of New York," in *The New York Waterfront: Evolution and Building Culture of the Port and Harbor,* ed. Kevin Bone (New York: Monacelli Press, 1997), 134. On New York City waterfront development and tensions between the city and the MAS, see Gilmartin, *Shaping the City,* 203–9.

117. On Chelsea Piers, see, for example, Mary Beth Betts, "Masterplanning: Municipal Support of Maritime Transport and Commerce, 1870–1930s," and Michael Z. Wise, Wilbur Woods, and Eugenia Bone, "Evolving Purposes: The Case of the Hudson River Waterfront," both in *The New York Waterfront,* ed. K. Bone, 71–74, 198–99; Stern, Gilmartin, and Massengale, *New York, 1900,* 49.

118. ACNY, *Report of the Art Commission for 1914,* 19–20.

119. Ibid., 20.

120. Ibid.

121. Exhibit 782-D, disapproved 12 January 1914; exhibit 782-H, approved 13 April 1914, ACNY.

122. ACNY, *Report of the Art Commission for 1914,* 20.

123. Lowell Limpus, *History of the New York City Fire Department* (New York: E. P. Dutton, 1940), 282, 279, 303, 310. See also http://www.nycfiremuseum .org/inner/history/history.html (accessed 6 November 2002).

124. See "New York City Police Department Timeline," http://www.nyhistory .org/previous/police/ptimeline3.html (accessed February 12, 2003). The *New York Times* cited a figure of 6,396 men on patrol in 1898. See "Amazing Progress That Has Been Made in Every Line of Municipal Activity and Development," *New York Times,* 22 December 1907, Sunday Magazine, 3.

125. School buildings at the turn of the twentieth century had a notable stylistic consistency as well, in good part because a single individual, C. B. J. Snyder, designed most of them. See Michele Cohen, "Art to Educate: A History of Public Art in the New York City Public Schools, 1890–1976" (Ph.D. diss., City University of New York, 2002), 43–69. Cohen's study also discusses extensively the ACNY's involvement with the public art of New York City public schools.

126. On the impact of Theodore Roosevelt as New York City police commissioner, see Burrows and Wallace, *Gotham,* 1201.

127. Michael J. Garvin, exhibit 200-C, approved 13 March 1906, ACNY.

128. Terry Golway, *So That Others Might Live: A History of New York's Bravest* (New York: Basic Books, 2002), 4, 144–82.

129. De Forest to McClellan, 9 October 1907, CF 295, ACNY. See also "Incongruous Variety of Firehouses," *Brooklyn Standard Union,* 27 October 1907, ACNY Scrapbook 1904–9, 77.

130. The exhibition included models of the Soldiers' and Sailors' Monument, the pavilion at Seward Park, and a tower from the Manhattan Bridge; drawings and photographs of the Pelham Bay Park Bridge, the College of the City of New York; John Jay Park bathhouse, Maine Memorial, Forty-first Street public bath, West Sixtieth Street public bath, Stapleton ferry terminal, Twenty-third Street bath, public comfort stations for Central Park and Delancey Street, sculptures for the Hall of Records vestibule, isles of safety and electroliers, Hamilton drinking fountain, croquet shelter for Prospect Park, and the Gates Avenue courthouse, Brooklyn. See Healy and Henry Rutgers Marshall to ACNY, 10 May 1904; Maltbie to Healy, 1 March 1904, 11 March 1904, 6 April 1904, 11 April 1904, 13 April 1904, 14 April 1904; Warner to Healy, 14 October 1904—all in CF 93, ACNY.

CHAPTER THREE

1. I have discussed elsewhere the ACNY's involvement with the city's larger sculptural projects, like the programs for the New York Public Library, the Brooklyn Institute of Arts and Sciences, the Maine Memorial and Pulitzer Fountain. See Michele H. Bogart, *Public Sculpture and the Civic Ideal in New York City, 1890–1930* (Chicago: University of Chicago Press, 1989; reprint, Washington, D.C.: Smithsonian Institution Press, 1997).

2. Randall Frambes Mason, "Memory Infrastructure: Preservation, 'Improvement' and Landscape in New York City, 1898–1925" (Ph.D. diss., Columbia University, 1999), 1; Max Page, *The Creative Destruction of Manhattan, 1900–1940* (Chicago: University of Chicago Press, 1999); Clifton Hood, "'Journeying to 'Old New York': Elite New Yorkers and Their Invention of an Idealized City History in the Late Nineteenth and Early Twentieth Centuries," *Journal of Urban History* 28 (July 2002): 699–719.

3. Page, *The Creative Destruction of Manhattan;* Mason, "Memory Infrastructure."

4. The term "Cultural fusion" is from Michael Lind, *The Next American Nation: The New Nationalism and the Fourth American Revolution* (New York: Free Press, 1995), 8, 55–57, 80. See also Michael Kammen, *Mystic Chords of Memory: The Transformation of Tradition in American Culture* (New York: Knopf, 1991), 228–53; Page, *The Creative Destruction of Manhattan;* Mason, "Memory Infrastructure."

5. On De Forest, see Amelia Peck, "Robert De Forest and the Founding of the

American Wing," *Magazine Antiques* 157 (January 2000): 176–81. On Stokes, see Deborah S. Gardner, "I. N. Phelps Stokes," in *Encyclopedia of New York City*, ed. Kenneth T. Jackson (New Haven, Conn.: Yale University Press, 1995), 1125; Page, *The Creative Destruction of Manhattan*, 217–49.

6. On the Samuel J. Tilden memorial at 112th Street and Riverside Drive, see Michele H. Bogart, "The Ordinary Hero Monument in Greater New York: Samuel J. Tilden's Memorial and the Politics of Place," *Journal of Urban History* 28 (March 2002): 267–99.

7. Karl Bitter, "Municipal Sculpture," *Municipal Affairs* 2 (1898): 73–97; Henry Kirke Bush-Brown, "New York City Monuments," *Municipal Affairs* 3 (1899): 602–16. For a lengthy discussion of the ACNY's actions on the Hall of Records decorations, see Bogart, *Public Sculpture and the Civic Ideal*, 140–54.

8. Bitter, "Municipal Sculpture," 73–97; Bush-Brown, "New York City Monuments," 602–16.

9. "New Statue Is Unveiled," *New York Times*, 20 April 1900, 14.

10. Minutes of the Meeting of the ACNY, 24 May 1899 (hereafter Minutes, . . . ACNY); Robert A. M. Stern, Gregory Gilmartin, and John Massengale, *New York, 1900: Metropolitan Architecture and Urbanism, 1890–1915* (New York: Rizzoli, 1983), 125; John Tauranac, *Elegant New York: The Builders and the Buildings, 1885–1915* (New York: Abbeville Press, 1985), 260–61.

11. The *New York Times* would propose such a concept in 1901 ("Sherman Looks for a Site," *New York Times*, 9 June 1901, 6).

12. Joseph A. Goulden to Charles T. Barney, 5 March 1898, Correspondence File (hereafter CF) 83; Minutes, 14 March 1898 — all in ACNY.

13. Goulden to ACNY, "Reasons for Selection of the Present Site by the Commission," ca. 17 March 1898, CF 83, ACNY. The quoted material is from Andrew S. Dolkart, *Morningside Heights: A History of Its Architecture and Development* (New York: Columbia University Press, 1998), 362–3.

14. Goulden to ACNY, "Reasons for Selection of the Present Site."
 Arguing that Sherman's fame would be "forever linked with the fame and name of Grant," under whose leadership Sherman forged his greatest victories, the *New York Times* endorsed a site near the proposed Grant memorial (never realized), which was supposed to be erected in the vicinity of the tomb ("Sherman Looks for a Site"; Donald Martin Reynolds, *Monuments and Masterpieces: Histories and Views of Public Sculpture in New York City* [New York: Thames & Hudson, 1988], 76).
 Paradoxically, by the second decade of the twentieth century, in views of Grant's Tomb looking north toward the Claremont Lawn, the tomb competed not with a sculptural monument but with a large gas tank, seen prominently in contemporary postcards.

15. The Society for the Preservation of Scenic and Historic Places and Objects would also oppose the Mount Tom site (Edward Hagaman Hall to Barney, 7 March 1899, CF 225, ACNY).

16. Goulden to ACNY, "Reasons for Selection of the Present Site."

17. Ibid.

18. "The Soldiers' Monument," *New York Times,* 14 June 1899, 7.

19. C. W. Stoughton and A. A. Stoughton to Goulden, 13 September 1899, CF 83, ACNY.

20. Ibid.

21. George C. Clausen to Goulden, 3 November 1899, CF 83, ACNY.

22. Cyrus L. W. Eidlitz to Barney, 5 December 1899, CF 66, ACNY.

23. Such objections made sense, however, in light of the fact that the Department of Park's original purpose in proposing Riverside Park in 1865 was to stimulate development of the West Side. Frederick Law Olmsted's 1875 plan specifically exploited the dramatic landscape features of the park in ways that would obscure the views of the Hudson River Railroad and other planned commercial uses along the waterfront. His plan also established Riverside Drive as a "scenic carriageway" and promenade in a manner that was premised on genteel residential development (Dolkart, *Morningside Heights,* 23–25).

24. Eidlitz to Barney, 5 December 1899, CF 66, ACNY.

25. "Soldiers' Monument Cornerstone Laid," *New York Times,* 16 December 1900, 14; "Memorial Day Exercises," *New York Times,* 29 May 1902, 16.

26. Judith Ewell, *Venezuela and the United States: From Monroe's Hemisphere to Petroleum's Empire* (Athens and London: University of Georgia Press, 1996), 7.

27. See, for example, "A Glance at Venezuela: Something about the Country and Its Valuable Resources," *New York Times,* 19 December 1895, 16.

28. As the *New York Times* put it, Bolívar "did great things in freeing South America from Spanish misrule at a time when the possibility of European interference with our affairs had been recently demonstrated" (the reference was to British "interference" in the War of 1812 ["A Gift Horse," *New York Times,* 9 March 1884, 6]). On Venezuela-U.S. relations, see Ewell, *Venezuela and the United States.*

29. "A Gift Horse," 6. See also "Sensitive about Poor Statues," *New York Times,* 1 March 1884, 3. The sculptor has been variously identified in then-contemporary sources as Leon de la Cuva, De la Coba, and Rafael de la Cova. His birth and death dates are unknown. See Rafael Pineda, *Simón Bolívar's Monuments throughout the World,* trans. Rafael Pineda (Caracas: Centro Simón Bolívar, 1983), 97.

30. "The Bolivar Statue Accepted," *New York Times,* 26 March 1884, 3; "Bolivar's Statue Unveiled," *New York Times,* 18 June 1884, 8.

31. With its own economic and political stability placed in jeopardy by the affair, the United States began flexing its muscles. Invoking the Monroe Doctrine, President Cleveland threatened to come to Venezuela's assistance. Britain backed off and the crisis was averted. Edwin G. Burrows and Michael Wallace, *Gotham: A History of New York City to 1898* (New York: Oxford University Press, 1999), 1210–11.

32. George S. Terry to Leroy B. [*sic*] Maltbie, 22 January 1903, CF 309, ACNY.

33. Ibid.; "Dislike Bolivar's Statue," *New York Times,* 27 August 1897, 12.
34. Giovanni Turini to Barney, 16 November 1898, Exhibition file 954, ACNY.
35. Daniel Chester French to Barney, 23 February 1899, 26 February 1899, both in CF 78, ACNY.
36. French probably suggested Edward Clark Potter, a sculptor with whom French had collaborated and who specialized in animals. He mentioned in a separate letter that he and Potter were visiting Turini's studio. The quote in the text can be found in French to Barney, 26 February 1899; Potter is mentioned in French to Barney, 30 April 1899, both in CF 78, ACNY.
37. French to Barney, 26 February 1899, CF 78, ACNY.

These circumstances were (and would remain) one of the common pressures faced by artists involved with the ACNY's design review. They underscore the shortcomings and the advantages of the process set forth by the charter. Financial pressures could force expeditious and satisfactory completion of projects in ways that verbal exhortations could not. At the same time, these predicaments were hardly unique to the art commission. They were part of the price paid for doing work in the public realm.

38. French to Barney, 30 April 1899, CF 78, ACNY. For illustration of Turini's statue, see "The New Statue of Bolivar," *New York Times,* 25 July 1897, Sunday magazine, 3.
39. Terry to Maltbie, 22 January 1903, CF 309, ACNY.
40. "The Week in Art," *New York Times,* 16 September 1899, book review, 620; "Giovanni Turini Dead," *New York Times,* 28 August 1899, 7; Pineda, *Simón Bolívar's Monuments,* 107–8. Before his death, Turini had filed a claim against the Venezuelan government for its failure to pay him, and he was beset by anxieties over his finances.
41. "Heard about Town," *New York Times,* 30 January 1901, 5; "Queries from the Curious and Answers to Them," *New York Times*, 3 January 1909, sec. 10, 10; "Queries and Answers," *New York Times,* 21 May 1911, sec. 10, 7. On Castro and the tensions between the United States and Venezuela from 1899 to 1905, see Ewell, *Venezuela and the United States,* 98–100.
42. Santos A. Dominici to Robert Landing, 28 October 1916, CF 295, ACNY.
43. Exhibits 954-A–H, ACNY; Margot Gayle and Michele Cohen, *The Art Commission and the Municipal Art Society Guide to Manhattan's Outdoor Sculpture* (New York: Prentice Hall, 1988), 237; "Venezuela's Bolivar Statue for Us," *New York Times,* 29 October 1916, sec. 20, 1.

The other two women with public monuments on municipal ground were Emma Stebbins (*Angel of the Waters,* Bethesda Fountain, Central Park, 1868), and Anna Vaugh Hyatt, *Joan of Arc* (Riverside Drive at Ninety-third Street, 1915).

44. On "heritage," a concept that dates back to the 1930s but became "a virtual cliché" in the post–World War II era, see Michael Kammen, *Mystic Chords of Memory* (New York: Knopf, 1991), 538–46; David Lowenthal, "Identity, Her-

itage, and History," in *Commemorations: The Politics of National Identity,* ed. John R. Gillis (Princeton, N.J.: Princeton University Press, 1994), 41–57.

45. On the Columbus monument, see John Tauranac and Christopher Little, *Elegant New York: The Builders and the Buildings, 1885–1915* (New York: Abbeville Press, 1985), 147–48. On Barsotti, see "Charles Barsotti, Publisher, Is Dead," *New York Times,* 31 March 1927, 23. On Hearst and Pulitzer's involvement with New York City monuments, see Bogart, *Public Sculpture and the Civic Ideal,* 185–217. The chapter also discusses in detail the art commission's engagement with two of the most notable works, the Maine Memorial and the Pulitzer Fountain.

46. A central aim of the celebration, according to its sponsors, was the assimilation and Americanization of immigrants. See Hudson-Fulton Celebration Commission, *The Hudson-Fulton Celebration, 1909, the Fourth Annual Report of the Hudson-Fulton Celebration Commission to the Legislature of the State of New York. Transmitted to the Legislature, May Twentieth, Nineteen Ten, Prepared by Edward Hagaman Hall* (Albany, N.Y.: J. B. Lyon, 1910).

47. "Has Verazzano Been Overlooked?" *New York World,* 18 July 1909; "Verazzano Remembered," *New York Evening Post,* 24 July 1909; "H. Hudson's Rival Unplaced," *New York American,* 29 July 1909; "Verazzano Monument," *New York American,* 30 July 1909, ACNY Scrapbook 1904–9, 199, 200, 201.

48. "Verazzano Remembered," ACNY Scrapbook 1904–9, 201.

49. "H. Hudson's Rival Unplaced." On Ximenes's donation of service, see Exhibit 434-A, 27 July 1909, ACNY.

50. "Has Verazzano Been Overlooked?" On De Forest and the American Wing, see Peck, "Robert De Forest," 176–81. See also Alice Cooney Frelinghuysen, "Emily Johnston de Forest," *Magazine Antiques* 157 (January 2000): 192–97.

51. John Quincy Adams to Herbert Adams, 20 July 1909, CF 2, ACNY.

52. Herbert Adams to John Quincy Adams, 22 July 1909, CF 2, ACNY.

53. Exhibit 434-A and B, disapproved 27 July 1909 on recommendation of committee of Herbert Adams, Frank Millet, and Frederic B. Pratt.

54. H. Adams to J. Q. Adams, 3 September 1909, CF2, ACNY.

55. The committee disapproved Broadway at Bowling Green; Riverside Drive at Seventy-fifth Street; inside Central Park at Fifth Avenue at Ninety-sixth Street; Central Park West at Eighty-first Street; Central Park West at 106th Street; north of the Claremont Hotel at 124th Street; East 116th Street and Fifth Avenue; Riverside Drive at 112th Street; Riverside Drive and 110th Street, Cathedral Parkway; and Riverside Drive north of Grant's Tomb. Exhibit 436-C.

56. The inscription was literal. Among the inscriptions on the original pedestal were the words: "Per la verità secolare, per la giustizia della storia, questo monumento rivendicatore eresse Il 'Progresso Italo-Americano, Carlo Barsotti, editore, la colonia Italiana concorde Il VI Octobre MCMIX." On Battery Park, see Burrows and Wallace, *Gotham,* 372, 500, 1056.

57. "Italians Offer City a Monument to Dante," *New York World,* 29 May 1910, ACNY Scrapbooks, 1910–13, 23. Barsotti sponsored a Dante memorial for Washington, D.C.'s Meridian Park as well. See James Goode, *The Outdoor Sculpture of Washington, D.C.* (Washington, D.C.: Smithsonian Institution Press, 1974), 416–17.

58. Exhibit 674-A-G, disapproved 2 July 1912. "Want Dante in Times Square," *New York Times,* 9 August 1911; "Examine Dante Monument," *Tribune* 27 June 1912, in ACNY Scrapbooks 1910–13, 103, 186, ACNY.

59. Reynolds, *Monuments and Masterpieces,* 189.

60. A perceived lack of restraint associated with Catholicism could also be bound up with size. A colossal bronze bust (fourteen feet total, including bust and pedestal) to philosopher Orestes Brownson (1803–76), for example, submitted by a group of clerics and the Catholic Young Men's National Union in May 1904, was disapproved four times over six years before receiving an approval. Its gargantuan size raised problems for each subsequent group of commissioners, in particular about the appropriate relationship of culture to nature. There was objection, for example, to the idea of having a gigantic bust dominating a park landscape and conflicting with its "natural" qualities. See Exhibition file 123, ACNY; "No More Busts in Parks," *Brooklyn Standard Union,* 22 July 1909, ACNY Scrapbooks 1904–9, 201.

61. Henry De Benedictis, "To the Municipal Art Commission," letter, 13 July 1912; "Dante Monument Rejected," *New York American,* 3 July 1912; "Rejection of Dante Monument Amazes Italians," *New York American,* 4 July 1912, ACNY Scrapbooks 1910–13, 180–81, 187, 189; "Il Monumento a Dante Alighieri in Nuova York," *Il Progresso Italo-Americano,* 28 May 1910, 1; "Il Monumento a Dante," *Il Progresso Italo-Americano,* 29 May 1910, 1; "Per il decoro dell'Arte Italiana e della Colonia," *Il Progresso Italo-Americano,* 5 July 1912, 1; "Per la dignitá, dell'Arte, della Patria e della Colonia," *Il Progresso Italo-Americano,* 14 July 1912, 2.

62. Exhibit 674-A–G, disapproved 2 July 1912, ACNY.

63. "The Latest Addition to New York's Many Statues," *New York Press,* 3 June 1912; "Dante Sculptor Coming," *Tribune,* 6 August 1912, ACNY Scrapbooks 1910–13, 182, 194, ACNY. On Barsotti's reputation and antagonisms with other Italian language newspapers in New York City, see George Enrico Pozzetta, "The Italians of New York City, 1890–1914" (Ph.D. diss., University of North Carolina at Chapel Hill, 1971), 238–42.

64. "Dante's Fate Still Uncertain," *Tribune,* 29 October 1912, ACNY Scrapbooks 1910–13, 203.

65. "Dante on the Dock Must Get a Move On," *New York Sun,* 6 April 1913; "Orders Dante Statue Removed," *Journal of Commerce,* 10 April 1913; "Dante Statue Not Wanted," *New York Times,* 6 April 1913; "Dante's Fate Still Uncertain," ACNY Scrapbooks 1910–13, 237, 230, 203.

66. Exhibit 674-H, withdrawn 2 September 1913, ACNY.

67. "Altered Dante to Be Erected," *Evening Telegram,* 11 September 1913; "Dante

All Broken Up as Row Rages over Statue," *Tribune,* 5 February 1914; "Dante Finds Hoboken Worse Than Inferno," *New York Press,* 6 April 1913—ACNY Scrapbooks 1910–13, 29, 49, 237; "Per la dignitá, dell' Arte, della Patria e della Colonía," *Il Progresso Italo-Americano,* 14 July 1912, 2.

68. Preliminary approval was established as a "recommended" procedure in 1919 in order to enable applicants to avoid having to submit detailed drawings and models for work that might not ultimately be approved. The ACNY also established a rule that its approvals were conditioned on work beginning within three years of the approval date. This requirement came about because the commission faced numerous instances where an approved project was never started, circumstances that hindered the city from reassigning the site to another project. Preliminary approvals required submission of "*tentative* drawings, designs or models" (draft, "Change of Procedure," CF 54, ACNY). The ACNY would often suggest that "certain features be restudied" (Robert De Forest to James Walker, 1 March 1926, CF 295, ACNY). Applicants had to submit finished drawings and full-size models in order to receive final approval, necessary in order to complete the project. Preliminary approval was optional until the late 1930s, when it became mandatory. Charles Downing Lay, "Forty Year History of the Associates," typescript, in William Adams Delano Papers, box 465, Manuscript Department, New-York Historical Society; ACNY, *Report of the Art Commission, 1919–1920* (New York: ACNY, 1921), 12–13.

69. The quote is from "Per la dignità dell'Arte, della Patria e della Colonía," *Il Progresso Italo-Americano,* 14 July 1912, 2; Exhibit 674-H, approved 13 October 1914, ACNY; "Dante All Broken Up," *Tribune* 5 February 1914; "The Latest Addition to New York's Many Italian Statues," *New York Press,* 3 June 1912, ACNY Scrapbooks 1910–13, 49, 182.

In 1924 a suit on behalf of a firm of Washington, D.C., lawyers charged Barsotti with owing them fees for services rendered when the firm fought claims that Barsotti took illegal exemptions for "charitable" contributions to "patriotic organizations" and other "undertakings" ("Attachment Put on Il Progresso," *New York Times,* 5 June 1924, 18).

70. Exhibit 674-S, disapproved 30 June 1921, ACNY.

71. Ibid. The first ACNY committee consisted of sculptor Charles Keck, architect-historian Isaac Newton Phelps Stokes, and businessman and lay member Henry W. Watrous; the second committee, was made up of architect William Welles Bosworth, Metropolitan Museum curator and commission representative R. T. H. Halsey, and Brooklyn Museum representative and Abraham and Straus Department Store magnate Edward Blum.

72. Exhibit 674-X, Y, approved 11 July 1921. J. V. Burgevin to Henry Rutgers Marshall, 25 August 1925, in exhibition file 674.

73. "Charles Barsotti, Publisher, Is Dead," *New York Times,* 31 March 1927, 23.

74. Representing a committee that enlisted him to serve as an intermediary, de Kay asked Healy whether the art commission would examine Bissell's model. The purpose of the memorial, he noted, was to "offer on the part of Ameri-

cans some token of admiration for the splendid charities of the late Baron and Baroness de Hirsch." These charities helped Americans, as well as Europeans, and were nonsectarian. But a second motive for the memorial was to "give public proof of the fact that in the United States the Jews are not despised but are treated on their merits without regard to religious or commercial vendettas" (Charles de Kay to A. Augustus Healy, December 1899, CF 56, ACNY). Six months after the dedication of the contested Heine monument, a de Hirsch memorial would allow New York City's cultural elites to display their broadmindedness (especially since the sculptor himself was not Jewish) and to prove that objections to the Heine memorial had been motivated by aesthetic concerns, not religious or racial prejudice. One small paradox of the enterprise was that the Baron de Hirsch Fund worked to protect immigrant Jews from Russia by shipping them off to farming colonies outside of the metropolis. The de Hirsches sought, in effect, to get Jewish immigrants out of New York City.

De Kay's concern was that the commission "not fall to a sculptor of the second or third class" and that it represent the "spirit of justice with which we propose to treat the Jews" (de Kay to Healy, 28 December 1899, 30 December 1899, CF 56, ACNY; de Kay to Healy, 28 December 1899, 30 December 1899; de Kay to Barney, 2 January 1900, CF 56, ACNY).

75. De Kay to Healy, 28 December 1899, 30 December 1899; de Kay to Barney, 2 January 1900, CF 56, ACNY.

76. "Baron de Hirsch Memorial," *New York Times,* 15 November 1899, 3; "De Hirsch Memorial Appeal," *New York Times,* 8 May 1900, 2; "De Hirsch Memorial," *New York Times,* 11 May 1900, 14; Jacob H. Schiff, "The de Hirsch Monument," letter to the editor, *The New York Times,* 12 May 1900, 8; "The de Hirsch Monument," *New York Times,* 14 May 1901, 2; "The Hirsch Monument," *New York Times,* 1 April 1901, 24; "The de Hirsch Monument," *New York Times,* 24 December 1903, 3; John Quincy Adams to Jacob H. Schiff, 17 July 1908; Kuhn, Loeb & Company to John Quincy Adams, 20 July 1908, both in CF 919, ACNY.

77. Exhibit 740-A, approved 9 June 1913; "Select Design for Memorial in Straus Park," *Evening Journal,* 21 March 1913, ACNY Scrapbook 1910–13, 231, all in ACNY. *Memory* is in Straus Park at 107th Street and Broadway.

78. Carl F. Pilat to Cabot Ward, 16 May 1914; the phrase "memorial historia" is in Pilat to John Quincy Adams, 28 May 1914, CF 304. On the Pulitzer Fountain, see Bogart, *Public Sculpture and the Civic Ideal,* 205–29.

79. Thomas Gillen to John F. Hylan, 25 November 1924; James Matthews to Marshall, 5 December 1924, CF 54, ACNY.

80. Marshall to De Forest, 16 December 1924; De Forest to Marshall, 18 December 1924, 15 January 1925; De Forest to Board of Estimate, 12 January 1925, all in CF 54, ACNY. The quotations are from De Forest to Marshall, 18 December 1924.

81. Marshall to De Forest, 5 November 1924, CF 54, ACNY. *Landsmanshaftn* were Jewish immigrant associations, whose members came from the same

town or region. The *landsmanshaftn* served as crucial support networks for immigrants, sponsoring benevolent causes and relief efforts in the United States and in their homelands. According to historian Daniel Soyer, the activities of the *landsmanshaftn* played a key role in negotiating relationships between ethnic and American identity—relationships that became crucial to the construction of national identity. *Farbanden* were federations of *landsmanshaftn* that came from the same regions or countries. See Daniel Soyer, *Jewish Immigrant Associations and American Identity in New York, 1880–1939* (Cambridge, Mass.: Harvard University Press, 1997), 1, 117, 160.

82. Born in 1740 in Lissa (Leszno), Poland, Salomon, according to Beth Wenger, "probably came to the United States in 1772, at the time of the first partition of Poland" ("Sculpting an American Jewish Hero: The Monuments, Myths, and Legends of Haym Salomon," in *Divergent Jewish Cultures: Israel and America,* ed. Deborah Dash Moore and S. Ilan Troen (New Haven, Conn.: Yale University Press, 2001), 124.

83. "Peter's Contributions," unattributed notes, CF 2 (1925–33), ACNY; Wenger, "Sculpting an American Jewish Hero," 127–28.

84. The quotation is from "Conference on Haym Salomon Memorial," n.d. [ca. 1931], Haym Salomon folder, Zelig Tygel Papers, RG 253, box 3, Archives of the YIVO Institute for Jewish Research (hereafter HS, YIVO); Wenger, "Sculpting an American Jewish Hero," 129.

85. Marshall to De Forest, 5 November 1924, CF 54, ACNY.

86. Ibid. Madison Square had been proposed because, the federation claimed, James Madison, the fourth president, was able to pursue his career of "revolutionary patriotism" thanks to the "generosity" of Salomon. "Government Records Show That Haym Salomon, Who Died Penniless, Gave Fortune to Nation," *New York World,* 31 July 1927.

87. De Forest to Marshall, 6 November 1924, CF 54, ACNY.

88. "The Monument," undated notice [1925] in the Aaron J. Goodelman Papers, reel 4933, frame 319, Archives of American Art.

89. Exhibits 1344-A-M, disapproved 9 June 1925. The committee consisted of sculptor Adolph Weinman, Frank L. Babbott, and Lucien Oudin.

90. Haim Salomon Memorial Committee, "Five Sculptors Engaged in Preparing the Haym Salomon Monument," n.d. [1925], Aaron J. Goodelman Papers, reel 4934, frame 1096, Archives of American Art. Schaaf, for example, created a doughboy for the Armory at Fourteenth Street and Eighth Avenue in the Park Slope neighborhood of Brooklyn.

91. "Select Model for Haym Salomon Monument to Be Erected by Jews in Madison Square," *Bronx Home News,* 2 August 1925, ACNY Scrapbook 1925, 37.

92. I. N. Phelps Stokes to De Forest, 12 September 1925, CF 54, ACNY.

93. Stokes to Victor H. Paltsis, 26 August 1925, I. N. Phelps Stokes Letterbooks, Manuscripts, New-York Historical Society (NYHS).

94. The phrase "estimable merchant" is in Stokes to De Forest, 12 September 1925, CF 54, ACNY, but quoted from C. Worthington Ford. See also Stokes to

Ford, 28 August 1925, Stokes Letterbooks, NYHS. Unattributed written testimony put the matter more bluntly, stating that "I am convinced that all patriotic Hebrews will condemn the erection of a monument, to any individual of their race, connected with America's Historic past, whose record is not substantiated by the most positive evidence." The author was submitting historical testimony that he believed would help the commission "to a fuller understanding of the real position occupied by Haym Salomon: broker" ("To the President and Members of the Art Commission," CF 2 [1925–33], 201, ACNY).

95. Adolph A. Weinman, De Witt Lockman, and Stokes to De Forest, 12 September 1925, CF 54; Exhibits 1344-O–R, disapproved 15 September 1925, both in ACNY.

96. De Forest to Louis Marshall, 16 September 1925, CF 54, ACNY. Although the *farbanden,* like the federation, helped to negotiate the terrain between their groups and the dominant American culture through their relationships with the "uptown" German Jewish acculturated establishment, there were tensions. More established Jewish leaders, mostly assimilationists and mostly German Jews, were aware of and sensitive to the political challenges posed by the sometimes aggressive tactics taken by *farbanden* and individual *landsmanshaftn,* whose actions were driven by more parochial interests. See Soyer, *Jewish Immigrant Associations and American Identity,* 117. See also Ron Chernow, *The Warburgs: The Twentieth-Century Odyssey of a Remarkable Jewish Family* (New York: Random House, 1993), 164, 243. The characterization of the matter as delicate can be found in De Forest to Marshall, Frank Babbott, Stokes, De Witt Lockman, 21 September 1925, CF 54, ACNY.

97. Marshall to De Forest, 18 September 1925, CF 54, ACNY. Marshall was all the more sympathetic with the commission's actions on learning that the federation had listed his name as being among the supporters of the cause when he had done nothing of the sort. De Forest to H. Marshall, Stokes, Babbott, Lockman, 21 September 1925, CF 54.

98. McCartan submitted his query through Assistant Secretary Edward Hagaman Hall (Hall to De Forest, 3 August 1928, CF 54, ACNY).

99. De Forest to Hall, 7 August 1928, CF 54, ACNY.

100. Exhibits 1344-S–U, approved 13 September 1928. See also Meyer Weisgall, "Monument to Be Raised to Haym Salomon, Jewish Revolutionary Patriot Who Gave Fortune to Cause of American Freedom," *Brooklyn Eagle,* 21 October 1928.

101. These debates over the relationship of nationality and the ethnic, religious, and class dimensions of Jewish identity are the primary focus of Beth Wenger's "Sculpting an American Jewish Hero" and are explored in much greater depth than is possible here. For Marshall quotation, see Wenger, 135.

102. Kohler argued that the work had not been undertaken by professional historians. Zelig Tygel, spokesman for the federation, responded that the lack of

funds prevented the group from hiring professionals but that prominent historians like Albert Bushnell Hart agreed with the federation's position (Report of Ruth Benjamin on Haym Salomon investigation, up to 12 August 1927; Albert Bushnell-Hart to Zelig Tygel, 19 April 1929; Tygel to Bernard G. Richards, 10 April 1931; Tygel remarks at conference on Salomon memorial, n.d., 4; Tygel to Max Kohler, 26 December 1929; Tygel to Nathan Straus, 17 February 1929, Haym Salomon folder, Zelig Tygel Papers, RG 253, all in box 3, Archives of the YIVO Institute for Jewish Research). See also Wenger, "Sculpting an American Jewish Hero," 135–36.

103. Tygel had solicited Warburg back in 1928, but Warburg informed him politely that "I do not see my way to take any part of this enterprise. As you probably know, I am a member of the Municipal Art Commission, which had this matter before it" (Felix Warburg to Zelig Tygel, 28 November 1928). By 1931 he was angry (Warburg to Benjamin Winter, 24 February 1931, 2 March 1931; Warburg to Tygel, 27 February 1931; Winter to Warburg, 4 March 1931). For other exchanges on the controversy, see Emanuel Celler to Tygel, 12 March 1931. Tygel remarks at conference on Salomon memorial, n.d., 4; Tygel to Max Kohler, 26 December 1929, Haym Salomon folder, Zelig Tygel Papers, RG 253, all in box 3, Archives of the YIVO Institute for Jewish Research. On Felix Warburg, see Ron Chernow, *The Warburgs*, esp. 90–101, 189–96, 240–47, 445–47.

104. Designed by Lorado Taft and completed by Leonard Crunelle, the Chicago memorial was unveiled at Wabash, State, and Wacker on 15 December 1941. See "A Great Patriotic Event for Chicago and the Nation," program for unveiling and dedication; Z. Tygel, letter "for out of town people," n.d., Haym Salomon folder, Zelig Tygel Papers, RG 253, box 3, Archives of the YIVO Institute for Jewish Research. See also Wenger, "Sculpting an American Jewish Hero," 137–40.

105. Tunis G. Bergen to ACNY, 21 October 1924, CF 54, ACNY. The statue, executed by Toon Dupuis, was a duplicate of an original, in The Hague, by Lodewyk Royer.

106. Quotations from Bergen to ACNY, 21 October 1924. See also Marshall to De Forest, 7 October 1924, CF 54; Gallatin to Marshall, 24 April 1925, CF 309, all in ACNY.

107. John M. Thomas to Marshall, 10 October 1925; Marshall to Thomas, 3 October 1925; A. T. Clearwater to De Forest, 10 October 1925, all in CF 54, ACNY.

108. Exhibits 1369-A–E, disapproved 21 December 1925. Built in 1811, the old-fort Castle Clinton (West Battery, 1811–15) housed, in 1925, the New York aquarium.

109. Marshall to Gallatin, 22 April 1926, CF 309; the quote is from W. De Graeff to Marshall, 15 April 1926, CF 54—both in ACNY.

110. "In Re Netherlands Memorial," undated memo [spring 1926]; De Forest to De Graeff, 28 April 1926—both in CF 54, ACNY.

111. Both times, the objection was over the appropriateness of the work for the

sites being proposed, City Hall Park (1906) and Thirty-fourth Street (1910). Exhibits 206-A–C, disapproved 15 May 1906; Exhibits 206-D–G, disapproved 8 March 1910, ACNY.

112. Exhibits 1410-A–D, disapproved 13 July 1926, ACNY. Palisades Interstate Park Commission, *Addresses Delivered at the Dedication of the Walt Whitman Statue on November Seventeenth, Nineteen Hundred and Forty, Commemorating the Gift of Mary Williamson Harriman in the Year Nineteen Hundred and Four Establishing the Bear-Mountain-Harriman State Park* (New York: Palisades Interstate Park Commission, 1941). On the "rediscovery" of Whitman by American authors of the 1920s, see Richard Ruland, *The Rediscovery of American Literature: Premises of Critical Taste, 1900–1940* (Cambridge, Mass.: Harvard University Press, 1967), 47–48, 87–90, 126–27, 193–94, 202–3, 250–53.

113. Kenneth Jackson, "General Slocum," in *Encyclopedia of New York City*, ed. Kenneth T. Jackson (New Haven, Conn.: Yale University Press, 1995), 457. See also "1904 Paddleboat Fire," http://www.ezl.com/~fireball/Disaster12.htm (23 June 2003); www.geocities.com/general_slocum/ (23 June 2003); http://www.lihistory.com/7/hs743a.htm (23 June 2003); Edward T. O'Donnell, *Ship Ablaze: The Tragedy of the Steamboat General Slocum* (New York: Broadway Books, 2003).

114. On *Vereine* and *Kleindeutschland,* see Frederick M. Binder and David M. Reimers, *All Nations under Heaven: An Ethnic and Racial History of New York City* (New York: Columbia University Press, 1995), 82–84.

115. Exhibits 195-A–C, disapproved 9 January 1906, ACNY. The committee consisted of sculptor John J. Boyle (chair), Howard Mansfield, and Walter Cook.

116. Exhibit 195-A, disapproved 9 January 1906, ACNY.

117. ACNY, *Report for the Year 1910* (New York: ACNY, 1911), 25.

118. On Green's role in consolidation and city building, see *Dictionary of American Biography,* s.v. "Green, Andrew Haskell"; David C. Hammack, *Power and Society: Greater New York at the Turn of the Century* (New York: Russell Sage Foundation, 1982), 189–96; David M. Scobey, *Empire City: The Making and Meaning of the New York City Landscape* (Philadelphia: Temple University Press, 2002), 196, 214, 243.

119. Exhibits 864-A–F, disapproved 12 July 1915, ACNY. The committee included Hermon MacNeil, William Boring, and Walter Crittenden.

120. Exhibit 864-P, approved preliminary, 14 May 1923, ACNY. The committee consisted of architect Benjamin Wistar Morris and lay members Lucien Oudin and William J. Wilgus. The projected cost was $2,000, down from the original $7,000.

121. Exhibits 864-S–U, approved 12 July 1927, ACNY. The committee had Edward MacCartan, Ernest G. Draper, De Witt M. Lockman.

122. Certificate 3403, 25 July 1927, ACNY.

123. Albert E. Davis to ACNY, 18 June 1901, CF 40, ACNY.

124. Richard W. Hill to John Quincy Adams, 4 March 1915; Douglas Mathewson

to De Forest, 30 November 1914; Adams to Mathewson, 11 March 1915—all in CF 296, ACNY; Exhibits 889-A–D, disapproved 10 April 1916, ACNY.

125. John Quincy Adams to De Forest, 1 November 1916, CF 54, ACNY. The Maine Memorial in Manhattan, dedicated in 1913, was an elaborate sculptural monument that the ACNY had reviewed many times and may well have also been a point of contrast. On the Maine Memorial and the ACNY, see Bogart, *Public Sculpture and the Civic Ideal,* 199–202.

126. Thomas Dolen to Adams, 25 February 1918, CF 296 municipal, ACNY.

127. De Forest to Adams, 24 October 1916, CF 54, ACNY. See "Monument of Patriotic Citizens Nullified by Officials," *Bronx,* n.d. [ca. October 1916], attached to De Forest letter.

128. Adams to Dolen, 22 March 1918, CF 296, ACNY.

129. The quote can be found in Edward W. Curley to Henry Bruckner, 30 March 1918. See also Bruckner to De Forest, 2 April 1918, CF 296; Exhibits 889-E–G, approved 13 May 1918, ACNY.

130. See Bogart, *Public Sculpture and the Civic Ideal,* 261, and that chapter as a whole for additional pictures.

131. Cabot Ward to Adams, 24 November 1914, CF 309, ACNY.

132. Karl Bitter to Frederick MacMonnies, 14 October 1914, CF 54; see also Exhibits 822-F, 822-H, disapproved 30 November 1914, ACNY.

133. Thomas Hastings to Ward, 6 January 1915, CF 309, ACNY.

134. "Personally," in De Forest to Ward, 13 January 1915, CF 309, ACNY. Adams to Ward, 14 January 1915, CF 309, ACNY.

135. De Forest to Ward, 24 July 1917, CF 309, ACNY.

136. "Crane Fountain," transcript of meeting of 15 December 1915, CF 54, ACNY.

137. De Forest to John Hylan, 26 September 1921, CF 54, ACNY.

138. Francis D. Gallatin to Fiorello La Guardia, 23 September 1921; De Forest to John Hylan, 26 September 1921; De Forest to La Guardia, 26 September 1921—all in CF 54, ACNY.

139. The responses to *Civic Virtue* are altogether another story. I discuss these reactions in *Public Sculpture and the Civic Ideal,* 264–70, and "Public Space and Public Memory in New York's City Hall Park," *Journal of Urban History* 25, no. 2 (January 1999): 243, 248.

140. The old City Hall had not always been so sacrosanct. In the late 1880s and early 1890s it had come under fire as inadequate to the task of housing the seat of city government. The city held a controversial competition for a new city hall, with plans either to tear down or to move the Macomb and Magnin building. Protests from coalitions of civic groups and individuals put that project on hold (Bogart, "Public Space and Public Memory in New York's City Hall Park," 239–47; Page, *The Creative Destruction of Manhattan,* 111–41).

141. The phrase "muchly painted" is from "Metz Checks Ahearn," *New York Times,* 13 October 1907, 16. Much of the information in this section is indebted to Mary Beth Betts, *The Governor's Room, City Hall, New York City* (New York: ACNY, 1983).

142. On Forest Hills Gardens and De Forest's role, see Susan L. Klaus, *A Modern Arcadia: Frederick Law Olmsted, Jr., and the Plan for Forest Hills Gardens* (Amherst and Boston: University of Massachusetts Press, 2002).

143. On the Metropolitan Museum's exhibition for the Hudson-Fulton celebration, see Peck, "Robert de Forest," 177–78; Francis Gruber Safford, "The Hudson-Fulton Celebration and H. Eugene Bolles," *Magazine Antiques* 157 (January 2000): 170–75.

144. Betts, *The Governor's Room*, 4, 5, 16, 17.

145. Hudson-Fulton Celebration Commission, *The Hudson-Fulton Celebration, 1909*, 3–7.

146. "The Seal and Flag of the City of New York" (1915), in scrapbook Seal and Flag of the City of New York (1915), ACNY. See also Mason, "Memory Infrastructure,"130; Page, *The Creative Destruction of Manhattan*, 130–31; Clifton Hood, "Journeying to 'Old New York,'" 699–719; Kammen, *Mystic Chords of Memory: The Transformation of Tradition in America*, 162–253.

147. See memorandum of conversation with John B. Pine, 25 June 1915, in the scrapbook Seal and Flag of the City of New York (1915), ACNY.

148. The associates were first organized at a dinner at the University Club on 6 February 1913 and incorporated on 19 May 1949. See Charles Downing Lay, "Forty Year History of the Associates," typescript manuscript; *By-Laws of the Associates of the Art Commission, Inc., Adopted 19 May 1949*. Both in William Adams Delano Papers, Box 465, Manuscript Department, New-York Historical Society Library. The associates voted that the art commission should not have custody over City Hall but that they should oversee the Governor's Room. The ACNY's authority over City Hall would vary and, ultimately, was limited to the oldest and mostly historically intact portions of the building's decorations.

149. For Pine recollections, see memorandum of conversation with John B. Pine. The description of the existing flag is from "Making over the Flag of the City," *Evening Post*, 5 March 1915; the uncertainty of its origins was raised in "The Municipal Flag," *New York Times*, 4 March 1915, both articles in scrapbook Seal and Flag of the City of New York (1915), ACNY.

150. John B. Pine, "The Seal and Flag of the City of New York" (1915), in scrapbook Seal and Flag of the City of New York (1915), ACNY.

151. "Ancient corporate seal," in memorandum of conversation with John B. Pine; "Caricature of the original design," in "The Seal and Flag of the City of New York" (1915).

152. Halsey (1865–1942), a stockbroker and collector who traced his American family lineage back to 1630, was a major benefactor of the Metropolitan Museum of Art's new American Wing. Although he was never actually hired as such, he became, in effect its first curator of American decorative art. Halsey served on the ACNY as a lay member from 1910 to 1912 and, then again, as a representative from the Metropolitan Museum of Art in the mid- to late 1930s. On Halsey, see Peter M. Kenny, "R. T. H. Halsey: American Wing Founder

and Champion of Duncan Phyfe," *Magazine Antiques* 157 (January 2000): 186; Wanda M. Corn, *The Great American Thing: Modern Art and National Identity, 1915–1935* (Berkeley: University of California Press, 1999), 310–13.

153. Minutes of Stated Meeting of the Board of Aldermen, 23 March 1915, in scrapbook on Seal and Flag of the City of New York, 1915, ACNY. On Hall, see Mason, "Memory Infrastructure," 85; Page, *Creative Destruction of Manhattan*, 127.

154. The Dutch flag served as a basic model, to evoke the historical precedent set when the Dutch incorporated New Amsterdam as their new commercial provincial outpost (*Commemoration of the Two Hundred and Fiftieth Anniversary of the Installation of the First Mayor and Board of Aldermen of the City of New York on June 24, 1665 and the Adoption of the Official City Flag on June 24 1915* [New York: City of New York, 1915], 50).

155. "Report of Committee on Rules," Minutes of Stated Meeting of the Board of Aldermen, 23 March 1915, no. 1549A, 1549B, in scrapbook Seal and Flag of the City of New York, ACNY. The quote is from John B. Pine, "The Proposed City Flag," *New York Times,* 4 April 1915, 12. See also ACNY, *Report to the Mayor, 1915* (New York: ACNY, 1917), 35–38.

156. "Report of Committee on Rules." For a graphic image, see drawing by Joe MacMillan on "Flags of the World" Web site, http://www.crwflags.com/fotw/flags/us-nyc.html#corr (accessed 20 March 2003).

157. The windmill was flanked on either side by "an Indian of Manhattan" (left) and a sailor with a plummet (on the right). The figures and arms rested on a laurel branch, beneath which was inscribed 1664, "the year of the capture of New Amsterdam by the English and the first use of the name of the City of New York." At the crest, an American eagle stood on a globe. A ribbon on the lower portion of the design was inscribed "Sigillum Civitatis Novi Eboraci." See "Report of Committee on Rules."

158. "Report of Committee on Rules."

159. Adams to Paul C. Wilson, 2 July 1915, CF 295, ACNY. The New-York Historical Society objected in particular to the fact that the stripes of the city flag were arranged in vertical bands, whereas the colors of the United Netherlands flag were arranged in horizontal bands. The society also objected to the use of the American eagle, which was not used until 1784. New-York Historical Society Resolution, 7 April 1915, in scrapbook Seal and Flag of the City of New York, 1915, ACNY.

160. Gerard Beekman to John Purroy Mitchell, 28 June 1915, CF 295 ACNY.

161. The quote is from John B. Pine, "The Proposed City Flag," *New York Times,* 4 April 1915, 12. See also P. C. Wilson to Adams, 1 July 1915, CF 295, ACNY.

162. Adams to Wilson, 2 July 1915, CF 295, ACNY.

163. Held on the occasion of the 250th anniversary of "the foundation of the present municipal government," the ceremony was a celebration of home rule, coming, as Mayor Mitchell put it, "at a time when New York is confident of its capacity for self-government, determined to make the highest use of its

cherished heritages of two centuries and a half, and eager as well as prepared for more adequate powers to govern its own affairs" (quotes are from, respectively, address by George McAneny, and that of Mayor Mitchell, both in *Commemoration of the Two Hundred and Fiftieth Anniversary,* 28, 30). See also Victor Herbert, *The Orange, White and Blue* (New York: G. Schirmer, 1915).

164. De Forest and Stokes, in their capacity as art commissioners, historians, and cultural influentials, were the principle forces behind the acquisition of the facade of the Old Assay Office (a branch of the Bank of the United States, formerly 15 1/2 Wall Street, a neoclassical structure built in 1823–24). When the bank proposed to tear down the old building to construct a taller one, Stokes and De Forest, at the urging of Manhattan's borough president, George McAneny, arranged to have the facade reassembled at the southern entrance of the American Wing in 1923 (Stokes to Oscar Wenderoth, 13 May 1913, 26 January 1914, 22 June 1915, I. N. Phelps Stokes Letterbooks, Manuscript Department, New-York Historical Society Library). See also Peck, "Robert de Forest," 179; Page, *Creative Destruction of Manhattan,* 145, 224–25.

165. N. A. [John B. Pine?], "Seal and Flag of the City of New York," typescript, 1920, scrapbook, Seal and Flag of the City of New York, ACNY.

166. Pine, "The Seal and Flag of the City of New York," 6.

167. Paradoxically and tragically, the flag enjoyed a revitalized signification, both similar to the aims of its past sponsors and yet ultimately fundamentally different, in the wake of the 11 September 2001 terrorist attacks on the World Trade Center and Pentagon by followers of militant Osama Bin Laden, the leading suspect. Declaring war on Bin Laden, his disciples in the terrorist network Al Qaeda, and the Taliban (the ruling Afghani Islamic sect that harbored them in Afghanistan), President George W. Bush and Secretary of Defense Donald Rumsfeld sent American troops and bombs into Afghanistan. After securing a key area near the spiritual center and stronghold of Khandihar and transforming it into a U.S. base for operations, American troops—in a gesture consciously reminiscent of Iwo Jima and of a similar action by surviving firemen at Ground Zero (as the site of the New York City attacks came to be known)—raised the New York City flag, along with the American flag, in memory of the nearly three thousand victims killed in the city on 9/11. The flag became not only a memorial but also a symbol of the bravery, solidarity, and spirit of New Yorkers and the resilience of the city. See Doug Mellgren, "Nation: U.S. Soldiers Raise New York City Flag at Afghan Base," *Nando Times,* 1 December 2001, http://www.nandotimes.com/nation/story/183751p-1777983c.html (accessed 2002; URL discontinued).

168. On the Improvement Commission, see Harvey Kantor, "The City Beautiful in New York," *New-York Historical Society Quarterly* 57 (1973): 158–60; Bogart, *Public Sculpture and the Civic Ideal,* 69–70; Gregory F. Gilmartin, *Shaping the City: New York and the Municipal Art Society* (New York: Clarkson Potter, 1995), 94–97, 99.

169. See Hammack, *Power and Society,* 111.

170. Lay also suggested that major intersections, such as that of Broadway and Fifth Avenue, "be reserved" for monuments "symbolizing ideas." Possibilities included "New York's supremacy in commerce, or the political enfranchisement of women, when it comes." Charles Downing Lay to Board of Park Commissioners, 16 September 1911, CF 309, ACNY. See also Bitter, "Municipal Sculpture"; and Bush-Brown, "New York City Monuments."

CHAPTER FOUR

1. See John Singer Sargent, *Portrait of Mr. and Mrs. I. N. Phelps Stokes,* 1897, oil on canvas, Metropolitan Museum of Art, http://www.metropolitanmuseum .org/Works_of_Art/viewOne.asp?dep=2&item=38.104&viewmode=1&is Highlight=0 (accessed 16 January 2005).

2. Wallace S. Sayre and Herbert Kaufman, *Governing New York City: Politics in the Metropolis* (New York: Russell Sage, 1960), 350, 249.

3. Michele H. Bogart, *Public Sculpture and the Civic Ideal in New York City, 1890–1930* (Chicago: University of Chicago Press, 1989), 185–217, and "Public Space and Public Memory in New York's City Hall Park," *Journal of Urban History* 25, no. 2 (January 1999): 241–47.

4. Gregory F. Gilmartin, *Shaping the City: New York and the Municipal Art Society* (New York: Clarkson Potter, 1995), 263.

5. Reminiscence on Union Square in memo, Leo Bogart to Michele H. Bogart, 10 March 2004. See also Ellen Wiley Todd, *The New Woman "Revised": Painting and Gender Politics on Fourteenth Street* (Berkeley: University of California Press, 1993), 86; Michele H. Bogart, "The Ordinary Hero Monument in Greater New York: Samuel J. Tilden's Memorial and the Politics of Place," *Journal of Urban History* 28 (March 2002): 267–99; Joyce Gold, "Union Square," in *The Encyclopedia of New York City,* ed. Kenneth T. Jackson, (New York: Yale University Press, 1995), 1211.

6. "Murphy Memorial Up to Park Chief," *New York Evening Post,* 15 August 1929, ACNY Scrapbook 1922–23, 109.

7. Stokes initially served as architect member. After 1916 he served as representative from the New York Public Library.

8. Deborah S. Gardner, "Practical Philanthropy: The Phelps-Stokes Fund and Housing," *Prospects* 15 (1990): 359–411.

9. Max Page, *The Creative Destruction of Manhattan, 1900–1940* (Chicago: University of Chicago Press, 1999), 223.

10. "Union Square to Be Raised by 3 Feet," *New York Times,* 6 June 1929, ACNY Scrapbook 1929, 105.

11. I. N. Phelps Stokes to Robert De Forest, 16 August 1929, I. N. Phelps Stokes Letterbooks, New-York Historical Society (hereafter, Stokes Letterbooks, NYHS). See Todd, *The New Woman "Revised,"* 93, 97, 106, for pictures of Union Square during this period.

12. Stokes to De Forest, 16 August 1929, Stokes Letterbooks, NYHS.

13. Ibid.; Edward Hagaman Hall to De Forest, 27 August 1929, Correspondence File (CF) 54, ACNY.

14. Hall to De Forest, 28 August 1929, CF 54, ACNY.

15. Hall to De Forest, 29 August 1929, CF 54, ACNY.

16. Stokes to De Forest, 4 September 1929, Stokes Letterbooks, NYHS.

17. Stokes to William White Niles, 25 September 1929; Stokes to Walter R. Herrick, 23 September 1929—both in Stokes Letterbooks, NYHS; Gilmartin, *Shaping the City,* 263.

18. "$80,000 Union Square Flagpole Finally Approved," *New York Times,* 22 May 1930; "Old Union Square Will Soon Be New," *New York Times,* 27 June 1930 —both in ACNY Scrapbook 1929–32, 142, 146. The ACNY gave preliminary approval to the plans on November 12, 1929, and final approval on December 5, 1929.

19. Stokes to Herrick, 24 October 1930, CF 309, ACNY.

20. Hard hit by the Depression, the parks department had no money for trees ("Spades Again Beautify Union Square Landscape," *Herald Tribune,* 13 December 1932, ACNY Scrapbook 1929–32, 235).

21. Stokes to Herrick, 1 March 1932, 8 March 1932; Herrick to Stokes, 4 March 1932—all in CF 309, ACNY.

22. Herrick to Stokes, 14 March 1932, CF 309, ACNY.

23. Stokes to Herrick, 28 March 1932, CF 309, ACNY.

24. Ibid.

25. "Herrick Resigns; Sheehy Gets Post," *New York Times,* 6 April 1933, ACNY Scrapbook 1933–34. The fifteenth district covered an irregular portion of the East Side from approximately Fifty-second to 118th Street from Third to Fifth Avenue and over to Eight Avenue south of Fifty-ninth Street.

26. Memorandum on submission of Park Plans, 16 June 1932, CF 309 (1932), ACNY. An earlier missive to Herrick had also noted the "formalization of the pond for sailing miniature yachts" on the east side of Central Park between Seventy-third and Seventy-fourth streets (Edward Hagaman Hall to Herrick, 29 March 1930, CF 309, ACNY).

27. Stokes to John O'Brien, 26 April 1933, CF 309, ACNY.

28. "Herrick Resigns; Sheehy Gets Post," *New York Times,* 6 April 1933, ACNY Scrapbook 1933–34. On the debates, see Roy Rosenzweig and Elizabeth Blackmar, *The Park and the People: A History of Central Park* (Ithaca, N.Y., and London: Cornell University Press, 1992), 412–38, 443–48. On memorial plans, see Bogart, *Public Sculpture and the Civic Ideal in New York City,* 286–92; Gilmartin, *Shaping the City,* 265–66.

29. "Fight Fails to Halt Sheehy's Park Plans," *New York Times,* 27 April 1933; "Dictatorship of the Rich Assailed by Park Head," *Daily News,* 27 April 1933; "Give the Kids That Reservoir," *Daily News,* 28 April 1933—all in ACNY Scrapbook 1933–34, 54, 56, 57.

30. "Dictatorship of the Rich Assailed by Park Head," 56.

31. The phrase "removable at the mayor's pleasure" is from "Give the Kids That Reservoir," *Daily News,* 28 April 1933; "New Park Project Is Called Illegal," *New York Times,* 26 April 1933, ACNY Scrapbook 1933–34, 60; I. N. Phelps Stokes, "Random Recollections of a Happy Life," unpublished manuscript, rev. ed. 1941, New-York Historical Society Library, 258; John J. Sheehy to Stokes, 3 May 1933, 6 May 1933, CF 309, ACNY. On temporary ball fields, see Rosenzweig and Blackmar, *The Park and the People,* 446–47.

32. Rosenzweig and Blackmar, *The Park and the People,* 447–48.

33. Stokes to Robert Moses, 28 December 1933, CF 309, ACNY.

34. Stokes, "Random Recollections of a Happy Life," 258.

35. Robert A. Caro, *The Power Broker: Robert Moses and the Fall of New York* (New York: Random House, 1974), 361–62; "Sheehy Park Plan Dropped by Moses," *New York Times,* 5 April 1934, ACNY Scrapbook 1934–35, 28; Stokes to Moses, 28 December 1933, CF 309, ACNY. Stokes, "Random Recollections of a Happy Life," 258.

36. Rosenzweig and Blackmar, *The Park and the People,* 448. On Moses, see Caro, *The Power Broker,* 353–62.

37. Stokes to Moses, 7 February 1934; Moses to Stokes, 24 May 1934, CF 309; certificate 4265, 20 February 1934; Exhibits 1839-A–J, Central Park Menagerie; certificate 4264, final approval of Exhibit 1858-A, Arsenal, 20 February 1934; certificate 4263, 20 February 1934, approval of relandscaping of Bryant Park, Exhibits 1843-G–J.

38. Stokes to William Andrews, 27 July 1934, CF 309, ACNY.

39. Caro, *The Power Broker,* 344–46, 382–83, 532–34. Sixty-eight thousand unemployed men and women were put to work on park refurbishment in 1933. Thousands more were employed on public construction projects. In December 1933, the formation of the Civil Works Administration and its Public Works of Art project, administered in New York City by Juliana Force, resulted in creation of hundreds of new public buildings, parks, and works of art for the city.

40. ACNY, *Condensed Report of the Art Commission of the City of New York for the Years 1930–1937* (New York: ACNY, 1938), 81. Ewing (1862–42), a lawyer and former commissioner of patents from 1913 to 1917, served from 1932 to 1934; Lamb, from 1932 to 1936. There had been some initial question about whether work performed by "emergency work projects" fell under ACNY jurisdiction. The corporation counsel evidently decided in the affirmative (George McAneny to Stokes, 14 November 1933, CF 309, ACNY).

41. Stokes urged Moses and other commissioners to telephone immediately after making a submission so that committee members could be notified quickly. He also reminded Moses to provide a general plan so that commission members could ascertain the relationship of a given building to "its surroundings" (Stokes to Moses, 28 December 1933, CF 309, ACNY).

42. *Condensed Report of the Art Commission of the City of New York,* 51.

43. Ibid., 11, 81; and Stokes to Moses, 28 December 1933, CF 309, ACNY.

44. "The characterization of the process as "a strain" is from Stokes to Andrews, 4 January 1935. The letter also lists examples of illegal projects, including mural decorations for Barrett Memorial Park in Staten Island (Richmond); the entrance steps of the Arsenal, Central Park, and a commemorative monument to Mme. Curie, signage of various sorts, and Downing Stadium on Randall's Island. See also Andrews to Stokes, 8 January 1935; Stokes to Andrews, 11 December 1935, CF 309, ACNY.

45. Edward Blum to Moses, 11 January 1939, CF 76A, ACNY.

46. Moses to Blum, 14 January 1939, CF 76A, ACNY. See also Aymar Embury II to Wallace K. Harrison, 21 January 1939; and Edward Blum to Harrison, 18 January 1939—both in CF 76A, ACNY.

47. Moses to Stokes, 5 May 1938, CF 309. See also Stokes to Walker, 23 May 1929, CF 295; and Edward Hagaman Hall, "West Side Plan," 23 May 1929, CF 54—both in ACNY. Exhibits 1914-A–R, approved preliminary 24 July 1934; Stokes to Samuel Levy, 15 October 1935; Stokes to Moses, 3 May 1938; and Allyn R. Jennings to Charles N. Lowrie, 4 May 1938—all in CF 309, ACNY. Stokes to La Guardia, 13 July 1936, 8 April 1937, CF 295, ACNY. See also "Moses Slashes Red Tape, So Art Commission Puffs," *World*, 1 February 1937, ACNY Scrapbook 1937, n.p.

48. Joel Schwartz, *The New York Approach: Robert Moses, Urban Liberals, and the Redevelopment of the Inner City* (Columbus: Ohio State University Press, 1993), 239–44.

49. Thomas Kessner, *Fiorello H. La Guardia and the Making of Modern New York* (New York: McGraw-Hill, 1984), 76–78.

50. Getting no satisfaction from Stokes, La Guardia went ahead and formed a separate 135-member Municipal Art Committee. He invited Stokes to join, but Stokes felt that this posed a conflict of interest and declined. "Mayor Unfurls Art Program in City Hall Bower," *Tribune*, 16 January 1935, ACNY Scrapbook 1934–35, 220. La Guardia to Stokes, 9 January 1935; Stokes to Mrs. Henry Breckenridge, 14 January 1935—both in CF 40A, ACNY. See also Alyn Brodsky, *The Great Mayor: Fiorello La Guardia and the Making of the City of New York* (New York: Saint Martin's Press, 2003), 334–35; Robert A. M. Stern, Gregory Gilmartin, and Thomas Mellins, *New York, 1930: Metropolitanism and Urbanism between World Wars* (New York: Rizzoli, 1987), 660.

51. Laurence Blanchen to Stokes, 3 January 1934, CF 295, ACNY.

52. Stokes, "Random Recollections of a Happy Life."

53. Ibid.

54. I. N. Phelps Stokes to Fiorello La Guardia, 30 December 1933, CF 295, ACNY.

55. Stokes to La Guardia, 30 January 1934, 2 July 1934, 5 October 1934, 27 November 1934, 12 June 1935—all in CF 295, ACNY. Every ACNY president had had difficulties persuading incoming mayors to fill vacancies and meet the commission members. Previously, Stokes had complained to Mayor James Walker that the Fine Arts Federation had made nominations for four vacancies and that none had been filled, forcing those whose terms had expired to

continue attending the meetings. Attendance and quorums were often a problem. Stokes to James J. Walker, 2 January 1930, 15 May 1931; see also Stokes to La Guardia, 27 November 1934—all in CF 295, ACNY.

56. La Guardia to Stokes, 3 March 1934, CF 181, ACNY. See also Stokes, "Random Recollections of a Happy Life," 262. Stokes, who quoted the letter in his memoir, wrote "I think I'll send him a copy of my monograph on false teeth."

57. Stokes to La Guardia, 6 March 1934, CF 181, ACNY.

58. The quote is from Stokes to La Guardia, 27 November 1934, CF 295, ACNY.

59. The quotation is taken from Stokes to La Guardia, 17 December 1934, CF 191.

 As of 1934, New York City still had no official department or commission of city planning, although the charter of 1937 would soon establish one. At the urging of planning activists, Mayor Walker had created the City Committee on Plan and Survey and appointed, in 1930, a commissioner and a nine-member citizens' advisory board. The fiscal crisis of the Depression, combined with overall lack of support from the borough presidents who otherwise controlled many aspects of land-use policy, resulted in the elimination of the commissioner's post and the board in 1932. Mayor La Guardia established his ad hoc Mayor's Committee of City Planning in 1934, an act that revitalized efforts to create a more permanent agency (Eugenie Ladner Birch, "City Planning," in *Encyclopedia of New York City,* ed. Jackson, 232–33).

60. Denis Tilden Lynch, "Mayor Ignores Art Commission in New Program of Civic Beauty," *Tribune,* 13 January 1935, ACNY Scrapbooks 1934–35, 226.

61. Stokes to La Guardia, 27 November 1934, CF 295, ACNY.

62. "Mayor's Snub to Art Board Revives a Feud," *Tribune,* 19 November 1934; "Board to Paint Out Art Group," New York *Journal,* 11 December 1934—both in ACNY Scrapbook 1934–35, 179, 189.

63. The "top hat" reference can be found in Stokes, "Random Recollections of a Happy Life," 204. Stokes, whether deliberately or not, probably meant to say "high hat," which is how La Guardia was quoted in the New York *Tribune.* See "Mayor Unfurls Art Program in City Hall Bower," 220.

64. The quote is taken from Lynch, "Mayor Ignores Art Commission in New Program of Civic Beauty," 226.

65. Ibid.

66. "Art Monitors Wait for Mayor to End Tirade," *Tribune,* 16 November 1934, ACNY Scrapbooks 1934–35, 178.

67. Paul J. Kern to Everett Peterson, 26 May 1934, with handwritten note from Peterson, CF 295, ACNY.

68. "Art Monitors Wait for Mayor to End Tirade," 178. See also I. N. Phelps Stokes, "The Art Commission's Functions," *Tribune,* 14 January 1935; "Jonas Lie Defends the Art Commission," *New York Times,* 18 November 1934, ACNY Scrapbook 1934–35, 226, 179. Lie argued that the commission had worked to protect the city from various mural projects—like a mural depicting the interior of a stable, rendered large for the Sheepfold Tavern in Central

Park—executed under Moses, who worked, Lie remarked, on a "time-clock basis."

69. "Mayor Praises Deutsch, Denies Real Friction," *Tribune*, 16 November 1934, ACNY Scrapbook 1934–35; Lynch, "Mayor Ignores Art Commission," 185, 226. "The Reminiscences of Charles Culp Burlingham," 1961, transcript, Oral History Research Office, Butler Library, Columbia University, New York City, 37.

70. "La Guardia Admits a Criticism Is Just," *New York Times*, 25 August 1935; "City Strengthens Its Art Commission," *New York Times*, 5 August 1935; "Dr. Erskine Named to City Art Board," *New York Times*, 30 July 1935—all in ACNY Scrapbook 1934–35, 148; Stokes to La Guardia, 26 July 1935, CF 191, ACNY; John Erskine, *The Memory of Certain Persons* (Philadelphia: J. B. Lippincott, 1947), 385.

71. "City Strengthens Its Art Commission," 148.

72. Stokes, "Random Recollections of a Happy Life," 265.

73. Ibid., 192–93; also Gilmartin, *Shaping the City*, 287. On Burlingham and La Guardia, see Kessner, *Fiorello H. La Guardia and the Making of Modern New York*, 291.

74. "The Reminiscences of Charles Culp Burlingham," 37. See also Gilmartin, *Shaping the City*, 284, 287–88.

75. Stokes to Herbert Adams, 5 June 1934; John Gregory to New York City Charter Commission, 22 June 1934; Gregory to La Guardia, 23 January 1934—all in CF 30A, ACNY.

76. Samuel H. Ordway to Stokes, 11 June 1934, CF 30A, ACNY.

77. Stokes to Samuel Seabury, 21 June 1934; Stokes to New York City Charter Commission, 12 June 1934—both in CF 30A, ACNY.

78. Ordway to Stokes, 11 July 1934, CF 30A, ACNY.

79. Stokes to Al Smith, 13 July 1934; Stokes form letter to charter commission members, 13 July 1934—both in CF 30A, ACNY.

80. Brodsky, *The Great Mayor*, 247–50.

81. See Barbara Blumberg, *The New Deal and the Unemployed: The View from New York City* (Lewisburg, Penn.: Bucknell University Press, 1979), and "Works Progress Administration," in *Encyclopedia of New York City*, ed. Jackson, 1274–75; *Condensed Report of the Art Commission of the City of New York, 1930–1937*, 12–13. New York City, partly because of its close ties with the Roosevelt administration, was given an exceptional degree of autonomy in administering its federal art projects.

82. On these programs, see Patricia Hills, *Social Concern and Urban Realism: American Painting of the 1930s* (Boston: Boston University Art Gallery 1983), 10; Karal Ann Marling, *Wall-to-Wall America: A Cultural History of Post Office Murals in the Great Depression* (Minneapolis: University of Minnesota Press, 1982); Marlene Park and Gerald Markowitz, *Democratic Vistas: Post Offices and Public Art in the New Deal* (Philadelphia: Temple University Press, 1984); Barbara Melosh, *Engendering Culture: Manhood and Womanhood in New*

Deal Art and Theater (Washington, D.C.: Smithsonian Institution Press, 1991); Gilmartin, *Shaping the City*, 290–91; Avis Berman, *Rebels of Eighth Street: Juliana Force and the Whitney Museum of American Art* (New York, Athenaeum, 1900), 332–60. See also Jonathan Harris, *Federal Art and National Culture: The Politics of Identity in New Deal America* (New York: Cambridge University Press, 1995).

83. Gilmartin, *Shaping the City*, 289; *Condensed Report of the Art Commission of the City of New York, 1930–1937*, 93.

84. Erskine's quote is from *The Memory of Certain Persons*, 384.

85. He served as architect member from 1911 to 1913, as New York Public Library representative from 1916 to 1918 and from 1921 until 1938. He was president of the ACNY from 1930 to 1938 (*Condensed Report of the Art Commission of the City of New York, 1930–1937*, 41–42).

86. On Ledoux, see "University of New Hampshire Library Special Collections: Poetry Individual Manuscripts," http://www.izaak.unh.edu/specoll/mancoll/poetman.htm (accessed 1 July 2002).

87. Increasingly sensitive to the negative political winds flowing the ACNY's way, Stokes appears to have sought to convince his colleagues to display a more compromising attitude; by 1937 he assured the mayor that the ACNY was disapproving projects much less frequently, although its members often still suggested "radical changes" (*Condensed Report of the Art Commission of the City of New York, 1930–1937*, 93).

88. *Condensed Report of the Art Commission of the City of New York, 1930–1937*, 95; Erskine, *The Memory of Certain Persons*, 385.

89. Daniel Paul Higgin to La Guardia, 18 February 1938, CF 76A, ACNY.

90. Wallace K. Harrison to A. E. Peterson, 24 May 1939, CF 76A, ACNY.

91. "Report of a Conference Held at the Board of Education," 16 February 1938; Harrison to La Guardia, 3 June 1938—both in CF 76A, ACNY. On the ACNY's engagement with art in the public schools, see Michele Cohen, "Art to Educate: A History of Public Art in the New York City Public Schools, 1890–1976" (Ph.D. diss., City University of New York, 2002), esp. 229–45 (discussion of disapproval of a later Hans Hoffmann mural).

92. Henry H. Curran to Art Commission, 20 April 1938, CF 76A, ACNY. See also Harrison to Stokes, 22 April 1938, 16 May 1938, CF 76A, ACNY.

93. "Art Commission Rejects Plans for Taft High School," *New York Times*, 30 March 1938; "New School Needed," 7 April 1938; "Two School Designs Set Beauty as Aim," *New York Times*, 14 October 1938—all in ACNY Scrapbook 1938, 34, 10, 133.

94. Archibald Manning Brown to La Guardia, 11 September 1941, CF 55A, ACNY; Exhibit 2381-A, disapproved 8 July 1941 (committee made up of Brown, Ordway, and Michael Rapuano).

95. Brown to James C. MacKensie, 2 October 1941; Brown to Peter Grimm, 30 September 1941—both in CF 55A, ACNY.

96. *Condensed Report of the Art Commission of the City of New York, 1930–1937*, 93.

97. The quoted material can be found in Erskine, *The Memory of Certain Persons,* 384.
98. *Condensed Report of the Art Commission of the City of New York, 1930–1937,* 9.
99. Ibid., 93.
100. "Memorandum Re Harlem Municipal Court Mural," 14 July 1936. See Exhibits 1926-L, 1926-M, approved 10 November 1936, ACNY.
101. On the Harlem riots and the suspicions about Communist complicity in their incitement, see Kessner, *Fiorello La Guardia and the Making of Modern New York,* 368–77; Brodsky, *The Great Mayor,* 317–21.
102. Exhibit 739-BL approved 8 October 1935 (committee: Ledoux, Peixotto, and Stokes); Exhibits 739-BQ, 739-BR, approved 8 December 1936 (committee: Peixotto, Erskine, and Lockwood), ACNY.
103. "Negro Eating Watermelon Ruled off WPA Mural as Frivolous," *Tribune,* 1 December 1936; "Negro Leaders to Replace Melon Eater in Court Mural," *New York Evening Post* 1 December 1936, 1; "Court Art Altered on Negro Protest," *New York Times,* 1 December 1936—all in ACNY Scrapbook 1936, 173, 176.
104. "The old tradition of the Southern Negro with a huge slice of watermelon from ear to ear is passé, and therefore a figure in the huge WPA mural . . . depicting such a happy-go-lucky person, is to be wiped out with concealing white paint, and the figure of Frederick Douglass substituted" ("'Watermelon Mural' in Court Ordered Erased," *New York Amsterdam News,* 5 December 1938, 1).
105. "Negro Eating Watermelon Ruled off WPA Mural as Frivolous"; "Negro Leaders to Replace Melon Eater in Court Mural," 1; "Court Art Altered on Negro Protest," 173, 176.
106. Lou Block to Joseph Fulling Fishman, 20 August 1933, quoted in Deborah Martin Kao, "Ben Shahn and the Public Uses of Art," in Deborah Martin Kao, Laura Katzman, and Jenna Webster, *Ben Shahn's New York: The Photography of Modern Times* (New Haven, Conn.: Yale University Press, 2000), 58. The information in this section is indebted to the insights of this book, and to Diana Louise Linden, "The New Deal Murals of Ben Shahn: The Intersection of Jewish Identity, Social Reform, and Government Patronage" (Ph. D. diss., City University of New York, 1997), chap. 1, esp. 19–42.
107. Kao, "Ben Shahn and the Public Uses of Art," 60–61. On the transformation of state prison reform in the second decade of the twentieth century, see Rebecca McClennan, "Punishment's 'Square Deal': Prisoners and Their Keepers in 1920s New York," *Journal of Urban History* 29 (July 2003): 597–619.
108. Linden, "The New Deal Murals of Ben Shahn," 33–42; and Kao, "Ben Shahn and the Public Uses of Art," 62–66 (quotes on 63, 66), offer exhaustive reconstructions and descriptions of the murals, with Linden highlighting ways in which Shahn's ethnic and class affiliations influenced the educational

and reform aspects of the mural, along with its iconography. Circumstances led Block to fall behind, and thus Shahn became principle point person on the project. See online exhibition on the murals at http://www.artmuseums .harvard.edu/shahn/servlet/webpublisher.WebCommunication?ia=tr&ic =pt&t=xhtml&x=introduction (accessed 5 August 2005).

109. Exhibit 1554-Z, disapproved 14 February 1935; Kao, "Ben Shahn and the Public Uses of Art," 134n65; Linden, "The New Deal Murals of Ben Shahn," 48.

110. Stokes, "Random Recollections of a Happy Life" 268.

111. A lengthy discussion of this controversy can be found in Kao, "Ben Shahn and the Public Uses of Art," and "Rikers Island Penitentiary Mural Project" in Kao, Katzman, and Webster, *Ben Shahn's New York,* 58–71, 296. This book also reprints several contemporary articles, including Stuart Davis's attack on the commission and, above all, Lie. See Stuart Davis, " 'We Reject'—the Art Commission," *Art Front* 1, no. 6 (July 1935): 4–5, reprinted in Kao, Katzman, and Webster, 286–90. See also "Vandalism and Jonas Lie," "An Open Letter to Jonas Lie, President of the National Academy of Design," and "Jonas Lie and Property Rights"—all in *Art Front* 1, no. 1 (November 1934), 1; "Treason Is Treason," *Art Front* 1, no. 4 (April 1935), 1; "An American Artists' Congress," *Art Front* 1, no. 7 (November 1935), 3; Stephen Alexander, "Jonas Lie, Red-Baiter," *New Masses* 15 (June 11, 1935): 28–29.

112. Kao, "Ben Shahn and the Public Uses of Art"; Davis, " 'We Reject'—the Art Commission," 70, 287; Linden, "The New Deal Murals of Ben Shahn," 50–52.

113. Stokes, "Random Recollections of a Happy Life" 268.

114. Austin H. MacCormick to Samuel Ordway, Jr., 18 February 1937, in exhibition file 1554. That year, the commission disapproved designs for other Rikers Island murals, one by Anton Refregier, another by Harold Lehman, but the Lehman, along with a photomural by Alexander Alland, were ultimately approved. Exhibits 1554-CE, disapproved 11 May 1937; 1554-BZ, disapproved 9 March 1937; 1554-CC, approved 11 May 1937. "Rikers Island Mural in Mess Hall Okayed," *Daily News,* 26 February 1941, ACNY Scrapbook 1941–46, ACNY.

115. The depiction of the schedule as light can be found in "Overpass Approved for Navy Yard Area," *New York Times,* 18 March 1942, ACNY Scrapbook 1941–46, ACNY.

116. "Others Are Sworn In," *New York Times,* 2 January 1942, ACNY Scrapbook 1941–46, ACNY, 20.

117. Georg Lober to Robert Moses, 18 March 1942, CF 309, ACNY; Henry Sellin, letter to editor, *New York Times,* 27 December 1941, ACNY Scrapbook 1941–46, 119.

118. "Bronze Generals Sought as Scrap," *New York Times,* 1 November 1942; "City's Cannon in Parks Going into War Scrap, *Tribune,* 17 August 1942, ACNY Scrapbook 1941–46, 28, 62. According to the *Tribune,* Roosevelt had

called for some statues to be melted down also, but Moses argued that it would be too troublesome to deal with the question of which should stay and which should go.

119. The quoted material is from "City Hall Art Is Taken out of Hiding Place," *Tribune,* 29 April 1944. See also "Metropolitan Museum Bringing Its Art Back from War Hide-Out," *Tribune,* 15 December 1943, ACNY Scrapbook 1941–46, 143, 125.

120. Wallace K. Harrison, memo to A. E. Peterson, "Report on Meeting," 31 January 1938, CF76A, ACNY; Peterson to Henry Curran, 16 February 1938, CF 295, ACNY. Also, "City Hall Is GHQ for Defense Aides," *New York Times,* 16 December 1941; "Noted City Hall Room to Be Defense Office," *New York Times,* 28 December 1941; "City Hall Treasures Sidetracked"—all in ACNY Scrapbook 1941–46, 118, 119. the complaint about civilian defense works comes from Harriet Aldrich, letter to the editor, *New York Times,* 16 December 1950, in William Adams Delano Papers (DP), box 465, New-York Historical Society (NYHS).

121. See Sarah Bradford Landau, "Delano, William Adams," in *Dictionary of American Biography,* ed., James A. Garraty (New York: Charles Scribner's Sons, 1980), 157–59; Christopher Gray, "Streetscapes: The Architecture of Delano and Aldrich: How an Upper-Class Firm Tweaked Classical Norms," *New York Times,* 27 April 2003, sec. 11, 7.

122. Robert Moses memo regarding requests for further information on the relative costs of a Brooklyn Battery Bridge versus a tunnel, 24 July 1939, CF 76A, ACNY.

123. Caro, *The Power Broker,* 645; Exhibits 1371-AA, 1371-AB, approved preliminary 6 June 1939, ACNY.

124. "Report, Committee on Control of Street Traffic, concerning an Alternative to the Proposed Battery-Hamilton Avenue Vehicular Bridge," 4 April 1939; Merchants' Association of New York to Harrison, 18 April 1939—both in CF 309.1712, ACNY. The Merchants' Association argued that the bridge would have a negative impact on trade and the welfare of the city (Caro, *The Power Broker,* 643–61).

Established in 1929 and funded by the Russell Sage Foundation (with De Forest's endorsement), the Regional Plan Association sought to implement the recommendations of the *Regional Plan of New York and Its Environs* (2 vols. [New York, 1929–31]). Developed by the Committee on the Regional Plan (formed in 1922), this multivolume study of regional development proposed new systems of land use and transportation in New York City, New Jersey, and Connecticut. The Regional Plan Association focused on land use, transportation (especially regarding ports and highway design), and effective uses of Manhattan's central business district (Robert A. M. Stern, Thomas Mellins, and David Fishman, *New York, 1960: Architecture and Urbanism between the Second World War and the Bicentennial* [New York: Monacelli Press, 1995], 42–43).

125. "A Reconstruction of Battery Park with Particular Reference to the Proposed Battery Park Bridge," minutes of meeting, 24 May 1939, CF 30 (1939), ACNY; "Report on Meeting of Special Architectural Committee of the Art Commission Held May 22, 1939," 5 June 1939, CF 76A, ACNY.

126. Caro, *The Power Broker*, 661–75.

127. Exhibit 1371-AB, 6 June 1939, ACNY.

128. Built three hundred feet offshore, Castle Clinton had once been connected to Manhattan by a causeway. The federal government in 1824 ceded it to the city, which utilized it as a reception and concert hall (made famous when Jenny Lind appeared there) during the mid-nineteenth century. In 1855 it became an Emigrant Landing Depot, a port of entry administered by the state until that task was transferred to Ellis Island in 1892. After a rehabilatation by McKim, Mead, and White, it became the aquarium. See Elliot Willensky and Norval White, *AIA Guide to New York City*, 3d ed. (New York: Harcourt Brace Jovanovich, 1988), 7.

129. Resolution, Fine Arts Federation, 2 April 1942, CF 309.1842, ACNY.

130. Robert Dowling to Delano, 24 February 1947; Delano to Dowling, 26 February 1947; Delano to Newton B. Drury, 10 September 1947—all in DP, 1947 file, NYHS.

131. *Hamilton v. Moses*, 275 A.D. 76; 87 N.Y.S.2d 717 (1st Department N.Y. App. Div. 1949). See also Delano to Oscar L. Chapman, 22 May 1952, 1952–54 file; William Adams Delano, lecture to Art Commission Associates, 2 February 1948; George McAneny to Delano, 18 March 1950—all in DP, NYHS. Delano to Harry S. Truman, 18 January 1949, 19 February 1949, 26 May 1949; Truman to Delano, 21 January 1949, 16 February 1949, 24 February 1949; John Steehmmant to Delano, 10 June 1949—all in Truman File, DP, NYHS. Caro, *The Power Broker*, 678–82.

The National Historic Landmark process had begun in 1935, when Congress mandated that the Department of the Interior designate "nationally significant historic sites, buildings, and objects" and promote "their preservation for the inspiration and benefit of the people of the United States." The structure had to possess "exceptional value in illustrating the nation's heritage." See http://www.cr.nps.gov/nhl/publications/bro2.htm. See also Caro, *The Power Broker*, 682–87.

132. Samuel A. Lewisohn to Georg J. Lober, 23 June 1948, CF 130A, ACNY.

The municipality provided formal acknowledgement of this reputation in 1948, when the ACNY, requested by chairman of the Mayor's Committee for the Commemoration of the Golden Jubilee, Grover A. Whalen, to develop an exhibit for the event, commissioned a film called *Our Heritage*. Through involvement with the film, which highlighted the ACNY's functions and worthy "city-owned monuments," the department became engaged in public relations and with the growing apparatus of commerce and tourism. The jubilee was held at the Grand Central Palace exhibition hall (Lexington Avenue between Forty-third and Forty-fourth streets) from 21 August to 19 September

1948. See Grover Whalen to Georg Lober, 13 June 1947; Harry R. Langlon and Clara R. Mason to Planning Board for City Exhibits, 17 October 1947; Wheeler Williams, memo, 9 February 1948; Williams to A. Gordon Lorimer, 7 June 1948; Delano to each commissioner, 15 June 1948; Allen Evarts Foster to Lober, 18 June 1948—all correspondence in CF 130A, ACNY.

133. Harriet Aldrich, letter to the editor, *New York Times,* 16 December 1950, in DP, box 465, NYHS.

134. Arthur Crisp to Delano, 19 December 1950; Delano to Vincent Impelliteri, 21 December 1950—both in DP, box 465, NYHS. "City Hall Museum Barred as Office," *New York Times,* 13 January 1951, 7. See also the amusing exchange between Harriet Aldrich, Office of Civilian Defense vice chair, and Delano, 16 and 18 December 1950 in DP, box 465, NYHS.

135. The quoted descriptions are in Albert R. Louis to Abe Stark, 26 January 1955. See also Allan Evarts Foster to Robert F. Wagner, 21 February 1955; Henry Epstein to Foster, 24 January 1955; Lawrence E. Gerosa to L. Porter Moore, 8 February 1955—all in CF 301, ACNY; Delano, "Report on Meeting," 31 January 1938, CF 76A; Wheeler Williams to William O'Dwyer, 17 May 1948, CF 295, ACNY. The conception of the entire City Hall as a museum began to be formed in 1938, when removal of the old post office precipitated a redesign of City Hall Park and a debate about the historical significance of the park and its built environment. See H. I. Brock, "Our Political Power House Is an Art Museum," *New York Times Magazine,* 6 February 1938, 7, 23.

136. Henry Lee, "Watchdog of the City's Art," *Tribune,* 6 April 1947, sec. 8, 8–9, 32.

137. Frederick B. Pike, *FDR's Good Neighbor Policy: Sixty Years of Generally Gentle Chaos* (Austin: University of Texas Press, 1995).

138. M. V. Rodriquez-Llamosas to O'Dwyer, 10 June 1946; Arthur S. Hodgkiss to Moses, 10 January 1947; Emilio P. Siri to O'Dwyer, 9 August 1948; Williams to O'Dwyer, 10 January 1949; Williams, "Memorandum for the Art Commission," 10 January 1949—all in CF 309, ACNY.

139. Williams insisted that the proposed site was "at best a makeshift solution encompassing, as it does, only the small city-owned dead end of a block, and therefore, presently and permanently entailing a background formed by the side walls of adjoining buildings to the east." He also observed that the work had "insufficient artistic merit" to stand "by itself" ("Recommendation to the Art Commission," 10 January 1949, CF 309, ACNY). On the Latin American "Hall of Fame" idea, see John Hettrick to Robert Moses, 6 February 1941; Hettrick to Nelson Rockefeller, 11 February 1941; Moses to Hettrick, 7 March 1941—all in CF 309, ACNY.

140. Exhibits 2774-A–B, preliminary approval, 4 November 1949 (committee of Wheeler Williams, Robert Dowling, and Charles Pratt). The landscaping plan, which included granite and asphalt block pavers, was developed by the firm of Clarke, Rapuano, and Holleran. Clarke and Michael Rapuano had

both served as landscape architect members on the art commission, offering a certain insurance that the job would be thoughtfully executed.

141. James E. Young, *The Texture of Memory: Holocaust Memorials and Meaning* (New Haven, Conn.: Yale University Press, 1993), 288; Stern, Mellins, and Fishman, *New York, 1960,* 759; "Huge Memorial to Nazi Victims Speeded by City," *Herald Tribune,* 19 July 1951, ACNY Scrapbook 1947–50, 181.

142. Moses to Delano, 13 July 1951, box 465, DP, NYHS.

143. Ibid.

144. The nature of the arguments spawned by Davidson's designs is described in Moses to Delano, 15 July 1951, DP, NYHS; "Memorial Model Shown at Museums, *New York Times,* 18 January 1950, ACNY Scrapbook 1947–50, 110.

145. Whether Moses meant, by "pathetic," heart-wrenching or simply awful or both is not clear (Moses to Delano, 13 July 1951, DP, NYHS).

146. "Memorial Model Shown at Museum," *New York Times,* 18 January 1950, ACNY Scrapbook 1947–50, 110; Young, *Texture of Memory,* 290.

147. Young, *Texture of Memory,* 290.

148. Moses to Delano, 13 July 1951; Moses to Hugo Rogers, 31 January 1952, file 1952–54, DP, NYHS. See photostats of correspondence on inscriptions in Exhibit 2875 Collateral, ACNY.

149. "Huge Memorial," *Herald Tribune,* 19 July 1951.

150. Moses to Delano, 13 July 1951, DP, NYHS.

151. Exhibit 2875-C, preliminary approval 16 July 1951, ACNY.

152. Delano statement, 16 July 1951, DP, NYHS.

153. Ibid.

154. Rogosin to Moses, 11 September 1951, DP, NYHS.

155. Moses to Rogosin, 12 September 1951, 14 September 1951; Moses to Frank Weil, 14 September 1951—all in DP, NYHS.

156. A. R. Lerner to Weil, 19 September 1951; Weil to Lerner, 21 September 1951, Exhibit 2875 Collateral—all ACNY; copies also in DP, NYHS.

157. Quotation in Mendelsohn to Moses, 1 October 1951, Exhibition file 2875 Collateral, ACNY. See also Mendelsohn to Moses, 31 January 1952; Hugo Rogers to Moses, 29 January 1952; Lerner to Moses, 10 June 1953; Moses to Lerner, 21 July 1953—all in Exhibition file 2875 Collateral, ACNY

158. Exhibit 2287-AX, disapproved 28 January 1965 (committee: Platt, Blum, and Fitch), ACNY; Young, *Texture of Memory,* 291.

159. Exhibit 2287-AV, disapproved 28 January 1965, ACNY. On Rapoport, see James E. Young, "The Biography of a Memorial Icon: Nathan Rapoport's Warsaw Ghetto Monument," *Representations* 26 (Spring 1989): 69–106.

160. "City Rejects Park Memorials to Slain Jews," *New York Times,* 11 February 1965, 1, 9.

161. Quotation in ibid., 9. See also Young, *The Texture of Memory,* 292.

162. "City Rejects Park Memorials to Slain Jews," 9.

163. Stern, Mellins, and Fishman, *New York, 1960,* 759.

164. Exhibit 2875-D, preliminary approval, 13 December 1965 (committee: Platt, Astor, and Blum), ACNY; Stern, Mellins, and Fishman, *New York, 1960*, 196–97, 759; Young, *Texture of Memory*, 292–94; Rebecca Read Shanor, *The City That Never Was* (New York: Viking, 1988), 219–20.

165. In his reports, Delano complained about the amount of time spent wrangling with the increasingly powerful Department of Traffic over how to keep order on the streets and sidewalks using signage, without cluttering the streets with layers of disparate signs combined with lampposts and parking meters. "Hours," in Delano to Allen Evarts Foster, 13 May 1953, 19 May 1953; Foster to Delano, 18 May 1953—all in DP, NYHS. By 1953, Foster, a partner in the white-shoe law firm of Lord, Day, and Lord, had succeeded Delano as president of the commission. See also Lee, "Watchdog of the City's Art," 32.

166. Commission President Allen Evarts Foster sought unsuccessfully, for example, to force the Triborough Bridge and Tunnel Authority to submit plans for the new coliseum at Columbus Circle (now the site of the Time Warner building) for art commission review. See Moses to Foster, 25 November 1950 [*sic* (correct date probably 1953)]; George E. Spargo to Citizens Union of the City of New York, 16 November 1953—both in CF 132A, ACNY.

 Authorities were semipublic enterprises dedicated to the "construction and operation of various kinds of facilities used by the people of the city and the metropolitan area." Authorities were allowed to conduct revenue-generating operations that enabled them to expend sums far above those that the city would be permitted to borrow. See Sayre and Kauffman, *Governing New York City*, 321 esp. 328–33.

167. Mayor La Guardia's support for the city planning enterprise had encouraged planners to lobby successfully for creation of a permanent city planning agency. The charter revisions of 1937, which went into effect in 1938, established the (paid) seven-member planning commission, whose chair managed a twenty-seven-member planning department. The commission's mandate was "to draw up a master plan and the capitol budget, maintain the official map, and oversee the zoning ordinance" (Birch, "City Planning," in *Encyclopedia of New York City*, ed. Jackson, 232–33).

168. On the City Planning Commission, see Stern, Mellins, and Fishman, *New York, 1960*, 119–25; Caro, *The Power Broker*, 780–86, 792–94; Gilmartin, *Shaping the City*, 301.

169. On the Landmarks Law, see Stern, Mellins, and Fishman, *New York, 1960*, 1120–21; Gilmartin, *Shaping the City*, 344–78. In 1995, the New York City Council passed legislation (Local Law 77) that removed the art commission's jurisdiction over landmarked structures, except in the cases of Scenic Landmarks, like Central Park.

170. August Heckscher, "Oral History Interview with August Heckscher at His Office in the Parks Department, New York City, May 1970: Interviewer, Paul Cummings," Archives of American Art, http://artarchives.si.edu/oralhist/

hecksc70.htm. On authorities, see Sayre and Kaufman, *Governing New York City*, 320–48. As an indication of the distance that now existed between the ACNY and the mayor, a directly appointed "mayor's representative" was added to the ACNY roster in 1971.

171. Heckscher, "Oral History Interview."

172. On Huntington Hartford Pavilion, a horizontal modernist glass structure proposed for the southeastern end of Central Park, see Exhibit 3348-B, approved 9 May 1960; August Heckscher, *Alive in the City: Memoirs of an Ex-Commissioner* (New York: Charles Scribner's Sons, 1974), 275; Donald Gormley to Arnold Whittridge, 18 October 1960, CF 187A, ACNY. On the Columbia-Morningside Park gymnasium, extending as box-like outcroppings into the park, see Exhibit 56-BB, Columbia College Gymnasium Building and City Recreation Center, Morningside Park, approved preliminary 8 May 1961; Albert S. Bard, "A Model Demanded for the Columbia Gymnasium in Morningside Park, 13 September 1961, CF 187A, ACNY; Stern, Mellins, and Fishman, *New York, 1960*, 740–46; Vincent J. Cannato, *The Ungovernable City: John Lindsay and His Struggle to Save New York* (New York: Basic Books, 2001), 229–36; Stern, Mellins, and Fishman, *New York, 1960*, 740–46.

173. Sayre and Kaufman, *Governing New York City*, 391.

174. Heckscher, "Oral History Interview."

175. On the Adele Levy playground, a proposed $1.1 million play space designed by Louis Kahn and Isamu Noguchi, see Exhibit 2287-AT, preliminary approval 9 November 1964, ACNY; Exhibit 2287, withdrawn by Department of Parks, 7 January 1966, ACNY; "Mayor Signs Pact for Play Center," *New York Times*, 30 December 1965, 31; "Mayor Now Backs Levy Playground," *New York Times*, 19 February 1966, 28; "City Is Enjoined on a Playground," *New York Times*, 28 April 1966, 45; "Playground Protest Turns to Cheers at Riverside Park," *New York Times*, 2 May 1966, 13. Playground illustrated in Stern, Mellins, and Fishman, *New York, 1960*, 759–61.

176. Heckscher, "Oral History Interview."

177. "Two Cultural Aides Asked to Resign," *New York Times*, 31 December 1965, 11; Terence Smith, "Lindsay Chides Planning Board," *New York Times*, 15 February 1966, 26.

178. According to Heckscher's oral reminiscences, mayoral control of ACNY membership did not necessarily help because of the personality of the individual professionals put on board. Heckscher singled out the then-current (unnamed) sculptor member (Theodore Roszak) as a difficult perfectionist who disapproved work by his colleagues because he applied standards overly influenced by romantic individualist ideals. Roszak objected to a number of modern works designed by sculptor Constantino Nivola for public schools, like Richmond High School. Thus although the ACNY was no longer "conservative," complained Heckscher, it was still "doctrinaire" (Heckscher, "Oral History Interview"; see also Theodore Roszak to Donald Gormley,

6 May 1971, Theodore Roszak Papers, reel 2135, frame 724, Archives of American Art; Constantino Nivola, *Academic Achievement,* Exhibit 3723-F, disapproved 12 May 1969, ACNY).

179. On Hoving's recommendation of updating the commission, see Smith, "Lindsay Chides Planning Board," 26; Exhibit 3470-L, approved 9 June 1965, ACNY; Heckscher, "Oral History Interview"; "Calder and Moore at Lincoln Center," *Progressive Architecture* 46 (December 1965): 43; Stern, Mellins, and Fishman, *New York, 1960,* 697.

180. Stern, Mellins, and Fishman, *New York, 1960,* 92–94. During this period, journalists, sociologists, and political scientists pondered extensively the bureaucracy, politics, and vicissitudes of New York City. See, for example, Roger Starr, *The Living End: The City and Its Critics* (New York: Coward-McCann, Inc., 1966), and *The Rise and Fall of New York City* (New York: Basic Books, 1985); Sayre and Kaufman, *Governing New York City;* David Rogers, *The Management of Big Cities: Interest Groups and Social Change Strategies* (Beverley Hills, Calif.: Sage Publications, 1971); Diana R. Gordon, *City Limits: Barriers to Change in Urban Government* (New York: Charterhouse, 1973). For a recent assessment of the aspirations and vicissitudes of the Lindsay administration, see Cannato, *The Ungovernable City.*

181. "Ford to City: Drop Dead," *Daily News,* 30 October 1975, 1. See also Stern, Mellins, and Fishman, *New York, 1960,* 34–35.

182. ACNY, *The Art Commission of the City of New York, 1898–1989* (New York: ACNY, 1989), n.p.

Long-term Metropolitan Museum of Art trustee member Muriel Silberstein-Storfer, the commission's first female president, recalled her frustrating attempts, during her tenure, to make the ACNY a more active and visible presence on the municipal scene. According to Silberstein-Storfer (then Silberstein), ACNY members and staff resisted her efforts, contending that the commission would fare better by keeping a very low profile (Muriel Silberstein-Storfer, conversation with the author, 3 June 2003).

CHAPTER FIVE

A note on format: I have identified projects using the titles that are listed on the art commission's meeting agendas and subsequently entered into the ACNY office database. This information will enable researchers to locate the exhibition file numbers of a given project in those circumstances where it is not provided below. The dates that accompany project citations are the dates on which the art commission reviewed the item in a public or committee meeting. I have not indicated the specific date of approvals or the dates on which the certificate of approval was issued. Nor have I provided details on whether a given approval was conceptual, preliminary, or final.

1. Under pressure to avoid an impasse, an ACNY vote typically achieves a quorum (six votes), even if it means that an absent ACNY member or an agency commissioner has to come in to vote.

Committee meetings proceed very much like the public meetings, except that there is no public testimony, no vote occurs, and the atmosphere is less formal. Applicants still seek conceptual, preliminary, or final approval. If the ACNY agrees on the item, it is placed on a "consent" agenda and approved in a block vote at the beginning of the next public meeting.

2. ACNY committee meeting, 22 May 2002.

3. ACNY, *The Art Commission of the City of New York, 1898–1989* (New York: ACNY, 1989), n.p.

4. David W. Dunlap, "Nowadays, Nobody Laughs at the City's Art Commission," *New York Times,* 19 June 1988, sec. 4, 6; ACNY, *The Art Commission of the City of New York, 1898–1989,* n.p.

5. The depiction of Patricia E. Harris as like a daughter to Mayor Koch was gleaned from informal conversations. Harris received her Bachelor of Arts degree in government from Franklin and Marshall College. See http://www.nyc.gov/html/om/html/bios/bio_om_dm_admin.html (accessed 29 December 2003). The administrator was the former executive secretary. Subsequently the title changed to executive director.

6. Margot Gayle and Michele Cohen, *The Art Commission and the Municipal Art Society Guide to Manhattan's Outdoor Sculpture* (New York: Prentice Hall, 1988).

7. In addition to the executive director, assistant director, and secretary, ACNY staff now included directors for the sculpture and mural surveys, a director of the archive and photo collection, a director and assistant to coordinate the Health and Hospitals Corporation Art Program, a director of special programs, and several other assistants (ACNY, *The Art Commission of the City of New York, 1898–1989,* n.p.).

8. In 1983, two women, Elizabeth Straus and Murial Silberstein-Storfer, served on the ACNY. By 1993, there were four (Connie Christensen, Barbara Diamondstein-Spielvogel, Suzanne Randolph, and Anna Soto), six in 1995 (Christensen, Randolph, Soto, Barbara Fleischman, Jean Rather, Reba White Williams). In 1998, six out of the eight ACNY members were women (myself, Rather, Joyce Frank Menschel, Abby Milstein, Jean Parker Phifer). By 2002, there were seven women out of ten members (myself, Menschel, Milstein, Phifer, Rather, Estrellita B. Brodsky, and Nancy Rosen), in 2004, seven out of eleven (Menschel, Milstein, Brodsky, Rosen, Alice Aycock, Signe Nielsen, LeAnn Shelton).

9. Art consultant and jewelry designer Suzanne Randolph (lay member) and sculptor John Rhoden served under Dinkins. Vivien Warfield was executive director. Bertina Carter Hunter, an art collector and patron, was the first African American to serve on the ACNY; she was appointed by Mayor Abraham Beame in 1974. "Bertina Carter Hunter, Arts Patron, 92," *New York Times,* 11 December 2004, A:17.

10. See Michael Lind, *The Next American Nation: The New Nationalism and the Fourth American Revolution* (New York: The Free Press, 1995), 74–85.

11. August Heckscher, "Oral History Interview with August Heckscher at His Office in the Parks Department, New York City, May 1970: Interviewer, Paul Cummings,"Archives of American Art, http://artarchives.si.edu/oralhist/hecksc70.htm (accessed 3 February 2004).

12. Lawyer Abby S. Milstein (as New York Public Library trustee) and art historian Estrellita B. Brodsky (as lay member), the wives of two of the city's major private real estate developers (Howard Milstein and Daniel Brodsky, respectively), served on the commission during the period 2001–5. In September 2003 James P. Stuckey, an executive vice president at Forest City Ratner—developers for the Metrotech complex and large portions of downtown Brooklyn (including a large and controversial Frank Gehry–designed basketball stadium)—joined the ACNY as lay member, succeeding me. Attorney Hugh J. Freund replaced Bud Konheim in 2004.

 The selection of monied New Yorkers was not some conspiracy. Wealthy women did not have to work and, thus, could devote time to public service. (Male appointees who were active executives had spottier attendance records.) The men were often retired, highly successful bankers and lawyers. These were highly educated individuals whose familiarity with art came from schooling, collecting, and involvement with museum affairs.

13. Although Felix Warburg was Jewish, he was, by virtue of his economic and cultural standing, an integral part of the New York professional and civic elite. Beginning in the 1920s, moreover, the majoritarian ethnic makeup of the northeastern elites expanded to include middle- and upper-middle-class Eastern European Jews. See Lind, *The Next American Nation,* 74–85.

14. During the period 1997–98, litigator Jennifer Raab, the (salaried) chair of the Landmarks Preservation Commission, was authorized initially to vet and select the candidates, at least one of whose names would be placed on the Fine Arts Federation slate of three potential candidates for a mayoral appointment. (Such action, of course, significantly limits the authority of the Fine Arts Federation, the body technically responsible for selecting the three names for the slate.) Attorney Michael Hess, who in 1998 became corporation counsel for the City of New York, served in 1997 as chairman of the Mayor's Committee on Appointments. His committee interviewed each of the three candidates for the lay position and advanced the recommendation for the candidate to be selected by the mayor. Interrogating me in December 1997, he asked pointedly whether I thought that the art commission under "this mayor" was "any different than under previous administrations." Presumably he wanted to hear that the ACNY was now operating magnificently, but having no idea of the answer, I responded blandly that "I really couldn't say" (author's notes, 18 December 1997).

15. Rather is wife of CBS anchorman Dan Rather. Sculptor John Rhoden (1918–2001), appointed in 1993 under David Dinkins, remained on the ACNY until his death in 2001. Rhoden's slot was not filled again until 2003. Between 1999 and September 2003 commission members, in addition to Rather and myself, were Estrellita Bograd Brodsky, Barbara Fleischman (succeeded by Abby

Milstein), Bud Konheim, Joyce Frank Menschel, Jean Parker Phifer, Robert Rubin (succeeded by Otis Pratt Pearsall), Ted Shen (replaced by Nancy Rosen), and Donald Walsh. The degree of commitment among commission members varied. Some were far more likely to attend site visits than others. Apart from the staff, the president and vice president did most of the work. Beyond that, the division of labor did not breakdown according to any clear-cut category.

On Williams, see Cade Metz, "North Carolinians in New York," *Metro Magazine* (September 2003), http://216.239.39.104/search?q=cache:nH AmAa-7qTIJ:www.metronc.com/issues/issue09_03/Newyork/profiles/nyc_ williams.html+Reba+White+Williams+President+Art+Commission&hl =en&ie=UTF-8 (accessed February 2, 2004).

16. Peter Powers served as first deputy mayor, Randy Mastro as deputy mayor for operations and chair of Giuliani's Charter Revision Commissions in 1999 and 2000, and John Dyson as deputy mayor for economic development.

17. "An Agency Loses Leader in a Struggle over Power," *New York Times,* 11 December 1998, B:3; Williams's negative rendering of Stern is reported in Randy Kennedy, "Foe of Bunny Sculptures and Weasel Words," *New York Times,* 24 March 1999, B:2; David M. Herszenhorn, "Art Agency's Ex-Head Sues City, Saying It Violated Charter, "*New York Times,* 30 March 1999, B:6; David Seifman, "Spurned Big Posts 10G Bounty for 'News' Scoops," *New York Post,* 13 March 1999, 4; Gersh Kuntzman, "She's Up in Yardarms over 3-Banner Flagpoles," *New York Times,* 5 April 1999, 18; *Williams v. Giuliani, et al,* 99 Cv. 3079 (HB 29 March 1999), Stipulation of Dismissal, 16 July 1999; David M. Herszenhorn, "The Cross Words over Crossbars Wind Down as a Lawsuit Is Settled," *New York Times,* 20 July 1999, B:3; "Mending Fences after a Flag Flap," *New York Times,* 19 August 1999, B:2; Tom Loftus, "Ahoy! Who Raised the Yardarm? Board Says It Must Go," *Observer,* 27 September 1999, B:6.

After leaving the ACNY Williams ran unsuccessfully for a seat in the New York City Council.

18. Anthony P. Coles, deputy mayor for planning, education, and cultural affairs was ostensibly in charge of ACNY staff. By the end of the Giuliani administration, the deputy mayor for economic development and finance, Robert M. Harding, was the official who interacted with ACNY Executive Director Deborah Bershad.

19. Construction of the Randall's Island Track and Field Sports Facility, Randall's Island, Manhattan, Exhibition files 5914-R–T; Construction of East River Ferry Landings, East Thirty-fourth Street, East Sixty-second Street, and East Seventy-fifth Street, Manhattan, (Preliminary), 10 June 2002; Construction of the New Queens Family Court, between 151st Street and 153rd Street, Jamaica, Queens, 1998.

20. Konheim remark, committee meeting, 22 March 2000. "Aesthetically challenged" projects outside of Manhattan included Construction of the South Beach Restaurant, on FDR Boardwalk, South Beach Park, Father Capodanno

Boulevard, Staten Island (2002, 2003), Exhibition files 3093-O and -Q; Construction of the Prospect Park Tennis Clubhouse, Parade Grounds, Brooklyn (2001); and Construction of the Croton Falls Machine Shop, Croton Falls Road, Carmel, New York (2001–2), Exhibition files 6295-A–G, ACNY. A twenty-thousand-square-foot restaurant designed for a converted severe "moderne" bathhouse at South Beach Park, Staten Island, was presented in a frilly pseudo-neo-classical style that was at odds with a second modern-style bathhouse and comfort station nearby. The proposed building had peculiar roof decks, an entrance with a pediment and acroteria, and a stucco base. The ACNY urged the architect to simplify the style of the design, to try to make it more consistent with the other large bathhouse, to reduce the number of projecting features, and to eliminate details like the acroteria. A new architect was brought in to redesign the project under Parks Commissioner Benepe.

A design for a tennis house for Prospect Park's Parade Ground, a one-story cement-stuccoed concrete masonry building with a peaked metal roof, raised quoins, and "decorative fascia detailing," also generated tensions, exemplifying a situation where the desire to make money through a franchise outweighed any sensitivity to context. In its initial stages, the building design was a hodgepodge. Its windows had all different shapes. The architects planned to use precast concrete in a cream color, supposedly to harmonize with the Renaissance-style "folly" at the edge of Prospect Park. The signage over the door was huge and had two large maple leaves on either side. Commission members urged the architect to clarify the window treatment. The architect lost his temper but did take heed, restudying the fenestration to make it more symmetrical, reducing the number and size of "maple leaves" from the entrance door, rendering the window trim a "visible component of the façade" and, in general, giving it a more "dignified" character. The tennis center was in construction as of August 2005.

From the ACNY members' perspective, public architecture on city property had to answer to the broader public interest. In certain cases the perspectives of the ACNY and the architects were simply irreconcilable, as with the construction of a headquarters for the Croton Police Precinct, a proposed two-story concrete masonry unit building with peaked metal roof, metal roll-down doors, and masonry wall. (New York City owns land surrounding the Croton Reservoir.) As one art commissioner put it (beyond the ears of the architect-engineers hired to design the building), the structure resembled a McDonald's restaurant, only worse. This project also underwent extensive revisions.

These and other small and medium-size projects with relatively small budgets were often the intractable ones. An additional problem was that the procurement procedures for agencies like the Department of Design and Construction (DDC) were extremely cumbersome, making it very difficult for its bureaucrats to select high-level architects. During the five-year period from 1998 through 2003, DDC had to choose firms based on bids from architects selected from an arbitrary list generated by computer from a master

list of prequalified architects. Prequalification was based on factors such as prior experience, ability to negotiate the thickets of municipal bureaucracy, and a track record meeting deadlines and budget limitations. Design excellence was often a secondary priority for some agency officials, juggling many constraints, who had to sign off on the selection. In 2004, Mayor Bloomberg instituted a "Design Excellence Initiative" that altered procurement requirements for certain types of projects (Robin Pogrebin, "City Seeking Rich Designs Instead of Lowest Bids," *New York Times,* 13 August 2005, B:1, 10).

21. The 2000 U.S. Census reveals the disparities in education and income between Manhattan residents and those of the other boroughs, with the exception of Staten Island. In 1999, the median household income in Manhattan was $47,030; Queens, $42,439; Brooklyn, $32,135; the Bronx, $27,611; and Staten Island, $55,039. The per capita income in Staten Island ($23,905) was far lower than that of Manhattan ($42,922), as were those of the other boroughs. In Manhattan, 49.4 percent of people twenty-five and over had a BA. Those percentages dropped to 24.3 in Queens, 23.2 in Staten Island, 21.3 in Brooklyn, and 14.6 in the Bronx. See http://quickfacts.census.gov (accessed 23 March 2004).

22. ACNY meetings, 17 March 1999, 17 August 1999, 22 March 2000.

23. Installation of Theodore Roosevelt, Millennium Park, Park Row and Broadway, Manhattan (Conceptual), 10 September 2001.

 On the Fred Lebow statue, see Lisa Rein and Tara George, "New Home for Lebow: Jogger Statue out of Bushes," *Daily News,* 2 January 1999, 6; Benjamin Cheever, "The Voice: Filling Fred's Running Shoes," *New York Times,* 7 November 2004, sec. 14, 4; Michele H. Bogart to Jean Parker Phifer (by e-mail), 14 March 1999. On the Percent for Art program, see "Percent for Art in NYC," http://www.nyc.gov/html/dcla/html/panyc_main.shtml (accessed 23 March 2004).

24. Installation of Nobel Monument, Theodore Roosevelt Park, between West Seventy-ninth Street and West Eightieth Street near Columbus Avenue, Manhattan (preliminary), 24 May 2001, 18 July 2001, 9 October 2001. See also Kelly Crow, "Battle over a Pillar to Nobel Yields No Statue, No Peace," *New York Times,* 13 May 2001, sec. 14, 7; http://www.swedeninfo.com/nobelmonument (accessed 11 October 2003). See also, Installation of decorative paving design, City Hall Park, Park Row and Broadway, Manhattan, approved preliminary 13 September 1999; Installation of bronze plaques, Union Square Park, between Union Square East and Union Square West from East Fourteenth Street to East Seventeenth Street, Manhattan, 23 January 2002. The phrase "dumbing-down" was used by DPR Commissioner Adrian Benepe in an early 2002 meeting with ACNY.

25. Elizabeth Bumiller, "Guarding the Turf, Stepping on Toes: Henry Stern, Passionate and Blunt, Champions the City Parks," *New York Times,* 23 July 1995, sec. 1, 27. See also Wayne Barrett, *Rudy! An Investigative Biography of Rudolph Giuliani* (New York: Basic Books, 2000), 296.

26. The "broken windows" theory, based on a 1982 essay in *Atlantic Monthly,* was the linchpin of the Giuliani administration's policies on crime. The argument was that, just as broken windows in a building signaled abandonment and invited vandalism, so too disorderly behavior, even if seemingly minor (like public urination or drunkenness), could ultimately lead to more serious crime if not stopped. See James Q. Wilson and George L. Kelling, "Broken Windows," *Atlantic Monthly* (March 1982), posted at http://www.theatlantic.com/politics/crime/windows.htm; Barrett, *Rudy!* 345.

27. Dennis Duggan, "The Parks Chief Who Went to War for Leafy Friends," *Newsday,* 11 March 1990, 6; Bob Liff with Michael O. Allen, "Commish Plays (Name) Tag: Parks Boss Gives His Assistant Wild Labels," *Daily News,* 8 March 1996, 8; Denene Millner, "Unleashed: A Day in the Life of N.Y.'s Parks Commissioner," *Daily News,* 21 July 1997, 25; David Sapsted, "New York Mayor Baffled by Apology to Tree," *Ottawa Citizen,* 4 April 1998, A:20. One newspaper occasionally willing to offer a critical view was the *New York Observer.* See "Stern May Be Goofy, but His Many Enemies Want Parks Boss Gone," *New York Observer,* 27 November 1999, 1, 8.

28. Joel Siegel, "Parks Art Going Wild," *Daily News,* 9 June 1997, 8. Even in 1997, some critics charged Stern with squandering money on chintzy animal décor while playground equipment and landscaping lay in disrepair.

29. See http://newyork.cowparade.net/ (accessed 3 February 2004).

30. See Reconstruction of the Clubhouse and Construction of a Miniature Golf course in Flushing Meadows Corona Park, Pitch and Putt Golf Course, Queens, 21 October 1998. See Exhibits 2103-NC–NF, ACNY.

31. The DPR proposed a Kenneth Lynch stone dog (no. 6136) for the dog run. Designers increasingly brought "animal art components" to ACNY committee meetings rather than to the public meetings, knowing that more often than not such features would be turned down (Construction of a Dog Run, Madison Square Park, Manhattan, 19 May 1999; Exhibits 1945-AU–AW, 14 June 1999). See also "101 Questions about One Dalmatian," *New York Observer,* 26 April 1999, 11; Construction of Vidalia Park (near West Farms Square), East 180th Street between Vyse Avenue and Daly Avenue, West Farms, Bronx, 13 December 1999 (Exhibition files 1212-D–F); Construction of Grant Playground, Northwest Corner Grant Avenue and East 169th Street, Bronx, 13 March 2000.

32. The Juniper Valley project scope also included a spray shower with camel bollard spray features (also used in Weidenbaum Park), a sundial and compass rose (also clichéd "parks standard" items under Stern), and a yardarm. More conventional and reasonable items included a new seating area with game tables, new play equipment, new drinking fountain, new plantings, and picket fencing. See Reconstruction of the Ballfields in Juniper Valley Park, between Juniper Valley Boulevard North, Juniper Valley Boulevard North South, Seventy-second Street and Seventy-fifth Place, Queens, 11 September 2000, Exhibit 2191-SU; "Juniper Valley Park," http://www.nycgovparks.org/

sub_your_park/historical_signs/hs_historical_sign.php?id=229, http://www
.nycgovparks.org/sub_about/parks_divisions/capital/pd_proj_month_feb_
01.htm. Reconstruction of Nathan Weidenbaum Park, south of the Brooklyn
Queens Expressway between Sixty-third and Sixty-fourth streets, Queens,
John Williams, Miceli Kulik Williams, architects, 13 March, 2000.

The "Verdi" animals were a feature of the project Construction of a New
Subway Headhouse at Seventy-second and Broadway, Manhattan, 13 July 1998.
Headhouses are the entrance structures expressly designed for the subways.

In addition, designs for a cricket field (part of an elaborate park project at
South Park Gateway Center in Brooklyn) included three-foot bronze crickets
encircling the fencing around the cricket field. Deborah Bershad pointed out
that the etymological derivation of crickets (insect) and cricket (the sport) had
nothing to do with each other. One commissioner exclaimed that the crick-
ets looked like large cockroaches. The landscaping project was approved on
the condition of their removal (Construction of South Park Gateway Center,
Spring Creek Park, near Starrett City [Gateway National Recreation area],
intersection of Shore Parkway and Hendrix Creek, Brooklyn, 13 December
1999). For more on the South Park Gateway Center project, see Nichole M.
Christian, "East New York Senses Promise in a New Mall," *New York Times,*
15 November 2000, B:1, 6.

33. Reconstruction of Seward Park, East Broadway, Canal Street, and Essex
Street, Manhattan, 12 April 1999, 20 October 1999, 8 November 1999. On
Togo, see newsclipping given to ACNY by Crowley: Robert McG. Thomas,
Jr., "Edgar Nollner, 94, Dies; Hero in Epidemic," *New York Times,* 24 January
1999; "Leonhard Seppala: The Musher Legend from Norway," http://home
.no.net/tunheim/seppala/seppalae.htm (accessed 6 February 2004).

34. In addition to the ludicrous bison (which, Browne assured the ACNY, would
be funded with "private" money), the submission included a modification
of a plan to place two owls at the entrance to Herald Square. Consistent with
the Stern "animal art" mandate, DPR planned two owls on pedestals for the
Thirty-fourth street entrances to Herald Square, to harmonize with the two
owls on the 1939–40 James Gordon Bennett (Bell Ringers) monument at
Thirty-fifth Street and Sixth Avenue. The Department of Parks and Recre-
ation commissioned Gregg Lefevre (sculptor of plaques in Union Square and
Foley Square), at $13–15,000 each. In addition, one owl would have its head
turned 180 degrees to glance down at a bronze cat, to evoke—in this gritty and
quintessentially commercial district—the song "The Owl and the Pussycat."
Lefevre had already cast the cat, although he should not have done so without
having received ACNY preliminary approval. He did not receive an approval
for the cat. The owls, previously approved, are in place (Installation of animal
art, Herald Square, Broadway, Sixth Avenue, West Thirty-fourth Street, and
West Thirty-fifth Street, Manhattan, 17 February 1998; Construction of a
Comfort Station and Concession Kiosk, Greeley Square, Thirty-second Street
between Broadway and Sixth Avenue, Manhattan, 18 November 1998).

35. ACNY special public meeting, 29 September 1999.
36. "An Agency Loses Leader in a Struggle over Power," B:3; *Williams v. Giuliani, et al,* 99 Cv. 3079 (HB 29 March 1999); Stipulation of Dismissal, 16 July 1999; Herszenhorn, "The Cross Words over Crossbars Wind Down as a Lawsuit is Settled," B:3; "Mending Fences After a Flag Flap," B:2; Loftus, "Ahoy!" B:6. Draft, ACNY Guidelines for Installation of Flagpoles and Yardarms on Flagpoles, Tuesday, 12 October 1999. The draft guidelines stated that "sites for Flagpoles with or without yardarms should be a minimum of 200 feet square . . . should be at least 50 feet from any work of art, and should not be located in any pathway leading to a work of art." War memorials were considered a special category, and only the American flag was considered appropriate. Yardarms had to be "at least twenty-five feet from any trees in the area, measured from the drip-line of the tree" and stand "in existing paved areas."
37. Henry Stern, address to Dutch Treat Club, New York City, 24 February 2004.
38. ACNY special public meeting, 12 September 1999.
39. Cross quotation an approximation, based on author's memory. Staats Circle event. See also draft, ACNY Guidelines for Installation of Flagpoles and Yardarms on Flagpoles, November 1999; special public meeting of the ACNY, 12 September 1999.
40. Oddo's recommendation followed on the heels of a previous unsuccessful move, by a Giuliani-initiated Charter Revision Commission, to put on a charter revision ballot a proposition to eliminate the ACNY in the name of efficiency. The argument made, incorrectly, was that the work of the ACNY was redundant with agencies like City Planning. Bill no. 756, 25 May 2000, New York City Council; Thomas J. Lueck, "Move Made to Abolish Art Commission," *New York Times,* 25 May 2000, B:3, and "Yardarms May Hang Art Commission," *New York Times,* 13 June 2000, B:1; Reginald Patrick, "Oddo Leading Charge to Dump City's Art Panel," *Staten Island Advance,* 25 May 2000, http://www.silive.com/news/advance/0525art25.html (no longer available); Andrew Roth, "Councilman Would Axe City Art Board," *Brooklyn Paper,* 12 June 2000, 3; Robin Finn, "A Defender of Public Beauty (as She Sees It)," *New York Times,* 2 June 2000, B:2; Michael J. Fressola, "Councilman and City Art Commission at Odds over Yardarm," *Staten Island Advance,* 17 June 2000.
41. Whitney North Seymour, Jr., a key figure in setting up the Friends of the Art Commission, served as the New York Public Library's ACNY representative from 1975 through 1978. As U.S. Attorney for the Southern District of New York, Seymour swore in Giuliani as an assistant U.S. Attorney (Barrett, *Rudy!* 73).
42. Deborah Bershad left in 2004 to complete her doctorate. Harris appointed Jackie Snyder, one of Harris's former employees on the ACNY staff, as the new executive director, further cementing ties.
43. For press observations on the changes, see Jennifer Steinhauer, "Suddenly, It's Art for the City's Sake," *New York Times,* 3 July 2002, B:1, 6.

44. For an example of private home improvements, see Installation of a Stoop and Fenced-in Area, 186th and East Ninety-third Street, Manhattan, 15 October 2002.

45. The Koch administration established the first BIDs in the 1980s, in response to the municipal economic crises of the 1970s, to enhance midtown streets and businesses, deter crime, counteract perceptions of a city out of control, and revitalize the districts as tourist destinations. The Grand Central and Thirty-fourth Street Partnerships in particular, developed coordinated street furniture plans that set a strong standard of design excellence. See "Bryant Park Restoration Corporation" http://www.bryantpark.org/park-management/overview.php (accessed 4 February 2004); "New York City Department of Small Business Services, Business Improvement Districts" http://www.nyc.gov/html/sbs/html/bid.html (accessed 4 February 2004); "Thirty-fourth Street: The Best of New York," http://www.34thstreet.org/partnership/who/index.php (accessed 4 February 2004).

46. An early distinctive sidewalk was installed in 1979, for example, as part of the reconstruction of Flatbush Avenue and Empire Boulevard, Brooklyn (see Exhibits 4185-C and -D, ACNY Minutes, 12 March 1979.

47. Examples include Installation of a Distinctive Sidewalk, Inter-Continental Hotel–The Barclay New York, 111 East 48th Street, Manhattan, 17 April 2002; Installation of a Distinctive Sidewalk, Hotel Sofitel, 44–45 West Forty-fourth Street and 45 West Forty-fifth Street, between Fifth Avenue and Avenue of the Americas, Manhattan, 10 May 1999; Installation of a Distinctive Sidewalk, Jil Sander America, Inc., 11 East Fifty-seventh Street, Manhattan, 10 June 2002; Construction of Boston Road "Zoo Way," Boston Road between East Tremont Avenue and Bronx Park South, Bronx, 20 September 2000.

48. Installation of Proposed "Fashion Walk of Fame," Seventh Avenue, between Forty-first and Thirty-fourth streets, Manhattan, 11 January 1999, 19 May 1999, 14 June 1999. See Exhibition files 6119-A–C, ACNY. On the sidewalk markers, see Hannah Fairfield, "Markers Honor Parades Honoring Heroes," *New York Times*, 14 May 2000, sec. 14, 8. Legalization of a Logo, Versace Boutique, 647 Fifth Avenue, Manhattan, 15 May 2001 (Exhibition files 6295-A–C); Installation of a Logo, New Forty-second Street Studios (American Airlines Theater), 229 West Forty-second Street, Manhattan, committee review, 21 February 2001.

Installation of a Distinctive Sidewalk, Kaufmans Army-Navy Store, 319 West Forty-second Street (disapproved), 13 September 1999. Here, the Community Board and the groups Disabled in Action and the Lighthouse objected that a camouflage sidewalk would confuse the visually impaired and set an "unfortunate" precedent by "spreading the showy Times Square atmosphere farther west on 42nd Street." The store got "expert" opinion from an ophthalmologist, who said the camouflage sidewalk would not impair anyone from seeing the street. Although Kaufmans agreed that if they vacated the store they would remove the distinctive pattern and replace it with a regular

sidewalk, the ACNY disapproved it, arguing that the design was not "appropriate" for the street.

The ACNY's review of logos in distinctive sidewalks (and complaints about them) dates back to 1983. See "Controversy Afoot over Sidewalk Imprints," *New York Magazine,* 24 October 1983; and Glenn Fowler, "The New Sidewalks of New York," *New York Times,* 18 December 1983, R:1, 14—both in CF 295, ACNY.

49. On DOITT policies regarding pay phones, see http://www.nyc.gov/html/doitt/html/pptfranchise.html (accessed 4 February 2004). In 2004, responding to ACNY and others' concerns, Bloomberg's commissioner of DOITT, Gino P. Menchini, instigated changes to the rules of the City of New York. The amended rules prohibit advertising on "public pay telephones in certain areas of Manhattan." See http://www.nyc.gov/html/doitt/downloads/pdf/rule_change_oct2004-city_record_notice.pdf (accessed 8 August 2005); http://www.nyc.gov/html/doitt/downloads/pdf/rule_change_oct2004-ppt_report.pdf (accessed 8 August 2005).

50. David W. Dunlap, "City Seeking an Exterior Decorator," *New York Times,* 2 June 1996, sec. 9, 1.

51. ACNY business meeting, 8 March 1999.

52. Dunlap, "City Seeking Exterior Decorator," 1. For a presentation on 11 July 2000, one lawyer shot pictures of every newsstand on Broadway from Eighty-sixth to Sixty-second streets to demonstrate how shabby they looked.

53. Design Modifications of a Prototype Newsstand, James Garretson, Offsite Technologies, 21 April 1999, 21 July 1999, 22 September 1999, 20 October 1999.

54. An ACNY disapproval of a newsstand on lower Broadway in the mid-1990s, based on an assessment of its potential aesthetic impact on its surroundings, had been held up by a judge after the owner sued. Between 1999 and 2003, neither the Giuliani nor Bloomberg administrations challenged the ACNY's right to assess newsstand installations. An additional consideration in evaluating individual newsstands was whether they would block important "view corridors," buildings of "distinction," or monuments or otherwise negatively affect the appearance of the street; such was the rationale for the disapproval (after a site visit of 17 March 1999) of a newsstand proposed for Fifty-ninth Street on Fifth Avenue, which would have blocked views of the Plaza Hotel, Pulitzer Fountain, and Sherman Memorial from the eastern side of the street.

Concerns about visual obstructions also arose from the fact that in some cases other newsstands stood right across the street or on an opposite corner. Older dilapidated newsstands were grandfathered in. Some of them were abandoned (as at Sixth Avenue and Forty-seventh Street), but at the time Department of Consumer Affairs (DCA) had not acted to secure occupants or to remove the stand. According to Robert Bookman, abandoned newsstands often sat for long periods without being removed because DCA had to offer the site to a waiting list of veterans. The process also had to go through the New York City Department of Transportation (DOT) bureaucracy before a stand

could be removed. Citizens could call DCA to complain, Bookman noted, but the process still would take forever. In addition, during this period DCA staff dealing with the issue were totally inattentive. Bookman contended that prospective owners were being penalized by the fact that there were numerous abandoned stands that had been there for five years, yet no new and nicer one could be substituted. Although Bookman argued that such inaction effectively penalized prospective new owners, the ACNY remained loath to approve new stands in already-occupied areas (ACNY Meeting of 11 July 2000).

55. Frank Lombardi, "Newsstand Deal Won't Be Stalled," *Daily News*, 8 October 2003, http://www.nydailynews.com/10-08-2003/boroughs/v-pfriendly/story/124490p-111735c.html (accessed 5 February 2004).

56. Geographers John Jakle and Keith A. Sculle describe this use of visual culture as a means of packaging communities as the creation of "place-product" (*The Gas Station in America* [Baltimore and London: Johns Hopkins University Press, 1994], 1).

On public authorities and development corporations in public administration, see Jerry Mitchell, ed., *Public Authorities and Public Policy: The Business of Government* (New York: Greenwood Press, 1992); Annmarie Hauck Walsh, "Public Authorities and the Shape of Decision Making," in *Urban Politics New York Style*, ed. Jewel Bellush and Dick Netzer (New York: Sharpe, 1990), and *The Public's Business: The Politics and Practices of Government Corporations* (Cambridge, Mass.: MIT Press, 1980). See also Lynne B. Sagalyn's *Times Square Roulette* (Cambridge, Mass.: MIT Press, 2001). On authorities in New York City, see Jameson W. Doig, *Empire on the Hudson: Entrepreneurial Vision and Political Power at the Port of New York Authority* (New York: Columbia University Press, 2001); Susan S. Fainstein. *The City Builders: Property Development in New York and London, 1980–2000*, 2d ed. (Lawrence: University Press of Kansas, 2001); and David L. A. Gordon, *Battery Park City: Politics and Planning on the New York Waterfront* (New York: Routledge, 1997). On pre-9/11 downtown redevelopment in general, see Bernard J. Frieden and Lynne B. Sagalyn, *Downtown, Inc.: How America Rebuilds Cities* (Cambridge, Mass.: MIT Press, 1989); Robert Fogelson, *Downtown: Its Rise and Fall, 1880–1950* (New Haven, Conn.: Yale University Press, 2001). The literature on place is voluminous, but significant discussions include Dolores Hayden, *The Power of Place: Urban Landscapes as Public History* (Cambridge, Mass.: MIT Press, 1995); James Duncan and David Ley, eds., *Place/Culture/Representation* (New York: Routledge, 1993); and Tony Hiss, *The Experience of Place* (New York: Knopf, 1990).

57. Exhibits 4153-C, 4153-D, final approval 3 May 1976. The Alliance for Downtown New York acquired the Heritage Trails and decided to concentrate on "heritage tourism" more generally rather than on maintaining the rubber markers that cumulatively formed the physical trail (committee meeting, 19 April 2000; Exhibits 4185-A and 4185-B, final approval, 8 January 1979 [Flatbush Avenue]).

58. On ISTEA, see "A Guide to Metropolitan Transportation Planning under ISTEA—How the Pieces Fit Together—U.S.D.O.T.," http://www.fta.dot .gov/library/planning/MTPISTEA/424MTP.html (accessed 2 January 2005).

59. The Jamaica project included new granite paving at the courthouses, colored concrete paving scored with diagonal lines, new light fixtures, a large gateway structure at 160th Street, new fences, new gates, and identity and way-finding signage. See Construction of Streetscape Improvements (Intermodal Enhancements), Jamaica Center, Sutphin Boulevard, Jamaica Avenue to Hillside Avenue including the Supreme Court Plaza, 160th Street from Jamaica Avenue to Ninetieth Avenue, 159th Street from Archer Avenue to Liberty Avenue, and LIRR Underpasses at 159th Street and 160th Street at Archer Avenue, Jamaica, Queens, 17 July 2002; Exhibition files 6181-A–C, Construction of Downtown Flushing Pedestrian Project, Thirty-seventh Avenue and Thirty-ninth Avenue near Main Street, Flushing Queens, 1999–2000, ACNY.

60. Kenneth Lynch used the term "way-finding" in his 1960 book *The Image of the City* (1960; reprint, Cambridge, Mass.: MIT Press, 1992), 3–4. Environmental planner and architect Romedi Passini is among the influential theorists of way-finding as a process of spatial problem solving helped and hindered by architectural landmarks and signage. See Romedi Passini and Paul Arthur, *Wayfinding in Architecture and Wayfinding, People, Signs and Architecture* (New York, McGraw-Hill, 1992). On way-finding systems, see John Mulhausen, "Wayfinding Is Not Signage," in *Signs of the Times,* article found at http://www .signweb.com/ada/cont/wayfinding0800.html (accessed 6 February 2004).

61. The Flatbush Junction project involved the New York City Economic Development Corporation (EDC), representatives from Brooklyn College, the architect and graphic designers, merchants from the local community, and a task force that included City Councilman Lloyd Henry, representatives of Brooklyn College (whose campus was across from the junction), and members of the Community Board (Construction of Flatbush Junction Sidewalk Amenities, Flatbush Avenue between Farragut Road and Avenue H, and Nostrand Avenue between Glenwood Road and Avenue H, and Hillel Place between Flatbush Avenue and Campus Road, Brooklyn, 20 January 1999). See Exhibition files 6089-A, 6089-B, 6089-D, ACNY. See also Emily Kies Folpe, "Some Recently Approved Designs," in *News from the Friends of the Art Commission,* Summer 2002, n.p. See also Flatbush Streetscape Improvements, Flatbush Avenue between Empire Boulevard and Parkside Avenue, Brooklyn, 8 May 2000; memo, David Hirsch to Lynn Bodner, 24 April 2000; see Exhibition file 6239, ACNY.

The Empire Boulevard streetscape application included a plan by Urban Architectural Initiatives to add metal panels with a "leaf-like pattern" and "prominent multi-colored tropical birds" as an ornamental diagonal "truss" for Flatbush Avenue light poles. We voted this proposal down but did accept for some of the light poles two-foot medallion signs, decorated with colorful

"Caribbean" flora and inscribed with the name of the local BID (Flatbush Gateway Community Development Corporation).

I found the tropical bird light fixture concept so preposterous that I began to giggle uncontrollably; well aware that I was behaving inappropriately, I found it necessary to put my head under the desk in order to regain my poise.

62. Reconstruction of the Harlem Gateway Corridor, Streetscape Improvements along 110th Street, Elizabeth Barlow Rogers statement, 19 May 1999, 14 June 1999; see Exhibition file 6097.

63. Executive Director Deborah Bershad of the ACNY raised concerns about whether the final product would look as good as the drawings and about quality control. She urged the ACNY to insist that the team provide a mockup, clarify the details of production and oversight, and demonstrate that they had a maintenance agreement with DOT. Business meeting, 13 September 1999. For press follow-up on the Heritage Poles and Malcolm X Plaza, see Anne Raver, "A Sliver of Paradise Blooms in Harlem," *New York Times,* 3 August 2000, F:10; Nina Siegal, "A 'Heritage Corridor' Bends to Preservationists' Wishes," *New York Times,* 20 August 2000, sec. 14, 6.

64. The Society for the Architecture of the City, Letter of Testimony, 23 March 1999. The Society for the Architecture of the City, Testimony to Landmarks Preservation Commission for March 23, 1999. Subsequently read to ACNY, 14 June 1999.

On theme parks and their influence, see Michael Sorkin, ed., *Variations on a Theme Park* (New York: Hill & Wang, 1992), xi–xv. Historian Neil Harris has demonstrated how the World's Columbian Exposition—whose aesthetics influenced and were championed by Progressive Era members of the ACNY—was itself criticized for its stereotypical character. See Neil Harris, "Expository Expositions: Preparing for the Theme Parks," in *Designing Disney's Theme Parks: The Architecture of Reassurance,* ed. Karal Ann Marling (Paris and New York: Flammarion, 1997), 19–27.

In testimony, the MAS urged that portrait plaques be placed only on the residential side. Owen Levy, a resident of 110th Street, stated that images of this kind did not belong on a residential street. It was not a destination like 125th Street, he contended, and "lampposts as culture receptacles" were "inappropriate." Janice Minot from Harlem City Councilman Bill Perkins's office strongly supported the project and its commemorative elements. Ron Noveda from the Harlem Community Development Corporation, a subsidiary of the Empire Development Corporation, argued that the Cityscape project would add jobs and bring tourism. Architect and historian Thomas Mellins highlighted the importance of the streetlamps as adding a public dimension of light in New York; the Cityscape project would reclaim the streets. Public testimony on Reconstruction of the Harlem Gateway Corridor, Streetscape Improvements along 110th Street, 14 June 1999. For iterations of the light pole, see Exhibition file 6097, ACNY.

65. On the question of who represents "the community" when public art is concerned, see Erika Doss, *Spirit Poles and Flying Pigs: Public Art and Cultural Democracy in American Communities* (Washington, D.C.: Smithsonian Institution Press, 1995); Jane Kramer, *Whose Art Is It?* (Durham, N.C., and London: Duke University Press, 1994); and Harriet Senie, *The Tilted Arc Controversy: Dangerous Precedent?* (Minneapolis: University of Minnesota Press, 2002).
66. Installation of Heritage Poles, 110th Street, final approval, 13 September 1999.
67. Installation of Plaques, Heritage Poles, Harlem Gateway Project, 110th Street, Manhattan, 21 February 2001, 17 October 2001.
68. The Conservation of Lin Ze Xu Statue, Chatham Square, Manhattan, 23 February 2000; Inscription for the Lin Ze Xu Statue, Chatham Square, Manhattan, 20 September 2000. "Inscription at the Statue of Mr. Lin Ze Xu in New York City, U.S.A.," submitted for ACNY meeting of 22 March 2000 (Exhibition file 4174).
69. Committee meeting, 22 March 2000; Inscription for the Lin Ze Xu Statue, 25 May 2000; Conservation of Lin Ze Xu Statue, Chatham Square, Manhattan, 23 February 2000, 10 April 2000, 25 May 2000. See Exhibition file 1474, ACNY.
70. Construction of the Third Water Tunnel Worker's Memorial (Sandhog Memorial), Traffic Circle at the Intersection of Van Cortlandt Park East and Katonah Avenue, Bronx, 9 September 2002.
71. Construction of Matthew J. Buono Monument at Buono Beach, near Alice Austin House, Hylan Boulevard at Edgewater Street, Staten Island, 10 January 2000. See Exhibit 4248, ACNY. See also Buono Beach historical signage information on Department of Parks Web site: http://nycparks.completeinet.net/sub_your_park/historical_signs/hs_historical_sign.php?id=10800.
72. Installation of the Battle of the Bulge Memorial, South End of Cornelia Avenue, Wolfe's Pond Park, Staten Island, disapproved 10 February 2003. See Exhibition file 6198-D, ACNY.
73. A similar strike destroyed a portion of the Pentagon; a fourth plane, destined for an attack in the District of Columbia, crashed in Shanksville, Pennsylvania.
74. James Russell, Art Commission of the City of New York and the Design Trust for Public Space, *Designing for Security: Using Art and Design to Improve Security: Guidelines from the Art Commission of the City of New York* (New York: ACNY, 2002).
75. At a review of 8 July 2003, for example, the ACNY and DPR discussed the redesign of the following parks: Wall Street, Coenties Slip, Old Slip, Bowling Green, Tribeca Park, Canal/Varick/Laight Triangle, Al Smith Park, Columbus Park, Sara D. Roosevelt Park, East River Park, Washington Market Park, and Hanover Square.
76. Installation of a 9/11 memorial for Brooklyn Firemen, Keyspan Stadium, Surf Avenue between West Seventeenth Street and West Nineteenth Street, Brooklyn (Preliminary), 23 October 2002.
77. See David Andreatta, "Island 9/11 Memorial 'nice but . . . ,'" *Staten Island*

Advance, 14 August 2003 http://www.silive.com/printer/printer.ssf?/base/
news/1060868804255720.xml (accessed 14 August 2003). For pictures and
information, see Council on the Arts and Humanities for Staten Island,
"'Postcards' Will Be Staten Island September 11 Memorial," http://www
.statenislandarts.org/September_11_Memorial/rfppage.html. See also "Cul-
tural Staten Island September 11 Memorial," http://www.bovislendlease.com/
llweb/bll/main.nsf/images/pdf_se_cultural_statenisland.pdf.

APPENDIX A

1. The commission's responsibility for City Hall and municipal artwork was an
 oversight function articulated through the ACNY's *Catalogue of the Works of
 Art Belonging to the City of New York* (New York: [Gilliss Press], 1909).
2. Robert De Forest to Francis Gallatin, 19 January 1921, CF 309, ACNY.
3. Samuel Ordway, Jr., to ACNY, 21 February 1927, CF 168, ACNY.
4. Adolph Weinman to James J. Walker, 21 June 1929, CF 173, ACNY.
5. William J. Pedrick to I. N. Phelps Stokes, 4 June 1930; Stokes to Pedrick,
 6 June 1930; Edward Rothschild to Julius Miller, 10 June 1930; Walter Her-
 rick to D. Everett Waid, 11 January 1932; Waid to Herrick, 15 January 1930;
 Stokes to Herrick, 20 February 1932, 27 February 1932, 24 March 1932; Her-
 rick to Stokes, 3 March 1932; Waid to Stokes, 8 March 1932—all in CF 309,
 ACNY.
6. See Stokes to New York City Charter Commission, 12 June 1934; I. N. Phelps
 Stokes telegram to Herbert Adams, 5 June 1934. See also John Gregory to
 Fiorello La Guardia, 23 January 1934. All in CF 30A, ACNY.
7. See ACNY, *Condensed Report of the Art Commission of the City of New York for
 the Years 1930–1937* (New York: ACNY, 1938), 35; Stokes telegram to Adams,
 5 June 1934, CF 30A, ACNY.
8. ACNY Minutes, 12 March 1979.

APPENDIX B

1. On Percent for Art, see Eleanor Heartney and Adam Gopnik, *City Art: New
 York's Percent for Art Program* (New York: Merrell, 2005).

INDEX

Note: Page numbers in italics refer to figures.